Art Against Dictatorship

BOOK TWENTY-NINE
Louann Atkins Temple Women & Culture Series
Books about women and families, and their changing role in society

Art Against Dictatorship

Making and Exporting Arpilleras *Under Pinochet*

by JACQUELINE ADAMS

University of Texas Press ⊷ Austin

To JUANITA CARRIÓN, SARA MENA, *and* MATILDE ESTRELLA ABRIGA, *and in memory of* ADA OCARANZA LÓPEZ

The Louann Atkins Temple Women & Culture Series is supported by Allison, Doug, Taylor, and Andy Bacon; Margaret, Lawrence, Will, John, and Annie Temple; Larry Temple; the Temple-Inland Foundation; and the National Endowment for the Humanities.

Requests for permission to reproduce material from this work should be sent to:
Permissions
University of Texas Press
P.O. Box 7819
Austin, TX 78713-7819
http://utpress.utexas.edu/index.php/rp-form

♾ The paper used in this book meets the minimum requirements of ANSI/NISO Z39.48-1992 (R1997) (Permanence of Paper).

LIBRARY OF CONGRESS CATALOGING-IN-PUBLICATION DATA

Adams, Jacqueline.
 Art against dictatorship : making and exporting *arpilleras* under Pinochet / by Jacqueline Adams. — First edition.
 p. cm. — (Louann Atkins Temple Women & Culture Series ; Book Twenty-Nine)
 Includes bibliographical references and index.
 ISBN 978-0-292-74382-3 (cloth : alk. paper)
 ISBN 978-1-4773-0204-0 (paperback)
 1. Women—Political activity—Chile—History—20th century. 2. Arpilleras.
 3. Decorative arts—Political aspects—Chile—History—20th century. I. Title.
 HQ1236.5.C5A33 2013
 305.40983—dc23

 2013000933

doi:10.7560/743823

Contents

Preface

One hot afternoon some years ago, a colleague at UNICEF in Santiago, Chile, and I were talking about the city's shantytowns,[1] when he spontaneously offered to take me with him to La Victoria, one of the most rebellious and repressed of these during the Pinochet regime. Curious to discover a part of Santiago I did not know, I accepted. We took the long bus ride to La Victoria's edge and entered the narrow, partially paved streets almost devoid of cars, which the inhabitants could not afford. Their absence and the resulting quiet lent the neighborhood the calm air of a village, further strengthened by the low, one-story brick and wood homes, and people walking around in a relaxed way in the sunshine. This peaceful atmosphere, however, was a fairly recent phenomenon. The Pinochet dictatorship had ended only two years previously, and many times during that era soldiers' shooting, raids on houses, and curfews made people afraid to step out of the gates of their homes.

My colleague led me to one of the few two-story houses, and we went upstairs to a spartan little room with wooden floors. This was the home of André Jarlan, he explained, the French priest who had worked in La Victoria and was sitting at his desk reading his Bible one day in 1984 when a bullet shot by a policeman smashed through the slim wooden wall, hit him in the neck, and killed him. There indeed, on the little desk, was a small, blackish-brown bloodstain. André Jarlan was just one of the many victims of repression in the shantytowns during the dictatorship. Many families had their homes raided by soldiers looking for weapons, and their people taken prisoner, beaten, or shot at if outside after curfew.

As André Jarlan was much loved, his death gave rise to a protest march in which hundreds walked from La Victoria, in the south of the city, to the cathedral

in the center. Among the marchers were inhabitants of his neighborhood and sympathizers from other shantytowns. Some would have been members of the many small groups that had sprung up to cope with exacerbated poverty and the repression: cooperatives of previously unemployed men and women, human rights committees, community kitchens, buying cooperatives, and community vegetable patch groups. Others would have been members of clandestine leftist parties; all would have been hoping for the regime's end. The front row of marchers carried what had become, for this resistance community, a symbol of the suffering and struggle against the regime: a picture in cloth called an *arpillera*. The *arpilleras* are the subject of this book.

Such protests and state violence were remote events when I was a child; Chile was a distant land from which my mother came. There were little pieces of it at home, however: Chilean books, a few craftworks, and the occasional Chilean dish. My mother sometimes made mashed avocado on toast, and *tortillas* (green bean omelets), and she would organize the selling of empanadas (Chilean meat pies) at my school fête's Latin American stand. A few pieces of Chilean pottery, some copper teapots, and a copper candlestick decorated our living room, and when I was five, my Chilean grandmother had come to visit, bringing me Chilean books and a large doll in traditional costume. One winter, Chilean family friends returned from their annual visit home and brought us a large embroidered woolen picture of rural life, which became a splash of color on the living room wall. It was made by the women of Isla Negra, a seaside community where families lived off fishing, baking, running small businesses, and serving the well-to-do from Santiago when they came to their second homes by the beach. The Isla Negra wall hangings are one of the art forms that *arpillera* makers claim as the precursor of their own more political art that is the subject of this book.

My mother was happily uprooted from Santiago. She was not part of the Chilean refugee community that began arriving in Switzerland soon after the 1973 coup, nor was she involved with its political activities, although she was anti-dictatorship. She had left Chile for Brazil in 1966 "for love," as I was later to explain to many Chileans who wanted to gauge my political position. A great many Chilean exiles lived in our cosmopolitan little city of Geneva, but as a family we never went to the events they organized. However, a friend took me to a *peña* (an evening of Chilean folk music aimed at raising funds for the struggle against the dictatorship), and I remember a warm, dim, crowded room in which locals and Chilean exiles intermingled, drinking red wine and eating empanadas to the accompaniment of Chilean folk music and dancing. Although I do not remember seeing any at the time, it was at such events that many *arpilleras* were sold. Many years after that first *peña*, this book picks

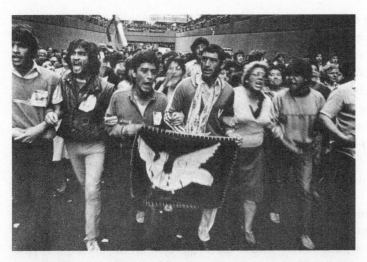

Two men in the front row of marchers carry an *arpillera* as they walk to the funeral of the priest André Jarlan, in the center of Santiago, 1984. The *arpillera* depicts a dove, symbolizing peace and alluding to the wish for an end to the state violence. Image scanned from a postcard; photograph by Álvaro Hoppe.

up these shadowy presences of Chile and of the Chilean exile and resistance community. In my midtwenties, it was the strong desire to learn more about Chile and meet my many relatives that pushed me to go and work there. It was then that I visited André Jarlan's house, a visit that contributed to my decision, three years later, to begin research on women from Santiago's shantytowns and their making of *arpilleras*.

Arpilleras are cloth pictures in cloth the size of a cafeteria tray, made out of cut-out pieces of old clothing (or new material in later years) sewn onto a rectangle of sacking or sackinglike material. During most of the dictatorship years, their makers, primarily the women inhabitants of shantytowns, portrayed in them the unemployment, poverty, and repression that they endured; their work to make ends meet; and their varied forms of protest. The *arpilleras* were smuggled out of Chile, primarily by a Catholic Church–affiliated human rights organization, the Vicaría de la Solidaridad (Vicariate of Solidarity, commonly referred to as "*la* Vicaría")—although also by the Communist Party, a feminist organization, and a Catholic nonprofit—to Chilean exiles and local human rights activists, mainly in Europe, Canada, and Latin America. These men and women sold the *arpilleras* to the public, thinking of their selling as part of "*la solidaridad con* Chile" (the solidarity effort for Chile), aimed at helping the *arpillera* makers and the resistance. They sent the money earned back to Chile, in most cases to the Vicaría de la Solidaridad, which used it to pay the

x women for the next batch of *arpilleras* made. Buyers, meanwhile, understood their buying of *arpilleras* as a way of sending money to the regime's victims and expressing their support for the women.

My research on the *arpilleras* would lead me to follow these pictures in cloth on their laborious journey from the shantytowns, through the Vicaría, and on to Europe and America, where I interviewed exiles and local human rights activists who had sold them and viewed shops in which they were still available. Like the *arpillera* makers, the qualitative sociologist constructs a picture, based on some of the stitches and cloth of her own trade: interviews, participant observation field notes, photographs, and archival documents, in the case of this book. I trust that my picture does justice to the lives of grinding poverty and determined and often dangerous work of these women of the shantytowns, as well as to the valiant efforts of the Vicaría staff, Chilean exiles, and human rights activists who worked hard to export the *arpilleras* and find eager buyers.

Acknowledgments

I am very grateful to the *arpilleristas*, the members of the Vicaría who worked with the *arpilleristas*, the Chilean exiles, and the human rights activists outside Chile who kindly granted me interviews. I would like to give very special thanks to Juanita Carrión, Ada Ocaranza, Sara Mena, and Estrella Abriga for their tremendous help in the field and for the care and friendship they showed me. I am also appreciative of the help of the Villa Sur group, the Paraméntica group, Gustavo's group, the members of the Conjunto Folclórico of the Agrupación de Familiares de Detenidos-Desaparecidos in Santiago, and the Bordadoras Lomas de Macul, with whom I spent many hours. I am very appreciative of the help and kindness of Alicia Salazar, Toya Díaz, Violeta Morales, Anita Rojas, Doris Meniconi, Inelia Hermosilla, and Yolanda Osorio; sadly, the last five of these extraordinary women have passed away. Thank you also to Valentina Bonne and Gustavo at Prisma de los Andes, Benita Villanueva, Aída Moreno, Viviana Díaz, and the professionals at FASIC, PIDEE, CODEPU, SERPAJ, CINTRAS, MEMCH, Tierra Nuestra, and FLACSO. I was assisted in the work of transcribing by social science students, including Paula Asún and Osvaldo Bañuelos, to whom I am grateful.

I wish to express my gratitude to the staff of the Vicaría's archive in Santiago, the Fundación Documentación y Archivo de la Vicaría de la Solidaridad, who gave me access to primary and secondary sources in visual and textual form and allowed me to photograph their albums and *arpilleras*. I am also very grateful to the staff of the Interlibrary Loan Service at the University of California at Berkeley, who brought from libraries in the United States and abroad the many documents and books that I requested. I benefited greatly from and thoroughly enjoyed the very stimulating intellectual environment at the Beatrice Bain

xii Research Group on Gender, the Center for Latin American Studies, and the History Department at the University of California at Berkeley, and in this regard would like to thank in particular Paola Bacchetta, Margaret Chowning, Mark Healey, and Harley Shaiken. Also while at Berkeley, I had the pleasure of training the following students in research methods, all of whom lent valuable assistance to the latter stages of producing the book: Meghan Lowe, Sarit Platkin, Dejanira Cruz, Beatrice Lau, Bram Draper, Priscilla Rodgers, Tamara Wattnem, Dennie Bates, and Jane Magee. At an earlier stage of the research I was at the University of Washington's Department of Sociology, to whose staff and students I am appreciative for their support and friendship.

I am deeply grateful to Howard Saul Becker at the University of Washington and Colin Samson at the University of Essex, who gave me guidance with all aspects of the research when it was in its earliest stage as a dissertation project. The question the dissertation addressed was different from that of this book, but there is overlap in the dataset, and the many skills I learned with them about data gathering, analysis, and writing were invaluable throughout. Howie's hospitality when I was "fresh off the boat" in the United States and his generosity in acting as a mentor in ensuing years have made a deep impression on me, and I wish to express my heartfelt thanks to him. I also wish to express my gratitude to my colleagues and friends Kathryn Poethig, Ellen Fernandez-Sacco, Michele Pridmore-Brown, Elly Teman, and Natascha Gruber, who read parts of the manuscript and offered helpful comments and delightful conviviality. Thank you also to the anonymous reviewers of my book, and to Theresa May, its editor, and her staff.

To my family, who has been wonderfully supportive, I am very grateful. My parents, María Angélica Adams and Paul Henry Adams, encouraged and supported me in many ways, and my aunt Pilar Moreno Saez and great-aunts Irene Moreno Wilson and Anita Morandé Fabres were most hospitable and affectionate. Thank you also to my friends Raúl Herreros, Esteban Cox, Bill Peria, Kaela Warren, Rebecca McLain, and Jim Preiss, with me while I was conducting fieldwork and writing, and to my husband, for whose intellectual and emotional partnership I am profoundly grateful.

Art Against Dictatorship

1 Solidarity Art

Repressive regimes can spark creativity, in that individuals who do not consider themselves artists seek ways to communicate that evade repression and censorship.[1] New art forms emerge, new artists arise, and preexisting artistic genres evolve, while more established art forms, venues, and artists may be repressed. When, for example, national security doctrines result in the incarceration of what come to be called "political prisoners," these prisoners may begin making art in their cells, and their relatives may begin creating denunciatory art. In Chile under the Augusto Pinochet dictatorship (1973–1990), political prisoners carved tiny sculptures of fists, doves, and villages out of avocado seeds and bones, and made etchings on pieces of scrap metal. At the same time, a small group of relatives of the disappeared (individuals who were taken away by the secret police and not seen again) produced protest songs and a protest dance as a way of denouncing the disappearances. Their *cueca sola*, (literally "cueca alone") was an adaptation of Chile's flirtatious national dance, *la cueca*, in which a man seduces a woman; in the *cueca sola*, the woman dances by herself, suggesting that her male partner has disappeared. Young people began painting murals with anti-regime and pro-peace statements on public walls in shantytowns at night.[2] Semiclandestine theater emerged, expressing ideas critical of the regime.[3] A "vast cultural movement" arose that included varied forms of artistic expression aimed at survival or active resistance.[4]

This is a book about one such form of artistic expression, which arose under the Pinochet dictatorship: the *arpillera*. The *arpilleras* were pictures in cloth depicting unemployment, poverty, repression, economic survival strategies, and protests. They were made mostly by women living in shantytowns in Santiago, Chile's capital, and were sold mostly abroad, to buyers who bought primarily

2 to support the women financially and express solidarity with them. In this sense, they are an example of what I term *solidarity art*, that is, art made by individuals experiencing state violence and economic hardship, which others distribute, sell, and buy to express solidarity with the artists and give them financial support. This book focuses not on the *arpilleras* themselves, but on the transnational community of individuals who made, exported, sold, and bought *arpilleras*. It examines the emergence of this community, the work of the individuals with-in it, and the consequences of this work for the regime and the artists. It aims to contribute to our understanding of resistance to dictatorship both within the country and abroad, and to our knowledge of art as a means of coping with and denouncing dictatorship and poverty.

Other categories of people in addition to women whose main problem was poverty also produced *arpilleras*, including female political prisoners, relatives of the disappeared,[5] low-income women from three rural towns near Santiago, a group of unemployed men who had been political prisoners, and Chilean exiles in Sweden and England, but the largest category, and the focus of this book, is women inhabitants of Santiago's shantytowns. To distinguish these women from the other groups of *arpillera* makers, I refer to the first group as "unemployed women" or "unemployed *arpilleristas*" (*arpillera* makers), since they thought their main problem was unemployment, and both they and the organizations that supported them called their *arpillera* groups "workshops of unemployed people" (*talleres de cesantes*). These shantytowns in which the unemployed *arpilleristas* lived stretched in a ring around the city's center on all sides but the northeast, having emerged mostly in the 1950s, 1960s, and 1970s as the result of government housing programs or illegal land seizures.

The *arpilleras* depict mostly their makers' experiences of the dictatorship.[6] They show, for example, shantytown women cooking food in community kitchens for local children whose families could not afford to feed them, men being turned away from factories in their search for jobs, and water-spraying vehicles and soldiers harassing protesters. Some *arpilleras* work at the symbolic level, showing doves in cages and hands in chains, and some illustrate the articles of the 1948 Universal Declaration of Human Rights.[7] Thousands were produced during the dictatorship, far fewer subsequently.

Differences in content marked the *arpilleras* of the various categories of *arpillerista*. Brigitte, an *arpillerista* from a shantytown in southern Santiago, described the unemployed women's *arpilleras* in this way: "You would do an *arpillera*, and in it you would show what was happening here. The repression, the protests, when the police arrived and began hitting people, shooting. We would sew all that. Like the *arpilleras* of the detained and disappeared, because they would show more, because they had their relatives who had this problem.

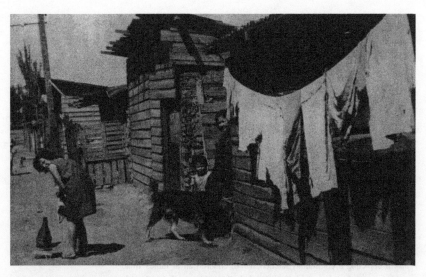

Photograph of a shantytown street in southern Santiago during the dictatorship. María Olga Ruiz, Eulogia San Martín Barrera, Centro de Promoción Humana Tierra Nuestra, *Las Mujeres en la Historia de la Comuna de La Granja* (Santiago: LOM Ediciones, 2001).

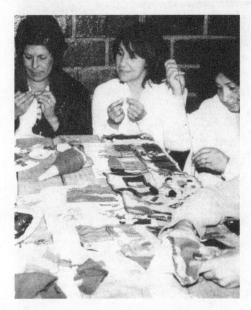

An *arpillera* workshop in a Santiago shantytown. The women talk as they sew. Vicaría de la Solidaridad, Agenda 1990.

4

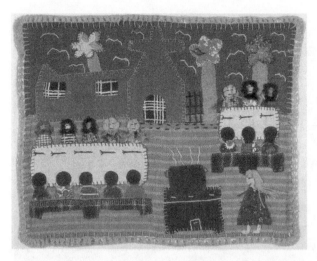

Arpillera depicting a community kitchen, 1978. Children sit at tables while a woman oversees a large pot. The church in the background denotes the priest's support. Scanning of an *arpillera* postcard produced in 1978.

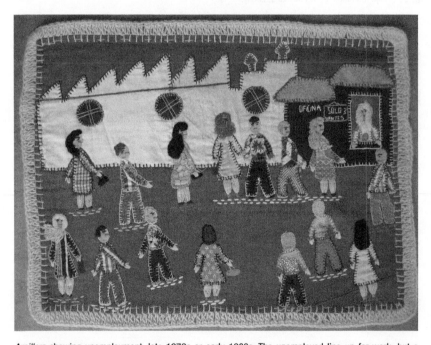

Arpillera showing unemployment, late 1970s or early 1980s. The unemployed line up for work, but a sign on the factory indicates that there are only three vacancies. Photograph by Jacqueline Adams of an *arpillera* in the collection of André Jacques and Geneviève Camus.

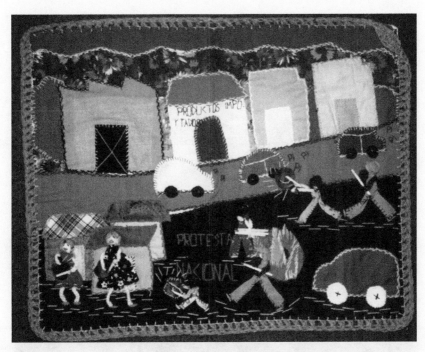

Arpillera showing a protest being repressed, late 1970s. Soldiers chase after protesters who bang on pots. Photograph by Jacqueline Adams of an *arpillera* in the collection of Verónica Salas.

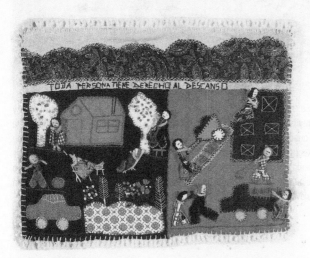

Arpillera depicting the right to leisure. On the left are people at leisure, probably in a wealthy neighborhood because of the car, trees, and flowers. On the right, people are working. The words read, "Everyone has the right to leisure." Scanning of an *arpillera* postcard produced in 1978.

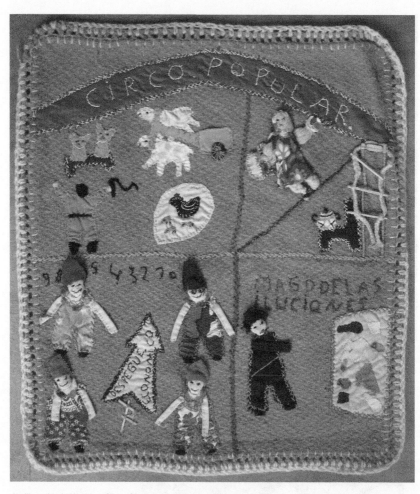

Arpillera titled "Working-Class Circus" that uses symbolism and humor to communicate that the country is poorly run and the economy is faring badly, late 1970s or early 1980s. The four members of the junta are in the bottom left-hand quadrant, dressed as clowns. By juxtaposing them with an upward-pointing arrow saying "economic takeoff," the *arpillera* maker indicates that the supposedly healthy economy is a joke. In the bottom right-hand quadrant, a magician produces food. In the top right, a woman tries to balance herself as she walks a tightrope. Photograph by Jacqueline Adams of an *arpillera* in the collection of André Jacques and Geneviève Camus.

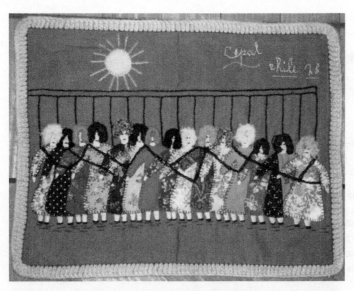

Arpillera by a relative of a disappeared person depicting the relatives protesting by chaining themselves to the fence of the United Nations building. Although this protest occurred in 1978, the word "Chile" on the *arpillera* suggests that it was probably made later, for a client abroad who asked for this subject. Photograph by Jacqueline Adams of an *arpillera* in the collection of Isabel Morel.

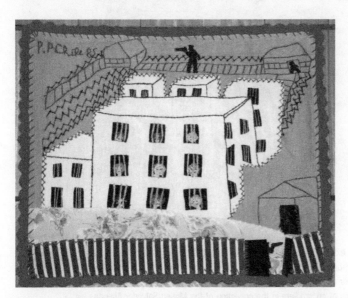

Arpillera by a political prisoner showing women in a heavily guarded prison. "P.P. Chile 85" indicates that it was made by "*Presas Políticas*" [Political Prisoners] in 1985. Photograph by Jacqueline Adams of an *arpillera* in the collection of Isabel Morel.

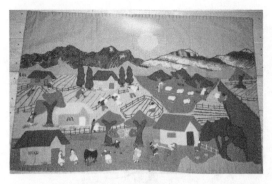

Arpillera made by women from the small rural town of Melipilla. It shows women making balls of wool and cooking in the foreground. The *arpillera* was photographed in spring 1995 in the storage room of Magasins du Monde in Lausanne, Switzerland, and probably made a few months before this. Photograph by Jacqueline Adams.

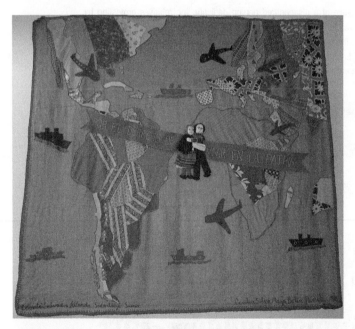

Arpillera by Chilean exiles in Sweden, saying "For the right to live in one's country." A man and woman embrace, probably because they have been separated by exile. The artists' names appear on the bottom. The date in the bottom right is 1980. Photograph by Jacqueline Adams of an *arpillera* in the collection of the Museo Salvador Allende, Santiago, Chile.

And we didn't. For example, in my house there was no relative in that situation. 9
The only problem we had was unemployment." Sometimes unemployed
arpilleristas made *arpilleras* depicting the problems of people other than
themselves, such as artists protesting against the regime and being sprayed with
water by military vehicles. The *arpilleras* of the relatives of the disappeared
evoked the disappearances, often showing the kidnapping of the disappeared
person, relatives searching for him or her, the emotional consequences of the
disappearance for the *arpillerista*, and protests regarding the disappeared,
although this group also depicted the economic survival strategies of the
unemployed *arpilleristas*. The *arpilleras* of political prisoners were often
explicitly about human rights, and depicted the prisons, exile, protests,
repression, and dreams for a better society; they were "sharply denunciatory,"
as a woman who exported them described them. Those by the women from
rural towns tended to have a countryside setting, and to include people at work
in the fields or tending to animals. The men's *arpilleras* were "more rectilinear,"
"schematic," and "symmetrical" in form, in the words of a staff member of the
main exporting organization. Finally, the *arpilleras* of exiles depicted exile,
return, and political prisoners, and some contained symbolic images.

While most *arpilleras* are anti-regime in content, those made toward the end
of Pinochet's presidency and since contain mostly cheerful scenes not intended
to contain political commentary. They show, for example, fruit picking, bread
baking, market stalls, children dancing in a circle, and children going to school.
Even though some of these activities had been forms of economic survival
while living in poverty under the regime, in depicting them the *arpilleristas* no
longer saw themselves as criticizing the government.[8] Post-dictatorship, some
arpilleras were made larger or much smaller than the original ones, or were
shaped differently. New *arpillera* products also made their appearance: letter
holders, vests, and other utilitarian objects, all containing some of the elements
that are always found in *arpilleras*, such as houses, people, and trees, and made
using the same appliqué technique. In sum, the *arpilleras* became less political
and more bucolic in content as time went on; meanwhile, the distribution
system became more commercial in orientation.

Most *arpilleristas* were married shantytown mothers of Spanish and
indigenous descent living in Santiago, although there were also some single,
widowed, separated, and partnered women who made *arpilleras*. They came
to *arpillera* making because their husbands had lost their jobs during a sharp
increase in shantytown unemployment caused by the regime's new neoliberal
austerity measures and national security doctrine, which encouraged the
politically motivated firing of leftists.[9] As there was little unemployment
compensation available and not everyone knew how to access it, these families'

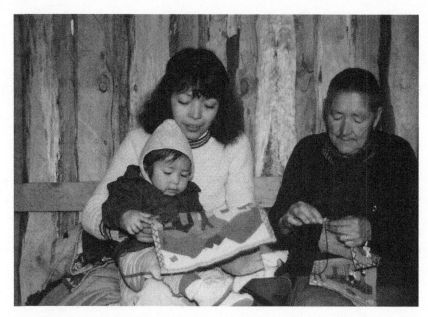

Two *arpilleristas* and a baby in a workshop in northern Santiago, mid-1980s. Photograph by Liisa Flora Voionmaa Tanner.

financial situation became critical, with many of the mothers having difficulty putting food on the table. In response to this exacerbated poverty, they tried to earn some money for their family's basic needs, and one of the ways in which they did so was by joining the *arpillera* groups that were mushrooming in the shantytowns, or the food-procuring groups and income-earning groups of another nature, which in some cases later became *arpillera* groups. They also sought jobs as maids, made food and drinks that they sold entrepreneurially in public places, and worked in emergency employment schemes, sometimes simultaneously joining *arpillera* groups for extra income.[10]

The women of the shantytowns endured not only poverty, but also *generalized repression*, that is, the repression that all shantytown inhabitants suffered,[11] which took the form of soldiers shooting people who were out after curfew, military men patrolling the streets, occasional helicopters overhead, and raids by soldiers on all homes in the neighborhood in the middle of the night, with the men in the family being marched off to an open space for a few hours. Some shantytown women also experienced *targeted repression*, that is, persecution of a more acute kind aimed at one individual, such as disappearance, incarceration, torture, murder, exile, or internal exile.[12]

The unemployed *arpilleristas* were numerically dominant vis-à-vis the other categories of *arpilleristas*, as suggested by the number of their groups. During the first months of *arpillera* making, there were five groups of unemployed women and one group of relatives of the disappeared in eastern Santiago; one unemployed women's group in northern Santiago; and one "mixed workshop," containing both unemployed women and relatives of the disappeared, in the south of the city. The unemployed women's groups soon multiplied and spread throughout Santiago. Meanwhile, the *arpilleristas* who were relatives of the disappeared went about creating mixed workshops in various neighborhoods. Isolda, a relative, said, "We started in the workshops that were forming in churches. And we did it there; we created 'mixed workshops' (*talleres mixtos*), as they are called, which were people from the shantytown and us, the relatives of the detained and disappeared." While there were several mixed workshops, half of whose members were unemployed women, there were only two groups in Santiago containing just relatives of the disappeared, one of which was created at the very beginning of the regime and the other later on.[13] Meanwhile, there were dozens of unemployed women's groups.

SOLIDARITY ART, SOLIDARITY ART SYSTEMS, SOLIDARITY ART COMMUNITIES, AND SOLIDARITY FLOWS

The *solidarity orientation*, or wish to lend support, of a handful of staff members of two humanitarian-cum–human rights organizations and of numerous priests was very important for the emergence of the *arpillera*. The first of these organizations was the Comité de Cooperación para la Paz en Chile (Committee of Cooperation for Peace in Chile), commonly called the "Comité" or "Comité Pro-Paz." It was set up less than a month after the September 1973 military coup by leaders of the Catholic Church; the Lutheran, Baptist, Methodist, and Methodist Pentecostal Churches; and the Jewish and Greek Orthodox faiths to help the victims of repression and recent unemployment. At the end of 1975, General Pinochet ordered that it close down, but one of its leaders, the Catholic cardinal Raúl Silva Henríquez, re-created it in January 1976 under a new name, the Vicaría de la Solidaridad (Vicariate of Solidarity). It ceased to be ecumenical, and its structure was altered slightly, but its work remained the same. As the cardinal made it legally part of the archdiocese of Santiago, it was relatively protected from another enforced closure by General Pinochet and from violence by soldiers, but its staff endured harassment.

One of the Comité's and the Vicaría's goals was to help shantytown families cope with unemployment and impoverishment. Part of their work in this regard involved encouraging shantytown women to make *arpilleras* and finding

12 buyers for them, locally and abroad. The Comité and the Vicaría exported *arpilleras* by the thousands, mostly to Europe, but also to North America, Latin America, and Australia. They sent them to Chilean exiles, human rights activists, and church staff, who were willing to sell them to the public in order to help the *arpilleristas*. These sellers set up stalls or exhibited for this purpose at Chilean and "Third World" solidarity events (as they called them), music festivals, churches after Mass, universities, women's buildings, neighborhood fairs, and craft markets, and some sellers sold to charities and fair trade shops. Most of the buyers were locals in the countries in which the sellers sold, and did not normally know much about the situation in Chile but learned more in the process of talking to the seller. They "bought out of solidarity" (*compraron por solidaridad*), as the *arpilleristas*, Vicaría staff, and sellers put it, wanting to help the women and express their support for the pro-democracy struggle. Sellers called them *gente solidaria* (solidarity-oriented or supportive people). Chilean exiles also bought *arpilleras*, in part as a way of sending money to the women. Within Chile, leftist Chileans, foreign visitors, and visiting spouses of exiles were the main buyers of *arpilleras*, although they were far fewer in number than the buyers abroad. They bought secretly, mostly from the Vicaría's office and directly from *arpillera* groups.

The *arpilleras*, as mentioned earlier, are an example of *solidarity art*.[14] The central characteristics of solidarity art that distinguish it from other forms of art are that it is distributed, sold, and bought by individuals wanting to express solidarity with the artists and send them money. Solidarity art tends not to be made by trained artists or to be "high art"; often it is art that some might classify as craft.[15] It may or may not contain a critique of the government. Often it is made collectively. Solidarity artists are active in many parts of the world; in the occupied territories of Palestine, for example, women embroider small bags that activists sell at peace marches abroad, such as at the anti–Iraq War march in San Francisco in May 2007, during which Palestinian immigrants were selling from stalls outside the central City Hall, where the march ended. In the southern Mexican state of Chiapas, indigenous women adapted the dolls they made to represent the Zapatistas, a Maya group struggling for indigenous rights, and liberals in Europe and elsewhere sold them in the 1980s to raise money for the struggle.[16]

Although solidarity art is born of repression and deprivation, its makers may be far from the impassioned individuals we might imagine them to be. Even when their art is denunciatory, they do not necessarily make it in order to protest or denounce; instead, they may be motivated by financial considerations or a wish to lessen their distress.[17] Over time, however, ideological motivations

may arise in addition to pragmatic ones, with the artists coming to want to denounce their oppression and poverty. Similarly, their motives may not be art-focused initially, and the ways in which they see themselves may not be art-centered; the artists may view themselves as doing a job to earn an income, more than as making art, and they may be slow to consider themselves artists, or never acquire this self-perception. They may never have engaged in an artistic activity previously, other than that which goes into work such as cooking and sewing, and they may have slipped into art making quite by chance, as an unintended consequence of another activity or objective, such as earning money.

There are similarities between solidarity art and fair trade products. The idea behind fair trade is to support producers in industrializing countries by offering them a fair price, thus avoiding exploitative practices. In a similar way, the sellers and buyers of solidarity art sell and buy in part to support individuals or a humanitarian cause. What distinguishes solidarity art from many fair trade products is primarily the way it is sold and bought: the aim of the fair trade organization is to make a profit, and fair trade buyers tend to purchase so as to acquire. Those who sell solidarity art aim not for a profit for themselves, but rather for money to give to those whom they support. Similarly, the buyers of solidarity art buy largely so as to *give*; the wish to acquire the art for themselves may also be a motive but is not the primary or exclusive one. A further distinguishing feature is that the solidarity art may contain messages about the suffering or resistance of the group being supported, whereas fair trade products rarely do. Solidarity art may change over time, however, losing its political content and becoming more like other fair trade products; it may even end up being sold mainly in fair trade shops, as happened to the *arpilleras* in the late 1980s and thereafter.[18]

Taken together, the activities of production, distribution, selling, and buying of solidarity art constitute what I term a *solidarity art system*. The word *system* is chosen to evoke a bundle of coordinated activities, as in a machine. Solidarity, in the sense of giving support to others, is the fuel that powers this system. It is the prime motivation for buyers' buying, sellers' selling, and exporters' exporting, and it is even, indirectly, a motive for artists' art making in that the artists hope and think that people will buy their work out of solidarity. Solidarity is the raison d'être of solidarity art systems.

The artists, exporters, sellers, and buyers who make this system work are a *solidarity art community*. Howard Saul Becker has brought us the concept of the "art world" to describe "all the people whose activities are necessary to the production of the characteristic works which that world, and perhaps others as well, define as art."[19] Whereas "art world" refers to the people involved in

14 the *production* of the art, "art community" refers to a broader group of people whose activities are necessary not only for the production but also for the distribution, selling, and buying of the art. However, a solidarity art community is more than a network of individuals cooperating to produce, export, sell, and buy art. Its members feel that there is shared thinking within the community, as well as a shared political stance; shared emotions; a sense of shared danger; shared protective measures; and shared secret information, trust, and mutual dependence as regards safety from repression. Solidarity art communities are different from other art communities in that solidarity is what motivates all parties. Another distinguishing feature is that what flows through solidarity art communities is more than art and money. Artworks together with information about suffering, instances of repression, human rights violations, and resistance flow in one direction, and money and moral support flow in the other; these constitute *solidarity flows*.

A solidarity art community is a resistance community that tends to be transnational. It is normally part of a broader transnational resistance movement that aims to help the survivors of a state violence and rid the country of its oppressor. The solidarity art system that such communities keep in motion is a particularly well-functioning part of the resistance movement, because there is something tangible that is circulating, and because most of the people within the solidarity art community are united by a simple, concrete, shared goal: to send money to groups in need and express solidarity with them. Hence solidarity art becomes the focal point for the formation of a transnational network of individuals working together to bring about the end of a repressive government.

Solidarity art is a subset within a broader category that I term *resistance art*, that is, art that helps the artists criticize those in power, or in some other way participate in resistance against a repressive government. Resistance art, like solidarity art, may or may not contain a critique. Solidarity art is a special kind of resistance art in that people help sell it and buy it in order to express solidarity with the artists and support them financially; within the broader category of resistance art are art forms that people sell and buy for other reasons. Dissident art, for example, is a subset of resistance art that people do not by definition sell and buy to express solidarity and support the artists. As a subset, it does, however, intersect with solidarity art in that some solidarity art expresses dissent from the government, a central characteristic of dissident art.

Resistance art has emerged under numerous repressive regimes, and during repressive periods under ostensibly democratic governments. In eastern Turkey, the Kurds have for decades used song to resist enforced "Turkification."[20]

In Soviet Russia, many resistance artists produced their work and exhibited secretly in apartments and other nonstandard places.[21] In Hitler's Germany, artists produced anti-Nazi postcards.[22] During the Second World War in France, writers used literature as a form of struggle against German occupation,[23] and in Prague, rabbis, when publicly humiliated by Nazis, sang in defiance.[24] In China, student members of the 1988 pro-democracy movement constructed a statue of democracy in Tiananmen Square, symbolizing the freedom for which they were struggling,[25] and they sang songs and published poetry containing hidden messages in newspapers. Brazil under dictatorship witnessed "theater of the oppressed," caricature, and music against the military regime.[26] During oppressive periods in the history of the United States, slaves produced slave narratives,[27] Japanese Americans in internment centers made crafts,[28] and Chicanos and Chicanas made murals against state repression and cultural and economic exclusion.[29]

One of this book's aims is to elucidate the concept of solidarity art. The book proposes that for solidarity art to emerge and continue to be produced under dictatorship, several key elements are necessary: first, artists with a compelling enough reason for making the art that they are willing to face the risks involved. These artists must also be able to overcome barriers such as repression, fear, gender expectations, and the absence of freedom of expression, and if the art is made in groups, barriers that would hinder group formation and continued activity, such as the absence of freedom of assembly. It is helpful but not essential if the artists know of other art forms made with inexpensive materials by people similar to themselves. A second necessary component for the emergence and production of solidarity art is buyers who are aware of the existence of the dictatorship and repression. Many, in the course of conversation with sellers of the art, become moved by the plight of the artists to the extent that they wish to offer support.[30] A third element is sellers who inspire trust that the money they collect will go to the artists. These sellers help build buyers' trust through face-to-face conversation, in what is an example of "transnational brokerage."[31]

Fourth, since solidarity artists may have few or no contacts that could help them sell their work, it is helpful that there be individuals or supporting institutions with contacts who are willing to sell and buy, both locally and abroad. The individuals or supporting institutions may have additional assets such as moral authority, financial means, a reputation as defenders of human rights, and the ability to offer protection from the onslaughts of the armed forces. These assets enable them to develop a network of sellers abroad, and make potential art makers less fearful of producing the art or joining groups in which it is made. Also helpful for the emergence of solidarity art is the support of local members of the clergy known to the artists and trusted by them. They

16 can offer the artists a room in which to meet where they feel relatively safe, help recruit new group members, and help sell their work.

As suggested earlier, a "solidarity orientation," or wish to help, is central to solidarity art systems. It is what motivates the supporting individuals or institutions, exporters, buyers, and sellers to do what they do. Buyers bought *arpilleras* and exiles and local human rights activists sold them so as to help the women who made them, and this same motivation prompted the Comité and the Vicaría, Communist Party members, and feminist organizations to export the *arpilleras*, and shantytown priests to support *arpillera* making in many ways. These individuals, and the staff of these institutions, feel sympathy for the victims and survivors of the repressive government and indignation with the oppressor, and these emotions fuel their solidarity orientation.

As well as examining the emergence and functioning of a solidarity art system, this book explores the consequences of solidarity art making, both for a dictatorship and for the artists. Solidarity art may whittle away the power of a dictatorship by helping inform people abroad and at home about human rights violations and social problems caused by the regime's policies. It can raise economic, moral, and political support for the victims and resisters of the regime. It may serve as a secret marker of membership in the anti-regime community and symbolize this community. If the artists work in a group, it is not merely the artworks that chip away at the regime but also the collective nature of their making. Art-making groups bring people out of isolation in a context in which forming organizations is difficult because of repression and fear. The groups form links with other resistance-oriented groups, and this helps rebuild civil society. In addition, they are spaces in which members can learn about and discuss human rights and the causes and extent of poverty and repression in the country.[32] This, in turn, makes the artists more likely to consider engaging in other forms of resistance and more likely to vote against the dictator should the opportunity arise. Solidarity art groups, then, are cells of resistance against repressive government, even if the artists did not join them with this resistance as their intention.

As well as shedding light on the questions of how solidarity art may emerge and be produced and distributed under a repressive regime, and the consequences of such production, this book offers insight into a number of other issues. One of these is the question of how repression affects solidarity art systems. Repression, it suggests, affects the production, export, selling, and reception of solidarity art, as well as the art itself. The *arpilleristas*, for example, met in their local shantytown church in part because they needed a place that was relatively safe from repression. They had to make their *arpilleras* in secret; when

they worked after curfew, some blocked their windows with blankets and used candles, and when they stopped working, they hid their *arpilleras*. When taking the *arpilleras* from their workshop to the Vicaría, some *arpilleristas* hid them under their skirts. The Vicaría staff forced the *arpilleristas* to tone down their more strongly denunciatory *arpilleras* because they grew afraid after *arpillera* making was criticized on the television news and in newspapers and packages of *arpilleras* were opened at the airport. They also devised strategies for preventing the *arpilleras* from being discovered as they were shipped out of Chile. Abroad, some sellers had their mail checked, and others found themselves the target of unpleasant articles in the Chilean press. The repression influenced sellers in still another way: it was something they talked about with buyers while explaining the *arpilleras*. Buyers bought *arpilleras* because they were moved to compassion, in part because of what they heard about the repression.[33] Repression, then, affected every part of the *arpillera* system (the solidarity art system for *arpilleras*).

The book also sheds light on the ways in which gender affects solidarity art systems, proposing that it influences the production, distribution, and buying of the art in addition to the art's form and content. In Chile, the women used the traditionally feminine skill of sewing to make their *arpilleras*. In them, they showed repression and poverty as they, as shantytown women, experienced them. The written messages that they put into their *arpilleras* often contained spelling mistakes and uncertain handwriting, reflecting the limited opportunity for an education that shantytown women tended to have. Shantytown-based gender expectations were part of the motivation for making *arpilleras*, in that, as women, the *arpilleristas* were responsible for putting food in the pot (*parar la olla*), and so felt compelled to find income-earning work when their husbands were unemployed, detained, or disappeared, and there was no money for meals. These same gender expectations created constraints; shantytown wives were supposed to stay at home looking after house and children, and so some faced reluctant or angry husbands when they went out to their workshop meetings, despite the family's need for money.

Motherhood impacts solidarity art systems and the solidarity art itself. It infused the way the *arpilleristas* worked; they took their children to workshop meetings and integrated them into *arpillera* making at home, appreciating the fact that with this work they could keep an eye on them while they sewed. In their *arpilleras*, the *arpilleristas* depicted children, sometimes their own children, sitting at the community kitchen, begging for food, languishing in jail, or being kidnapped, subsequently to disappear. The fact that the *arpilleristas* were nearly all mothers shaped the act of selling *arpilleras* many thousands of miles

18 away, in that the sellers told buyers that the *arpilleras* were made by impoverished shantytown mothers struggling to feed their children. In doing so, they were drawing on notions of womanhood as motherhood and motherhood as requiring protection, and this resonated with buyers.[34]

METHODOLOGY

The findings in this book emerge from the analysis of interviews; photo elicitation; archival data; ethnographic data, including participant observation field notes; and visual data created by photographing and by scanning photographs. I conducted 121 individual and group interviews, five and fifteen years after the end of the dictatorship, in 1995–1996 and 2005–2006. I interviewed *arpillera* makers; Vicaría and Comité staff; the staff of other institutions and commercial enterprises that sold or exported *arpilleras*; sellers of *arpilleras* in Switzerland, France, and England; and buyers in Europe, the United States, and Chile. I also interviewed professionals from the nonprofit sector in Chile who offered training to *arpilleristas* or interacted with them in other ways, and I interviewed General Pinochet's wife, who was the director of a large Chilean organization of mothers' centers in which low-income women made pro-regime *arpilleras*. All my interviewees came from a snowball sample with a very broad base.[35] I found my first shantytown women interviewees with the help of a Vicaría staff person who had sent their *arpilleras* abroad, and subsequent ones thanks to referrals by these women, by other Vicaría employees based in other areas of the city, by the staff of other humanitarian organizations, and by middle-class professionals who worked with shantytown women's organizations. The shantytown *arpilleristas* whom I interviewed came from the north, south, east, and west of the city. The interviews lasted between one and three hours and were semistructured. Aiming to let the interviewees speak for themselves, I used a short list of topics to be covered. Sometimes, as the interviewee was speaking, I probed for more detailed information. The interviews were recorded, transcribed, and coded; they were the main source of data on which the analysis for this book is based.

 As well as semistructured interviews, I conducted a small amount of photo elicitation during fieldwork in 1995–1996 and 2005. This is a technique, described by John Collier in 1967, whereby the researcher asks the research subject to talk about what is in a photograph. I showed some shantytown *arpilleristas* photographs of *arpilleras* by other groups and recorded their reactions; I also asked them to explain what some of these photographs depicted. Additionally, I conducted what I term "art elicitation," whereby I showed my subjects other examples of cloth-based artwork, including *arpilleras* by

different groups in Chile and by women in Peru, and encourage them to comment. Through this photo elicitation and art elicitation I learned about matters of technique, form, and content, and about shantytown women's experiences under dictatorship. For example, as most of the *arpilleras* I showed my subjects depicted women's poverty, the repression, organizations for coping with poverty, and protests, my subjects would tell me about these issues in the course of describing what was happening in the *arpillera*.

Another source of data was a year's worth of field notes from participant observation with groups of *arpilleristas*. I began this fieldwork in July 1995, five years after General Pinochet stepped down. Two of the *arpillera* groups were based in southern Santiago, and were composed of women from shantytowns there. A third group was the Folk Music Group (Conjunto Folclórico) of the Association of Relatives of the Detained and Disappeared (Agrupación de Familiares de Detenidos-Desaparecidos [AFDD]), nearly all of whose members had been *arpilleristas*. They were the wives, partners, mothers, sisters, daughters, and a sister-in-law of people who had disappeared, and they lived in shantytowns in different areas of Santiago, as well as in more central working-class neighborhoods. In addition to these groups, I observed two *arpillera* groups that also contained women from a range of shantytowns and more centrally located working-class neighborhoods who met once a week in a nonprofit organization in central Santiago to make *arpilleras* and learn how to run an *arpillera*-making cooperative. I also observed a group of women who made embroidered pictures and lived in a working-class neighborhood in Macul, a neighborhood southeast of the city center that was slightly too well-off to be called a shantytown. Because these last three groups had either formed after the dictatorship or did not make *arpilleras*, I did not analyze my field notes about them for this book, but rather gained insights from reading them and learned from the contrasts between these groups and my "main" groups.

All these groups accepted me as a participant observer, in which role I watched their work and helped as much as I could without changing what they normally did. I observed them for a year, except in the case of one of the groups of women from southern Santiago, which I observed for two months. Even though I concluded the participant observation five years after General Pinochet stepped down, the data gained are still pertinent to the issue of the emergence, production, and distribution of solidarity art under dictatorship, as they enabled me to learn about how women made *arpilleras*, about the shantytowns, and about shantytown family life. For example, while walking to the bus stop with an *arpillerista* one day, I learned that shantytown families worry about burglary and so build fences, preferring metal fences to

20 wooden ones, but not normally being able to afford them initially. Snippets of information such as this helped me better appreciate how women in shantytowns experienced poverty.

The book also draws on a visual database that I created, containing several hundred photographs of *arpilleras*, and a few of *arpilleristas* and their homes and of shops selling *arpilleras* in Chile and Europe. I began photographing *arpilleras* in 1994, beginning with the collections of human rights activists who had helped sell them in England, *arpilleras* displayed in fair trade shops in Switzerland, and a buyer's collection in Los Angeles. When I began fieldwork in Chile in 1995, I photographed *arpilleras* owned by the Association of Relatives of the Detained and Disappeared, ex-Vicaría employees, returned exiles, human rights organizations, and researchers. I later added to my database scanned copies of photographs of *arpilleras* from books, journal articles, and booklets.

Lastly, the book draws on archival research. I mined the Vicaría's archive at the archdiocese of Santiago (the Fundación Documentación y Archivo de la Vicaría de la Solidaridad) for articles and photographs of *arpilleras*. I took photographs of *arpilleras* hanging on its walls, and of photos of very early *arpilleras* contained in its photo albums, integrating these images into my visual database. In addition to the interviews, photo elicitation, fieldwork, creation of a visual database, and archival research, I read memoirs by people who had lived in or visited shantytowns during the dictatorship. These helped me learn about subjective experiences of shantytown life, and so inform this work.

My analysis of the data began while I was in the field. I regularly wrote analytical memos about important themes in the interviews and field notes, later checking what I had written by asking questions. Once the interviews were transcribed, I analyzed them by coding them, that is, by identifying key themes and giving them a code, and marking that code in the text. I then compared the parts of the interviews and field notes that were pertinent to a particular code, following the principles of grounded theory.[36] I used the articles I found in the Vicaría's archive to supplement information gained from interviews and as a way of checking what my other data revealed; one article, for example, was useful with regard to the thorny question of who had had the idea of making *arpilleras*. With the visual database, I conducted a thematic analysis of the images of *arpilleras* so as to be able to identify the most prominent themes in them.

The book's structure follows the *arpilleras* on their journey from shantytown *arpillera* workshops to the Comité and the Vicaría, to the sellers in Chile and abroad, and finally to the buyers. Toward its close, it examines the consequences of the *arpillera* system for the various parties involved. Chapters 2

and 3 address the emergence of *arpillera* making, and Chapter 4, its spread. Chapter 4 also introduces the *arpillera* groups of the relatives of the disappeared, political prisoners, and women from rural towns. Chapter 5 examines the production of *arpilleras*. Chapter 6 explores initial efforts to sell *arpilleras*, the emergence of the international distribution system, and selling by human rights activists abroad. Chapter 7 introduces the reader to buyers and the buying process, and Chapter 8 explores selling, gift giving, and exhibiting in Chile, along with government crackdowns. Chapter 9 looks at the women's and the Vicaría's perspectives on the consequences of *arpillera* making, while Chapter 10 provides concluding commentary.

THE DICTATORSHIP AND WHAT PRECEDED IT

Unlike many Socialist regimes that emerged in the twentieth century after a violent episode, Chile took a more peaceful route. "The Chilean way" (*La vía chilena*), as President Salvador Allende called it,[37] would bring Socialism to Chile through democracy and legal means. Allende became the first democratically elected Marxist president in the world, taking office on November 3, 1970, leading a coalition of leftist parties called Popular Unity (Unidad Popular, or UP). His Popular Unity program was premised on "beginning the construction of socialism in Chile."[38] Whereas the orthodox capitalist model for economic development encouraged private capital and foreign investment and anticipated trickle-down,[39] the Popular Unity program emphasized using the power of the state to reorient resources toward the poor through the continuation of agrarian reform, enlarging the sectors of the economy controlled by the state, and instituting social welfare programs that included giving a pint of milk a day to each child, expanding health services for the poor, creating day-care centers, and constructing low-income housing. It also aimed to generate employment at a decent wage level for all Chileans, reduce inflation, accelerate economic growth, and create a national unified education system. Importantly, it emphasized that Popular Unity would be multiparty and respect the rights of the opposition.[40] Although a change of course for Chile, this program was in some respects an extension of what had been done earlier; efforts toward land reform in rural areas had been promoted since 1958, for example, becoming more systematic after 1964. Chile's development strategies during the twentieth century had alternated between an export-oriented or growth-directed outward model and a growth-directed inward model emphasizing industrialization through import substitution.[41]

The Popular Unity's plans met with severe opposition. The Christian Democratic Party slowed down change in congressional negotiations, and the delays motivated impatient rural inhabitants of the south to occupy large

22 farms illegally,[42] often encouraged by such organizations as the Revolutionary Peasant Movement.[43] Factions within the Popular Unity coalition became apparent, with some members wanting to move toward Socialism quickly, ignoring legal constraints, and others preferring to advance through legal means.[44] There was also opposition from upper-middle-class housewives, who marched in the streets banging empty pots in October 1972, when food was lacking in local supermarkets. Meanwhile, business owners concerned about nationalization shut down businesses and services in what was known as the "October Strike," which lasted for four weeks and was settled with the incorporation of military men into the cabinet, the beginning of the armed forces' overt politicization.[45] Allende thus faced severe political challenges.

He also had to cope with economic problems. Inflation rose very rapidly, and by July 1973, the inflation rate for the preceding twelve months had reached 323 percent, fueled by large government deficits.[46] As an authority on the period states, "The Chilean wage earner saw his entire 22 percent wage readjustment disappear in the first five months of 1972, and shortages of food and replacement parts led to massive dissatisfaction expressed in women's marches, shopkeepers' strikes, and continued violence in the streets."[47] Meanwhile, alarmed about the threat to U.S. corporate interests that Allende's expropriation policies represented, the Nixon administration carried out a program of economic destabilization, denying Chile loans and credits from both American and international lending institutions and secretly funding opposition groups.[48]

Chileans had feared a coup but had not expected the levels of violence that accompanied that of September 11, 1973. It was on this day that the leaders of the armed forces stormed La Moneda, Chile's governmental palace. Before they had seized control completely, Salvador Allende addressed the nation to inform it about the coup and his unwillingness to resign.[49] Remaining within La Moneda, he allegedly committed suicide. The acting Commander in Chief of the Military, Augusto Pinochet, very quickly became the head of the military junta that was to rule Chile until 1990.

In the weeks and months after the coup, thousands of Chileans who had supported Allende were detained by the police, military, or secret police. Soldiers raided homes, rounded up thousands of suspects, took them to Santiago's main soccer stadiums, and tortured and executed many of them. The targets of this state violence were members of the Allende government, the Popular Unity parties, the Movement of the Revolutionary Left (Movimiento de Izquierda Revolucionaria; MIR), and workers and peasants suspected of participating in extralegal takeovers of factories and estates.[50] Of the 33,221 detained in Chile over the course of the dictatorship, 94 percent were tortured[51]

by the DINA, Pinochet's Directorate of National Intelligence,[52] akin to the Gestapo, and its successor, the National Information Center (Central Nacional de Informaciones; CNI). These institutions were responsible for many of the detentions and disappearances that occurred as well. The numbers killed during the regime were an estimated 1,068, not including the disappeared,[53] which are currently numbered at 1,163.[54] Adherents of the political Left had little choice but to flee Chile, and many were kicked out, becoming refugees and exiles. As an authority on exile states, "Between 1973 and 1988, an estimated 200,000 men, women, and children—nearly 2 percent of Chile's population—were forced out of their country for political reasons."[55]

The military junta's first political acts included the banning or recessing of political parties, the dissolution of congress, the implementation of a curfew and state of siege,[56] strict censorship and control of the press,[57] and the reversal of many of Allende's reforms. Unions soon became severely weakened,[58] while leftist parties and organizations went underground and their leaders were harassed, fired, imprisoned, or executed,[59] or escaped Chile. In December 1973, the regime issued a decree forbidding elections at any level, even in athletic and educational institutions.[60]

The economy was put into the hands of a group of economists known as the "Chicago Boys," whose neoliberal economic policies between 1973 and 1981 fostered the growth of nontraditional exports, consumer imports, and foreign loans.[61] They abolished all price controls, reduced tariffs, devalued the currency, slashed public spending, privatized industries that had previously been nationalized, and opened up Chilean markets to foreign investment.[62] The government responded to high social costs with a minimal safety net that targeted expectant mothers, small children, and the "extremely poor."[63] The results of such policies have been debated. Inflation and unemployment declined, although in 1980 the number of jobless was still twice that of 1970.[64] The years 1975–1976 and 1982 were ones of economic crisis and extremely high unemployment. Protests swept the country in 1983, much as they had under Allende. There followed an adjustment of the radical neoliberal economic policies;[65] as an authority on economic policy notes, "The change from dogmatic, orthodox neoliberalism to a more flexible, 'pragmatic' neoliberalism brought some tangible benefits. By 1985, the economy had begun to recover."[66]

Cells of resistance emerged throughout the nation, although because of the high levels of repression and fear, much of their activity was clandestine or semiclandestine. The "resisters" were primarily human rights advocates, leftists, centrists, workers, church leaders, and politicians.[67] Shantytown women and men were also important participants,[68] as were students, trade union leaders, and shantytown priests and nuns. Many of the subsistence

24 organizations that shantytown inhabitants formed in order to survive their impoverishment worked "on the side" to raise consciousness, inform, affirm community, participate in street protests, and give support to the survivors of targeted repression and people even poorer than they were.[69] Relatives of the disappeared, executed, and exiled and of political prisoners formed associations in which they worked to inform the outside world about what was happening, wrote letters to Chile's leaders, conducted hunger strikes, and protested in creative ways in public places. Resistance from artists and intellectuals took the form of demonstrations, plays, writings, and underground organizing. In both shantytowns and middle-class neighborhoods, cultural resistance was enacted through murals, music, theater, poetry, and staged protest actions that were made to appear spontaneous. The earliest street protests occurred in the mid-1970s, the Association of Relatives of the Detained and Disappeared being among the first to organize them. Mass protests did not begin until May 1983, when miners, students, workers, dissident political leaders, and members of shantytown groups took to the streets to register their discontent with the regime's economic, political, and social programs. Abroad, Chilean exiles organized to raise money and inform people and the government in their host countries about human rights violations, as did many sympathetic human rights–oriented locals.

Pinochet attempted to legitimize his authoritarian rule through the development of a new formal constitution, which he brought to a public referendum. The opposition was unable to mount a successful campaign against it and was hurt by the lack of an official alternative and by disagreements among parties;[70] the Chilean public voted in favor of it in 1980. The constitution called for a plebiscite by 1989 on a presidential candidate to be chosen by the military junta; if the candidate won, he would serve as president until 1997; if he lost, competitive elections for president and congress would be held a year later.[71] If the public voted against Pinochet in the plebiscite, the position of commander in chief of the army was reserved for him. When 1988 arrived, the opposition united in preparation for the plebiscite, and the Chilean populace voted Pinochet out of power, setting the stage for a return to democracy.

The democratic transition was the product of a pact between the right-wing forces that supported Pinochet's dictatorship and the center-Left sectors that took over in 1990. Its basis was the commitment to retain the neoliberal model and arguably to keep civil society demobilized so as to guarantee governability.[72] The civilian governments increased free trade policies,[73] Chile's economy continued to depend on commodity exports, and foreign investment in Chile rose significantly between 1990 and 1999.[74] At the same time, public investments in infrastructure, education, and health care increased.

After 1990, the economy showed structural growth and enabled almost every-
one to experience improved living standards.[75]

From 1990 until 2009, Chile was governed by a democratically elected alli-
ance of center-Left civilian political parties called the Alliance of Democratic
Parties (Concertación de Partidos por la Democracia, or "la Concertación"),
and only in 2010 was a right-wing president elected. The Christian Democrat
Patricio Aylwin was the Concertación's first president, taking office in 1990. His
government's main goals were to smooth over civil-military relations, reduce
poverty, respond to popular demands for social services, and assure economic
growth. The Concertación began reforming social and labor policies within
the free market framework. Many of Aylwin's programs were not maintained
under the next president, Eduardo Frei (1994–2000), because of budget con-
straints,[76] but the president after him, the Socialist Ricardo Lagos (2000–2006),
created new social and poverty programs.[77] President Michele Bachelet (2006–
2010) reinforced and expanded the public policies directed at the poor and
disadvantaged.[78] Sebastián Piñera, president since 2010, heads a center-Right
coalition with open economic policies, moderate social welfare policies, and
reform designed to promote economic growth and reduce poverty.

Chile did not become a democratic country immediately; many authori-
tarian "enclaves" remained. General Pinochet had placed numerous reaction-
ary judges loyal to the armed forces in the courts, shaped electoral laws to
favor his followers, appointed nonelected senators that included retired mili-
tary commanders, created rules preventing the president from firing military
leaders, made the constitution he had drawn up in 1980 difficult to change,
and instituted an amnesty for human rights crimes committed during the
dictatorship.[79] He continued as head of the army, keeping present the threat
of military intervention until he stepped down and became a senator for life
in 1998.[80] Civilian governments were eventually successful in removing these
authoritarian holdovers,[81] but as late as 2009 the Chilean Right enjoyed a
virtual veto power. Although in the 1990s little progress was made toward
removing these holdovers, the changes became faster after Pinochet's deten-
tion in London in 1998.[82] Aylwin's government had created a Commission on
Truth and Reconciliation, which produced the Rettig Report, as it was called,
documenting a total of 2,279 killings, not counting the cases involving the
disappeared,[83] about whom information gradually came to light as Chile's
democracy grew stronger. However, trial and punishment of members of the
armed forces for human rights abuses came only slowly, gathering momen-
tum under President Michele Bachelet. Pinochet died in 2006, on Human
Rights Day, without having been formally tried.

2 Beginnings

Unemployment and Joining Groups

To create art containing messages about the failings and aggressions of the Pinochet dictatorship was a dangerous enterprise. How, then, did the *arpilleras* and *arpillera* making emerge?

LIVES OF THE UNEMPLOYED WOMEN

When they began making *arpilleras* in early 1975, the very first *arpilleristas* were living in poverty in shantytowns. Most were married, looking after their small children, and not working for an income.[1] Their poverty had very recently worsened because their husbands, the family breadwinners for the majority, had lost their jobs.[2] This unemployment was caused in part by the regime's national security doctrine and use of violence to rid Chile of Marxists. Leftists were detained in soccer stadiums and detention centers or had to go into hiding, resulting in the loss of their jobs. At the same time, companies were firing leftist party or union members.[3] As early as mid-October 1973, workers who were union leaders or sympathizers of the Allende government were being summarily dismissed from their jobs.[4] Cristina, a member of one of the first *arpillera* groups, for example, told me that her husband had lost his job in a copper company because he was a Communist; he was being persecuted and had to flee to Peru and Bolivia. The junta's "Shock Treatment" plan of economic recovery was another reason the men were losing their jobs. Begun in early 1975, it brought soaring unemployment, together with a depression, the decline of industrial and agricultural production, and price increases. Forty thousand public employees lost their jobs in the first six months of 1975.[5]

The men's unemployment made their family's financial problems more severe than usual. A year's unemployment benefits was available under certain

conditions, but if these conditions were not met, there would be only sporadic income from the unemployed person's engaging in very short-term, one-off jobs (*pololos*), sometimes lasting only part of a day.[6] Cristina, who lived in the shantytown of Villa O'Higgins[7] in eastern Santiago, said, "We were very poor; we were all very poor." Shantytown women found it difficult to pay for essentials such as food, water, electricity, and the children's education, and this caused them considerable anxiety. Another of the very first *arpilleristas*, Anastasia of the shantytown of La Faena in eastern Santiago, discussed the women's various deprivations with me:

JA: And when you got there [to the *arpillera* group], what did you talk about?

Anastasia: About the subject matter of our *arpilleras*, about what we were going through, about what each of us was short of, about how difficult it was living at that time. [...]

JA: And when you say that you would talk about what you were short of, what does that mean?

Anastasia: The things we were short of; that they would cut off the electricity, that they would cut off the water, that we didn't have, let's say, the means with which to subsist at that time. And that's why we would look for those alternatives [joining groups]. So, the deprivations that affected us, "I didn't pay the electricity bill this time," "I don't have money to pay for this," "Tomorrow I won't have anything to make a meal with," and . . . We would look for the solution together.

JA: And they would cut off the electricity because people would not pay?

Anastasia: There was no money to pay for it.

JA: And the water, too?

Anastasia: Also, yes, they would cut off the water, the electricity, and there were many people who would hook their homes up to the electricity cables, and sometimes they would get caught, and the company would cut the cables.

The conversation to which Anastasia refers points to the women's anxiety about not having enough food for a meal or money for other essentials; their basic needs were threatened. Moreover, when one's water and electricity were cut off, this produced still further difficulties. As well as talking about these deprivations during their workshop meetings, they depicted them in their *arpilleras*.

Another poverty-related problem that worried many *arpilleristas* was having inadequate accommodation. Many lived with their husband and children in a room in a relative's home, or in a very small, rudimentary wooden hut. The lucky ones lived in a small, semidetached brick house. Babette, one of the first *arpilleristas* of northern Santiago, described her home at the time she began making *arpilleras*:

Babette: It was a little house made of wood.

JA: One room?

Babette: Let's see, when we arrived here, we had a room six meters long, six meters by three. When all of us arrived, that's what we had; it's called a *mediagua*. We had a part that was three meters for the beds, and the other part where there was a dining room and kitchen, so we all lived that way, and that was how we raised our children.

JA: And when you started to make *arpilleras*, was it like that?

Babette: Yes, it was.

Like Babette, many of the women had to put up with crowded conditions. It was common for shantytown inhabitants to have only one room at first, and to add on other rooms gradually, if their shantytowns had originated as a government low-income housing development. If their shantytown had originated as an illegal land seizure (*toma*), on the other hand, they tended to have started off living in a tentlike structure. In sum, the earliest *arpilleristas* could not afford decent housing, their husbands were not working, and they tended not to have enough money to buy sufficient food or pay for electricity and water. Meanwhile, shantytown family hardship was exacerbated because the delivery of food, medicine, and other social services to shantytowns was cut back.[8]

As mentioned earlier, shantytown women endured not only poverty but also repression. Most suffered only generalized repression, but a minority also endured targeted repression. In Babette's neighborhood in northern Santiago, homes were raided; soldiers with painted faces prowled the streets, sometimes behaving roughly with children; and the local church was mysteriously burned to the ground. She painted a vivid picture of the range of state violence:

JA: What was the repression like here in this neighborhood?

Babette: It was strong, very strong. We thought that we didn't have any reason to experience such strong repression. At the beginning of the dictatorship, the streets started to be permanently watched by soldiers with painted faces. And that, for the children, was really horribly tough. The fear that they could not sort of . . . from time to time they would be badly treated, a child who was just there in the street. And the fact that they went around with painted faces meant that you could not recognize who the person was. And they always treated people very roughly. Well, as I was saying, there were raids here. We had our house raided and my husband was threatened as well, that if he, if some news reached their ears that he was continuing to be active, he would simply disappear. So, it was always quite strong. We suffered serious consequences here, like, for example, the fires. The chapel where we started to participate was burned down completely.

JA: Did someone set it on fire?

Babette: Yes, someone set it on fire.

JA: Because the *arpillera* group was there?

Babette: No, we were not yet making *arpilleras*, but we were already participating in groups. That chapel was like the birth of the movement in Huamachuco. So there were already . . . like, for example, people set up health groups, there was a group of pastoral workers, they ran *comedores* [community kitchens for children], which were not yet called *ollas comunes* [community kitchens for all the community]. They had communal vegetable patches, they raised rabbits, they had many, many activities going on there. And, for example, the last group that had formed was the group of pastoral workers, and the pastoral workers' group was watched very closely, because the workers' pastoral was clearly a group of Christians who would reflect on the theme of the worker. So in those years they started to work on the document produced at the Puebla meeting, which was a document where they clearly said how the bosses abused the workers and everything. So those years were very conflict ridden. And one day, at dawn, or at midnight, the church was burned to the ground, to the ground.

The church was not merely a house of worship; it was also where many neighborhood people came together in groups to carry out activities that ensured their subsistence, engaging in resistance activities on the side. It was usually the only place where they could do so and feel fairly safe, thanks to the Catholic Church's relative immunity from direct attack by the military; hence to burn it would have increased the sense of insecurity locals felt.

A number of unemployed *arpilleristas* suffered not only generalized repression but also targeted repression. Babette's eldest son was arrested, and as we saw, her husband was warned that if he continued to be politically active, he would disappear. As mentioned earlier, Cristina, another *arpillerista*, had her husband go into hiding in Peru and Bolivia, as he was a trade union leader and a Communist and was in danger, while Anastasia's husband had been arrested and was a political prisoner for a week to ten days. We discussed this:

JA: And they [the other workshop members] also had husbands who were arrested?

Anastasia: Political prisoners, there were disappeared people, even today there are people who are disappeared, people whom the soldiers killed as well, and in full sight and in the presence of everyone because, for example, a fellow *arpillerista*, Mrs. Ana Pacheco, her husband was killed; they shot him in front of his house. [. . .]

Anastasia: And many, many disappeared who never again . . . [for example,] Aguilera's wife; Mr. Aguilera never appeared.

Another woman in Anastasia's group had a daughter in prison. Short-term and longer-term detention, disappearance, and executions were experiences

30 that some *arpilleristas* had, not only in their groups but also within their own families.

The generalized and targeted repression caused *endemic fear*,[9] that is, an ongoing state of fear not focused on a particular act of repression. Babette's answers to my questions about the effect of a raid on her family suggest endemic fear:

JA: And your husband, was he unemployed for a while or not?
Babette: Yes, my husband was unemployed on several occasions because he was a trade union leader. What we lacked was a bit of knowledge, when our house was raided, about asking for help in some embassy that could have gotten us out of here. Because my husband, psychologically, was left in a really, really bad state after we had our house raided. When the children were growing up, my husband wanted them to just be in the house, and for me not to mix with anyone at all, no one at all. Because I started to participate in shantytown groups secretly, practically. When he went to work, I could go out, and when he was in the house, I had to stay in.

The raid was a traumatic experience that caused terror in Babette's husband, and thereby restrictions on family members' freedom of movement. In addition to endemic fear, there were *specific fears*, such as the fear that a family member would be imprisoned. Cristina from southeastern Santiago said:

There were financial problems, but my husband had political problems that were serious. [. . .] Yes, every day you would hear that they had taken away someone whom someone had accused, and they took him away to such and such a place.

Cristina's words imply that she lived with the knowledge that someone might do the same to her husband. Fear was a part of life under the regime, and the women felt afraid almost constantly.

Initially the women claimed they did not understand political matters. Cristina described the *arpilleristas* to me in this way:

We were very poor, very poor, all of us. Unemployed husbands, disappeared husbands, people who had never had anything to do with politics, who were discovering for the first time that their husbands were arrested for political reasons, but they had no idea why. So this thing produced quite a stir.

Cristina's mention of women's not knowing why their husbands had been arrested suggests little knowledge or understanding of political matters or of the

regime's national security doctrine. Similarly, Anastasia, like many *arpilleris-tas*, said she knew very little about political parties before joining the *arpillera* groups but came to understand more in time:

JA: What was your political position before joining?

Anastasia: The truth is that I had no idea about anything. I had no idea, and I would argue with my husband because he would come home late because of his meetings, because he would go out, because they would call him, and come and fetch him here. So I would get upset about this, because he spent very little time with us. But I never participated in anything, except for some party get-togethers. They would go, and once, I think, he took me along so that I would shut my mouth; to show me that he was not doing anything else, and that that was it. But I had no idea; let's see, I was not able to define something as Right or Left. I had no idea, none whatsoever, none whatsoever.

JA: None. And what party was he in? The Communist Party?

Anastasia: Communist.

JA: But you had voted, I imagine. Did you vote for Allende, for example?

Anastasia: Yes, yes.

JA: So, you still felt more sympathy for the Left, didn't you?

Anastasia: But I didn't have any idea, my dear, I had no idea whether I was right-wing or left-wing. I mean, it was because I liked him, and because I was a little girl when Salvador Allende traveled by train to the South, giving out sweets, giving out balloons and pieces of candy, and we, as small children, would go to the station because we knew that he would pass through and give out things, sweets, for example. And because my father worked for the railways, so they were, let's say, supporters of Allende in those years, but I was small. So, when I voted, I voted for Allende, but without knowing anything about anything. Now my ideas are straightened out, and I am clear about what I want and the direction I am heading in. But not in those years. So after having joined the solidarity workshops [*arpillera* groups were sometimes classified as *talleres solidarios*, or solidarity workshops], let's say that from that time on things started to become clearer for me, and I started to notice what was happening, and now, obviously, I am not so clear about things, but I think I know more than before.

Like many *arpilleristas*, Anastasia described herself as having been ignorant of the meaning of left- and right-wing, and as not having participated in political activities. There were some *arpilleristas* who were, however, politically aware; Cristina, for example, described one, the wife of a Socialist Party member, as "very political."

Many of the women were initially ignorant about the extent of exacerbated poverty and unemployment in their neighborhoods, thinking these problems

32 were unique to their family. In addition, they described themselves as not hav-
ing known about many aspects of the repression, in particular the disappear-
ances and torture. Anastasia, for example, said:

> **Anastasia:** Because there, we had many women who were ignorant in many ways; igno-
> rant because we spent all our time in the house with the children, and we would not
> see what was going on outside. Maybe our own problem was simple compared with
> that of other women who were experiencing worse things, like still today, with their
> husbands disappeared, with children disappeared. So the fact of being in your world
> of the house, with the children, well, you had a scare because your husband was
> arrested, but luckily he came back, and your life returns to normal, and you think
> that nothing is going on outside, that outside everything is fine. And no! So, at those
> day-long meetings or training sessions [organized by the Vicaría or a feminist grass-
> roots organization], it was useful because we would talk about all these topics, for
> example, about some workmates being in a worse situation than others, and we
> would try to find a solution. That's what those meetings of women were for, those day-
> long meetings that they would organize. [. . .] For me, the *arpilleras* were very impor-
> tant because I felt fulfilled as a person. I gained knowledge of things that I was ignorant
> of, about what was happening outside, about daily life, let's say, about some workmates,
> because I didn't have any idea about what was happening.
>
> **JA:** Like what, for example?
>
> **Anastasia:** Well, the torture, the political prisoners, the disappeared. Because, as I say,
> even if my husband was arrested, it was really nothing compared with the sufferings
> of other workmates. I maybe would have stayed shut up in my house; what happened,
> happened, and I would simply have shut myself in.

Anastasia's words suggest that the gender expectation that women spend most
of their time at home with the children was responsible for their ignorance
about aspects of the repression. Their eyes were opened when they joined
arpillera groups, where they discussed these matters with other women. There
were *arpilleristas* who were more knowledgeable about the repression, however.
Cristina, for example, knew about political persecution, since her husband
was a Communist and in hiding in 1975, and she had been in contact with the
Comité in 1973 and 1974, helping people find their disappeared relatives.

 As might be expected from most women's professed lack of knowledge
about politics, repression, or the extent of others' poverty, they tended to de-
scribe themselves as not having been involved in political parties, groups, or
activities.[10] This was the case even though there were *arpilleristas* whose hus-
bands were left-wing party members or active in trade unions. Their non-
involvement in political parties may be explained in terms of shantytown

gender expectations and the fact that some of the women were afraid of political parties because party members were among the most repressed groups in society after the coup, and the junta vilified politics. In 1995 interviews, the women voiced suspicion of political parties and politicians, seeing them as using people and not being sincere, and this suspicion may have been present at the beginning of the dictatorship as well. Over the course of their involvement in *arpillera* groups, the women did become involved in political activities such as protests, writing open letters, and supporting protesting groups.[11] A minority of *arpilleristas*, meanwhile, had been involved in political groups or parties all along.

Although mostly not active in parties, a few *arpilleristas* had been active in land seizures,[12] and some had participated in struggles for basic infrastructure, a school, and other services in their new shantytown. They had joined social organizations that, according to Vicaría staff member Zoe, were political without necessarily being party related. Babette, one of the first *arpilleristas*, was from a shantytown that she described as highly socially and politically engaged from its beginnings in the Allende period, and she participated in the struggle that won it its school, clinic, and public telephone:

Babette: And, well, our experience in terms of the struggles that happened here, we practically started struggling from the days when we arrived here at this shantytown, which was in 1970. This shantytown came into being in 1970, under the government of Salvador Allende. So everything that is here in Huamachuco, the school, the clinic, a public telephone, was won thanks to the efforts we made in those years, at the time of Salvador Allende. Then the military coup happened in '73 when we were in the middle of our struggle here to get the place we had won for ourselves off the ground. This was this place here. It was a committee. So people, before receiving their plot of land, came to guard the land, with tents.

JA: In the place that the government was going to give you they came with tents.

Babette: Yes, that's right, they came with tents. It was very similar to a land seizure, but it was not a land seizure. People were careful that a land seizure did not happen. They guarded it, and all that.

The inhabitants of Babette's shantytown had organized to prevent a land seizure and acquire basic services, and Babette had been involved with the latter. The *arpilleristas*, then, although active in struggles to secure housing and infrastructure, tended not to be involved in political parties or initially to have much understanding of politics or the extent of poverty and repression.

JOINING GROUPS

To solve or lessen their severe financial problems, the women created or joined subsistence organizations in their neighborhoods,[13] some of which eventually became *arpillera* groups. These organizations aimed to earn money or procure food cheaply. They included community kitchens for children (called *comedores infantiles*, *comedores populares*, or simply *comedores*) in which the mothers and middle-class volunteers prepared and served lunch to children in a room lent by the local priest, community vegetable patches (*huertos familiares*), buying cooperatives in which women bought food in bulk so as to lower the cost (*comprando juntos*), and groups in which unemployed people produced a product or service for an income while simultaneously helping each other find jobs (*bolsas de cesantes* or *bolsas de trabajo*).[14]

Most of the very first unemployed women's *arpillera* groups were originally *bolsas*. The work done in *bolsas* included shoe repair; clothing alterations; collecting recyclable materials; making sewn, knitted, or leather items; and baking bread or *empanadas* (Chilean meat pies). Some *bolsas* contained several *talleres* (workshops). *Bolsa* members might also share a newspaper, pass on information about potential jobs, and look for jobs together.[15] As they sometimes included ex–trade unionists, the *bolsas* acquired a reputation for being among the more political of subsistence organizations. Anastasia, who was without work and did not have food to give the children while her husband was in prison for a few days and later chronically unemployed, emphasized financial need in answer to my question about her motivation for joining the *bolsa de cesantes* out of which her *arpillera* group developed:

Anastasia: Finding myself without work, not having anything to give to the children; the children would ask and I didn't have anything. They would ask for bread and there was none. So, in some sense, by joining the *taller solidario* [solidarity-oriented workshop] I could have the chance, every week, to earn a little money with the work that we did, which was *arpillera* making, and from that be able to have some money to get through the week with.

JA: And your husband, was he unemployed? Or disappeared?

Anastasia: No, no, not disappeared, no. Arrested, yes; he was arrested, he was a political prisoner.

JA: At that time?

Anastasia: At that time.

JA: That's why you had to . . . ?

Anastasia: Yes, that's why I found myself needing to look for a way to join a group or associate myself with people in the same situation. Everyone, all the women were in

the same situation. That was the motivation for coming together in the chapels and supporting one another; so as to be able to help ourselves economically.

[...]

JA: And when you say that you would come together, what does that mean? Would you come together to physically work together? Or in what sense?

Anastasia: Because of the situation we were living in, with our husbands unemployed, some in prison. So, under those circumstances we found ourselves needing to group together, to do something, to invent what to do to be able to subsist because we all had small children at that time. So, to look for some chance to earn something or to help each other.

All of Anastasia's workmates in the *bolsa* needed money badly in order to feed their children and pay for other essentials, as their husbands were unemployed or in prison.[16] Some were active both in the *bolsa* and in a community kitchen before they began making *arpilleras*.

Motherhood was central to the women's motivation for joining a group, as Anastasia's phrases "small children" and "not having anything to give to the children" suggest. Shantytown gender expectations demanded that mothers feed and look after the children. According to a study of shantytown family survival strategies, the mother would organize daily life in the home, taking on domestic work and raising the children. She was the one responsible for "turning the available resources into meals, clothes, a clean and pleasing environment, robust children, and well-fed husbands."[17] When I talked to a coordinating committee of seven *arpillera* workshops in eastern Santiago, among whom were some of the earliest *arpilleristas*, one member explained: "They [the people who paid them for their *arpilleras*] would offer us a certain amount, and we, because of the need for work and the children who were small, we had to do it." Having small children made making *arpilleras* an imperative, since these children could not work and the women knew they needed to be properly fed for healthy development. Celinda, Comité Pro-social worker who worked with these and other women in eastern Santiago Paz, thought that their self-esteem was bound up with their fulfilling the shantytown expectation that women care for their children:

> To my mind, the most important point was the issue of survival. I mean, that's what I believe. What most interests the women is to be able to contribute resources to their family. Because unfortunately in our Latin American countries, the woman is the center of the family. So if she does not manage to make sure that her children have a better life, it's her fault. So there is a whole psychological issue of self-esteem.

36 The expectation that mothers feed their children and look after the home and family was part of what induced them to join local groups in which they could work to earn an income or make food collectively and cheaply.[18]

The repression was also partly responsible for the women's joining groups. We saw earlier how it caused job loss and family impoverishment. Husbands who were in hiding could not easily earn an income either, as a result of detention and the politically motivated firing of leftists. Anastasia said: "We started to come together as a group there because the husbands lost their jobs, some had been arrested." Some husbands were being hunted for because they were trade union leaders, and had to go into hiding or leave the country, and they, too, could not earn an income easily. When Cristina's husband returned from Peru and Bolivia, as neither he nor she had work, she joined a *bolsa de cesantes*, collecting bottles and newspapers and making *arpilleras*.

The repression also fostered participation in groups by making some women want to understand why it was happening. Babette wanted to comprehend why her home had been raided, and the fact that a women's discussion group that she joined talked about such issues motivated her to stay in it. Later on it became an *arpillera* group. She said:

> But a shantytown group was for going to talk about what was happening in each of our lives; it was to discuss something related to development. Like, for example, that first time that I went to that group, the subject was economics related, about the economy, and there was an economist talking about this topic, and I remember so well that he was drawing a circle and he would divide up this circle, and we realized that health had a little bit of money, resources, this other thing had another little bit, and so on, but the part that had most was the part that the government managed. And we started, I mean, I, at least, started to become very interested, as my house had already been raided. In those years I was not participating in groups related to social matters, or politics, or anything; I was a mother and housewife. So I was curious about a lot of things, and after the raid, the desire to know why awoke in me. Why this? Why that? [...] So I found that the subjects we discussed were subjects that really interested me, and I started to voice my opinion a lot, I started to participate fully.

Babette was already somewhat familiar with participation in groups in that immediately before joining the women's group she had been in a Christian Base Community (a local group of Christians who regularly discussed the Bible, their difficulties, and social problems), to which her local priest had invited her because her house had been raided. Hence repression drew Babette into

the base community, and curiosity about repression kept her in the women's discussion group, which became an *arpillera* group. It was more common, however, that the repression brought women into groups by causing them to need to earn an income.

Obstacles

To take the step of joining subsistence groups was no easy matter. A number of women called it "an achievement." An important hurdle was "getting out of the home," where they had spent most of their time. Anastasia said:

> Well, I was a woman who spent all her time here in the home. I never knew what a solidarity group was or why they would meet. Until I found myself needing to be able to participate and find some means of subsistence for my family, since my husband was not there at that time.

Anastasia was not used to being out of the house much. Many women used the expression "shut up between the four walls" to describe their homebound lives, suggesting a sense of having been isolated and trapped. A number of Vicaría staff also talked of the women as having been isolated at home,[19] one saying that the isolation was such that they had lost the capacity to express themselves.

Strong forces opposed the women's exit from "the four walls." Shantytown gender expectations not only dictated that they be responsible for all the cooking, cleaning, and child care, while husbands were supposed to work and provide; they also dictated that the women not work for an income outside the home, join groups, or leave the house much.[20] Membership in a group was viewed as neglecting the children and household duties, and wasting time talking and gossiping.[21] Many husbands tried to obstruct their wives' participation in *arpillera* groups, arguing with them when they left to go to group meetings or being grumpy when they returned. However, along with the many accounts of begrudging men, there was mention of men who did not mind their wives' participating, and even husbands who encouraged them, as did the political prisoner husbands of the women who formed the Nuevo Amanecer *arpillera* workshop in eastern Santiago.[22] The men's unemployment and the difficulties with subsistence that it caused made it more difficult than it would otherwise have been for them to oppose their wives' joining workshops. Meanwhile, some of the women developed strategies to counter men's resistance; as we saw earlier, Babette went out to her groups while her husband was at work, and later told him that she joined an *arpillera* group so as to be able to

38 have work. The Santa Teresa *arpillera* group invited all members' husbands to a dinner shortly after it formed in the 1980s so that they would cease worrying about who their wives were mixing with.

Other barriers that the women had to overcome were not being used to supporting a family and not having had a job since their marriage or the birth of their first child.[23] Anastasia was one of many such *arpilleristas*:

Anastasia: I mean, when I got married, I didn't work.
JA: After getting married.
Anastasia: After getting married, I didn't work until I found myself needing to, when my husband was arrested and with my small children, so I found myself needing to.

Compounding the problem of not having worked for a long time was the fact that the women had low levels of education, many not having completed secondary school and some not being able to read, and this had limited their chances of finding stimulating work. As well as not having had jobs for many years, it was common for the *arpilleristas* not to have been in groups before.

Fear was a further barrier to joining groups. The women thought that by being in groups they might be viewed as "political" or "leftist," which could bring dangerous consequences, as the government was vilifying politics and had banned left-wing parties. Even political activities within groups were feared. Some members of Anastasia's *bolsa de trabajo* did not dare to engage in activities aimed at raising public awareness of the political situation, for example. Anastasia said:

We tried to raise consciousness in people about what we were experiencing, but only people who took the risk of doing so, because there was so much fear that maybe . . . people were aware, but out of fear they didn't do it.

In addition to the fear of being thought political or leftist and thus risking arrest, endemic fear caused women to be nervous about joining groups.

Because of these fears, those who were creating the groups had to find ways to persuade the women to become members. Babette, who created a new *arpillera* group in Huamachuco, explained:

I saw that the most important thing for me was for people to be able to wake up, and not continue dying between these four walls, as it were. There were a lot of people who would say, out of fear, "No, I'm not going to get involved in anything at all, anything at all, anything at all," but when things become critical, they

nevertheless come to the person who has a little more information to ask them what they can do. [. . .] I adopted techniques like, for example, inviting people to participate myself. And later working with them, offering them the chance to change our lives, to have the opportunity of some work thanks to some, some little pictures, I would say, that we would embroider. So, as they were so distrustful and so afraid, they would say to me: "Look, I'll go, but I'm very afraid that it will be something related to politics." "No," I would say to them. "Of course not!" So when we got together, I would explain about the *arpilleras* and give them each a blank piece of paper and a pencil. So I would say to them—this was in the church, with the new group—I would say that each of them had to draw a moment of their life, any moment, and after that we would share it with the others. So they were saying that they didn't want anything to do with politics, but they were drawing their problem, and their problem was clearly about the political moment we were in.

Babette's words suggest how afraid women were of joining groups, and they point to her use of several strategies to circumvent this fear, including persuasion, emphasizing that groups would bring them work (which they badly needed), hiding the political nature of *arpillera* making, and making use of the traditionally feminine associations and apparent innocuousness of sewing. Described as "little pictures that we would embroider," the *arpilleras* did not sound subversive. Fear was an obstacle to joining groups, but like the other obstacles, it was overcome by the force of necessity or the strategies of group leaders.

THE COMITÉ PRO-PAZ AND THE VICARÍA DE LA SOLIDARIDAD

The involvement in the emergence of the *arpillera* system of two humanitarian-cum–human rights organizations, the Comité de Cooperación para la Paz en Chile and its successor, the Vicaría de la Solidaridad, came about almost by chance and against the odds. Supporting *arpillera* making was not these organizations' central activity, and only a small part of what they did. Moreover, some staff members were initially against giving this support, and even demoted a colleague who advocated it. After this initial reticence, however, the Comité and the Vicaría found people abroad willing to sell and buy the *arpilleras*, carried out quality control of the *arpilleras* produced, shipped the *arpilleras*, sold a small number on their own premises, initially lent the *arpilleristas* rooms in which to hold their group meetings,[24] lent support for their recreational activities, and channeled donations to them. They also arranged for the *arpilleristas* to receive training in the making of *arpilleras* and in group management, and offered them workshops aimed at raising their self-esteem, their awareness of the extent of poverty and repression, and their

40 understanding of human rights and women's rights. This work was important
to the functioning of the *arpillera* system.

Less than a month after the coup, alarmed at the state violence, represen-
tatives of the Catholic, Lutheran, Baptist, Methodist, Methodist Pentecostal,
Greek Orthodox, and Jewish faiths created the Comité. The archdiocesan de-
cree of October 9, 1973, that gave the Comité legal existence stated that it was
to be "a special commission to serve Chileans who, as a result of recent politi-
cal events, are in serious financial or personal need. This commission will give
legal, economic, technical and spiritual assistance."[25] The Comité at first aimed
to assist political prisoners and their families, and workers who had been
fired.[26] Soon, like the Vicaría that it became, it offered free legal assistance in
cases of disappearance, detention, other forms of state violence, and job loss.
People came to it for help, having read its two discreet advertisements in the
newspapers or heard about it from others in the same plight.[27] The Comité and
the Vicaría also offered medical and psychological assistance to released prison-
ers, people who had been tortured, relatives of the disappeared, other victims
of repression, and people who did not have medical coverage because they were
unemployed.[28] They also worked to help the newly unemployed and impover-
ished in the shantytowns by supporting their creation of community kitchens,
bolsas de cesantes, and other groups. In parallel to these activities, the Comité
and the Vicaría liaised with ambassadors and clandestine party networks in
matters of political asylum and helping people leave the country. In the provin-
cial towns and cities, the Comité helped the disappeared, the poor, and farm-
workers.[29] Although this work involved defending the victims of human rights
violations, the initial Comité team of five did not at the outset conceive of its
activities in terms of human rights.[30]

The Comité and the Vicaría kept records of arrests, disappearances, and
torture as victims came to them for help, and of courts' reactions to cases. They
also collected information on unemployment, poverty, sickness, and malnutri-
tion throughout the country. They shared this information on request with law-
yers, journalists, students, and activists, and used it to produce reports, which
they sent to the bishops in Chile, international church organizations support-
ing the Comité's work, the human rights commissions of the Organization of
American States, and the United Nations. These reports provided the outside
world with accurate, first-hand testimonies of human rights violations in Chile,
and were the basis for the first annual condemnatory vote against the Chilean
government in the United Nations for its human rights record, at the end of
1974. In addition to producing its own information, the Comité exchanged
information with the foreign press, which had published many accounts of

military brutality in Chile. The Comité was constrained in the amount of information it could disseminate nationally, however, as its brief included the defense of the persecuted but not overt criticism of the government.[31]

Initial funding was 15,000 German marks from the World Council of Churches, an ecumenical organization based in Geneva, Switzerland, that continued to be the principal funder in years to come.[32] Other early funding came from Protestant sources in Western Europe. While the Comité was ecumenical in sponsorship and administration, it came under the legal jurisdiction of the Archdiocese of Santiago. The religious leaders who had created the Comité made up the directing body, with Fernando Ariztía, a Catholic auxiliary bishop in western Santiago, and the Lutheran bishop Helmut Frenz, serving as copresidents, and a Jesuit priest, Fernando Salas, as executive secretary. The headquarters were at 2338 Santa Monica Street in central Santiago, and soon there were offices in twenty-four provincial centers.[33] From an initial team of five, the Comité grew in response to demand to some 150,[34] its staff including lawyers, social workers, university professors of social work and public health, doctors, priests, and nuns. The staff included both Christians and non-Christians; most were of the Christian Left and particularly of the Marxist-Leninist party MAPU (Movimiento de Acción Popular Unitario),[35] but there were also members of the Socialist and Communist Parties, some Christian Democrats, and individuals without political affiliation.[36]

At the end of 1974, social workers on the Comité staff went to the shantytowns to support the setting up and functioning of subsistence groups[37] that the unemployed or their wives set up. A unit within the Comité provided initial financial and technical assistance for the self-supporting enterprises that those rendered unemployed for political reasons proposed to create; by the end of 1975 it had supported 126 enterprises, employing nearly two thousand people.[38] Trini, a Comité social worker, described it this way:

So to this institution came all those whose life and liberty were at risk, and also those in a similar situation, because people who lost their job for political reasons were left exposed to the risk of also losing their freedom and their life. So this meant that people started to come to ask for . . . first they asked for help with defending themselves in the face of their dismissal from their job—with the recuperation of their rights, and so on, for some compensation, for some amount of money that was due to them and that had not been paid. But soon they started to ask for help with finding work. So the Comité Pro-Paz acquires some resources to help small companies of workers, where two people, five people, would get together and set up a bread-selling stall, or start selling eggs, or create a café, or sell pants, or whatever.

42 This had very little success because there was no economic feasibility study. Because on top of this there was an economic crisis in the country, and this meant that they would fold very quickly. So the Church starts to try to organize assistance from local churches. I mean, the Comité Pro-Paz would help people in an office in the center of Santiago, and so it decided to work on some of the issues that the local churches of the Catholic Church brought to its attention. And it created what became the "Vicarías zonales" [branches of the Vicaría in areas of Santiago other than the center], as they were called, to see to the social and economic needs of this conglomerate of people who had been sort of marginalized, and victims of all the economic and repressive policies of the military government. So in that context the *ollas* [community kitchens for people who could not afford food] appeared.

As Trini expressed, the Comité, and later the Vicaría, helped fired workers claim their rights, gave them economic assistance if they wished to set up a small subsistence organization, and helped their families set up community kitchens. Early on, it began collaborating with Catholic priests in the shantytowns.

To conduct this shantytown-based work, the Comité opened an office in the "eastern zone" of Santiago, and this office helped many of the very first *arpillera* groups. *Zones* was the term used by the Comité and the Vicaría to denote the areas into which the archdiocese divided the Metropolitan Region. There were six zones—northern, southern, eastern, western, central, and "rural-coastal"—each with its own "Vicaría zonal" (Vicaría area office) except for the rural-coastal and central zones. The team in the eastern zone office, consisting of Hilda, Hilaria, a priest, and a nun, focused its efforts on the task of supporting shantytown *comedores*, *bolsas de trabajo*, *arpillera* groups, other subsistence organizations, and day-care centers. It sought the collaboration of local priests in this enterprise.

Creating the Vicaría de la Solidaridad

The government and media took steps to discredit the work of the Comité and the information it produced, and to frighten its leaders, but because of the authority of the Catholic Church, they held back from direct attack for some time. The first arrest of a Comité member occurred in September 1975, and by November 1975, ten staff members in Santiago were under arrest, as were five pastors and priests connected with the provincial offices.[39] The government revoked the residency permit of the German-born copresident of the Comité, Helmut Frenz, in October 1975, when he left the country. Meanwhile, some Vicaría-supported shantytown subsistence organizations were raided by the police, and in some cases participants were detained for short periods.[40]

In the second week of November 1975, after a conflict involving television and radio broadcasts between Cardinal Silva Henríquez and Jaime Guzmán, a prominent lawyer associated with the regime, the cardinal was called to General Pinochet's office. The general asked him to dissolve the Comité, saying that otherwise he would be obliged to order it done by force. At the cardinal's request, General Pinochet followed this meeting with a letter dated November 11, 1975, urging him to close down the Comité, since "it is a means which Marxist-Leninists use to create problems threatening the tranquility of citizens and the calm that is necessary, the maintenance of which is my main duty as governor. Therefore, a positive step toward preventing more serious ills would be the dissolution of the Comité."[41] Of the ecumenical base, only the Methodists and Grand Rabbi were left; the Greek Orthodox, Baptist, and Presbyterian Churches had withdrawn from the Comité, and Methodist Pentecostal support had dwindled.[42] In addition, one archbishop and one bishop openly criticized the priests and religious who had helped members of the leftist group MIR (Movimiento de Izquierda Revolucionaria; Movement of the Revolutionary Left). Faced with these pressures,[43] Cardinal Silva disbanded the Comité at the end of December 1975. In his letter to General Pinochet, he agreed to his demand "with the express reservation that the charitable and religious work carried out until now by the Comité, on behalf of those suffering diverse forms of poverty, will continue to be pursued within our own respective ecclesiastical organizations."[44]

In January 1976, the cardinal set up the Vicaría, which operated despite harassment until 1992. It was an integral part of the juridical structure of the Archdiocese of Santiago, and dependent on the cardinal, who housed it next to the cathedral in Santiago's central square, the Plaza de Armas. Father Cristián Precht, former secretary of the Comité, was named *vicario* (vicar, in effect, director). Despite its ecclesiastical status, the Vicaría was a predominantly lay and pluralist institution, in both religious and political terms.[45] Most of the Comité staff were kept on. Numbering approximately three hundred[46] at the organization's height, they were almost entirely lay professionals, mostly lawyers and social workers, as well as medical personnel and administrative staff.[47]

The Vicaría was wholly foreign funded, the principal funding bodies being based in the Netherlands, Britain, Norway, Sweden, Germany, Belgium, Austria, Switzerland, Ireland, France, Spain, Australia, Canada, and the United States. Catholic Church funding was essential initially, when less than 10 percent of the Comité's and the Vicaría's finances came from nonconfessional sources, but nonconfessional funding came to represent an increasingly large proportion of the Vicaría's budget source, especially beginning in the mid-1980s, when

44 the Ford Foundation became a key funder. The World Council of Churches and its member churches, the United Nations High Commissioner for Refugees, and the Commission of the European Community were also funders. Much of the funding made no stipulations as to precise use,[48] and none of the Vicaría's programs ever had to be curtailed for lack of funds.[49]

Cardinal Raúl Silva Henríquez had written an important pastoral letter in 1975, entitled "Pastoral of Solidarity," which "profoundly influenced the founding of the Vicaría," in the words of Cristián Precht.[50] Central to the letter and to the organization's goals and discourse was the concept of solidarity, which the cardinal defined as "the mutual dependency among men which means that some cannot feel contented when the rest are not."[51] Defending the rights of the poor and persecuted was fundamental to the meaning of solidarity.[52] "The pastoral," as Patricia Lowden, an important analyst of the Vicaría, notes, "committed the Church of Santiago to continue and expand these experiences [of *comedores* and *bolsas de trabajo*], encouraging the further participation of the Christian communities in promoting them. It made explicit that the defense of collective or economic rights was also integral to the defense of human dignity."[53] The letter emphasized the importance of responding to the economic hardship suffered by the poor as much as to the needs of the victims of repression.[54] Bound up with the idea of the importance of helping the poor was the notion that it was important to protect and stimulate organization in civil society, and this, too, was one of the principles of the Pastoral of Solidarity.

The concept of human rights was central to the Vicaría. Most of the Church hierarchy came to see the work of defending human rights as something they would have to do for as long as the regime embraced national security principles. This was in line with the ideas of the new pope in the 1980s, John Paul II, who showed his concern for the issue of human rights in regimes with national security orientations.[55] When they gave their support to shantytown groups, the Vicaría staff saw themselves not only as helping people cope with poverty and thus helping defend their economic rights, but also as defending the right of the poor to organize and assert their collective identity. In a convincing analysis, Lowden argues that with its ethical concern for human rights and solidarity, the Vicaría was the heart of moral opposition to authoritarianism.[56]

The Vicaría offered the same services as the Comité. It continued to support an array of grassroots organizations, including the *comedores infantiles*, *bolsas*, *arpillera* groups, and *coordinadoras* (coordinating committees made up of representatives of such groups).[57] It also continued to provide legal and

psychological assistance to the victims of political persecution, as Nora, the wife of a disappeared person, testifies:

> In the Vicaría there was a lot of help to be had, apart from the legal help: medical help. All our lives we had medical assistance, psychiatrists, psychologists, so they were always supporting us in that way. In my case, a psychiatrist, Insunza, was very helpful, and I managed to pull through, yes; I was in a very bad way. And for the children, too; for the children they did group therapy, recreational activities on Saturdays, all the children would come together in the Vicaría branch offices, and they would organize activities for them, and they would all spend time together, and at least forget the problem for a moment, or at least for an afternoon. And we would all participate; with these things we always had the support of the Vicaría.

Nora was grateful for the Vicaría's legal and psychological support. While associations of victims of repression, clandestine political parties, women's groups, the Chilean Commission for Human Rights, and nongovernmental organizations also helped people in need, the Comité and the Vicaría were nationally and internationally recognized as Chile's foremost humanitarian and human rights institutions.[58]

The Influence of Liberation Theology and the Left

Liberation theology was an indirect influence on the emergence of the solidarity art system centered on the *arpillera*. It was a movement in the Catholic Church aimed at helping the poor and oppressed, which emerged slowly in the 1950s across Latin America, and then experienced explosive growth in the 1960s in the aftermath of Vatican II (1962–1965) and the Latin American bishops' conference in Medellín, Colombia, in 1968. Its fundamental features were an emphasis on working with the poor and the combination of a message of worldly redemption with the traditional message of spiritual salvation.[59] The central texts of the Medellín conference denounced social and economic inequality and proclaimed that the Church should exercise a "preferential option for the poor."[60] One of liberation theology's key proponents, the Peruvian Gustavo Gutiérrez, wrote *Teología de la liberación* (1971), in which he proposed that Christian theology should entail a commitment to construct a just society. Influenced by classical Marxism and by dependency theory, Gutiérrez came to champion the liberation of the poor. Proponents of liberation theology envisioned replacing capitalist structures with a Socialist order of full and equal participation.[61] Working at the grassroots level, they organized base communities, developed community leadership, and fostered an awareness of the causes

46 of oppressive conditions. Liberation theology attracted Vatican and conserva-
tive criticism, but had (and still has) a strong following in Latin America.

In accordance with the ideas in liberation theology, in the 1950s, activist
priests and nuns together with lay persons organized what became known as
Christian Base Communities (*comunidades eclesiales de base*, or CEBs), that is,
small grassroots study groups that related the Bible to daily life and aimed to
develop a social and political awareness among participants.[62] Through their
creation of these communities they sought to empower the masses. Their
pastoral work carried the political message that the poor do not have to accept
powerlessness. There was an emphasis on giving the poor access to land and
housing, and helping them develop basic services, including water, health care,
and education.[63] Meanwhile, committed Christians in the base communities
worked to understand biblical lessons, and to translate those lessons into the
transformation of their daily lives.

The liberation theology movement received a mixed reception in Chile. An
authoritative commentator on the Catholic Church during the regime surveyed
Church staff in 1975 about their opinions concerning the usefulness of libera-
tion theology as a pastoral strategy and found that although 86.9 percent of
bishops felt there was no place for its methods, 40.6 percent of the priests, 36.4
percent of the nuns, and 34 percent of the lay leaders disagreed, and many said
they were trying to combine in their parishes or base communities the teach-
ing of religion with a critical reflection on political and economic problems.[64]
Priests and nuns, then, were more open to the ideas of liberation theology than
were the upper echelons of the Church hierarchy.

The Comité's and the Vicaría's emphasis on helping the poor and oppressed
may have been influenced by liberation theology. The key advisor to the Vicaría
department that worked with the poor in the shantytowns was a leading
liberation theologian. There were priests and nuns working in the Vicaría, and
it is possible that the ideas of liberation theology influenced their thinking and
work. Some *vicarios* (leaders) of Vicaría branch offices were supportive of the
Church's active involvement in social organization, in line with the principles
of liberation theology. Most Vicaría staff, however, were lay professionals and
therefore less likely to be under the movement's influence.

Liberation theology influenced many shantytown priests, who were as
important as the Vicaría and the Comité in the emergence and continued
production of *arpilleras*. At least one *arpillerista* describes her local priest in
ways that strongly suggest that he was imbued with the ideas of this theologi-
cal movement.[65] Some priests set up discussion groups and Christian Base
Communities[66] in their churches, and at least one of these groups later be-
came an *arpillera* group. Christian Base Communities were also a precedent

for the phenomenon of subsistence organizations meeting in local churches, and for the tendency of such organizations to take action to help the less fortunate. Moreover, whether or not they intended it, in giving support to subsistence organizations, priests were acting in accordance with the tenets of liberation theology. Not only did they lend these organizations a room on church premises, they also gave them food and other items with money sent from abroad, wrote letters that community kitchen members could show to market stall owners when begging for food, and offered a space in which to store saucepans and other cooking materials. With the *arpillera* groups, they channeled donations of clothing and food to the women, took *arpilleras* abroad with them to sell when they traveled, sent *arpilleras* to colleagues in churches abroad to sell, and persuaded the Vicaría to buy groups' *arpilleras* and offer them training if it were not already doing so. Liberation theology was not the only likely influence on priests lending their support in these ways; these priests had also become radicalized by their contact with poverty,[67] and they wanted to help the poor improve their lives.

Hence liberation theology, an international movement within the Catholic Church, arguably became instrumental in the emergence of a dissident art form that, as we shall see, helped catalyze anti-regime activism internationally and nationally and led to the development in some of the most marginalized members of Chilean society of an awareness of human rights and women's rights. Later on, the decline of liberation theology may have contributed to the Chilean Catholic Church's move toward the Right, which contributed to a change in the *arpillera* system from solidarity oriented to more commercial, as well as to a change in the content of the *arpilleras* and to the *arpilleristas'* increased alienation from their work and return to a more homebound life.

Some of the ideas within Allende's Popular Unity coalition were another influence on the Comité and the Vicaría staff, and through them the *arpillera* system. In the Zones Department, whose staff worked closely with the *arpilleristas*, a radical Left orientation was dominant. The social workers were nearly all from the MAPU, and the department's first head was a priest from the Christians for Socialism movement; they wanted their work with subsistence organizations to encourage people to view the meeting of basic needs not as an act of beneficence by the Church but as their right, even if political circumstances necessitated the intervention of the Church through the Vicaría.[68] In addition, echoing Allende's valuing and support of Chilean culture and industrial production as opposed to foreign cultural influences and economic domination, a Comité staff member who taught one of the earliest *arpillera* groups in the northern zone suggested that they use only materials made in Chile. Socialism had left its mark on the staff of the Comité and the Vicaría.

Support for the Emergence of *Arpillera* Making

The Comité and the Vicaría staff began supporting *arpillera* making indirectly, by supporting the subsistence organizations that became *arpillera* groups. They assisted the *bolsas*, initially providing some of them with a room in which to meet,[69] and in some cases offering start-up funding. The Comité gave US$100 to the laundry cooperative that became one of the first *arpillera* groups in Lo Hermida, and a Comité volunteer helped the women with the proposal that won them this money.[70] Comité members also channeled donations to the groups, bought the products that groups produced so as to give the women money, and did personal favors for them, such as selling the *arpilleras* to university classmates. This support helped the groups survive, and drew women out of the home and into groups, enabling them to learn how to run an organization, become used to working for an income, and benefit from the support of other group members.

The Comité staff were "solidarity oriented," genuinely committed to helping the inhabitants of shantytowns survive their unemployment and poverty, as suggested by the fact that even outside their official work, they lent support and showed real caring. Celinda, the head of the Comité's solidarity team in the eastern zone, gave an example of such solidarity:

> I always remember that when I was still in the central Vicaría office, or on the refu-gees committee, I would always laugh because she [Hilda, a Comité staff member in the eastern zone] was always sort of inventing things so that people would have less of a hard time, let's say. I have the impression that when I joined, I joined with a vi-sion that was a bit colder. More about planning, looking at things, more about cause and effect, you see? I think that in that first period it was something very emotional. I remember having arrived at the eastern zone, I mean before working there, and hearing, "These socks, buy these socks," so then you would buy the socks. Then you would give them back to them [the women], so that they could sell them to some-one else. I mean, there was a whole sort of thing halfway between social welfare—a looking for ways in which people could earn a little money and work.

The Comité staff bought the socks the women made not to keep them but just to help the women; meanwhile, while on the job, they made an effort to think of ways in which women could earn money.

There were many additional ways in which the Comité and Vicaría staff helped the *arpillera* groups. They hired teachers to teach new groups how to make *arpilleras* and arranged for drama students to help some groups improve their *arpilleras*. They persuaded the occasional reluctant priest to let the groups meet in his church. They lent groups rooms in which to meet in their eastern

zone office. They helped the women sell some of their first *arpilleras*, and once the *arpillera* groups were established, they developed an international distribution system for them.

The Comité and the Vicaría also offered the *arpilleristas* extensive training in how to run groups effectively, taught them about human rights and the extent of poverty and repression in their own communities, and worked with them to raise their self-esteem. In a group in the northern zone, the training process began even before the group switched from being a discussion group to an *arpillera* group, with the Comité working to raise the women's awareness of the causes and degree of poverty and repression by having experts give them talks, and encouraging the women to conduct a neighborhood survey, thanks to which they realized how desperate their neighbors' financial situation had become. Babette, a group member, said:

Babette: The Vicaría did an exercise with us, before the *arpilleras*. It did an exercise with us so that we would grow and there would be a lot of empowerment, basically, for us, and they gave us a large number of surveys so that we would carry them out, surveys to see how our people lived, our families. So we had to survey our neighbors, the people from the community here, more or less ten surveys each. And doing the surveys, we experienced tremendous growth because we realized that there were many neighbors, many people who lived off the garbage dumps, when the supermarkets sent rotten food in trucks to be dumped. They would dump them here next to the hill, so people would go there and collect the rubbish. They had their spots that they would fight over, to collect the food that came in, already rotten. Many, many people lived like that. Others lived by prostituting themselves; that, too. They were living in ways that were not right. And for us it was a shock to recognize that these were our people, and that they lived in these conditions. And then afterward the Vicaría gives us the chance to learn this trade, to learn to make *arpilleras*. We had to go to Señor de Rentas, which is about two kilometers away, walking.

JA: Is it a church?

Babette: It's another church.

JA: And it was the Vicaría that invited you?

Babette: Yes, the Vicaría. The Vicaría gave us a teacher. She's a very famous woman called Wendy Werner.

The Comité raised the women's awareness about the poverty in their neighborhoods and offered training in how to make *arpilleras*.

Five features of the Comité and the Vicaría—their moral authority, relative immunity from attack, social capital, reputation, and access to financial resources—enabled them to contribute to the emergence of *arpillera* making

50 and the development of the *arpillera* system. The same was true for shanty-
town priests, who possessed the first three of these characteristics, and in some
cases the last two as well. The Comité, the Vicaría, and priests enjoyed moral
authority due to their connection with the Catholic Church. This made it easier
for them to support the *arpilleristas* because the women trusted them to help
and not betray them at a time when there was much distrust and many
people believed that organizations were "infiltrated" by individuals reporting
to the government. Babette told me, "In the middle of the dictatorship, no one
would get together with anyone else, no one trusted anyone, and you could
only trust the priests." In the case of the priests, familiarity with them from hav-
ing attended Mass and seen them in the community contributed to the trust,
which in turn helped the women overcome their fear,[71] and meant that when
priests or the staff of the Comité or the Vicaría approached them, the women
were open to what they had to propose.

The Comité, the Vicaría, and shantytown priests enjoyed relative immunity
from direct and violent attack by the military because of their connection with
the Catholic Church. Knowing this, the *arpilleristas* felt safe meeting on their
premises and being supported by them, and this feeling of safety would have
lessened their initial fear of joining groups. Cristina, an atheist, expressed her
sense of the importance of the Vicaría's protection:

> But if the Catholic Church in this country had not opened its doors, we would
> not have been able to do it, because the military dictatorship in this country
> was very severe. And very hard. So you had to be sort of very brave to get together.
> And if the Catholic Church had not had, if Monseñor Silva Henríquez had not
> had the willingness to open up a way for us, we would have been able to do very
> little. And the *arpillera* really was a denunciation in its time. Yes, it really was a key
> to our existence; yes, it was a key to our subsistence. It was also something very,
> very much for denunciation, and that's what the Vicaría enabled us to do. We
> would not have been able to denounce our problems if we had not had the protec-
> tion of the Vicaría. Afterward, we organized ourselves really well, we would
> create workshops, I mean, we created the selling team, we created a strong leader-
> ship committee for the whole group, for the eastern zone, we created workshops
> in the zone.

In Cristina's view, the Vicaría's protection enabled the women both to get
together and to denounce the regime. As an analyst of shantytown organizing
rightly states, "The most important factor in a country's pre-authoritarian
heritage for understanding the re-emergence of base-level organizational
activity under authoritarian rule is the presence of a 'protective umbrella' that

can provide base-level organizations with the necessary organizational space to begin functioning in a repressive environment. In Latin America, this role has been typically filled by the Catholic Church or other religious organizations."[72] While the protective umbrella may not be *the* most important factor in a country's preauthoritarian heritage, it is certainly a significant one. The Comité's and the Vicaría's ability to offer some protection made it more likely that the women would join the *arpillera* groups or groups that became *arpillera* groups than if the groups had functioned independently, been sponsored by an organization not connected with the Church, or been run from people's homes rather than from churches.

The Comité, the Vicaría, and shantytown priests were by no means completely immune from attack, it must be noted. The armed forces raided churches; harassed, killed, and expelled priests; and accused priests and bishops of being Communists. In a memoir, the shantytown priest Jesús Herreras Vivar, who worked with *arpillera* groups in southern Santiago, describes being detained, insulted, and kicked in a police van for several hours as well as being subject to intimidation on his church premises.[73] In March 1985, a Communist lawyer working with the Vicaría was assassinated by the secret police, and in the same year Monsignor Ignacio Gutiérrez, a Jesuit who had been in charge of the Vicaría, was informed that he would not be allowed to return to Chile after a trip to the Vatican.[74] However, the fact that the Comité, the Vicaría, and priests were part of the Catholic Church forced the military to exercise a degree of restraint and handle matters carefully, as we saw earlier, as General Pinochet wanted to maintain cordial relations with the Catholic Church.

In addition to their protection, the Comité's, the Vicaría's, and priests' social capital was important in the emergence of *arpillera* making. These institutions and individuals had many contacts abroad, in churches, religious organizations, humanitarian organizations, and among exiles, and these contacts were essential for the development of the *arpillera* system. It was to them that they sent *arpilleras* to be sold. In addition, priests had social capital that made it easy for them to make contact with the Vicaría and ask it to begin to export *arpilleras* for the groups of women that met on their premises, as the women had difficulty selling their work. Meanwhile, the Comité's and the Vicaría's reputation as the foremost human rights institutions in Chile made sellers and buyers abroad, as well and diplomats and foreign travelers in Chile, feel confident that their money and efforts were being put to good use. It also enabled members of these organizations to approach priests and be taken seriously when they asked them to help by hosting groups on church premises; had they instead been a clandestine political party, they might not have met with such success in this regard.

52 Also important in the emergence of *arpillera* making were the Comité's and the Vicaría's financial resources. These enabled the Comité and the Vicaría to maintain offices in the zones, in which some groups met initially, and from which staff worked closely with the *arpillera* groups, supporting their leadership and organizational development. These resources also enabled the Comité and the Vicaría to hire lawyers, social workers, art teachers, and other professionals who gave the women training. Financial resources enabled priests to travel abroad and so sell *arpilleras* internationally. In addition, priests received donations from abroad and from CARITAS Chile,[75] with which they were able to help the women.

Despite the importance of the link to the Catholic Church for much of what the Comité and the Vicaría did, occasional tensions between these parties did arise, particularly in the latter years of the regime. The Vicaría staff complained of the Church's having become more conservative and having moved to the Right in the mid-1980s, and of its not wanting the women to receive training, for example, on certain topics that the Vicaría staff would have liked to have offered. Wilma said that it had not been possible to set up a women's program in which the *arpillera* groups would talk about sexuality, because of opposition from the Church:

> So I think that it's a very interesting experience that the Church promotes in one way and discourages in another. Because when we started to create programs focused on women in the workshops, that was when—I mean, I left the eastern Vicaría office precisely for that reason; because it came to a point where we had to talk about sexuality, and at that point the Church said "No," you see?

Irritated by the Church's restrictions in the area of gender and sexuality, Wilma found employment elsewhere. Another employee complained of increased conservatism on the part of the new Vicaría leader (a member of the clergy) in her zone, and problems regarding the appropriation of funds. There were also complaints about the Church's not wanting the *arpilleras* to be so denunciatory after the mid-1980s. Relations were not always smooth, but they remained smooth enough for the Church and Comité and Vicaría staff to work together for the duration of the dictatorship.

Although the Comité and the Vicaría were by far the main supporting and exporting organizations, there were groups of *arpilleristas* that functioned independently of them. Not having contacts abroad stopped most from doing so, as foreign contacts were essential, given the limited domestic market, but some *arpillera* makers were fortunate enough to have foreign visitors offer to sell their *arpilleras* when they returned to their countries, or foreign priests

willing to sell for them when traveling abroad or to send their *arpilleras* to contacts. There were also other organizations that exported *arpilleras*. The Catholic Church–affiliated organization known as Fundación Missio supported the making of *arpilleras* in northern Santiago, and sold them through its ties with churches in Germany.[76] The ecumenical human rights organization Foundation of Christian Churches for Social Assistance (Fundación de Ayuda Social de las Iglesias Cristianas; FASIC) sent *arpilleras* to an exile in Paris to sell. Both organizations had contacts abroad because they were church related or in touch with exiles. The Chilean Communist Party also smuggled *arpilleras* out of the country when its members went abroad to give talks, and a feminist organization did so, too. The Comité and the Vicaría, however, were by far the largest exporters of *arpilleras*.

Arpillera making emerged, then, because large numbers of shantytown men lost their jobs as a result of neoliberal austerity measures and a national security doctrine that targeted leftists. This caused shantytown families to suffer exacerbated poverty and not be able to buy food or pay the bills. Wanting to acquire food or other essentials for the family, shantytown mothers joined food-procuring and income-earning groups, some of which soon became *arpillera* groups. In doing so, they overcame numerous obstacles, including gender expectations that kept them relatively homebound, husbands' disapproval, and fear. The support of the Comité Pro-Paz, the Vicaría, and shantytown priests was very important to the emergence of these groups and of *arpillera* making. These institutions and individuals helped the women set up their subsistence groups, lent them rooms in which to meet, and, as we shall see in the next chapter, fostered the switch to *arpillera* making.

3 The First *Arpillera* Groups

With one exception, the first unemployed women's *arpillera* groups started off as income-earning groups that specialized in *arpillera* making in 1975. They were based in the shantytowns of Puente Alto, Lo Hermida, Villa O'Higgins, and La Faena in the eastern zone, and one group was based in the shantytown of Huamachuco in northern Santiago. At about the same time, a mixed workshop (whose members included unemployed women and relatives of the disappeared) was starting in the southern zone, and a group of just relatives of the disappeared began meeting in the Comité's eastern zone office; both these groups will be discussed in the next chapter. Cristina, one of the earliest *arpilleristas* and a member of the Villa O'Higgins workshop, said:

> All the women who belonged to the groups of unemployed people would meet there [in the eastern Comité office]. We were the wives of trade union leaders, unemployed women by nature because we had been unemployed for a long time. And we started to group together. So all the workshops from different parts of Lo Hermida, of Puente Alto came together. At that time we had only four workshops: Lo Hermida, Puente Alto—I'll repeat: Lo Hermida, Puente Alto, Villa O'Higgins, which was us, and the people who were starting to get together at the Comité Pro-Paz, the Agrupación. We started getting together in the Vicaría in April 1975, but our *bolsa de cesantes* here in this neighborhood was created in 1975, at the end of 1975. So we grouped together and everything, and started to make the first *arpilleras*, which were a denunciation of what was happening to us, of our industries that had closed, of our husbands who were hunted down. And the wives of the detained and disappeared [worked] with these [other] themes, in the Agrupación [the Association of Relatives of the Detained and Disappeared].

Cristina did not mention the La Faena group, but a Comité staff member, Anastasia, who was from that group, stated that it was formed at the same time as Lo Hermida's.

The *arpillera* groups in the shantytowns of La Faena and Villa O'Higgins had started off as *bolsas* whose members collected and sold newspapers and bottles for recycling, and sewed. I discussed this with Anastasia of La Faena:

JA: And when did you begin to make *arpilleras*?
Anastasia: In the year 1975, 1975.
JA: Ah, from the beginning.
Anastasia: Yes, from the beginning.
JA: And when you joined the workshop, what was it like?
Anastasia: The workshop started as a *bolsa de cesantes*. Yes, we did different things, an *olla común* in the chapel of San Carlos. There we began to group together because our husbands had lost their jobs, some of them had been arrested. And we started to invent how to, how to do something to be able to subsist.
JA: And what did you do, at the beginning?
Anastasia: At the beginning we did sewing, like aprons, mending clothes, and later looked for something more, that would bring in more money, to be able to earn more money.

Anastasia's group switched to *arpillera* making because the women wanted to earn more money, and because the Comité's support opened up this possibility. Anastasia continued:

Anastasia: And the *arpilleras* started.
JA: How did they start then?
Anastasia: We started together to create, to invent a way to do work, and in some way to be able to, let's say . . . but the work that we started doing was on sacking, on "*arpillera*." And later, looking for, let's say, later we put ourselves under the protection of the Vicaría de la Solidaridad. Thanks to contacts that other people gave us, also, because they would give us the information and we would make use of it. So we came together, the La Faena workshop with the workshop of Lo Hermida, and we were the only ones, the first workshops that started the *arpilleras*.

Contacts and the Vicaría's protection helped consolidate the switch to *arpillera* making.

The *arpillera* group in the shantytown of Villa O'Higgins was a *taller* (workshop) within a *bolsa*. Its members worked alongside male members collecting and selling bottles and newspapers; they simultaneously tried to raise consciousness in people, engaging in a "political struggle," as Cristina, a member,

56 put it. Meanwhile, some women sewed *arpilleras*, and the others soon learned
with the help of a Comité teacher. The *bolsa* became an *arpillera* group when
the men left. Cristina said:

> So the *bolsa de cesantes* was starting to meet, and I go there and everything, and they
> tell me that they are starting to sew these things. [...] We would go out and ask for
> newspapers, bottles, with carts; we would collect the bottles, the newspapers, and
> sell them for our organization in the church, our *bolsa de cesantes*. There were men
> and women in our group. There were very few women, contrary to what, to what
> you always had, which was that it was mostly women. Here there were very few of
> us when we started out, but afterward there were more women, and the men disap-
> peared; they found work in construction, they could no longer go. At that time we
> would meet at night, before curfew. We would come home just before curfew, and we
> would do everything, I mean, what, from pamphlets, to arousing people's conscious-
> ness, everything. We would meet as a *bolsa de cesantes* to carry on a political struggle,
> normally, talking about our problems because we were unemployed. [...] Over here
> you had the workshop, which was the *bolsa de cesantes* and then it was converted into
> just an *arpillera* workshop because all the men disappeared. We had two workshops,
> one *arpillera* workshop and one shoe-repair workshop, which was for the men.

Cristiana's arpillera group emerged from a *bolsa* whose members engaged in
a range of activities, including shoe repair, recycling, *arpillera* making, and
raising awareness.

The members of what was arguably the very first unemployed *arpilleristas*
group, the María Magdalena group of Puente Alto, were part of the "Bolsa de
trabajo de Puente Alto,"[1] in which they worked together to raise their family
income, producing sheets and baking bread. Hilda, a Comité employee in the
eastern office, who had worked with them, said:

> That was where we started, with the *comedores*, with these *bolsas de cesantes*, as I
> was saying, with a number of things. Anyway, and with all that, these groups of
> women appeared, let's say, who started to do different things: to bake bread, then
> they would buy, I mean, with stiff cotton they would make sheets. It was, in reality it
> was more of a, it was a reason to get together because in business terms it was very
> insignificant.

The *bolsas* were unable to earn much money, despite their flexibility in terms
of activity, but they were important as a way of coming together. Hilda was
not sure how the switch to *arpillera* making occurred, but thought it might
have come about when Anabella, an artist employed by the Comité, came to

teach the women. However, she also expressed that the women may have been making *arpilleras* before this and that the idea of using scraps of used cloth was already in the air.

The Lo Hermida group was originally a laundry cooperative (*taller de lavandería*) in which women washed clothes for clients for a fee so as to meet their families' subsistence needs. They had successfully applied to the Comité for a grant of US$100, with which they had bought two wooden wash basins (later depicted in some *arpilleras*). Zoe, a Comité volunteer who assisted them with this enterprise, described the group's beginnings:

JA: Could you please tell me, Zoe, about your first contact with the *arpilleras* or *arpilleristas*?

Zoe: They weren't *arpilleristas* yet. When I started, in '74, at the end of the year, the Vicaría[2] had just started to function in the zones, to cope with the problem of unemployment that had become much more serious. People were living—there was a crisis at that time; in the shantytowns there was a 60 percent unemployment rate.

JA: You were working for the Vicaría?

Zoe: At that moment I came to work for the Vicaría. I came because I went to offer some time, some time as a volunteer to this Vicaría that was starting out. So they asked me to be responsible for the first workshops that formed, because the Vicaría had set up some projects of a hundred dollars. They were very low sums, right, so the Vicaría asked people to present their proposal, a very simple proposal. They were shantytown proposals, so I went to work with shantytown people, and the first group was a group that created a laundry workshop. You had to create workshops that did not require much capital, because we only had a hundred dollars with which to work. So a laundry workshop was created: people who would wash for families where the husband and wife had to work and couldn't wash in their homes. So they would go and fetch the clothes, wash them, and then they would drop them off.

In Zoe's description, the high rates of unemployment and the Vicaría's policy of supporting the unemployed are factors in the emergence of the laundry cooperative.

When these women found that they were not earning enough money for everyone in the group, they tried making sewn items, but as this did not work well either, they switched to *arpillera* making. According to Zoe, Anabella, an artist hired by the Comité, came with the suggestion that the group make the switch:

So I started to work with this workshop, but we had to find clients and all that, and it did not produce enough for many people. Five people started out, but there were many more in the shantytown who were looking for work. They were thinking

58 about sewing work. We went to many factories where they would give out sewing
 work, but that didn't work out, and suddenly Anabella arrived with this proposal
 of a handicraft that they were making in Colombia, something similar, so she sug-
 gested the idea of making *arpilleras*.

The need for enough money for all group members and the Comité's support
in the form of Anabella prompted the change to *arpillera* making, in Zoe's
recollection.

While all these *arpillera* groups were in eastern Santiago, there was one very
early group in the northern zone, in the shantytown of Huamachuco. Unlike
the others, it was not a subsistence group but rather a women's discussion
group that the Comité had taken under its wing. Babette, a group member,
called it both a *grupo popular* (working-class people's group) and a *grupo de
mujeres* (women's group). Within it, the women talked about their financial
and other problems. The Comité worked closely with them, trying to increase
their understanding of the causes of their poverty and teaching them about the
history of resistance in Chile and about human rights, sometimes by providing
outside speakers. Babette told me how she joined:

Babette: And then after that someone invited me, saying they were in the chapel, with the
Vicaría's support. They came to invite me to participate in a women's group called Villa
Huamachuco.

JA: And who came to invite you?

Babette: A woman who had already started in it, invited by the Vicaría; a woman came to
invite me, a neighbor, rather, a neighbor from here, from the community. So she said
that she had come to invite me to participate, if I wanted to, in a women's group, a
shantytown group. Anyway, I had had experience of groups from before, in a mothers'
center, you see. A mothers' center, which is different from shantytown groups, because
in mothers' centers you only learn to make things with your hands, you see. And you
have tea, and put together money to go on an outing; that's a mothers' center. But a
shantytown group was for going to talk about what was happening in each of our lives;
it was to discuss something related to development.

In Babette's first group meeting the women discussed the national budget,
and subsequently the Comité staff arranged for the group to learn about
the difficulties their neighbors had feeding their families and about workers'
movements, the First of May (Worker's Day, equivalent to Labor Day in the
United States), the women's movement, rights, and the economy. They invited
professionals to give talks and lead group discussions, and had the women
conduct a survey, as mentioned earlier. They also encouraged the women

to reflect on their different life stages and identity as part of a "personal development" course. After several weeks of consciousness-raising, they invited the women to learn how to make *arpilleras*, sending someone to teach them. Babette said:

> It was not an *arpillera* group yet, it was a group of women; they were called popular groups. It was just to go and reflect, to discuss a subject, and so on. So more or less, I'm talking about '74, more or less, between '74 and '75 they invite us to receive this training in [making] *arpilleras*, because at that time there was already a lot of unemployment, we were already running an *olla común*, you see, and we were trying to find a means of subsistence. And then the Vicaría gave us the opportunity to learn this skill of making *arpilleras*. [. . .] The Vicaría sent us a teacher, a very famous woman called Wendy Werner.

The women's need to cope with their poverty and the Comité's invitation brought about the metamorphosis into an *arpillera* group. With the exception of Babette's group, then, the very first unemployed women's *arpillera* groups started off as income-earning groups. The women started making *arpilleras* because they saw this as a way of earning money for their family's needs. This was a response to their exacerbated poverty caused by their husbands' loss of a job, due in turn to new neoliberal economic policies, the national security doctrine, and persecution of leftists. Later on, once they had begun making *arpilleras* and come to understand the causes and extent of the poverty and repression through group conversation and talks presented to them, the wish to denounce the evils of the regime became a new motive for their *arpillera* making. They came to want to tell the outside world about their poverty and the repression, and so contribute toward bringing about the end of the dictatorship.[3]

Many of the women in the earliest *arpillera* groups (as well as later ones) were active in community kitchens, acquiring food from the Comité and shantytown priests, and by asking market vendors for donations. In many cases, they stopped participating in these community kitchens when the Comité started buying their *arpilleras*, as the *arpillera* work gave them steady and sufficient income, and both the women and their children felt embarrassed about having to use the community kitchens. Anastasia said:

> We had the *olla común* until the Vicaría de la Solidaridad opened its doors to us, and we could hand in, let's say, the amount of work that we would hand in at the beginning. We would hand in work every week; we would hand in any amount we liked. I mean, whatever amount we had, the Vicaría would buy.

60 Although they stopped using the community kitchens, the women engaged in various other strategies for coping with poverty, such as buying food in small quantities and on credit, cutting certain items out of the family diet, not paying bills and certain expenses, and having family members other than the head of household enter the labor market.[4]

Women who joined groups in later years followed the same path as the earliest *arpilleristas*. They faced the same poverty and poverty-related problems, joined income-earning groups, and the groups eventually switched to *arpillera* making. Brigitte of San Bartolomé, for example, said:

Brigitte: Before [joining the group] I was like this: [gestures] between the four walls—in the home. At that time I was living with my husband, you see? And he lost his job in 1975, no, in 1973. That's right, after the coup, two months after, he was unemployed. He was unemployed for two years, during which we had to sell even the everything. We sold everything, absolutely everything; everything.

JA: That made you go out, right?

Brigitte: And that, that's how I came to the church.

The shantytown priest told Brigitte about the community kitchen for children, which she joined and worked in for two years, whereupon it became a group in which the women knitted squares for blankets for an income, then painted cloth, and finally switched to *arpillera* making. The Vicaría bought all these products.

FORERUNNERS OF THE *ARPILLERA*

Arpilleras in the sense of appliquéd pictures depicting unemployment, poverty, repression, and resistance had not existed in Chile before the Pinochet regime, although other art forms had borne that name and were sources of inspiration or forerunners of the *arpilleras*. Among these were embroidered wool tapestries, also called *arpilleras*, made by Violeta Parra, a Chilean composer, singer, collector of folk songs, poet, and visual artist. From humble origins, Violeta Parra became famous for her folk music in the 1950s and 1960s. Her *arpilleras* were pictures about a meter high or wide, that depicted mostly imaginary or symbolic scenes, including "The Tree of Life," "The Bald Singer," and "The Circus." They attracted international attention when they were exhibited in Paris's Musée des Arts Décoratifs, next to the Musée du Louvre, in April 1964.[5] Some *arpilleristas* claimed Violeta Parra's *arpilleras* as sources of inspiration, while others thought of them as forerunners of their own.[6] Nancy, an unemployed *arpillerista* from the shantytown of San Francisco in southern Santiago, discussed this with me:

JA: And who taught these five women [referring to the first five women of her group] how 61
to make *arpilleras*?

Nancy: They gave us a sample, you see?

JA: Who?

Nancy: In a Vicaría meeting that they went to, they brought samples, for example. Er, because the actual *arpilleras*, the person who created them was Violeta Parra. And from that basis, of what Violeta Parra did, they went about producing the other themes. But over time they began to say what themes you had to do, and how you had to do it. Because Violeta worked directly on the cloth, the burlap, you see. And these [Nancy's group's *arpilleras*] were not like that; they were made of other types of material, a different type, with other material on top, making up the motif of what you were doing.

Nancy, whose group began making *arpilleras* in the early 1980s, understood that Violeta Parra's *arpilleras* were forerunners of the kind she made.

Others in the *arpillera* community shared this view. Daniela, the sister of a disappeared person, who helped initiate *arpillera* making in a group in southern Santiago, recalled that this group created their first *arpilleras* thinking of Violeta Parra. Similarly, Hilaria, a lawyer in the Comité and the Vicaría, said that she created the first *arpillera* group of relatives of the disappeared, thinking that it could produce something like Violeta Parra's *arpilleras*: "But I was not very clear about what I could do with those drawings [that the women made], so suddenly—and this is why they are called *arpilleras*—I remembered

Arpillera by Violeta Parra titled "La cantante calva" ("The Bald Singer"), 1960. On Web site "Violeta Parra," http://www.violetaparra .cl/sitio/arpilleras.

62 what Violeta Parra used to do," she told me. However, Anabella, the middle-class artist whom Hilaria brought on board to help the women develop what she had in mind, asserted forcefully that Violeta Parra was not the inspiration. My field notes describing a meeting with her in her office on June 18, 1996, say, "She [Anabella] made three points. First, that Violeta Parra was not the inspiration for the *arpilleras* and she was a very individualistic woman. Secondly, that if I attributed the origin of the *arpillera* to Violeta Parra, I would have to attribute all naïf Chilean art for the last 150 years to Violeta Parra, and this was not the case. Thirdly, she stressed her involvement with the *arpillera* in the early days and told the story saying that she started the *arpillera* off in Puente Alto and Lo Hermida [two shantytowns] as well as in the Agrupación [the Association of Relatives of the Detained and Disappeared]." While Anabella was a dissenting voice regarding Violeta Parra's influence, the *arpilleristas* and other Vicaría staff tended to name her as the inspiration or forerunner of their work.

 Another oft-cited source of inspiration for the *arpilleras* was the embroidered woolen tapestries of Isla Negra, a village on Chile's central coast. Isla Negra was originally a fishing hamlet, but is now a beach and cultural tourism destination, harboring one of the homes of Pablo Neruda, a Nobel Prize–winning Chilean poet and icon of the Left. In this village, the wives of fishermen and local shopkeepers began making remarkable woolen naïf art wall hangings showing scenes of rural and fishing-village life, and Pablo Neruda is known to have appreciated their work. Several *arpilleristas* mentioned them as sources of inspiration, and the Comité lawyer Hilaria said she had them in mind, in addition to Violeta Parra's work, when trying to find a suitable form of artistic expression for the relatives of the disappeared.

 There were three other sources of inspiration, each one mentioned by one of the earliest *arpilleristas*. Cristina, of the Villa O'Higgins *arpillera* group, suggested that an elderly woman in Puente Alto had come up with the idea of the *arpillera*; her group was making *arpilleras* dedicated to the Virgin del Carmen:

Cristina: The *arpillera* comes from a folk art form, which I don't know who invented, in Puente Alto. I think that the person who had the idea in Puente Alto is dead now, because she was very old. Because it occurred to her to make something for the Virgin, and you will see the imperfections it has when you go and see it. I mean, it has nothing to do with what *arpilleras* are today. [. . .]

JA: And how is it that in Puente Alto people started to make this sort of religious *arpilleras*?

Cristina: Because they were very Catholic and felt that all these things were trials that God was sending us, the dictatorship, things . . .

Woolen tapestry by a woman from Isla Negra, showing a scene of rural life, early 1970s. Photograph by Jacqueline Adams of a wall hanging belonging to her family.

The *arpilleras* to the Virgin are currently housed in the Temple of Maipú in western Santiago. While the subject matter was different from that of most later *arpilleras*, both the unemployed women and the relatives of the disappeared did make some *arpilleras* with religious themes.

A relative of the disappeared mentioned the embroidered woolen tapestries of the *bordadoras de Macul* (embroiderers of Macul) as inspiration for the *arpilleras*. Macul was a lower-middle- and working-class neighborhood in southeastern Santiago. These *bordados* (embroidered tapestries) contained cheerful scenes of children playing, typical Chilean characters such as the street musician or peanut seller, and traditional Chilean events or customs. Zara, one of the first members of the *arpillera* group of the relatives of the disappeared, said, "And so, during the get-togethers, they [the earliest *arpilleristas* in her group] slowly formed the idea that they could make some *arpilleras*, thinking of the *arpilleras* of the embroiderers of Macul, which are made of stuck-on wool, but which are decorative, not denunciatory. Or those of Isla Negra." The Macul embroideries are not, in fact, made of stuck-on wool; they were embroidered with stitches.

Isolda, another *arpillerista* and relative of a disappeared person, mentioned a final source of inspiration: pictures made of chains of crocheted wool sewn onto a base, produced by the members of her mothers' center in her shantytown in southern Santiago during the Allende years. Mothers' centers were neighborhood-based groups of low-income women, first created in the 1960s

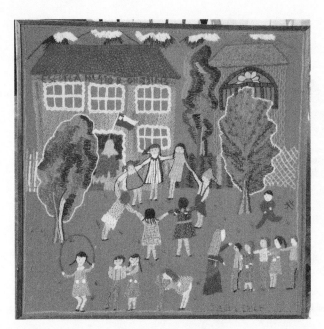

Bordado by the embroiderers of Macul, showing children playing, 1970s. The figures are embroidered in wool. Photograph by Jacqueline Adams of a wall hanging in a private collection, Geneva, Switzerland.

during the presidency of Eduardo Frei, whose members learned domestic and a variety of handicraft skills. Isolda began making these pictures, which she calls *arpilleras*, in her mothers' center in 1972 and 1973; she and her fellow members depicted attractive Chilean landscapes, and also more political themes such as the seaside resorts built by Allende for the poor; the lines for food in shops and supermarkets; and the lack of tea, sugar, and other essentials. Isolda described one of her mothers' center *arpilleras*:

Isolda: It's a very green landscape, with mountains, because our Chile is full of big hills, of mountains, you see? And with palm trees. So what the lady who made us do this work had most insisted on was that there not be any palm trees or beaches. She wanted countryside landscapes. And I did a countryside landscape with some huts, a house, a type of hut, with its clay oven, with bread being baked, with a fire, and so on. But the landscape was full of palm trees, and it was not the beach. It was a place in Cocalán, as it is called, which is inland from Rancagua. [...] And I drew it, you see, from a magazine that my husband would bring me, which was called *A Journey*; it was a magazine of the State Railways. And in it there was a picture of this place in Cocalán. I added the rest on

my own initiative. I mean, the house, the oven, the people who were there, even a little dog, and so on. That was the first *arpillera* I ever made. [. . .]

JA: May I ask about the other *arpilleras* that you would make in the mothers' center? What were their themes?

Isolda: They were themes that one could choose. In those days, people did the lines in the shops, the supermarkets, for example. And I didn't do that theme, but I saw people doing it. I mean, I saw people who were doing the things that were happening in those days. For us [relatives of the disappeared] it was useful, later on, in terms of doing what we would do; I mean, we would put our denunciation of the problem of the detained and disappeared into the *arpilleras*. But in those days that was one of the things [we put in]. The other theme they would do also was, for example, the working-class seaside resorts that Salvador Allende created. The places of Ritoque, which afterward were prison camps, Puchuncaví; they were recreation centers for children, for children from the shantytowns. And they did that type of *arpillera*. But you would also see *arpilleras* that showed that there was no food, no tea, no sugar, those sorts of things, which was the reality of what was happening, and which people accepted. [. . .]

JA: And those *arpilleras*, what was the technique like?

Isolda: They were embroidered [. . .] in wool. [. . .] Embroidered all over. Yes. And with an edging that we would make; and I remember that they would make it like little waves, like this, with crochet, all that. And the rest was with a needle. With the stitch, what's it called? The backstitch, the chain stitch; that's what we used to sew.

JA: The edge?

Isolda: No, the embroidery, the motif. Everything. For example, the mountains that were white on top, green toward the bottom. So they were gradated. They were very attractive, the works that came out of this.

JA: And how did you learn this technique?

Isolda: Just watching how it was done. I mean, they would give us a piece of cloth, what's it called, *osnaburgo* [stiff clothlike sacking] measuring 45 by 35 [centimeters]. So in that part we had to more or less draw and put in what it occurred to us to do at that moment. And if we wanted, we could draw it and you would do it, in fact we would do it with a pencil, a lead pencil. And we would do the drawing and then sew it in parts, trying to make sure it didn't get bunched up.

Isolda said later on that she used the same technique when she first began making *arpilleras* in her mixed workshop of relatives of the disappeared and unemployed women, until a teacher from a nongovernmental organization (NGO) came and taught them how to make *arpilleras* out of cloth. The group began using cloth with some wool, and finally made the *arpilleras* entirely out of cloth. These mothers' center artworks, then, were among the sources of inspiration for the *arpilleras*, along with the woolen tapestries of Violeta

66 Parra and Isla Negra, the *arpilleras* to the Virgin by a group in Puente Alto, and the embroideries of Macul. All are textile artworks by working-class women, some of whom were associated with the Chilean Left.[7]

The fact that these textile artworks existed helped foster the emergence of the *arpilleras*. These forerunners provided a repertoire on which to draw as far as materials and technique were concerned. Like them, some of the first *arpilleras* were of wool or contained several figures embroidered in wool. An early *arpillera* from the eastern zone, belonging to Zoe, the Comité employee who worked with the group in Lo Hermida in its earliest days, shows hesitant beginnings in wool. A *Solidaridad* article quotes a woman who fits Anabella's description as saying that the *arpilleristas* made *arpilleras* entirely out of wool at first, but as their selling price was too high, they switched to cloth.[8] Zara, of the *arpillera* group of relatives of the disappeared, said that her group's members made *arpilleras* out of both wool and cloth to begin with, but the cloth form predominated. Isolda, a member of a mixed workshop in José María Caro in southern Santiago, said that after her son disappeared, the first three *arpilleras* she made were of wool, like those she had made in her local mothers' center. It was when a man from an NGO came to teach them how to work out the price of their *arpilleras* that the group switched to the cloth and appliqué technique, which he taught them. She said:

> Yes, we would finish an *arpillera* in four hours. Sometimes we would work one hour a day, and the *arpillera* took time to do; it would take longer. But that was more or less what he worked out approximately, what we had to do. And he also taught us to make *arpilleras* with pieces of cloth. To make the houses, the windows, the doors. And that was another type of *arpillera*, but the first *arpilleras* which I also made in—sort of because of our problem, as relatives of the detained and disappeared—were knitted in wool. In just the way I had learned before. I made three *arpilleras* like that, which were justice, when she is with the scales, like this, unbalanced, and with her eyes covered. It's a woman, in that one, right? Afterward I made one about the political prisoners, who were behind bars, for example. All embroidered as well. And these were slower to make than—afterward with the ones made of cloth, the process became sort of faster. But there, the people of the workshops also, let's say the people of the shantytown, would do this sort of work, and would also take up the problems that were our problems, as well as their own problems. We combined our efforts, let's say, combined our efforts because they would take up our problems and we would take up theirs. Because there was also the unemployment, there were the *ollas comunes*, there was the lack of work also, there was the unemployment, the closing of factories, for example, which showed up a lot in our *arpilleras*.

In Isolda's mixed workshop, wool was being used for the earliest *arpilleras.* 67
Her words also suggest that there was communication about one's experiences
and problems between the relatives and the women who were not relatives,
and such exchanges led to the *arpilleristas'* developing an understanding of
how the regime's policies affected various groups, as will be discussed in Chap-
ters 9 and 10.

In addition to providing a repertoire of materials and techniques on which
to draw, the forerunners were important in that the prospect of making an
arpillera was daunting to many women when they started out, but the knowl-
edge that other working-class women had produced similar art perhaps made
it more conceivable that they could do so as well. Violeta Parra and the artists
of Isla Negra were female and working class, and in this regard the women
could identify with them. Moreover, while the *arpilleristas* for the most part
did not think of themselves as leftists when they began making *arpilleras,*
several were from families that appreciated Allende, and so the leftist associa-
tions of Violeta Parra and of the art of Isla Negra may have resonated with
them. The forerunners were important in two final ways. The making of wool-
en art forms in mothers' centers provided a local precedent for shantytown

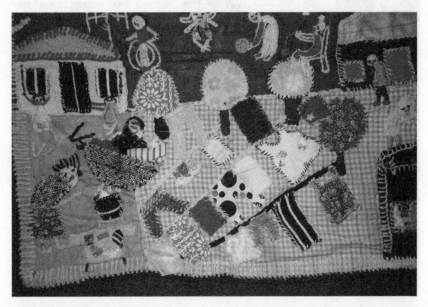

Detail of a very early *arpillera* from Lo Hermida, probably from 1975. Most of the figures are embroidered
in wool; some are made using the appliqué technique. Photograph by Jacqueline Adams of an *arpillera* in
the collection of Verónica Salas.

68 women making crafts in a group. Lastly, one forerunner probably gave the *arpilleras* their name. Although one analyst of the *arpilleras*[9] attributes the name "*arpillera*" to the Spanish word for burlap (also *arpillera*), my research suggests that the women rarely referred to burlap as "*arpillera*," but called it "*saco*" instead. It is arguably more likely that the name "*arpillera*" derives from Violeta Parra's work, as Hilaria had said. Compounding the influence of these forerunners, the "art of the people," namely folk art, folk music, and crafts, had been encouraged by the Allende government, and this may have made it less strange to the women to be producing *arpilleras*.

Two people mentioned artworks that were not Chilean as sources of inspiration for the *arpilleras*. Anabella, the Vicaría artist, claimed to have come up with the idea of the *arpillera* when she noticed a *mola* from Panama (*molas* are colorful appliqué pictures, often of abstract forms and animals, made by women of the San Blas Islands) and thought of American patchwork quilts. Meanwhile, Zoe, who was a colleague, remembered her as having been inspired by an art form from Colombia, but she was unable to specify which one.

Detail of an oven glove using the *mola* technique, purchased in Panama's main airport in 2006. Although its motif may not have existed in the early 1970s, and *molas* at the time were not adapted to oven gloves, the technique used is much the same. Photograph by Jacqueline Adams of an oven glove in her possession.

THE IDEA OF THE DICTATORSHIP-ERA *ARPILLERA*

There is controversy over who thought up the dictatorship-era *arpillera* and had the idea that groups of women could make it. One version of the story attributes this to the women themselves, while another credits Anabella, the Vicaría artist. Cristina, one of the first unemployed *arpilleristas* in the eastern zone, is one of several who remembered the women themselves as having come up with the idea:

Cristina: A mural was made in this country, and it is in the [temple of the] Virgen del Carmen, in the temple [in Maipú]. [...] That's the first one [*arpillera*].

JA: And who made it?

Cristina: The people of Puente Alto. [...] She [Anabella] taught us to use used cloth, but she was not the creator of the *arpillera*. [...] Anabella taught us the technique of the *arpillera* applied to blouses and loose shirts. [...] But Anabella is an artist and she teaches like one, but she is not the creator of the *arpillera*. The *arpillera* comes from a popular art form that I don't know who thought of it in Puente Alto. I think that the person who thought of it is dead right now, because she was very old. Because it occurred to her to do something to the Virgin, and you will see the imperfections it has. [...] We were making *arpilleras* before Anabella arrived [at the Vicaría]. Puente Alto was making *arpilleras*; Villa O'Higgins arrived at the same time as Anabella. We would meet here, and there was a woman called Nelly who doesn't belong to anything now, and doesn't want to be interviewed, she doesn't want to be involved in anything else. But she was a very political woman, the wife of a Socialist leader. She made *arpilleras* before Anabella arrived. Anabella came to perfect our technique, I mean, to teach us to use scraps.

Several other of the earliest *arpilleristas* of the eastern zone said that Anabella helped improve their *arpilleras* but did not invent them. They mentioned that other individuals helped them improve their work as well, including a group of drama students and a woman called Marcela, all of whom came after having approached or been approached by the Comité or the Vicaría. Anastasia said:

And, well, several people came, also, to give us some, I mean, how can I say, to do the *arpillera* sort of in a different way, you see? Because we did it in a very simple way. I mean, it was not something that was so attractive, so creative. So, somehow, some people came, also, to teach us a bit more creativity; among them was Anabella. She came at some point to help us. But she was not the first, the initiator of the *arpilleras*. She came to teach us, and other people came, too, whose names I don't remember. There was a girl called Marcela, and she also came to teach us how to cut,

how to make it look as good as possible, because you don't do it with a pattern or anything, you just do it off the cuff. So Marcela was helping us make stencils, make the pattern to be able to cut, and she taught us to do them with perspective, because we had no idea about that. So, they came . . . and Anabella would always say that you had to do what you saw, in the way you saw it, and you had to have quite a lot of skill to see that.

In Anastasia's description, the women had already started making *arpilleras* when Anabella and others came from the Comité to help them improve their work.[10]

According to the second version of the story, put forward by Comité staff, Anabella came up with the idea of the *arpilleras*. Hilaria, a Comité lawyer, told it this way: she was preparing an application for the enforcement of constitutional rights (*recurso de amparo*)[11] for a group of relatives of the disappeared who came regularly to Comité headquarters, and she thought that it would be helpful to the women to *participar* (engage in a socially relevant group activity), and that this activity could be producing woolen tapestries like Violeta Parra's. However, she felt she needed to hire an artist to help the women with this, and asked Anabella, who had experience working with low-income women. After spending some time with the women, Anabella thought up the *arpillera*. Hilaria was demoted because her colleagues thought that creating an *arpillera* group was neither a lawyer's job nor a Comité priority, and sent to the eastern Comité office. She brought in Anabella to teach the women in the *bolsas* in eastern Santiago how to make *arpilleras*, beginning with Puente Alto and Lo Hermida. Hilaria said:

> So for me it meant really serious problems because my workmates told me that I was being more of a social worker. And on top of that, most of the workmates were men, almost all of them. So, they lowered my wages, but apart from that, they sent me to work as a social worker. Now, the good thing about that was that they assigned me to a zone, the eastern zone. And there I went, in charge of helping some churches. And so I went to work in Puente Alto and Lo Hermida. So in Puente Alto there were the *comedores populares,* which, together with Hilda, another workmate, we practically invented. We worked with them. And after a little while, I started to make *arpilleras* with shantytown inhabitants, because of their extreme poverty. And so I asked Anabella to, with the idea of the relatives, to help these women make *arpilleras*. And then the same in Lo Hermida. This is how the workshops were: first, the workshop of the detained and disappeared; then, the workshop of Puente Alto—it was called María Magdalena—and then the workshop of Lo Hermida.[12] So Anabella assisted these other two.

Hilaria's words suggest that she brought *arpillera* making to two groups of un-
employed women in eastern Santiago, with Anabella's help, and that *arpillera*
making emerged despite resistance from other colleagues in the Comité, and
as the result of her own liberal interpretation of her duties as a lawyer. After
this, Hilaria added later, Anabella taught other groups in the zone. This ver-
sion of the story was echoed by Anabella, one other Comité employee, and a
member of the group of relatives of the disappeared who had accompanied
Anabella abroad and heard her give this account many times. Several of the
earliest unemployed *arpilleristas* of the eastern zone and one Comité employee
contest this account. The question of how the earliest groups began making *ar-
pilleras* was a sensitive one, perhaps because over the years *arpillera* making had
become a prestigious activity for shantytown women to be involved with, and
the *arpilleras* had been the object of inquiry by researchers and journalists.

Because the unemployed *arpilleristas* of the eastern zone speak with such
indignation about the claim that Anabella created the *arpillera*, and because
they assert on separate occasions that she only helped them improve their
arpilleras, I believe they were making *arpilleras* before Anabella arrived on the
scene. An article written in January 1976 and published in the first issue of the
Vicaría's bulletin, *Solidaridad*,[13] suggests the same thing. It quotes a woman
who fits Anabella's description (no names are provided) as saying that the
techniques and form emerged from the imagination and needs of the women,
while she only taught elementary things, and was learning alongside them. The
article is about the Lo Hermida *arpillera* group, which grew out of a laundry
enterprise, one of the first two groups to which Hilaria took Anabella.

Whether or not Anabella brought the idea of the *arpillera* to the groups, it
is clear that she had a large impact on the form the *arpillera* was ultimately to
take. She encouraged the production of cloth as opposed to woolen *arpilleras*.
According to the earliest *arpilleristas* of the eastern zone, she told them about
using scraps of used material and taught them the appliqué technique and
how to embroider. She also taught them to make *arpilleras* of a standard size,
and told them about perspective and about which colors were appropriate for
expressing certain emotions. She suggested that they depict what was around
them and base their depictions on close observation.[14] Lastly, she created
"*arpillera* rules," which were written down, according to Hilaria. One of these
was that the *arpilleristas* depict experiences that they had actually had, or
events that had really occurred. Cristina, one of the earliest *arpilleristas* from
the eastern zone, said:

JA: So Anabella is not the one who came with the . . . ?
Cristina: No, she did not create the *arpillera*. Or did she tell you that she had created it?

72 **JA:** Mm, more or less, yes.

Cristina: Look, middle-class women in this country—maybe what I say will be very unpleasant to you.

JA: No, no, no, not at all.

Cristina: But people who are middle class, when they help someone, especially if they help working-class people, generally they think they created it. No. She guided us, she taught us colors, she taught us what we had to do when something was sad, what the colors were, because you have to understand that if a person got to second grade of primary school, naturally the spectrum of colors, which is the thing that gives you the colors you need, is something that they teach you when you are in fifth or sixth grade. You don't learn it before that. People didn't know about it, and there was no reason for them to know about it. So, that's what she taught us. When a landscape is sad, the grays, blacks, dark blues, bla, bla, bla, that stuff. She taught us what colors to use for happiness, and so on. And people who embroidered, as I did . . . I didn't have any problem, but the others who didn't know how to embroider did, you see, and that's what she did. She taught us to use scraps of cloth, but she was not the creator of the *arpillera*. [. . .] My cousin next door, when we hear "I invented it, I created it," no! Not true! What we are creating now is the technique of the *arpillera* in any other thing, that is created by anyone. I mean, I can tell you we invented the cosmetics bags, we invented the shirt fronts. What Anabella taught us was the *arpillera* technique applied to blouses, to long shirts. We would put the mountains here, and there we would put the landscapes of the mountains. She was the first person who dared to go around with these little things; that was something she did teach us. But Anabella is an artist and she teaches like one, but she is not the creator of the *arpillera*. [. . .] But the creation of the *arpillera* itself, I think, at least regarding who had the idea, who invented this format, this 45 x 50 [cm] format—this comes from Anabella. I mean, because she saw these things that were coming out so disorganized, she said, "No, we need to be able to sell them." And she was absolutely right. I think Anabella helped us a lot, but she was not the inventor. I mean, I think that there is no reason for it to be this way, I mean, from my perspective one has to say things as they are, more honestly. [. . .]

JA: But were you making *arpilleras* before Anabella arrived or not?

Cristina: In fact, Anabella, er—we were making *arpilleras* before Anabella arrived. [. . .] Anabella came to perfect our technique a little, I mean, to teach us to use scraps, because for us it was very . . . we were very poor, very poor, all of us. [. . .] So, well, she came to teach us to use scraps, I mean, how to take apart an article of clothing and use it in the *arpillera*, that sort of thing. She was with us only a very short time; she was not in these workshops for very long, she was here a relatively short time. I would say that it was like from April or May to December.

Cristina's mention of the *arpilleras* "coming out so disorganized" adds 73
veracity to her assertion that the women were making *arpilleras* before Anabella
came to their group. However, the things that she said Anabella taught them
are so fundamental to the *arpillera* that there is a fine line between teaching
these things and creating a new art form. Anabella was certainly highly influ-
ential in shaping the *arpillera* as it came to be: a picture in appliqué, of used
cloth, depicting the experiences of shantytown women. She was also impor-
tant in that she taught many groups, if not the first, how to make *arpilleras*
from scratch, and in so doing, contributed greatly to the rise of the unemployed
women's *arpilleras* and to the spread of *arpillera* making.

Arpillera making among unemployed women, then, began in four groups
in eastern Santiago and one group in the north of the city. Most of these
groups grew out of other kinds of subsistence organizations that mushroomed
in shantytowns because of the unemployment that the neoliberal austerity
measures, national security doctrine, and repression were causing. The wom-
en's motivation in specializing in *arpillera* making was primarily to earn more
money with which to feed their families and run their households. The emer-
gence of the *arpillera* was much helped by the support of shantytown priests
and a handful of Comité and Vicaría staff, both within and outside their offi-
cial work. The strong desire of these parties to help the women points to the
importance of solidarity for the emergence of the *arpillera* system. The *arpi-
llera*'s emergence was also assisted by the *arpilleristas*' knowledge that other
working-class women had made woolen wall hangings; some of these fore-
runners served as sources of inspiration for the new *arpilleras*. The next chap-
ter briefly discusses *arpillera* making among the relatives of the disappeared in
eastern Santiago and in mixed workshops in southern Santiago, and it explores
the spread of *arpillera* making.

Arpillera Making in Other Groups and Its Spread

THE EMERGENCE OF *ARPILLERA* MAKING AMONG THE RELATIVES OF DISAPPEARED PERSONS

The relatives of the disappeared who made *arpilleras* were the mothers, wives, partners, sisters, and daughters of people who had been taken away by the secret police and never seen alive by their families again; nor were their whereabouts known. In total there were 1,163 disappeared.[1] Most were working class[2] and leftists from the Socialist and Communist Parties and the Movement of the Revolutionary Left (Movimiento de Izquierda Revolucionaria; MIR). Their relatives met each other while searching for them in prisons, morgues, government offices, and the courts, and while seeking legal assistance at the Comité.[3] A small number of these relatives formed an *arpillera* group that met regularly in the Comité offices in eastern Santiago. I call them the "Agrupación *arpilleristas*," since they were a subset of the group of relatives that soon formed the Association of Relatives of the Detained and Disappeared, or Agrupación de Familiares de Detenidos-Desaparecidos (AFFD) in Spanish.

As with the unemployed women, there are contradictory accounts about how the Agrupación *arpilleristas* began making *arpilleras*. One set of accounts, by the earliest members of the group, describes the initiative as coming from the women themselves. The other, put forward by Comité staff members Hilaria and Anabella, and with which one of the first Agrupación *arpilleristas* agrees, affirms that *arpillera* making began at the Comité's instigation.[4]

According to the first set of accounts, the women began making *arpilleras* without prompting in the eastern zone Comité office.[5] They were looking for a way to earn money, derive therapeutic benefit, express themselves, or denounce the regime and its practices, their emphasis varying from person to person.

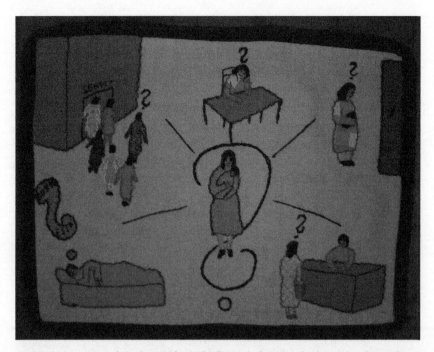

Arpillera by a member of the Agrupación de Familiares de Detenidos-Desaparecidos (Association of Relatives of the Detained and Disappeared), depicting her search for her disappeared relative in government offices and her constant wondering where he or she is; late 1970s or early 1980s. Photograph by Jacqueline Adams of an *arpillera* in the collection of André Jacques and Geneviève Camus.

For those who badly needed an income, the money was a primary motivation, whereas for those who were more comfortably off, solace and self-expression were more important. Fabiola, a group member and mother of a disappeared woman, for example, said that the Agrupación *arpillera* group started because the relatives needed a way to vent their feelings, and because Julieta Neri, the middle-class mother of a disappeared man, who possessed knowledge about different kinds of Chilean folk art, suggested that they vent their feelings by expressing themselves in cloth and formed a group for this purpose. The group members knew about *arpilleras* made in rural areas of Chile and modeled their work loosely on these. About a year later, drama students came to help them depict movement in their work. Fabiola said:

> And as I say, with this searching, when we realized that the days, weeks, and months were slipping by, there came a moment—I don't really know how the idea came about—but there came a moment when it was necessary to find a sort of escape valve, a way of somehow expressing your sorrow or your pain, or that we receive

some sort of therapy basically, which would do us good, because at that time you didn't know what to think or do. As we went every day—we were going around doing this [searching in detention centers and going to the Vicaría area offices] every day of the week. [. . .] The relatives who lived in Ñuñoa would meet in the Vicaría of Ñuñoa [in eastern Santiago], those who lived in the center met in a Vicaría office designated for them in the center, those in the south met in the south, and so on. The groups [of relatives] formed. I in fact didn't belong to the eastern zone, and they invited me to one of these meetings where they were starting to create what was in fact called an *arpillera* workshop, asking what we thought about the idea— but in fact we didn't have anything like a teacher to guide us or anything—"What did we think, for example, if somehow we started to depict our sorrow, our pain, in a piece of cloth with, any way we could, as we knew how to sew, making something?" And that's how this began, without any technique, without anything. Because there were what were called *arpilleras*, which I think exist somewhere, I don't know, near Los Andes or near another village, or in Chiloé, things called *arpilleras*, you see, which we had heard about or something. But the point was to put in what you felt, because the important thing at that time was that we, that you do anything. No one would say, "Look, I want you to do, for example, a song, and I want you to do something related to fruit," or some specific theme. And one of the women who, as far as I understand, at that time Julieta Neri was sort of the one who, not who had the idea—I don't know who gave it to her—but who started to speak to us, asking us what we thought. And we started to meet. And she told us to bring pieces of cloth, which all of us had, being housewives. And this wonderful group was created, where we started to depict what we wanted at the time. Because time passed, and the Vicaría offered us sort of a way to help because there were many people, also, who needed money at the time, because the disappeared person had been the household head. As a way to help them, you see, they would pay us for this work; the Vicaría would sort of buy this, and the work would go abroad, they would send it abroad and it would be sold in Europe, you see. So you received an income, because if we made one [*arpillera*] a week, you would have four a month, so this was at least some money that you were bringing home, you see. So, as I say, there were people who had never done this sort of work, and we had no idea, either, when we were putting in the figures, no idea about what we wanted to do, or about creating a sense of movement. [. . .] And when about a year, as far as I remember, had passed since we had begun doing this, some very young women, like you, came; they were studying theater, I think they were at the Catholic University or the University of Chile, and among them was one of the actresses, who is very good, who works—Norma Quilpúe, I don't know if you know her. [. . .] And she started to teach us how to communicate movement, I mean so that you could, how can I say, so that the arms would not look stiff, so that knees—I don't know

if you understand what I mean. The thing was that ours were sort of static, and 77
flat, and this was a way for you to see that there was movement.

Various elements of Fabiola's description suggest that the women themselves
came up with the idea of making *arpilleras*, along with their form and content.
Julieta Neri asked the women what they thought about creating a group[6] and
suggested they bring spare cloth to their next meeting, but there was no "teacher-
guide" with them when they came up with the idea of making *arpilleras*, and
about a year later drama students came and helped them depict movement in
their work. When asked directly, Fabiola did not know who Anabella was:

JA: Someone spoke to me about Anabella. What was her role there; do you remember
her, or not?
Fabiola: I really have trouble with names these days. [. . .]
JA: I'm not very clear about her role in this; she is very short, black-haired, in those days
she was about thirty-five, and apparently she helped your group with something; I
don't know if you remember someone helping you with this?
Fabiola: Did she maybe come afterward? Because right now, as I say, the only person I
remember as the leader of the group if you want to call it that, who helped us and said,
"Look, the idea . . ."—because we would discuss it, saying in the beginning, "Look, I'd
like to . . . it really would be nice . . ." [. . .]—was Julieta.
JA: And where did Julieta's knowledge about this come from?
Fabiola: No, no one had any knowledge about anything. The only knowledge we had, as I
say, was that people were making *arpilleras*, which as I say, had subject matter that was
typical of that area, like for example fishing.

Fabiola's words suggest again that Julieta prompted them to form a group to
make something, and that Anabella was not involved. The earliest *arpilleristas*
were not the only ones to say that Julieta was central to the development of the
idea of the *arpillera* among the relatives of the disappeared. So, too, did Celinda,
a social worker in the Comité's eastern zone office: "It was Julieta Neri who
was the catalyst [for the *arpillera*], at least in the eastern zone. I think she was
also connected with the other zones."

Zara, who joined the group one month after it began, also suggested that
Julieta was the leader, but unlike Fabiola, she remembered Anabella, and said
that she was called in once the women were already making *arpilleras* to help
improve them:

I joined one month after the workshop had begun. We saw that it was necessary, as
they [the *arpilleras*] went out without quality control, to speak to an expert, and we

spoke with Anabella so that she would help us, show us what we could do. She asked me to show her an *arpillera*. And I felt very pleased because she is a sculptor and knew about art. She was from a reactionary family. She congratulated me warmly because I made the first *arpillera* in four sections. Here, I showed us in the house. There, I showed myself going out of the house. This one has a blue sky, that one a gray sky. I was walking past a tree; and now that time has passed I have two trees like this outside, one dead one, and one green one. For us, the tree has always symbolized life. We established that it was the tree of life, because it gives you shade, fruit, life. In that *arpillera* I am going out with my mother, between these two trees. She asked us why I had depicted it like that. I said that our walking and our first months meant uncertainty for us. We wanted to find them alive. But maybe they were dead. The last section had a dark sky, a sky of tragedy. But I was always walking with my mother next to me, doing the things I had to do. And this *arpillera* made a strong impression on Anabella. I had never embroidered, and I thought that I would not be able to. I started working in the workshop after the first month because Julieta Neri told me to join; they needed someone to manage it. They named me secretary of the workshop. [. . .] In the Comité there were two workshops. Ours, which was an *arpillera* workshop, was the first one in Chile, and the laundry workshop for unemployed people was the other one. Zoe and her husband and the Comité bought a machine and they set up the workshop in Lo Hermida.

Zara's description of the group as already making *arpilleras* when Anabella was called in, together with the fact that Anabella asked Zara to show her an *arpillera*, suggest that the initiative for *arpillera* making did not come from Anabella. Julieta's inviting Zara to join the group suggests that she was the de facto leader, as Fabiola had implied.

I asked Zoe, a Comité volunteer, about Anabella's involvement and recorded in my field notes:

> Anabella came along once they had started, and made them do more religious *arpilleras*. She made them use symbols like the dove for peace and the sun for hope. "To soften them," said Zoe. They wanted to have stronger messages though. She got them to do the Via Crucis [the Way of the Cross, an *arpillera* mural depicting the problem of the disappeared]. And helped with quality control.

The group did indeed make a mural out of several *arpilleras* sewn together, calling it the "Via Crucis." Anabella's "softening," meaning making the subject matter less denunciatory, may have been due to Hilaria's having promised the *vicario* that the women would depict religious themes.

In the second set of accounts about how the idea of the *arpillera* was born in the Agrupación group, Hilaria and Anabella were central to the beginning of *arpillera* making. Her lively story is worth quoting at length:

Hilaria: I'll tell you the story. I came to work at the age of twenty-three as a lawyer of the Comité Pro-Paz, when the Comité Pro-Paz was born in 1973. And among the jobs I had was to work with the relatives of the detained and disappeared. So, the problems we had, which were serious, were that . . . there were several problems. One was that their [the relatives' legal] actions were absolutely unsuccessful, a failure. They didn't have anything that they could do while searching for their loved ones. Because they didn't get any response [from the legal system]. And there was no activity that they could come together as a group around. On top of this, they had no resources; they didn't have money for transport, for anything. But they had a tremendous need to express themselves, to talk. These were pretty much the problems they had. The problem I, as a lawyer, had was that I didn't have much time to work with them on a case-by-case basis. There were very few staff as far as social workers were concerned, there was no psychologist, nothing of the kind, so basically you had meetings that were very painful. Remember that each person had lost a relative, two relatives, even four relatives. So one day I thought that it was necessary that they be in a group; that was the basic idea. And so I asked them what they knew how to do. Most of them had not worked before. They were housewives, and they didn't have much education; they didn't come from a high social class, they were working class. So we started to do, I remember, at a table like this one, a big table in, in the Comité Pro-Paz, which was in Santa Mónica, I asked them to take out a piece of paper and do a drawing, and to draw their most beautiful and their most painful moment. The drawings were both good and bad. But I didn't have a very clear idea about what I could do with those drawings, so suddenly—and this is why it is called *arpillera*—I remembered what Violeta Parra did. And Isla Negra . . . Anyway, at that time people talked about the *arpilleras* and thought that they were embroidered. So, I mentioned this idea to the chauffeur of the Comité Pro-Paz whose name was . . . a charming fellow who lives in France now, and his name is, I don't remember the name. His surname was Tirado. I told him this and he said . . . and I said to him, "You don't by any chance know of anyone who knows about craftwork, who knows about this kind of thing, do you?" My question was absurd. And I said that in addition it should be someone who would be able to work with relatives of the disappeared. So he said, "Look, I know someone who is charming, a woman who worked in the south of Chile and whom I think you could ask." And he took me to Anabella's house. I didn't know her at all, not in the slightest. I arrived at Anabella's house.

JA: Because at that point they weren't doing anything at all? [. . .]

80

Hilaria: No, no, no, they . . .

JA: Nothing at all.

Hilaria: No, it was 1974.

JA: Yes.

Hilaria: No, nothing, they were wrapped up in their grief and would do whatever they could to find them [their disappeared]. They didn't do anything collectively that I know of, no. No, there was no Agrupación yet at all, so organized, like now. They would get together from time to time. So I talked to Anabella [the artist] and told her about the idea. And Anabella, as you will have seen, is a great woman, a very, very appealing woman, very powerful. But on top of that she was very practical, so she said "Look, you can't, you can't do it with wool because wool is very expensive." Anyway, in short, she said, "Let's go and get the women together and see what we can do." So I organized the meeting. I told them that we would do a project together, and that for the next meeting they had to bring needles and cloth. It was Anabella, I remember, who told me to bring pieces of cloth and everything I could find. We had the meeting and right away, immediately, instead of starting with something that would be complicated, like an explanation, she said, "Okay, get your things out, and we'll start working." And she gave them a subject and they started to work. And Anabella would correct them, you see, while they worked, making sure that their work was all right, etc. And I would say that that's how they started out. The *arpilleras* started out with the detained and disappeared; they did not start out with the more urban side of things [the unemployed women's *arpilleras*, which depicted urban scenes], I mean. They started out because of a problem of denunciation; that's what I talk about in that article, how they started out because of the ineffectiveness of the legal system, basically.

In Hilaria's view, *arpillera* making began as a result of her efforts to give the relatives the chance to come together around an activity. She wished to meet the needs that the relatives had for solace, a chance to express themselves and talk with others, and above all to *participar* (be active, in a group), since they were extremely distressed and their efforts on the legal front with writs of habeas corpus were failing.

Anabella, the artist, said that from her early meetings with the relatives she realized how anxious they were, and this prompted her to search for a means of expression that the women could manage. She said:

Anabella: So I started my meetings, I had to do a lot of things with my hands, weaving, I came with a whole different thing. But we had meetings and in these meetings the only things that came up were the crises, crises of anxiety. [. . .] Anyway, so I started, later, to talk with them, and their anxieties were enormous, so I thought that they could draw. Draw a bit of what was happening to them. Thinking that maybe they could draw those

things or describe them. But the women were just too hysterical to be threading nee-
dles and things and embroidering on top of it, so we changed the technique and I
started with something that I had never done, which was appliqué. Taking a bit from
patchwork, a bit from the *molas* of Panama, we came up with a new technique.

JA: And how did you get the idea?

Anabella: No, it didn't occur to me, I mean, they really were very hysterical, you know,
so I was prowling around like a caged lion there, and I didn't know, and suddenly,
well, among the pictures I had in my house, there was a *mola*. Suddenly I was looking
at it and I said, "Well, these people do it with needle and thread, so why can't we?"
So we started. I started to teach the women a bit about drawing, a bit about, about
human proportions, a bit about composition, and a bit about color. While they
were making these things, we created a simple language: you couldn't have a light
color over another light one, but rather light over dark, dark over light. You shouldn't
put material with a pattern on top of material with a pattern, or sewing over sewing.
We started to make simple rules [. . .]. So, by the time about two weeks were up, we
already had rules and things that come out through observation. I'm a teacher, and you
understand that I have the ability to notice the mistakes and to quickly change the way
of doing things.

JA: And about the patchworks, are you talking about quilts?

Anabella: I am talking about bed covers, those things.

JA: Okay, yes. Had you seen it in books? [**Anabella:** No.] Or how? [**Anabella:** No.] Had you
seen them directly? Were there any in Chile?

Anabella: Within the field of art it's something that is known as a source, you see? Also
because in the United States you can see those things; because in magazines you see
them. And they're not only from the United States; they are also made in Europe, and
you see them in films, and, you know, there is always someone who has some that they
brought, that they were given, or that they made. No, those things are always part of the
culture, of your surroundings that you see, you see?

[. . .]

JA: And so it was like a mixture of the two things.

Anabella: A mixture, yes. A mixture for, for this business of the base and everything.

Anabella's words suggest that she thought the women were too anxious to be
able to handle threading needles and making embroidery, and so she tried to
think of something else and was inspired by a Panamanian *mola* in her house
and by quilts. Both were women's art forms; Anabella was drawing on female
artistic traditions. There is contradiction in her account in that on the one hand
she thought that the women were too anxious to be threading needles and
embroidering, and on the other, the *arpilleras* that she had the women make
required much sewing.

82 Anabella stated that for the content, she encouraged the women to tell their stories, and taught them how to summarize an idea and identify the essential element in their experience. She wanted the women to have a "*desahogo*" (release, or chance to vent their feelings) in making the *arpilleras*, and thought of *arpillera* making as a "therapy of release." She continued:

Anabella: They came up with the subject matter.

JA: Where do the themes come from? And what did you say to them?

Anabella: Well, that they tell their stories, I mean, how to tell them. I mean, for me it's something simple, whereas for others it's not, it's not simple. For me it was, because if I want to paint a picture, I have to know what I want to paint and how to frame it, the fragment that I want to use. If I want to take a photo, I also know what fragment of the whole of what surrounds me I want to take, because I can't take a panoramic photo like this because it could be that this panoramic photo doesn't tell me anything. But sometimes a small fragment can tell me a lot, so that was what I taught the women; in other words, how to summarize an idea. And from that idea, what was the crucial thing? What point had been the most crucial one? What point was the one that had had the greatest impact, you see. Because to the extent that they could depict that, they were going to be able to vent their feelings. It's like when you tell a psychologist what the most decisive point is, there is a relaxation, you see? Of when you finally discover it. Well, it worked; it worked quite well. And the women were able, then, to start a sort of venting therapy, visually.

JA: And what did they put in those *arpilleras* at the beginning? What were the themes?

Anabella: Usually the first thing that they depicted was how they [the secret police] had come in and taken away that person. That was very violent for them. In general, they were about violence. And the other thing, the moment at which they had been warned, and what they imagined might be happening. Seeing their families sort of submerged in a hole, in an inferno, that's what it was. When they knew they were in prison, how they imagined or how, if they managed to see them, how they were. But it is the thing that is with you at a moment of crisis, you see? Because if you are experiencing sorrow, you know what place hurts the most with this sorrow, and that is what it is. That's what it was. I had a lot of friends who were psychologists, you see, who could, who helped me at that time, with how to bring the conflict to the surface.

JA: And how many [group members] were there at that time?

Anabella: Not many. There must have been, let's see, some . . . not everyone had the skills to do it visually. I mean the most, the most introverted ones, usually, were the ones who could do it. The others couldn't do it. I thought that they could do literary workshops. They did something there, yes, they did it with the lawyer. I don't know what the result was. I think there were some testimonies.

JA: Was it for them to write what had happened?

Anabella: Yes, but with a lot of fear because their houses were liable to be raided, and if they were raided and there was a written document, it was rough. So what they mostly did was tell, have a clear idea how to tell the story, or the story of their anguish, to other people. Because that was important too.

Anabella encouraged the women to depict what they had experienced and their anguish, and taught them how. Taking Hilaria's and Anabella's stories together, Hilaria suggested the general idea for the artwork, having thought of the woolen *arpilleras* by Violeta Parra and the women of Isla Negra, and Anabella, after experimenting with drawing, had the women make something like the *molas* and quilts, using their experiences as subject matter. Both Hilaria and Anabella assert that from these beginnings they took *arpillera* making to groups in the shantytowns.

If we believe Hilaria's and Anabella's accounts about both the Agrupación group and the groups of unemployed women, chance played a role in the emergence of the *arpillera*.[7] Several crucial steps involved considerable luck, such as Hilaria's happening to mention to the Comité chauffeur that she needed an artist who could work with the relatives of the disappeared, the chauffeur's happening to know such an artist, and Anabella's having exactly the right qualifications—and being available. It was also fortunate that when Hilaria was demoted she was sent to the eastern zone office, as this move was conducive to the rise of *arpillera* making in the shantytowns.

The *arpillera*'s emergence within the Comité happened against the odds in that it depended on work by employees that was not part of their job description as Comité employees and that they did outside working hours. For example, if we believe that Hilaria set up the Agrupación *arpillera* group, she did so at her own initiative; it was not part of her already demanding workload as a lawyer, and furthermore it was work of which her colleagues disapproved. The Comité volunteer Zoe, who helped start the women's laundry workshop that eventually became an *arpillera* group, made efforts to sell *arpilleras* to university classmates outside her Comité working hours. Celinda, a social worker who came to lead the eastern zone's team, bought *arpilleras* in order to help the women earn the money they needed, and in so doing she was acting individually, not in her capacity of staff member, and this buying was not something her job required her to do. Her buying, like Zoe's selling to fellow students, was important because the women badly needed an income and had found very few buyers of their own; so without this help it is possible that they would have stopped making *arpilleras* and looked for another way to earn money. Hence, without

84 the work of Comité staff beyond the requirements of their jobs, and in their free time, *arpillera* making may never have come about.

There is still another way in which the *arpillera* emerged against the odds. *Arpillera* making encountered strong opposition from within the Comité. Hilaria's efforts were met with levels of disapproval that would have discouraged many people. Not only did her colleagues demote her to the position and salary of a social worker, and move her to the Comité's eastern zone to work with shantytown inhabitants; once she was there, the *vicario* (leader) of the eastern Comité office said he thought that the *arpillera* groups were not a positive development. He was afraid they would engage in illegal activities or generate extreme left-wing groups, and believed that it was not healthy for the women to meet and talk to each other about their problems.[8] Hilaria recalled having to persuade him that the relatives of the disappeared should be allowed to meet there and make *arpilleras*; she succeeded by telling him that they would depict religious themes in their *arpilleras* and not fail to tell the truth. This disapproval by Comité staff occurred despite the fact that bringing women into groups to earn an income was in line with the Comité's goal of supporting the victims of the regime and fostering the creation of organizations. Part of it, such as the *vicario*'s concern, was a symptom of the climate of fear created by the persecution of leftist groups. If it had not been for Hilaria's strength of conviction, determination, and endurance of her demotion and loss of prestige in the eyes of her colleagues, *arpillera* making might not have continued in the group of relatives of the disappeared or spread to groups in the shantytowns, if we believe her story.

There was a gender dimension to the emergence of the *arpillera* system. The main promoters of *arpillera* making were women, and some of the opponents were men. The Vicario and Comité colleagues who disapproved of Hilaria's efforts to form *arpillera* groups were men. There were also instances of priests within and outside the Vicaría opposing the coming together of groups, according to Wilma, another Vicaría employee who worked with the early *arpilleristas*. Meanwhile, the primary *arpillera* group promoters were women with a solidarity orientation and proto-feminist sensibilities. They felt for the *arpilleristas* in their anguish and poverty, saw the value of their coming together to work, and believed that they should have the opportunity to do so. They believed in women's right to participate in groups, work together, earn an income, and express their feelings and experiences. Their ideas about the importance of collective *arpillera* making for the *arpilleristas*, coupled with their solidarity, conviction, and determination, led to their overcoming barriers erected by a number of gatekeeping men. Despite initial obstacles within the Comité, all accounts agree that the Comité soon began paying the relatives

for their *arpilleras* and sending the artwork abroad. As time went on, the 85
relatives had many other buyers who approached them directly, including
people living outside the country.

MIXED WORKSHOPS, WOMEN POLITICAL PRISONERS, AND *ARPILLERISTAS* IN RURAL TOWNS
Mixed Workshops

While the Agrupación group was forming in the eastern zone, other relatives of
the disappeared were creating mixed workshops of unemployed local women
and relatives of the disappeared in churches in the shantytowns of southern
Santiago. Isolda, the mother of a disappeared man and creator of some of these
groups, said:

> Because we started to make *arpilleras* afterward, in the Agrupación. We started to do
> it in the workshops that were being created in the churches. And that's where we did
> it. We would create "mixed workshops," as they are called, which was people from
> shantytowns and us, the relatives of the detained and disappeared.

Isolda later explained that she and other relatives thought that forming a mixed
workshop was an opportunity to denounce the disappearances; they hoped that
the unemployed women would carry the message to people who were unaware of
the problem. It was also, they thought, a way of coming closer to the unemployed
and people in the shantytowns, of requesting solidarity from them and express-
ing solidarity with them, of doing things together, of talking to people who also
had problems (knowing about the different problems of the unemployed wom-
en helped them, they believed), and of rebuilding a working-class movement.
Moreover, the unemployed women were already familiar with *arpillera* making,
whereas many of the relatives were not, and the unemployed women had needs as
great as theirs.[9]

Isolda's mixed workshop had begun making *arpilleras* thinking of the woolen
tapestries that Isolda had made in her mothers' center, and later on, an NGO
employee taught the group how to make *arpilleras* out of used cloth, as mentioned
earlier. Daniela, a relative of a disappeared person and member of another very
early mixed workshop in the southern zone, recalled that her group came
up with the idea of the *arpillera* by thinking of Violeta Parra's *arpilleras*. The
relatives of the disappeared in mixed workshops typically depicted the theme of
disappearance, portraying the arrest, searching, and despair, but they also made
arpilleras depicting the community kitchens, unemployment, protests, and
other topics favored by the unemployed women. Meanwhile, the unemployed
women took up some of the relatives' themes. The Vicaría bought and exported

86 this work, sending it to the same sellers as those to whom they sent the other *arpilleras*, described above.

Women Political Prisoners

Women prisoners, arrested because they belonged to leftist groups and clandestine resistance organizations, also made *arpilleras*, in addition to a number of other crafts. Some worked on the *arpilleras* individually, while others formed a production line. Their goals were to earn money and denounce the human rights violations occurring in Chile. Both the Vicaría and an association of relatives of political prisoners sold their *arpilleras* abroad, and with the money they received, the prisoners bought the food and personal items that they needed and supported their children, who were staying with relatives.

They enjoyed the chance to be creative and the momentary escape that *arpillera* making provided, as they would imagine places they had been to in the past, and choosing colors was absorbing. They chose what to depict based on what they were experiencing, current problems outside the prison, memories of places they knew, news items, or conversations they had had. Consequently, the themes of their *arpilleras* were human rights, political prisoners, torture, the disappeared, the murdered, exile, poverty, protests, and the society they wanted to build after the dictatorship. They always signed their *arpilleras* "P.P.," standing for "Presas Políticas" (Women Political Prisoners), and sometimes they included the year, the name of the prison, and their own name, or they simply wrote "Chile." For a time, they added to the *arpilleras* a small piece of paper with an explanation of what the *arpillera* depicted, so as to help the buyer understand its contents.

Relatives or Vicaría staff would visit the political prisoners and sell their *arpilleras* or send them abroad to be sold. Before this, however, the prison guards checked them. Knowing that *arpilleras* depicting policemen on patrol were often confiscated, the women would not sew the green-uniformed policemen onto the *arpilleras*, but hide them on their person as they were being checked by the guards, and then secretly hand them over to the relative, who would sew them on later. Where exactly they hid them would depend on which guard was on duty; they knew their search styles and strategized accordingly. They also devised ingenious ways to hide written messages, squeezing them between small *monitos* (the human figures on the *arpilleras*) or adding them to the confusion and messiness of barricades on fire depicted in their *arpilleras*.

Arpilleristas in Rural Towns

Another category of *arpillerista* was women living in the small rural towns of Melipilla, Talagante, and San Antonio, the first two being less than an hour's drive from Santiago, the third located on the coast about two hours away. Like the *arpilleristas* of Santiago, many of these women had not worked for an income outside the home, occupied as they were with raising children, but some were working in the agricultural sector during the summers, in construction, as employees in shops, or selling cakes by the freeway, according to Lilly, the Vicaría employee in charge of the rural-coastal zone of which these three towns were a part. The *arpilleristas* of Melipilla whom I interviewed lived in the poorer neighborhoods of this town. Economic necessity drove them to run a community kitchen for children, to which their local priest gave his support, and in which they both cooked food and made aprons. Their community kitchen closed down, but they had enjoyed meeting with other women and felt the need to get out of the house and have a space of their own, so they created a *comprando juntos* (buying cooperative). Subsequently, they began making *arpilleras*, partly because they wanted to learn a new skill. A Vicaría staff member trained them.

The Melipilla group had always made *arpilleras* with countryside themes that included mountains, fields, and animals. They had never portrayed denunciatory themes because they could not depict what they had not experienced, according to Bettina, a group leader. Bettina and her *arpillerista* colleagues were still producing *arpilleras* in the 1990s portraying cheerful rural scenes. The fair trade shops I observed and photographed in Switzerland had many countryside *arpilleras* of the type they made. In 2006, many of their *arpilleras* were being sold in the shop of the Vicaría's unit that worked with the *arpilleras*, which came to be called the Fundación Solidaridad after the fall of the regime.

THE SPREAD OF *ARPILLERA* MAKING
The Creation of New Groups

Once the first *arpillera* groups in the eastern zone were established in Puente Alto, Lo Hermida, La Faena, Villa O'Higgins, and the Comité's office (in the case of the Agrupación group), a new workshop called Nuevo Amanecer was created in the same zone. Its members were the wives of newly released political prisoners, whom Cristina from the Villa O'Higgins group taught how to make *arpilleras*. With the addition of this workshop, the number of *arpilleristas* grew to about 120. The number of groups remained stable for two or three years, and then *arpillera* making began to spread. Cristina said, leaving out the La Faena group:[10]

88 Afterward there were about two years, three years, during which no one else
 appeared except for the Vicaría, and there were very few of us; it was just the eastern
 zone, the Agrupación, Puente Alto, Lo Hermida, Villa O'Higgins, and when they
 were released from Cuatro Álamos, Nuevo Amanecer. These were all the workshops
 there were. Later Los Copihues appeared, and after that all the other shantytowns.

The number of groups stayed the same for two or three years because the
women had difficulty selling their *arpilleras*. Groups began mushrooming in
many shantytowns when the Vicaría was able to buy their work, thanks to its
success with developing a distribution network abroad and growing demand.

The other zones lagged behind the eastern zone. Wilma, a Comité and
Vicaría employee who had worked first in the southern and then in the eastern
zone, recalled:

Wilma: I was in the southern zone. It must have been in '77, '78, and then in '79 I went to
work with the eastern zone team. I came to where *arpillera* making was most devel-
oped, because they had already begun.
JA: So they hadn't begun in the other zones?
Wilma: No, it was much slower. Maybe it happened simultaneously. There was a group
in José María Caro [in the southern zone], but in the eastern zone there were already
six workshops and here [in the southern zone] there was one. And these groups
started to grow, since there started to be demand for the *arpilleras*. And the Vicaría de
la Solidaridad organized a department, an office that sold them.

Since the unemployed women made *arpilleras* because they needed money,
there had to be someone to buy their work for *arpillera* making to be viable
for them. Demand increased because the Vicaría found more and more people
abroad willing to help sell them, and so the groups multiplied.

Eventually there were fourteen groups in the eastern zone. Wilma continued:

I remember that the women of the Association of [Relatives of the] Detained
and Disappeared were still in the eastern zone. There must have been at least . . .
at one point there were as many as about fourteen workshops, but seven or eight
big ones: the workshops of Lo Hermida, La Faena, Nuevo Amanecer, Villa
O'Higgins, Los Copihues, the Agrupación, and Puente Alto. They were sort of
the seven biggest ones.

As the *arpillera* makers considered 20 women a normal size for an *arpillera*
group, if some groups were larger and others were smaller, the number of
arpilleristas in the eastern zone was probably 280 at that time.

In addition to growing demand from abroad, other factors contributed to the increase in the number of groups. The availability of training in *arpillera* making was important, as was the women's interest in learning. The Vicaría played a central role in the spread of *arpillera* making in many parts of Santiago by sending a Vicaría employee or experienced *arpillerista* from the eastern zone to teach new groups. It used the discourse of solidarity when requesting this help, and offered to pay the bus fare. The experienced *arpilleristas* were willing to teach and made the effort to do so. Cristina of the Villa O'Higgins group said:

Cristina: I was training many areas of Santiago, let's say, because what started to happen was that we in the eastern zone were the promoters, as it were, you see? But we started to have groups interested in making *arpilleras*, so the Vicaría asked us for solidarity, saying could we go and teach them. They would pay us for the bus fare, and we started to go, one to one shantytown, others to another shantytown, and that way the *arpillera* started up all over Santiago.

JA: And where did you teach? In the churches?

Cristina: In the churches. Everything was in the churches, everything was with the protection of the Church. [. . .] All the *arpilleristas* that you are going to meet were trained by these people who started out; we were groups, we were groups of women, among them the people of the Association of [Relatives of the] Detained and Disappeared, the people of Puente Alto who made many *arpilleras* for the Virgin, let's say, for the Catholic thing.

Cristina's words point to the importance of the Vicaría's encouragement of teaching, the *arpilleristas*' willingness to teach, groups' interest in making *arpilleras*, and the priests' support in lending a room. Zara, an Agrupación *arpillerista*, was also recruited:

Afterward the other workshops emerged in the other zones.[11] But *arpillera* workshops emerged that we taught and trained. I went personally to Los Copihues, to Lo Hermida, to Puente Alto, to Batuco, to teach. We started to train the other *compañeras* so that they would also go and teach. Because abroad, what foreigners wanted was *arpilleras*. Not so much the other products.

The Agrupación *arpilleristas*', unemployed *arpilleristas*', and Vicaría's willingness to offer training and the demand for *arpilleras* from abroad was a factor in the increase in the number of groups. Other Agrupación *arpilleristas* went to other shantytowns to teach new groups.

A further factor in the spread of *arpillera* making was the initiative of shantytown women in setting up *arpillera* groups. Babette, a group leader in

90 northern Santiago, disliked the constraints the Vicaría imposed on her group, so she created a new one, teaching it herself and asking her local priest to send its *arpilleras* abroad to be sold. Similarly, the leaders of a health group in southern Santiago set out to learn how to make *arpilleras* from political prisoners and relatives of the disappeared so as to be able to create *arpillera* groups, and they taught the technique to women in already existing subsistence groups. Also contributing to the spread of *arpillera* making was the increase in the number of subsistence groups since the beginning of the dictatorship, which meant that there were many groups that could potentially switch to *arpillera* making.[12] Finally, as suggested earlier, the support of shantytown priests was important. In the mid-1980s in the southern zone, some priests encouraged the subsistence groups that met in their church to switch their focus to *arpillera* making, knowing that the women could earn more money this way. They made contact with the Vicaría, asking it to teach the women and sell their work. They themselves also helped sell the *arpilleras* by taking or sending them abroad. Often several of these factors worked together simultaneously, catalyzing the spread of *arpillera* making. For example, members of the Association of Relatives of the Detained and Disappeared talked to priests in the shantytowns, asking if they might set up *arpillera* groups, obtained their consent, set up mixed workshops, and in some cases went to teach these new groups.

New Groups and Their Members in the Southern Zone

In 1978 and into the early 1980s, a number of new *arpillera* groups arose out of preexisting groups of women dedicated to sewing, knitting, or giving catechism classes, in shantytown churches in the southern zone. They switched from these activities to *arpillera* making at the instigation of a Vicaría staff person, local priest, or local health team leader. A Vicaría staff person approached the local priest in one shantytown, for example, suggesting that the groups that met in his parish could make *arpilleras*, which the Vicaría would sell. The priest responded favorably, since he was sympathetic to the goal of helping shantytown inhabitants overcome their problems, so he informed a group about what the Vicaría was proposing and arranged a meeting between it and the Vicaría staff member, whereupon an *arpillera* group was formed. The Vicaría's international distribution system for *arpilleras* was already functioning well, there was demand for *arpilleras*, and from the women's perspective, *arpillera* making gave them the chance to earn an attractive and steady income.

 In San Bartolomé, another shantytown, Laura's group went from an *olla común* (community kitchen) to a knitting and sewing group, to an *arpillera* group, and the local priest was responsible for the transition in each case; for

the switch to *arpillera* making he worked with the Vicaría. Laura did not have
enough food to feed her children, so at a neighbor's suggestion, she joined her
local *olla* and participated in the cooking and acquiring of food. The priest
then closed down the *olla* and formed a workshop. In Laura's words:

> At that time all my children were very small, the three that I had. My husband lost
> his job, so I was desperate because they were going to school; he would say, the
> oldest would say, "I'm hungry," he would say. And a friend I had here, just behind,
> said, "Laura, why don't you go to the church, because they have an *olla común* there,
> for everyone, for everyone whose husband doesn't have work." I approached the
> church through her. And as my children didn't want to go there, because they were
> ashamed to be sitting at the big tables eating, the Father gave me a little piece of pa-
> per where he gave us permission to go and fetch the food there [at the *olla*]. So every
> day I would go there, but I had to go twice a week and help cook. And go to the mar-
> ket, go to beg, with a letter from— for food, vegetables, anything. And a group of us
> women would go at six in the morning. And with those vegetables we would make
> meals. In addition to what the Vicaría would send us—beans, flour—we would
> bake bread. And one day the priest said, "You know what," he said, "It's better if I
> shut down the *olla*. Because the mothers are not cooperating." Because the mothers
> would never go and work when it was their turn. They would send their children to
> eat there, and it was always the same ones who went. He closed it down and created
> a workshop. And he bought us knitting needles first, and he bought wool. And they
> taught us how to knit, how to mend clothes for our children, because people would
> send clothes to the church, and with those clothes they taught us how to mend
> clothing. And afterward the Father, I don't know how he did it, but what happened
> was that someone came from the Vicaría and an *arpillera* workshop was created.

The local priest and Vicaría instigated the switch to *arpillera* making in Laura's
group, which was knitting and mending clothing. The range of activities in
which the group engaged points to the priests' caring and the women's flex-
ibility and need for food or income.

In some cases, it was group leaders and local health team staff who took
the initiative to bring *arpillera* making to already existing groups. The health
team based in San Bartolomé consisted of a handful of local women who
taught nutrition and personal hygiene in local *ollas*. As mentioned earlier, they
went to prisons to learn how to make *arpilleras* from *arpilleristas* who were
political prisoners, and they also learned from members of the Association of
Relatives of the Detained and Disappeared, meeting with them in a room lent
by the human rights organization Foundation of Social Assistance of Christian
Churches (Fundación de Ayuda Social de las Iglesias Cristianas; FASIC), in

92 central Santiago. They then returned to the groups and taught them what they had learned. Once the groups had learned, some of their members went on to teach still other women. Nicole, a health team leader who taught these skills to one of the first unemployed women's *arpillera* groups to emerge in the mid-1980s in the southern zone, said:

Nicole: Yes, and the political prisoners would also teach. When we went to see them, they would teach us all sorts of things, how to make *arpilleras, lanigrafía* [pictures in wool].
JA: And where did you go and see them?
Nicole: We would go and see them, for example, in San Miguel.
JA: Those were prisons?
Nicole: In Santo Domingo prison.
JA: And they taught in the prisons themselves?
Nicole: Yes, the visits became classrooms [both laugh].
JA: And the Agrupación gave you classes. And you would come and teach here.
Nicole: Yes, we would teach in the workshops.
JA: And where exactly were the workshops?
Nicole: The workshops were in Valledor Sur, in Santa Adriana, Dávila, Villa Sur, Santa Olga. There were seventeen workshops in the zone. I don't remember all their names. And afterward new ones were created in Pudahuel, in Maipú [western Santiago].
JA: And how many of you were instructors? Can you remember?
Nicole: There were a lot of us, about thirty, but we were also bringing in more people, because we wanted others to take it up, and the same thing with the workshops. People in the workshops would go out and teach others who didn't know. We were leaders, but we integrated people from the workshops so that the people of the workshops would have the power in their own hands, and feel like subjects, and not objects that could be easily manipulated. So we tried to integrate them, and they would go and teach. They would invite us to the marches.

As there were normally 20 or more members in each group, seventeen groups signified 340 or more women. Group members were encouraged to teach because empowerment was one of Nicole's goals.

Some of the women who joined the new groups forming in the southern zone at the end of the 1970s to early 1980s had been working for an income, unlike the very first *arpilleristas*. They had lived through two economic crises during which their husbands were unemployed, often for extended periods; some had no husbands. They had worked as maids, in the government's emergency employment programs, and at home doing sewing piecework for companies or making food entrepreneurially, which they sold in the street or at a local school. Others had been active in groups based in their local church.

Beatriz, for example, was a member of her local health team, and gave talks on
nutrition, hygiene, and child health at the local *olla común*. The first four wom-
en that formed the San Francisco *arpillera* group had been giving catechism
classes in their local church; one had also been taking a course on first aid at
the church. Some, however, like Bárbara of the San Bartolomé group, were not
active in either work or groups and described themselves as "living between the
four walls."

In most cases, the women joined the group that became an *arpillera* group
because they needed an income or because the group offered them a way of
obtaining food, just as had the earlier *arpilleristas* in the mid-1970s. During my
interview with the Santa Teresa group, a young woman said:

> A friend invited me because my husband was unemployed. She told me that there
> was a workshop where I could work, earn a little, to be able to get by. And that's
> how I came here, looking for a way to survive. That's how I came.

Her use of the word "survive" suggests how severe her family's poverty was.

Many households were "in crisis," with not enough money to feed the chil-
dren. Even if husbands were working in the emergency employment programs,
they earned so little that more money was badly needed. *Arpillera* making was
well paid, and this income was attractive to the women. Natalia said:

> And I am really grateful because they almost never rejected my *arpilleras*; they
> always passed them. And when they passed them, I would receive my money, and
> my money was useful for the house, for my home, for my children. Because, as I say,
> they were young at the time, and the father earned very little; I was with him. So
> that money— my goodness, how I liked it when the moment came to hand in the
> work and then get paid. Because that was what we needed, to be paid, because there
> really was a very big need. At least in people's homes, like my home, many of our
> workmates were in crisis. Because there were even husbands working in the POJH
> [Programa de Ocupación para Jefes de Hogar (Employment Program for Heads of
> Households)] and PEM [Program de Empleo Mínimo (Minimum Employment
> Program)], and at that time they would pay us 3,000 pesos.

Natalia's words express the urgency of her poverty and the importance of the
income motive for being in the *arpillera* group.

As with the earliest *arpilleristas*, motherhood was central to many women's
joining the *arpillera* groups and groups that preceded them in that not having
enough money for their children's food or schooling was their main reason for
wanting to earn an income. Immediately above, we saw how Natalia's having

94 children who needed food was what prompted her to make *arpilleras*. Simi-
larly, Francisca, who had been a member of her local Christian community,
joined her *arpillera* group in La Victoria in order to earn much-needed money
for her home and children:

JA: When you joined the workshop, what was it that made you want to join?

Francisca: Well, at that time I was a member of the Christian Base Community. Well,
rather, what motivated me was the economic aspect. My husband was unemployed—
there was a lot of unemployment in the country—and, because of financial problems.
I had a young boy, my girls who were in school, so it was to earn some pennies. To
contribute something for the home, because the situation was quite [pause] critical.

Being a mother who had to support her children was part of what pushed
Francisca to join the group, when her husband lost his job during the 1982
economic crisis.

There were also other reasons why women joined *arpillera* groups in the late
1970s and early 1980s. Bárbara had an abusive husband, and her sister-in-law
suggested she join one as a form of therapy. Natalia joined one both to earn
money and because she felt lonely; very soon she found that the company did
her good, and that being in the group helped raise her self-esteem, and these
became motives for staying on. A member of the Santa Teresa group joined fol-
lowing an invitation framed in terms of "*participar*" (to be in a group) and the
opportunity to receive training. In Teresa's case,[13] the priest made it a condition
for her joining the local *olla común* that she also join an *arpillera* group. She also
joined to have money to help with her difficult financial situation; she wanted
to earn money rather than have it be given to her.

The main "recruiters" into *arpillera* groups were shantytown priests. Often
the women came to the *arpillera* group or the group that preceded it because
they approached their local priest to seek help with a pressing financial prob-
lem, and he told them about the group and suggested that they join. Many
women only saw their priest once a week at Mass, whereas others knew him
a little better if they were participating in a group or activity in his church,
but for all of them, he was a prominent local figure whom they felt they
could trust. Teresa, for example, had approached the priest asking for help
because she was unable to pay her youngest child's schooling fees, whereup-
on he wrote to a charity that gave her the money, and then suggested or put
pressure on her to join the *arpillera* workshops.[14] She did so, and simultane-
ously joined the local *olla*. Nancy from San Francisco, similarly, told me how
her local priest informed her about the group, saying it might help her earn
some money:

So one day a priest, who was Irish, and who was here in the church, says to me, he said, "You know," he said, "Did you know that there in the church"—the church was a big church here in San Francisco—he said, "there is a woman, there are about four of them," he said, "and they are making some *arpilleras*, some small pictures," he said, "out of cloth," he said. "Why don't you go there and that way you can work if you want," he said, "and you can organize yourself," he said, "so that you have a bit more money." Because he would help us a lot with food; sometimes he would help us. Right then, I went, and there were five people in the group, and I joined. I went there to see if they would allow me to join. I joined, and then I started with the *arpilleras*. And I remember that the first *arpilleras* I made showed some children playing, throwing a ball about. So at that point I joined, and I started to work with the *arpilleras* in 1982.

It was at the priest's suggestion that Nancy joined the group; he knew about her financial difficulties.

In some cases, a neighbor or family member in the group had invited the women to join, mentioning the chance to earn money, grow as a person, or receive training, all of which attracted the women. Once in, those who found they liked the group stayed on. Many did not at first think they would be capable of making *arpilleras* but later realized that they could. Natalia, for example, was invited by a friend whom she had met in an emergency employment program, who said she would grow as a person and that she would be able to earn some money. We discussed this:

JA: What was your motivation for joining?

Natalia: Well, my motivation for joining was because I was working in the POJH at that time. You know how there was the POJH and the PEM [emergency employment programs], at the time of the Pinochet government. So the reason was that a friend invited me, Sandra, someone whom I first met thanks to Nancy. And she said, "Let's go to the workshop"; she said, "You will feel good, you will feel like a person, you will develop as a person." And I said, "Okay." "There, they are going to teach you to sell those little *arpilleras*, and with that money you will be able to buy things," because at that time you earned very little with the POJH. So "Okay," I said, "let's go." So I realized that it was something good, something that was of benefit materially and spiritually. Because at the time I felt lonely, I didn't have contact with anyone, I didn't have any personality at all, as I was telling you, I didn't have sort of a really developed personality, like now. But it helped me a lot, because there we had teachers who would teach us to be, how shall I put it, to be people, to have our way of, how shall I put it, to show the world that we as women were people, how shall I say, that a man was not worth more than a woman, but rather a woman was worth the same as a man, you understand?

96 Natalia was attracted by the suggestion that she would develop as a person and have the opportunity to earn money, as she was earning very little in the POJH program and her partner was not contributing to the household; and in addition she felt lonely. Normally, when someone was invited to join a group, they would come to a meeting, after which the group would decide whether she might join or not, and invite her to return.

GENDERED CONSTRAINTS AND SKILLS

Arpillera making was work that was particularly well suited to the skills and constraints that the *arpilleristas*, as women, faced. Being from poor families, they had not had the opportunity for an extensive education, and this had limited their skill set. It was easier for them to find work in local groups than with employers demanding credentials. Also limiting their employment opportunities was their gendered responsibility for looking after the house and children. This made *arpillera* making attractive; it was work they could do in their homes while keeping an eye on their offspring. A member of the Villa Leiva group explained:

> It is difficult for a person to be able to work in something else because of having the house. That's why she works making *arpilleras*; because you can work in the house, you don't have to go out. And if you go out [to the workshop], you go out from 3 to 5 or from 3 to 6. Before we used to come three times a week.

Arpillera making was work the women could do without leaving the house for long, and so without going against the pressures they felt to stay at home for most of the day cooking, cleaning, and taking care of children. Moreover, the women tended to be unfamiliar with many neighborhoods other than their own, and the fact that workshop meetings took place in their local church, a place with which they were familiar, made it less difficult for them to become *arpillera* workers, as well as more likely that they would hear about the *arpillera* groups.

The traditionally "feminine" association of the skill of sewing made *arpillera* making a feasible form of work for them. Many had been taught sewing as girls. Tamara, who had made *arpilleras* in prison, said:

> I had always enjoyed sewing, so for me it was, it was easier. Now with embroidery, I knew, yes, I had always known how to embroider. I mean, I had always known how to sew, and how to embroider, so it wasn't difficult for me.

Because it required sewing skills that they had learned in school or at home as 97
girls, *arpillera* making was something for which many women were already well
equipped.

The *arpillera* work, then, enabled the *arpilleristas* to put to work gendered
skills that they already had, to manage their household and maternal respon-
sibilities, and to bypass constraints they faced because of gender expectations
and not having had the opportunity for an extensive education. These features
contributed to its spread, and beginning in the mid-1970s, new groups formed
in all zones of the city. From its beginnings in unemployed women's groups
and the Agrupación, *arpillera* making also spread to mixed workshops, women
political prisoners, and low-income women in rural towns. In the next chapter,
we explore the process of *arpillera* production, with a focus on the unemployed
women.

5 Producing the *Arpilleras*

The women did most of their *arpillera* work at home. During workshop meetings, which took place one to three times a week in their local church, they continued with work already begun, started designing *arpilleras* for which they had just received orders, or added the final touches to *arpilleras* they were about to hand in. They were creative about acquiring the raw materials for this work.

ACQUIRING THE RAW MATERIALS

To raise the money for the raw materials for their very first *arpilleras*, the earliest *arpillera* groups of the eastern zone organized folk music evenings (*peñas*) with the help of drama students who were helping them depict movement in their *arpilleras*. Cristina, a member of one of these groups, said:

> They [the students] did the very first steps for us with organizing *peñas* and things to raise money to be able to buy materials and things. Because we were unable to sell our product, so we'd go from door to door, but imagine, who would buy an *arpillera* that was a denunciation?

Selling fritters was another way in which these women raised money to buy the initial materials. The Comité and Vicaría staff helped them with some of their fund-raising activities.[1]

In parallel, as they were too poor to afford new cloth, the women used their own clothes or those of family members. The coordinating committee of *arpillera* groups in the eastern zone said:

Miriam: First we started with scraps, for example, clothing you had that you were no longer using.

Marisol: Because none of us had the money to buy cloth, we started with that, just scraps.

JA: So she taught you to work like that?

Gladys: With ties, with shirts.

Miriam: I mean, they were not really scraps, because you would use the hems of your skirt to be able to make one. There was no money to buy [cloth] with.

Marisol: Men's pants, the pants were frightened; we used everything we could lay our hands on.

Marisol's reference to pants feeling afraid refers to their "knowing" they were going to be turned into an *arpillera*, another example of humorous humanizing that the women used for the human figures in the *arpilleras* as well. Babette from Huamachuco in the northern zone used the expression *desarmar ropa* (taking apart clothing) to describe this way of getting the necessary material, and mentioned washing and ironing the material before using it:

> Sometimes you had to sell *arpilleras* and we didn't have cloth, so we would take apart our clothes, wash them, iron them really well, and use them to make *arpilleras* with.

The women recycled clothing.

Cloth could be acquired in several other ways as well. Some *arpilleristas* went at night or early in the morning to a neighborhood near the Mapocho River where tailors and factories threw away scraps of cloth in the evenings, and dragged bagfuls home, sometimes with the assistance of one of their children or another *arpillerista*. The Melipilla group asked seamstresses to give them scraps that they were throwing away; they also used pieces of cloth discarded by factories and the material the Vicaría gave them. Exchanges within the group were another source of cloth; the women usually gave pieces of material to group mates who did not have the particular color they needed. In addition, the Vicaría staff who worked with the *arpilleristas* asked colleagues, friends, and seamstresses to donate scraps of cloth or old clothes, and channeled these to the women. Priests gave the women donations of secondhand clothes from abroad. The women also received donations of cloth directly; an actress, for example, donated her son's clothes to the Agrupación *arpillera* group.

After the early 1980s, some workshop leaders took over the job of acquiring the necessary raw materials, buying the cloth and wool their group needed from shops that sold scraps. They drew on a fund of money to which the women

100 contributed every time they were paid for their *arpilleras*. When there was a new order for *arpilleras*, they would distribute the cloth among workshop members. In Anastasia's group, in the eastern shantytown of La Faena, it was often the group leader who bought the cloth, but the group also appointed two or three different members each time to form a *comisión* (committee) to buy it. In the 1990s, the women obtained the cloth they needed themselves, from shops, but they simultaneously continued to take apart old items of clothing, exchange pieces of cloth with other women, and occasionally use donations of clothing.

The women acquired the other materials they needed in a variety of ways. For the sewing on the *arpilleras,* the women used wool, sometimes splitting it into fine threads. In the earliest days of *arpillera* making, they often took this wool from their own sweaters, whereas in the 1990s, they tended to buy it from the local street market. As with the cloth, if a group member was short of wool, the others would offer her some, as part of ongoing reciprocal exchanges within the group. The *osnaburgo* (stiff material) for the base normally had to be bought. The women sometimes used in *arpillera* their *arpilleras* additional materials that were available at little or no cost. Pieces of paper denoted news-papers, tiny twigs represented wood, grains of rice or pieces of spaghetti stood for food, and the plastic capsules for tablets represented bowls. They used bits of paper for the theme of *la papelera* (the woman who would pick up paper from the street) and cardboard for the theme of *el cartonero* (the person who would collect cardboard and sell it to a recycling company).

With these raw materials and techniques, the *arpilleras* bore the stamp of the women's poverty and gender. Because the women were impoverished shan-tytown inhabitants, the raw materials had to be free, recycled, or inexpensive. The *arpilleristas'* gender shaped the *arpilleras* in that all the materials came from domains of life that were shantytown women's responsibility: the home, the kitchen, and the family. They used not wood or metal, which were arguably materials that men were more likely to work with, but homely cloth, needles, and wool. As mothers, they were in charge of the family's wardrobe, and so it was not unreasonable for them to appropriate family members' old clothes. Lastly, in regards to technique, sewing and embroidery were "women's work."

RECEIVING ORDERS FOR WORK

In the earliest years of *arpillera* making in the eastern zone, one or more leaders from each group would go to the Vicaría's eastern zone office to find out how many *arpilleras* her workshop had to produce, with what themes, and by what date. The trip was also the occasion for handing in *arpilleras* made for the pre-vious order. Anastasia explained:

By way of example, we would go on the fifteenth to hand in our work, and they
would give you a list—I can show you a list for the next time—for the fifteenth of the
next month. So in that list it would say, "Three law courts, four of each theme." She
would make out a list for us, of all the themes that people were asking for.

The Vicaría would write down what it wanted the women to produce, and if
they had gone there together, the leaders would distribute the work equally
among each of their groups.

In later years, however, Talleres (the Vicaría department dealing with *ar-
pilleras*) would speak only to the leader of the *coordinación*. The *coordinación*,
more often called *coordinadora*, was the coordinating committee of *arpillera*
groups in a particular zone. It was made up of one or two representatives from
each workshop, who were also called *coordinadoras*, or *encargadas de coordi-
nación* (representatives on the commit-tee). These women were elected by the
members of their *arpillera* workshop. Some were simultaneously *coordinadora*
and *encargada de taller* (workshop leader). Talleres would tell the *coordinación*
leader how many *arpilleras* it needed, give a due date, and either request par-
ticular themes or say *tema libre* (free choice of theme). The leader of the *co-
ordinación* would then call a meeting with the other *coordinadoras*, at which
they would decide how many *arpilleras* each workshop would make. Work was
shared out equally except when, in the mid-1990s, there was not enough work
for every workshop, and *coordinadoras* drew lots or took into account which
group leader's financial situation was worse, making sure she had work.[2]

After this meeting, the *coordinadoras* would go back to their *arpillera* groups
and tell group members about the order, dividing the work up among them.
In the earliest days of *arpillera* making in the eastern zone, each woman could
produce as many *arpilleras* as she had time for and be paid accordingly; those
who produced more would be paid more. After this initial period, however,
group leaders distributed the work to be done equally among workshop
members so that all would receive the same amount of money; all wanted
as much work as possible. The women placed great emphasis on equality of
treatment. Some groups divided middle- or large-sized *arpilleras* between two
members if necessary, so as to equalize the amount of work each woman had.
The leader of the Santa Teresa group said:

> At a certain point, each of us had to produce the same amount. If I say "Here we'll
> make five small *arpilleras*," they all make five small *arpilleras*, whether or not they all
> hand in their orders or want to save them. And later, when we have the money, we
> distribute it equally among all of us.

102 Her words point to the group's emphasis on equality, but the reality did not always measure up. Occasional conflict arose in some workshops if one woman felt that another had been given more work than she had, which was upsetting because more work meant more money. There was suspicion as well; Laura reported that the leaders of her workshop would hand in more work than the other women. Rivalries also cropped up at the beginning, when the women could produce an unlimited amount of *arpilleras* and be paid accordingly; some women made more *arpilleras,* as they had more time or more family members helping them, thereby earning more money than the others.

As the work was being distributed among members, a workshop secretary or treasurer would note down the number of *arpilleras* each had been assigned, and the amount of money owed to them, subtracting 100 pesos for cloth. Immediately afterward, the group leader would distribute cloth and wool if she had bought them for everyone. The women would then begin designing their *arpilleras* or deciding what to depict. Natalia said:

> As I was telling you, look, "Girls, we have to have such and such a number of *arpilleras* ready for the next two weeks," because it was every two weeks with the *arpilleras.* For example, some twenty small ones, some six large ones, medium-sized ones. Because there was small, medium, and large. So I would start, because Señora Nancy would buy all the sky [blue cloth] and wool, and she would give us a piece of sky each, and we had to look for lining from some old pants, from a skirt, whatever we could, to be able to make it, to be able to sew it. So she would tell us the quantity, and you knew, you see, the quantity you had to have, to start to make it. They would give me four, six, and that very night I would start to work, basting them, and composing them so as to then simply start to . . . So I would leave them all ready and then I would just sew.

Nancy, the leader, would tell the women how many *arpilleras* were due and distribute light blue cloth and wool.

Most orders for work came from the Vicaría, but there were other sources, too. The priest in San Bartolomé, for example, once ordered a "giant *arpillera*" depicting the shantytown. A man named Negaldo ordered *arpilleras* from Teresa's group, which worked on them at the same time as they worked on those for the Vicaría. Francisca's group had their local French priest sell *arpilleras* for them in France, and a woman in Belgium also bought their *arpilleras.* Nancy's group sent work to a buyer in Holland.

The Rhythm of Work

As far as the rhythm of work was concerned, the women produced and handed in *arpilleras* every week when demand was high, but when it dropped, they handed in work only once a fortnight, once a month, or less. By 1995, they were handing in work only every few weeks, when a client placed an order with Talleres. The number of *arpilleras* a woman made per week might be one or none in months of low demand, and up to five or six medium-sized *arpilleras* or ten small ones when demand was high. In 1975 and 1976, there was little demand, as the international distribution system had not yet taken off, but soon afterward demand grew, and the women said they were able to make as many as they wished, knowing that the Vicaría would buy them. By the mid-1980s, demand was variable; some women said there were few orders for *arpilleras*, others said that sometimes there were many orders. After the plebiscite, demand dropped, according to many women, although Nancy talks of a "huge demand" for *arpilleras* in 1990–1991, which might be due to large orders from the relief organization Oxfam, which ordered a thousand *arpilleras* at a time, in her recollection. Also, at this time, the Vicaría was making efforts to sell to free trade organizations in Europe.[3]

The women liked having a lot of work, as it meant that they would earn more money. They liked to have so much that "*me amanecí cociendo*" (I woke up sewing), as they put it. When this happened, it was common for them to work late into the night, as well as from the moment they woke up. Natalia described:

> So Sra. Nancy would say, "X number of *arpilleras*," and so we would make twelve *arpilleras* and sometimes you had to wake up and immediately begin making *arpilleras*, and be all day long embroidering and changing colors and putting in the little *monos*.

For a big order, the women had to work under pressure, but when they had fewer *arpilleras* to make, the pace was more leisurely. Having a lot of *arpilleras* to make in a short period of time was what they called having *trabajo apurado* (work to be done in a hurry) or *pedidos rápidos* (fast orders). Intense demand of this kind was usually seasonal, especially occurring before Christmas. Having institutions in addition to the Vicaría buy their work increased the amount they made, as when Teresa's group handed in *arpilleras* both to the Vicaría and to an individual who exported. When demand was low, some of the groups engaged in another handicraft activity in addition to *arpillera* making. The *arpilleristas* in Melipilla sometimes knitted, for example.

SEWING THE PIECES TOGETHER

The women saw the work of making an *arpillera* as made up of distinct stages and components, to which they gave names. The first step was to create the *base* (base). This involved sewing together the blue material for sky, referred to as *cielo* (sky), and the brown or other dark material for land, referred to as *fondo* (bottom part). When sewn together, they formed the *base*. The next stage was to cut out the pieces of cloth that would be appliquéd onto the base. This was called *cortar* (to cut) or *recortar* (to cut out). Some groups used stencils (*plantillas*) or patterns (*moldes*) for cutting when they first began making *arpilleras*, but others did not. Next, one had to work out the composition and affix the elements of the *arpillera* onto the base, normally with a glue stick. This was called *plasmar* or *armar*. Some women distinguished a step within this stage, which involved planning the composition without sticking on the elements, and called this *diseñar* (to design). Some were in the habit of fixing the elements onto the base in a certain order; Teresa from the southern zone would glue the mountains on first, then the houses and trees, then the human beings engaged in an activity (called the *tema*, or theme), and finally the sun. The "theme" was "what the *arpillera* was about"; it was the central activity, which contained the message. Themes included *el comedor*, with children around a table, or *las lavanderas* (the washerwomen), with two women washing clothes outdoors, for example. A medium-sized *arpillera* could have more than one theme.

After *plasmar* came the stage of *bordar*, meaning to sew on the elements of the *arpillera*. The sewing was normally done using the cross stitch (*punto de cruz*), although at the beginning of *arpillera* making it was done using the buttonhole stitch (*punto de ojal*), a U-shaped stitch often found around the edge of old blankets. Among the elements to go onto the *arpilleras* were the human figures, called *monos* or *monitos* (the diminutive form of *monos*). Initially they were two-dimensional and would be sewn on in the same way as the other elements in the *arpilleras*, but by the mid-1980s, they had become three-dimensional and so were sewn on at the end, in a stage referred to as *pegar los monos* (sticking on the figures).

The stage after *bordar* involved making and attaching the *forro* (lining) onto the back of the *arpillera*. This was called *forrar* (to line), *pegar el forro* (to stick on the lining), or *ponerle el forro* (to put on the lining). The lining was a rectangle of stiff cloth with tiny holes, cut to the same size as the *arpillera*. In the early days of *arpillera* making, the women often used sacking, calling it *el saco*. They used flour sacks or *bolsas de quintales* (brown rectangular sacks, often used for potatoes). In later years, however, they used new cloth, also stiff and with small holes, called *osnaburgo*. Many groups first sewed a small pocket measuring about 3 x 3 cm onto this lining, into which they would put a

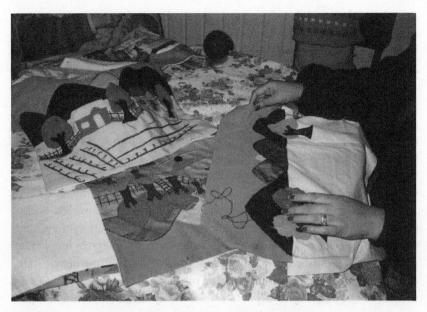

An *arpillerista* in a workshop in southern Santiago is making an *arpillera*; she is at the stage referred to as "*plasmar*," 1996. Photograph by Jacqueline Adams.

small piece of folded paper containing five or six lines of handwritten text that explained the *arpillera*'s message or stated that the social problem depicted in the *arpillera* existed in Chile.[4]

Once the *forro* was attached, there was one remaining step: sewing the edge of the *arpillera*, using the *punto de ojal* (buttonhole stitch) or, in the case of the Agrupación *arpilleristas*, political prisoners, and some unemployed women's groups, making a crocheted edge. This was called *hacerle la orilla* (doing the edge) or *hacer el festón* (doing the scallop trim). Teresa, an *arpillerista* from southern Santiago, described parts of the process of making an *arpillera*:

JA: So to make an *arpillera*, how would you do it? What was the first stage?

Teresa: The first step was to put together the sky and the ground. After that you would put in the houses and trees. Then you would do the theme, the sun, the mountains. I had forgotten—the mountains first, then the houses, and then the theme, below.

JA: And after that?

Teresa: After sewing all that, you would line it with the sacking.

JA: Ah, at the end?

Teresa: That was at the end. Then you would crochet the edge, all round the edge, and then you were finished.

106 Teresa's words reveal that there was a standard procedure, as well as standard components, for making an *arpillera*, suggesting limited scope for creativity. But within these constraints, the women made decisions of their own, although there was less and less opportunity for this as time went by.[5]

Although the steps involved in the making of an *arpillera* were numerous, the women tended to think in terms of two main stages: *plasmar* and *bordar*. One group, the women from the town of Melipilla, described choosing, washing, and ironing the used cloth as the first stages in the production of an *arpillera*. If the completed *arpillera* was rejected at quality control, there were more jobs to be done: *desarmar* (to undo the *arpillera*) and *arreglar* (to alter it in accordance with the corrections demanded).

In the unemployed women's groups, each group member worked on her own *arpillera*, so each person knew how to produce every part. However, the work had a collective component in that there was considerable input from group members during workshop meetings, in particular at the design stage, when the women might consult with the others about the number of figures needed, or the best way to depict a theme. Group members would also give

Message from a pocket on the back of an *arpillera*, describing the scene depicted, late 1970s or early 1980s. Photograph by Jacqueline Adams of an *arpillera* in the collection of André Jacques and Geneviève Camus.

input once the *arpillera* was finished, the idea being that helpful feedback would prevent the work from being rejected at quality control. Although in most cases each *arpillerista* produced her *arpillera* by herself, albeit with input, there was one group in the southern zone that formed a production line for a period, whereby different women worked on different stages of the *arpillera*, but the group later went back to having members work individually.[6]

Normally an *arpillerista* worked on one *arpillera* at a time. However, at least one woman, Natalia from the southern zone, made several at the same time, designing them all simultaneously, then sticking the elements onto the different *arpilleras*, and finally doing the sewing for all the *arpilleras*. She said:

> They would give me about four, or six, and that same night I would start to work, basting them and working out the composition, so as to be able to start sewing straight away. So I would leave them all ready, and then later I would just sew. So it was easier that way than doing it one by one, working out the composition for one, then another, you see.

Natalia's words suggest that speed and ease prompted her to work in this way.

It was common for the women to work together if they had to make a "big" *arpillera*. They would work in a team of two or three, each doing a different part. One woman would sew the base onto the rest of the *arpillera*, another would sew the edge, and a third would sew the details, Teresa said. They would then share the money. Some groups very occasionally made *arpilleras* with the intention of putting them together as a mural. The Agrupación group in the eastern zone, for example, made a mural in 1975–1976 entitled "Vía Crucis de los Detenidos-Desaparecidos" (Way of the Cross of the Detained and Disappeared), in which they told the story of how they heard about the disappearance and reacted to it, and how the Comité helped them. Soon afterward, the unemployed *arpilleristas* in the eastern zone made their own version of the "Vía Crucis."

The *monos*, the human figures on the *arpilleras*, were originally made of flat cloth glued and then sewn onto the *arpillera*. Later, they were made in bas relief, with some stuffing under the cloth. Finally the *monos* became three-dimensional. A woman from Lo Hermida invented the three-dimensional *mono*, and as the Vicaría liked it, all the other groups had to follow suit, to their distress, as the *monos* were dressed in pieces of clothing that they had to make and were considered difficult and time-consuming to produce. They were about 3–4 centimeters in height, had tiny faces with eyes and a mouth, and hands. Laura from the San Bartolomé group told me that most of the

108 women were unable to make the *monos* at first and would prick their fingers. Cristina, from the early Villa O'Higgins group, said:

> The *monitos* were invented by the people of Lo Hermida, by a woman there, a very creative woman, Nena. One day she created a little doll and dressed it like a, I think a cloth doll, you know? She dressed it, and it occurred to her to stick it onto the *arpillera*. [...] The *monitos* were taught to us by this creative woman, Nena, who one day—she had always made scrap dolls, and so all she did was make them smaller, shorter and shorter. And, well, the *monito* has suffered no end, because the *monito* is very simple now. With the *monitos* we made before, for women you had to include a lace petticoat; and it took you forever to make a *monito*. I hated them, I swear, because you had to put so many things on them, because, as I was telling you, if you lifted up the dress, there was a petticoat, so you had to add lace, if you lifted up—so it was a nuisance, you see. Afterward it became simpler; the *monitos* made today are nothing like the *monos* we used to make.

At the Vicaría's request, Nena's innovation became the standard for all *arpillera* groups. It was not only the three-dimensional *monos* that were difficult; in the earliest days of *arpillera* making, the women in the eastern zone had difficulty giving the *monos* expression. Drama students helped them with this, coming to the groups with the permission of Hilaria, the Comité employee, so as to observe the women and produce a play based on them, which became *Tres Marías y una Rosa*.

The women saw making *monos* as a job in itself, and because it was difficult and often not to their liking, some bought *monos* from another workshop member who made large quantities to sell, earning some extra money this way. Teresa, for example, made only *monos* when she first joined her workshop in the late 1980s, producing three to four hundred a month for her workmates; she called herself a *monerista*. She was reluctant to make *arpilleras* for fear of rejection. If the women made the *monos* themselves, they tended to keep a stock ready to add to their *arpilleras* when needed. The *monos* were often a source of laughter; the women would talk about them as if they were real people, making up amusing stories or joking, sometimes bawdily, about them. The Melipilla group began to laugh just telling me about them:

Bettina: Other *arpilleras* that they ask for a lot are the ones that show Chilean-style weddings.

JA: Ah, really?

Bettina: Yes, recently, in other words, with the church, the bride and groom, the witnesses, the horse and carriage. I mean, you have to do the carriage with the horses, the driver.

Nina: With lots of flowers.

Bettina: You have to decorate it, you have to put in little candles as in a Chilean wedding. We have also made an *arpillera* version, and the bride and groom turned out nicely.

Nina: Yes, you do the bride and groom, the witnesses, and people waiting.

Bettina [laughing]: I always remember that someone stole Teresa's bride and groom, and she was in such a hurry, and the bride had turned out so nicely. I made her for Teresa, I remember; and I made her with a sun hat. I tried to put on a veil, but she was stuck with a sun hat, and she looked so elegant [laughs]. And someone stole the bride and groom, and she didn't know what to put into the *arpillera*, and she had to go to Santiago.

Nina: What, [stole them] from the *arpillera* or from her directly?

Bettina: From the *arpillera* [laughs]. I don't know if someone took her [the bride] out of the *arpillera* or if she fell off, but you should have seen her putting together another bride.

Nina: Or maybe the bride had second thoughts.

Bettina [laughs]: I think that's it, she had second thoughts.

The women often talked wittily about the *monos* as human beings with emotions and mishaps, and this was one of several sources of laughter in the workshops.

The *arpilleristas* generally liked making *arpilleras*. They referred to the work as *un trabajo bonito* (nice work). Many had preferences for certain stages of the process. Teresa, for example, expressed her feelings about three of the stages involved:

JA: What is it you like most when making *arpilleras*?

Teresa: I like to sew. *Plasmar* is boring, my goodness! There have been times when I have worked on the composition all day long. It bores me, and you have to really concentrate, so that everything . . . the colors, making sure that things are stuck on properly, not crooked, because if they look a little wonky, they give them back. You have to really concentrate to do this. I like the *monos*; that's what I like best, as I started out with them.

Teresa had strong negative feelings about one stage, but liked another. Like her, Natalia enjoyed making *monos*:

It was what I most loved doing, making the *monitos*, because some found it difficult to do the *monos*, but I found it easy, so I would make them for everyone, the *monitos* for the *arpilleras*.

The incorporation of another woman's *monos* contributed an element of collective production into the mostly individual process of making an *arpillera*.

DECIDING ON SUBJECT MATTER: CREATIVITY AND CONSTRAINTS

How did the women decide on content, or the *tema* (theme), as they called it? Often the Vicaría staff suggested a theme, based on a particular order it had received or its perception of what would sell. However, particularly in the early years, they also frequently asked the women to produce *arpilleras* with *tema libre* (their own choice of theme). The women knew which sorts of themes the Vicaría would buy and which it would not, and they knew that their *arpilleras* were "meant" to be about poverty, survival strategies, repression, and resistance, and so they chose this subject matter. Hence their freedom was somewhat constrained, but within these boundaries, they could depict what they liked. They tended to make *arpilleras* about an act of repression that they had witnessed or heard about, such as a shantytown raid or an episode of soldiers beating protesters, or about a part of their daily experience, such as participation in the community kitchen or the increase in the price of food. They might also create an *arpillera* about something in the news.

They sometimes chose to depict a particular theme based on the conversation in the group that day, as Anastasia said:

Anastasia: What would be in them? Well, for example, in the first *arpilleras,* the deprivation endured by children; deprivation. Children would take food from garbage bins, and we would put that into the *arpilleras*. People being beaten, with soldiers; we would put that in the *arpilleras* as well. The raids, we would sew them into the *arpilleras* also. Because this was, like, a way to denounce. I'm talking about the first period, I mean, the most difficult time, the toughest time, when you could not say anything. That's what we would put into the *arpilleras*: repression. We would denounce the repression.

JA: How would you decide "I'm doing this theme"; how would that happen? Was it up to you?

Anastasia: It was up to each one of us, and it was to do with what each of us was thinking. And we would work out how to put it into the *arpilleras*, in the way we saw it, so depending on how we saw it, we would sew it into the *arpillera*.

JA: And did you all do different themes each time?

Anastasia: Each of us would do her own work, each one of us, and each one of us would make her own *arpillera*, with what she was thinking; she would make it alone. No one gave us models; no one said, "Do this" or "Do that."

JA: And when they did a theme, was there some discussion about the theme or not? In the meeting, I mean.

Anastasia: Yes, yes we would talk about it, comment on it, yes.

JA: With someone there in charge?

Anastasia: No, just among ourselves, just among ourselves, "Hey, did you hear about what happened in such and such a place?" "They gave such and such a person a beating,"

or "They broke such and such a thing in the house." All that. So from the comments came the idea of being able to make it, even if you hadn't seen it. We imagined what was happening.

Anastasia's words make clear that the subject matter of the *arpilleras* came from workshop conversation about recent repressive events and from what the women were thinking about at the time; in both cases the wish to denounce was an influence.

Certain groups had a "tradition" of depicting certain themes, so this was the basis of some women's decision about what subject matter to depict. These themes had originally arisen in the course of workshop conversation. Francisca, an *arpillerista* from La Victoria, said:

Francisca: Usually there were sort of five or six set themes that we always made. We would change a few details.

JA: What were the set themes?

Francisca: For example, the set themes were what I was telling you about before: the washerwomen, the woman baking bread, the factory saying there is no work, *comprando juntos* (buying cooperative). There was also the theme of the milk; the milk for each block that was organized in the church, and money arrived from France, here especially, and they would distribute milk to the children. So each block would organize and distribute milk to the children every day; that's another one we would do. In other words, the ways in which we organized to cope with the situation.

JA: And how did you end up with those themes? How did these themes you mention arise?

Francisca: I think they arose through the conversations we had. We would try to work out what we could do, and we would give each other ideas, also.

Francisca's description suggests that her group produced the same themes over a period of time, and that these themes had originally come out of workshop conversation.

As Anastasia's earlier words suggest, repression was a popular theme. The women tended to depict local instances of repression, or events occurring elsewhere that they had just heard about. Francisca said:

Lots of things happened here [in her shantytown]. For example, when they expelled the priests, because there were three French priests, and Pinochet expelled all three of them. So we would put in all that as well, because it was what was happening here. There was a lot of repression in those years, really a lot. People being killed, some teachers had their throats slit, people were being burned.

112 Instances of repression were often the subject of the *arpilleras*, even if not experienced directly by the women, but there was an emphasis on the local and the personally experienced. Poverty, unemployment, and other social problems, along with the women's experiences with these ills and with combating them, were other common themes. The themes fell into two broad categories in the women's minds. First, there were *temas fuertes* (strong themes)[7] that were sharply denunciatory and included soldiers beating people, homes being raided, protests, the courts of justice, and the *velatorios* (candlelight vigils paying homage to the fallen). Second, there were the *temas no fuertes* (milder themes), including, according to Anastasia, the *comedores*, literacy workshops, washerwomen, kindergartens, *rondas* (children dancing in a circle), and kitchen gardens.

Directives

The Comité and the Vicaría exercised considerable control over the content and form of the *arpilleras*. This began when they sent teachers to the groups. Comité teachers taught many women what to depict and how to do it. Accounts about Anabella's teachings suggest how significant this was as a way in which the Comité shaped the content of the *arpilleras*. Anabella told the *arpilleristas* of the eastern zone to observe the shantytown and streets carefully, looking at buses, protests, police vans, or barricades on fire, and to depict what they saw, in the way that they saw it. Members of the coordinating committee of *arpillera* groups in eastern Santiago said:

Gladys: But she always taught us that first we had to cut the piece of cloth out well so it was not lopsided, and then that we always had to include the mountains and the sun, that was the first thing. And for the part below, she would say "Go out into the street and look at what is there. There is the shantytown. Go to Grecia [a big road next to the shantytown], look at the police van, or look at the fires [shantytown inhabitants would build barricades and set them on fire], and work out how you can put it into the cloth."

Bárbara: You had to be very creative to work out how to depict it on the cloth, you had to be very creative.

As we saw earlier, Anabella also told the women to depict their experiences, to use used cloth, to put light colors with dark, and to avoid placing printed cloth on top of printed cloth. Cristina remembers her teaching the Villa O'Higgins group which colors to use to express sadness or happiness, showing them how to sew the *arpilleras*, and telling them to use used material. Anabella taught many groups the appliqué technique, and she determined the size of the *arpilleras*. At

the beginning, the *arpilleras* were all *medianas* (medium-sized), and normally
measured 45 x 50 cm (some groups report 38 x 48 cm).

Anabella developed "simple rules," as she called them, early on, when she began working with the Agrupación. These became the basis of her teaching and of that of the Agrupación *arpilleristas* who went out to teach other groups all over Santiago. She said:

> I started to teach the women a bit about drawing, a bit about human proportions, a bit about composition, a bit about color. While I was doing these things, we created a simple language, you couldn't put a light color on top of a light color, but it had to be light over dark. We started to create simple rules, and I was looking at American patchwork. But many of those rules were formed in the process of doing this work. So after, what, two weeks, we already had rules and things based on observation. I am a teacher; you understand that I have the ability to notice mistakes and quickly correct the *arpilleras*.

Anabella states that there was joint creation of "a language" and "rules" that emerged in the course of doing the work. Her words also suggest that her influence took the form of teaching, defining things as mistakes, and correcting.

While the rules Anabella mentions were about form, there were also rules about content. Anabella had said, for example, that the *arpilleras* should show "the reality," by which she meant the economic and social problems the women were experiencing, and the repression. She also stressed that the women must depict their own experiences.[8] She even produced a document in the earliest days of *arpillera* making, entitled "The Rules of the *Arpillera*."[9] One rule was that they depict only what had actually happened to them. Hilaria, the Comité lawyer, recalled the following case:

Hilaria: I remember the case of Nena Coronel really well. Her husband had committed suicide because of their problems, and the suicide had been terrible, because he had hung himself from the little tree that—I will never forget—that could hardly bend. That image was engraved on my brain, and one day we were working, we were working on that theme, and Nena depicted a barbecue; she imagined everyone eating and having a good time. Obviously it was an experience that she had not had. One of the laws of the *arpillera* was that you could depict only things that had happened to you. There was a—perhaps I have it in my house—a document that contained the *arpilleristas'* rules.

JA: Really?

Hilaria: The *arpillerista* couldn't depict just anything. She couldn't, for example, depict a raid if she had not been in a raid, she couldn't . . .

JA: And whose idea was that?

Hilaria: Anabella's. It was very good, because that way no one could tell a lie, and that way we avoided the commercialization of pain.

The phrase "laws of the *arpillera*" suggests the extent to which the Vicaría controlled the women's creativity. The women did sometimes depict instances of repression that they had not personally witnessed or experienced. As long as these things had actually happened, such *arpilleras* were acceptable, as they fit with Anabella's emphasis on depicting what was "real."

Anabella was not the only teacher to shape the *arpilleras*, but she was influential; when the first women whom she had taught went out to teach new groups, they spread her teachings. Other teachers from the Vicaría or *arpilleristas* trained by them taught the women how to cut figures and how to use stencils and patterns, and explained the fundamental principles of perspective. One told a group to use Chilean-made materials only. Through these teachings the Vicaría shaped the subject matter. There was one group of teachers from outside the Vicaría, but even this group had to seek permission from the Vicaría to enter into contact with the *arpilleristas*. This group of drama students came to help three early groups in the eastern zone, teaching them how to observe; how to reflect on their reality; how to find new themes, colors, and characters; how to communicate the message they wished to get across; and how to give the *monos* expression.

The Vicaría teachers' looking over a group's *arpilleras*, giving feedback, and demanding corrections was another way in which the Vicaría shaped content. Anabella told one *arpillerista* of the eastern zone to take flowers out of her *arpillera*, and another to include people.[10] These women said:

Gladys: I remember the first *arpilleras* I made. They were very nice, they worked out as she had told me. I did them like that, but I didn't include people. My goodness, I was very pleased with myself as I came to hand in my work, and she arrived and took it, and said, "You'll have to take all the work away with you, it's all bad." "Okay, and why?" "There are no people, this scene is dead, there are no people, there's no life." The *arpillera* was attractive, but there were no *monos*, none at all.

Natasha: I had put in flowers, and I had to take all the flowers out because at that time there were no flowers.

Anastasia: Now what they most ask for is flowers, and we ended up doing things like that. We started to get good at it and do them well.

Gladys: And create, and create, because that's what it all was about, creating.

[...]

Anastasia: And she would check them, she would check them and if she liked the *arpillera*
. . .

Such corrections and demands forced the women to do as Anabella decided.

A further way in which the Vicaría exercised control over content was by suggesting that the women depict particular themes. In 1978, it asked the women of the eastern zone to make *arpilleras* about the articles of the Universal Declaration of Human Rights, lending them a copy of the document. The women discussed this:

Gladys: Remember they sent us that thing on human rights.
Anastasia: Yes, and we had to be creative.
Mónica: And it became more and more difficult to develop a theme each time.
Gladys: Our heads were about to explode because we had to work out article X, every
 person has the right to this or that. We had to do that, and work out how to do it.

The Vicaría's prompting led to the women's producing numerous *arpilleras* illustrating the articles of the Universal Declaration of Human Rights.

On occasion, the Vicaría staff stated very precisely the theme they wanted when ordering *arpilleras*. They did so when sellers or buyers abroad requested these themes, or because they had formed ideas about what would and would not sell, based in part on feedback they received from sellers abroad. Anastasia remembered the Vicaría giving her group orders for particular themes, as well as lists of themes to work on:

JA: And was there a point at which the Vicaría started to ask for certain themes?
Anastasia: Yes, they started to ask for themes of repression, when people asked for this
 from abroad, like, for example, the courts of justice with the protests of the relatives
 of the detained and disappeared. With the protests of exiles, of political prisoners, all
 that, let's say; people would ask for that. If they did the courts of justice when suddenly
 people learned something negative, that was when there would be a protest, because
 people expected something positive. So we would make them and hand them in to
 the Vicaría, and people would ask for them. People would ask for the strong themes,
 I say strong themes because they are that sort: the courts of justice, the protests, the
 candlelight vigils, the raids. People would ask for all that, and the Vicaría would ask
 for them, obviously. Yes.
JA: When was it that the Vicaría started to ask for themes, more or less?

116 **Anastasia:** From the beginning, from the beginning, yes, yes. It started to say, "Do this theme because that's what sells best, or it's the one that is asked for most." So it was from the beginning, yes.

The women did not object to being asked to make more repression-focused *arpilleras*, because they soon came to want to denounce what was happening. In later years, however, they resented the Vicaría's telling them what to depict because it started to demand *arpilleras* without denunciation.

Around 1976, Yanni, a Vicaría headquarters staff member in charge of the distribution of *arpilleras*, started giving instructions about color and content, according to one of her colleagues. Not long after that, elements of content that suggested violence were "banned." Zara, a member of the Agrupación group, explained,

> It didn't want machine guns. I mean, the Vicaría was very good with the Agrupación. But not with the workshop because they didn't want machine guns, they didn't want *arpilleras* with blood, they didn't want this, they didn't want that, they wanted everything to be . . . Because the gringos, they said, were bothered by that. Because people—what would happen—they were describing a reality that they experienced daily. In other words, their son was taken away in that way. And they would depict the way they had taken him away. They were not going to lie or say something different. But the Vicaría couldn't understand that.

The detailed instructions from the central Vicaría office, in addition to making the Agrupación *arpilleristas* unhappy, produced conflict between the Vicaría headquarters staff, who exported the *arpilleras*, and some of the Vicaría staff in the zones, who thought that the women should be allowed to express themselves without too much control.

By the early 1980s, the Vicaría had become quite authoritarian, telling the women what themes to depict, how to depict them, what elements in the *arpilleras* to include and not include, what shape and size to make these elements, and what colors to avoid. For a woman joining a workshop at that time, learning to make *arpilleras* meant learning a series of rules. Natalia, who was one such woman, discussed this with me:

JA: And what other rules were there? For example, four *monos* for a small *arpillera*, not less than four? What other rules were there with the *arpilleras*?

Natalia: It was, in the medium-sized ones, I think there were eight [*monos*], I think, yes, yes. And there were two themes. And you had to do not one theme but some two or three themes in the medium-sized ones, yes. And the rule was that they had to be well

done, with lots of flowers, and that they stand out, that they stand out from the base, you understand? Let's put in the sky and later the mountains, so that it looked like the houses were going to cover up the mountain, so you had to use a lot of bright material, a piece of material that stood out and was not dull. Let's say, a light blue with beige was not a good combination, but if I put in a green or, because there are different greens, a light green, aquamarine. So you had to always make sure that that part stood out. The sun had to be yellow, like this, and so on. And you had to put in a mountain, and then another mountain, so that there would be many mountains, and so that the ones at the back could be seen. That's how the *arpilleras* had to be, they would say, just like the houses, very lively.

JA: And these rules, were they there from the beginning, when you arrived, or later?
Natalia: No, they were there from the beginning.

The rules related to numbers of figures, colors, and the placing of objects. Also, the sky, ground, mountains, and sun had to be present in every *arpillera*.

The Vicaría came up with new rules as time passed, resulting in a standardizing of the *arpilleras*. In the early days of *arpillera* making, as they were employing used cloth, the women did not always have the right color for an element in their *arpilleras*, so they might use an "unrealistic" color. Anastasia recalled using blue for car wheels, for example, because people would use the color they were able to find. However, by the late 1980s, the colors had to be realistic and were set for each item. The sky would be light blue, the earth brown or another dark color, and the sun yellow, according to Babette. The sizes of the *arpilleras* became standardized into *medianas* (medium-sized), *grandes* (large), and *chicas* (small), and their exact measurements were fixed. The *chicas* had to measure 18 x 22 cm, for example, according to Anastasia of the La Faena group. By the 1990s, there were set ways of doing certain themes, such as the *ronda* (children dancing in a circle) or a school: with a set number of figures and a bell on one end of the school building and not the other, for example. These conventions came about as the result of Vicaría teaching, feedback, and rejection of work that did not conform—all of which contributed to the standardization of the *arpilleras*.

On occasion, the Vicaría gave some groups a model to copy from when it ordered a particular theme. Laura remembered that it gave groups in the southern zone drawings of the *arpilleras* that were required. These were "models" that the women would photocopy and reproduce in their *arpilleras*. For Christmas, for example, they had a model of the Nativity, and for September, they had *arpilleras* of circuses. Laura from the San Bartolomé group, which began making *arpilleras* in the early 1980s, said:

Laura: They [the leaders of the group] had the model of what we had to do, so they had to explain. Because they would explain it to them over there, and then they would explain it to us.

JA: Ah, could you tell me what it was that she would explain?

Laura: How—the order for *arpilleras*. So they would bring along a piece of paper, like a sheet from an exercise book, with a drawing of the *arpillera*. And we had to make them from that, copy them. So what we would do was make several copies, I mean photocopies, to have it in our home, because there would be just one.

JA: And when did this begin, with models?

Laura: From the beginning.

JA: They would give you models from the beginning?

Laura: Yes, they would give us models.

JA: And who would give you the model, the Vicaría or . . .

Laura: The Vicaría, yes.

JA: The Vicaría gave the model. And what did they ask you to do, for example?

Laura: For Christmas, we had to make *arpilleras* of the Nativity; for September, we made, we had to make *arpilleras* depicting circuses, different models but in the shape of a circus. And for the protests, you had to do it showing what you saw.

JA: There were no models for that?

Laura: No, not for that.

JA: What other themes were there?

Laura: *Rondas*, squares, street markets where they would sell . . .

The models gave the women little opportunity for introducing their own content or ideas. Laura does also mention, however, that the women were sometimes free to depict what they wanted.

In addition to these direct methods of control, there were indirect mechanisms. One way in which the Vicaría influenced the *arpilleras* was through the venues it found for exhibiting them. When *arpillera* making began, these venues were religious in character, probably because the Catholic Church's properties were among the few that soldiers could not openly raid. The Jesuit school of San Ignacio was the first place in which the Comité exhibited *arpilleras*, and another early venue was the San Francisco church in central Santiago. Some of the earliest *arpilleras* of the eastern zone had religious themes because they were exhibited here.

Much of the Vicaría's control came about through the women's internalizing of its rules. The women took in the message that they had to depict things that were really happening, for example. Beatriz, a group leader from the southern zone, told me that the idea was that the women depict their experiences, hence her group made *arpilleras* showing how they had built their shantytown, and

what they were experiencing at the time when they were making the *arpilleras*. Similarly, Nancy said that her group did not receive orders for specific themes but knew they had to depict what was happening at the time in Chile. They had internalized the rules.

What the women came to think of as a good *arpillera* matched, for the most part, the Vicaría's ideas. The women thought the *arpilleras* should be *bonitas* (attractive) rather than *feas* (ugly), and *bien terminadas* (well finished); these were the same words that the Vicaría staff used. The women also thought they should be varied, which was what the Vicaría encouraged. The San Bartolomé group, for example, stated that it was good to work as a group because the *arpilleras* turned out more varied as a result, as members would contribute ideas. In addition, the women knew what specific themes the Vicaría liked to order and what customers wanted, and they chose their subject matter accordingly.

Group leaders and members passed on information about what made for a good *arpillera* to new members. Workshop mates, for example, showed Natalia how to make an *arpillera* and designed her first few *arpilleras* for her. Then the group leader commented on her work, effectively enforcing the rules:

> With the first ones, it was practically all of them doing the composition, and then I started to form my little *arpillera* alone. And then I would show it to Sra. Nancy, "How is it, Sra. Nancy?" and she would say, "Let's see, right, it's good, yes," according to how she thought they were.

Workmates contributed to the Vicaría's control over *arpillera* making by teaching the rules and not questioning them.

Injecting Creativity

We saw earlier how, although there were constraints on the women's creativity in all periods, at the beginning of *arpillera* making the women were less restricted in what they could depict than later on. They could, for example, make stronger denunciations, such as soldiers beating people, homes being raided, protests, the courts of justice, and people paying homage to the fallen with candles.[11] There were times in the mid-1980s when these *temas fuertes* were not allowed. The women could also use unrealistic colors and used cloth in the early years of *arpillera* making, whereas later, the Vicaría demanded better or new cloth, more realism in the colors and patterns in the cloth, and improvements in the quality of stitches. Not all women objected to these limits on their creativity, as some had trouble thinking up new themes. Teresa's group, for example, always depicted the washerwomen, bread baking, fruit selling in the market, and fruit

120 picking, not coming up with any ideas for new themes unless their leaders told
them to.

Despite the constraints, some room for creativity existed at all periods. Occasionally, a woman might think up a new subject for her *arpillera*, and the Vicaría would like it and not only accept it but ask other women to make the same. Bárbara, for example, had the idea of making an *arpillera* showing a man with balloons, and the Vicaría liked it so much that it put it in its catalogue and ordered it from other groups. The Vicaría staff would occasionally ask the women to "invent" new themes, when they thought that there were too many *arpilleras* on the same theme, and it later had other women copy these new themes. In the early 1990s, for example, they asked them to invent themes of typical local characters, and Nancy invented the *volantinero* (kite seller), while other *arpilleristas* created *arpilleras* showing peanut sellers, fruit sellers, cotton candy sellers, and the *chinchinero* (a street musician who played several instruments at once, including the drum and cymbals). Even here, though, the Vicaría had given the women set measurements for the *arpilleras* they created.

There was also some leeway for creativity with regard to form. Within the acceptable dark or light ranges and requirement that the colors be realistic, for example, the women could choose their colors. Groups came up with new ways of representing elements within the *arpilleras*, as when a woman from Lo Hermida invented the three-dimensional *monos*. The women also left their mark on the background of the *arpilleras*. The leaders of the Melipilla group, for example, said that their *arpilleras* reflected what they saw in Melipilla: the rural landscape, the mountains, and a particular type of roof. This group felt, also, that they expressed their mood in their *arpilleras*.

More freedom or creativity was possible when the women had buyers other than the Vicaría. The Vicaría tended to find some of Francisca's group's *arpilleras* too "strong" and reject them, to the group's annoyance. But the group was able to depict protests, raids, *el maltrato* (ill-treatment) by soldiers, and other sharply denunciatory work because it did not rely solely on the Vicaría for sales. As it had contact with a woman in Belgium, and the local priest sent its *arpilleras* to France, it was still able to make and sell sharply denunciatory work. Francisca and I discussed this:

JA: Ah, so lots of repression. And would you put those themes into the *arpilleras*?

Francisca: Yes, when there were protests, we would meet every week, twice a week we would meet in the workshop, and we would talk about what had happened, trying to put it into the cloth. When there was a lot of repression, also, showing how they would hit people. I remember that once something really tragic happened, which was

that a soldier cut off the scalp of a young man with a knife, a *yatagán*, as they call it. He took off his scalp, in the way the Indians used to do, he took it off, and, well, a workmate did that one; she did it. From time to time what happened was that we would put these things into the *arpilleras*, and they would arrive at the Vicaría, and the Vicaría would give them back; it didn't want such strong *arpilleras*. So that used to bother us a lot, because it was what had happened here. It might not be happening in other shantytowns, but here it was more severe, in this shantytown it was a lot more severe! So they would give us back the *arpilleras*. But it sometimes happened that we made contact with other people—via other people—in France, in Belgium especially. A woman from Belgium came here to buy *arpilleras*. She came here, and we could send her those ones. Once a year, something like that, we could send out that type of *arpillera*, a few times. And the Father, the priest, he also, Father Dubois, he also bought some to send to France.

JA: Where would he send the *arpilleras*?

Francisca: I don't have . . . He would send them to France, I don't know where.

JA: And the woman in Belgium, do you know where she would send them?

Francisca: In Belgium itself. I don't know where.

JA: And how did you get in touch with her?

Francisca: Because she came here with a Chilean woman who had been living there for many years, and they came here together. I don't know how they came, but they came to make contact with me here. They came to my house, and I took them to the workshop, and then she continued to buy for a long time, that lady.

[. . .]

JA: And the women from abroad, the woman from Belgium?

Francisca: No, there was no problem. We put what we wanted into the *arpilleras*, and there was not much of a problem with that.

Having other buyers gave Francisca's group more freedom in terms of the content of its *arpilleras*. Not all buyers other than the Vicaría were flexible in terms of content, however. Teresa's group made *arpilleras* for a man called Negaldo, who returned a very large number, even if there was just a small problem with them, without allowing the women to redo them. Some buyers, like the Vicaría, made orders for specific kinds of work, as happened with a buyer from Holland, who ordered *arpilleras* from Natalia's group.

THE IMPACT OF MOTHERHOOD AND THE REPRESSION

The women's gender and motherhood infused their *arpillera* making. One of the attractions of *arpillera* making was the opportunity it provided to work while keeping an eye on their children. Anastasia said:

And that was the special reason, let's say, why they invited me to the workshops, to be able to earn money and not leave my children's side. Because we would make the *arpilleras* in our homes, we wouldn't go out.

For women whose main responsibility, they felt, was to take care of house and children, to be able to both work and do this was very desirable. It meant that they did not have to leave the children in the home alone or in the care of their eldest child. They tended to fit *arpillera* making around motherly or housework duties. Some women talked of working on the *arpilleras* during their "moments of rest" from housework or childcare. Teresa, for example, did the housework in the morning and made *arpilleras* in between housework tasks, continuing in the afternoon. When there was a lot of work, however, she would neglect the housework and her husband would cook. Many women worked late into the night, because this was when they did not have to take care of the children or do housework; Bárbara, for example, worked until 2:00 or 3:00 AM. Natalia designed her *arpilleras* at night when her children were asleep, but did the other aspects of *arpillera* making during the day:

Natalia: So I would always try, at least when the children were sleeping, I would start to give them form, what is it, that word they use?

JA: *Plasmar*?

Natalia: That's it, *plasmar*. Yes, so I would sit there, and so what would happen was that I would start to baste, or else I would put a drop of glue on the back, so that they would stay stuck on, so that they would not slip, so as to be able to sew. Because if they slipped, they would not be done right, they would be lopsided. So that's what I would do; I would do the composition at night, and then if I could, I would sew because there were times when tiredness won out, tiredness. Sometimes I was like this, and suddenly [gestures]. I would always be pricking myself a little with the needle. So it was something—there were a lot of nice experiences that we had. I was sitting there and I would start falling asleep, so I would say, "I have finished this one, tomorrow I will stick on the little *monos*, I will stick on the lining, and then I will go and hand it in." It would always take whole days and whole nights.

Natalia's work rhythms were determined in part by her children's.

Motherhood infused the women's work in still another way: many integrated their families into the work. Francisca's children, for example, helped her make *monos*. Laura's youngest daughter helped her make *arpilleras*, as did Anastasia's daughters and husband; he made the bags, bread-baking tools, and pickets that the *monos* held in their hands. The coordinating committee of the eastern zone

described a woman who had all her family make *arpilleras*, and mentioned that 123
their own husbands would help them sew. Babette had all her family involved,
her eldest making *arpilleras* while her youngest would find pieces of cloth and
suggest what they would be useful for. She said:

> I remember that there was one month where I made twenty; twenty with my eldest
> son, who was about fifteen. I got all my family involved. In fact, we all did exactly
> that, from the smallest child. I remember that in those years one of my children was
> very small; he was about a year and a half, and we would go around looking on the
> floor, and when he saw a piece of cloth he would say *"arpilleras."* So the family was
> so familiar with the *arpilleras* that when the children saw a piece of light blue cloth
> they would say, "For the sky, Mommy, sky." And if they saw a piece of dark cloth,
> they would say, "Look, Mommy, for the ground," or a piece of yellow cloth, "Look,
> Mommy, the sun." So they knew what the colors were for.

Family members might also help acquire the raw materials; as we saw earlier,
Natalia had her daughter come with her early in the morning to collect bags
containing scraps of cloth from a street near the center of Santiago and carry
them home.

Many of the women saw *arpillera* making as being intimately related to their
children's growing up, since they took the children to the workshops from a
young age, made *arpilleras* in the home surrounded by their children, and paid
school fees and bought food for the children with the *arpillera* money. They
sometimes said, with great feeling, that their children had grown up "with" or
"amid" the *arpilleras*, and were educated "thanks to" them. At least one woman
saw *arpillera* making as a skill that was being passed down from generation to
generation in her family. Natasha said:

Natasha: As far as the *arpillera* is concerned, I hope it never dies out because this is some-
thing that is being passed on from one generation to the next, because my daughters
know how to make them.

JA: What do you mean by "passed on"?

Natasha: That it is passed on from one person to the next. For example, I know how to
make *arpilleras*, my daughters also know, and even my grandson, who is five years old,
already composes small *arpilleras*, it's incredible. And he said to me once, he says, "Are
you working, Grandma? I am going to help you." And he put in the mountains; and
he is five years old, and makes little *arpilleras*, and it makes me laugh. So it is being
passed on, but time is passing, and I hope it never dies.

124 What Natasha describes is something of a family tradition of *arpillera* making, her children and grandchild having learned how to make them. Many women talked nostalgically about their children having "grown up with the *arpillera*."

The *arpilleristas*' gender and motherhood also shaped the ways in which they made space for their work. Some of them developed strategies for preventing disturbance from their children; Francisca, for example, had her older children look after the younger one. Natalia would wrap up her little girl and put her in an armchair while she worked. The women also scaled back the housework; if Teresa cooked, for example, she only cooked lunch, or cooked for two days in a row, and she neglected the housework. Some of the men took over part of the family work that their wives normally did, since they were unemployed. Teresa made *arpilleras* while her husband cooked, for example.

Gender shaped *arpillera* making in that some *arpilleristas* were members of community groups focused on women or on caring for members of the community (arguably a gendered preoccupation), and their work rhythms were affected by these commitments, which caused them to be able to work on their *arpilleras* only when they were not doing this other work. Babette, for example, was director of a women's organization and leader of an *arpillera* group, and she would work in these groups in the daytime, and on her *arpilleras* at night. Similarly, Natalia worked on her *arpilleras* in the afternoon, when she was not working at the local church, where she was a volunteer helping to run a group of young people, keeping them away from drugs, and helping the elderly.

Gender was not the only shaper of the women's work on *arpilleras* in the home; so, too, were the repression and national security doctrine. The curfews and occasional presence of soldiers in the streets of some shantytowns meant that the women had to take care that no light could be seen from outside while they worked on their *arpilleras* at night, so some used candles rather than electric lights. In the shantytown of La Victoria, in southern Santiago, the women put black curtains over their windows. Nancy, the leader of a group in a nearby neighborhood, gave a lively description:

Nancy: We had all been born in a free country, and to suddenly have this coup that was so tough, so severe that so as to work you had to close up everything, having it be dark, at night, so that they would not pass by and see; because the light would be on until so late. There were people who, for example, even worked with candles at night when they made *arpilleras*. For example, in La Victoria, which was a shantytown where they treated people really brutally, they always said that what they would do, since they lived surrounded by soldiers always watching over them, was put black curtains in the windows, covering up everything so that you couldn't see the light, so as to be able to work until late.

JA: Making *arpilleras*?

Nancy: Making *arpilleras*. So that was the way of being able to work and hand in the work, because often when they came to raid La Victoria, which was very often, they had to hide everything. Often we had to hand in our work and they couldn't hand theirs in because they hadn't finished it. So the situation was very tough. Of course there were some who suffered more than others; for example, we didn't have such a hard time of it, but in other shantytowns, where it was far worse than here, they did.

The presence of soldiers forced women in La Victoria to take measures to protect themselves while making *arpilleras*. The Agrupación *arpilleristas* adopted a similar strategy, as Zara described:

But there was an enormous amount of abuse in those years because people couldn't sew until late, as there was a curfew. So you had to make sure they couldn't see that you had the light on. And it was essential to do this work. The work was done with candles, in the case of the first ones [*arpilleras*]. And it was very significant and very difficult, because many tears were spilled onto the *arpilleras*. Because it was difficult; it was like a piece of yourself that you were pulling out. And many times you had to cover up the windows with two or three blankets so that they couldn't see a single ray of light from outside, so you wouldn't be arrested, because they would come to your door, can you imagine, and arrest people.

Zara's words convey something of the intense fear and desperation that the women felt while making *arpilleras*, because of the repression.

Hiding was a way in which the women protected themselves from the repression. We saw above how they hid the fact that they were working. They also hid the *arpilleras* themselves when they were not working on them, in case their home were raided. Francisca, from La Victoria, hid them among her clothes:

Francisca: Yes, there was a raid here, yes. Well, there were raids on one house after another once, after a general was attacked. I don't remember his name, but they went from house to house, examining absolutely everything. My daughters had their room at the back, and they examined their books, and if they saw a psychology book they would say, "What type of psychology?" I mean, as if it was bad to have psychology books. In our house we have always had a lot of books, we have always liked studying and reading, and they would check everywhere. And so when we had *arpilleras*, we didn't know where to put them, because if they caught us with the *arpilleras* in which we would depict what was happening, they could arrest us. So we would hide them, and we didn't know how; we would put them in among the clothes so that they would not find them.

126 **JA:** In among the clothes in the wardrobe?

Francisca: Yes, yes.

JA: And how many times did they come in like that?

Francisca: About three times, here.

Francisca's words convey that the women were afraid, and this pushed them to adopt the self-protective strategy of hiding their work. Hence the insecurity and fear induced by the repression and national security doctrine shaped aspects of the production process and what it meant to the women to produce *arpilleras*: it was risky work.

At times the fear that the repressive climate caused rose to crisis levels. A newspaper article came out after *arpilleras* on their way out of the country were discovered by the authorities, and the *arpilleristas* were described in negative terms as producing defamations. The women were "out of their minds," in the words of Wilma, a Vicaría employee:

Wilma: And that is what is interesting about the *arpilleras*, how, in coming together, in going to look for pieces of cloth, I mean, the ties between them are so strong. Anyway, afterward, there comes a threat from abroad—because they would sell their work with the Vicaría's help—that they could be arrested, you see. So they find themselves having to take on these things. I remember in Puente Alto, a, a house almost burned down because the *arpillera* caught fire in the oven, when . . . have you talked to the people of Puente Alto?

JA: One, Natasha. But what happened?

Wilma: Well, imagine how frightened these women were; they were housewives, you see, whose husbands had worked until a certain point, and then suddenly they were unemployed, and they had to support the family, so they started to . . . I remember when once the newspapers said, "The *arpilleras* . . . ," and the *arpilleristas* arrived at the Vicaría half out of their minds. "What should we do?" There was a lot of fear; but they survived and they would help each other, you see?

Producing *arpilleras* meant that they could be arrested, and they felt acute fear at crisis moments, but Wilma's words imply that their closeness and solidarity helped pull them through.

WORKING AT WORKSHOP MEETINGS

The women worked on their *arpilleras* at home, mostly, but they did some work on them during workshop meetings, which were normally one after-noon a week, and sometimes two or three.[12] Groups differed in the amount of work they did during these meetings. Francisca said her group mostly talked,

whereas Teresa said her group worked, talking very little. Workshops were the time when the group leader said how many *arpilleras* would be made by each person, shared out the cloth and wool among members (in some groups), and conducted quality control. Members gave each other pieces of cloth and wool when they lacked the right color, *mono* makers sold *monos* to other members, the women handed in their finished *arpilleras*, the group's treasurer paid members, and the group had its *onces* (tea break in the middle of their meeting). The members would bring their children along to the meetings, and the children would either stay in the room with the *arpilleristas* or play in an adjacent yard if there was one, sometimes under the supervision of teenagers who volunteered. At teatime, the women served the children first, sometimes with donations passed on by the priest or the Vicaría. The women's status as mothers left its mark on workshop meetings.

At these meetings, the women often either began *arpilleras* for a new order about which they had just been told, or finished *arpilleras* that were due in that day. They would add the final touches and give each other input on elements that were missing from the composition or not well sewn, to avoid rejection at quality control. They would also help each other finish their work by lending each other *monitos* or sewing on details that remained to be done. The goal was to hand in all the work due in that day and prevent it from being rejected at quality control. Natalia explained:

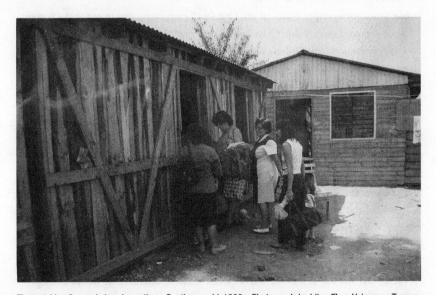

The outside of a workshop in northern Santiago, mid-1980s. Photograph by Liisa Flora Voionmaa Tanner.

But as we were close, when one person didn't have enough *monitos*, someone would lend her one and so on. We would lend each other things. And if someone had some work to do still, to finish her *arpillera*, we would also help her finish it. So that we could all hand in the work we had been given, I mean the order we had received. Because you had to make the whole thing, you had to do the sky, the mountains, the houses, the trees, all those things.

The spirit of helpfulness, cooperation, and solidarity is clear from Natalia's words. Later she added that members gave each other wool if they did not have any. In Teresa's workshop also, everyone helped each other:

Teresa: We wouldn't have tea there at all; we would only work on the *arpilleras*.

JA: What would the other women there do? You were doing the *monos*. Were they all making their *arpilleras*?

Teresa: The *arpilleras*. Their *arpilleras*. They would start to compose them, others to finish them, and we would ask, "I don't have this. Can you lend it to me?" So everyone helped each other, "I don't have this color, I don't have wool." They were close; in general everyone was close because everyone was going through the same thing.

JA: What were they going through exactly?

Teresa: The situation we were in, so everyone helped each other. If one didn't have something, the other would give it to her, and so on.

JA: What would they give each other?

Teresa: Wool, for example, pieces of sky. Or a small piece to be able to put at the bottom, when someone said, "I don't have beige." And that's how they would help each other to finish the *arpilleras*. "I don't have material for the sun, I don't have yellow." "I have some!" and so on. So if one didn't have it, another did. [...] Sometimes we would go to finish the *arpilleras*. To see what details were missing, and we would all help each other, working together.

The women worked together in a convivial and supportive way, this helpfulness being a manifestation of the "*solidario*" (solidarity-oriented) nature of the groups. As well as cloth, the women gave each other input with ideas for themes and helped each other remember rules.

The women shared a sense of being united in the effort to avoid rejection when the Vicaría conducted the quality control sessions. Bárbara, of the San Bartolomé group, reminisced:

I really like the way it was, the way we made *arpilleras*. Because we would all help each other. All of us; there was no one who would say, "No, no, I'm not going to show you," because all of us would say, "There is this wrong with it and that wrong

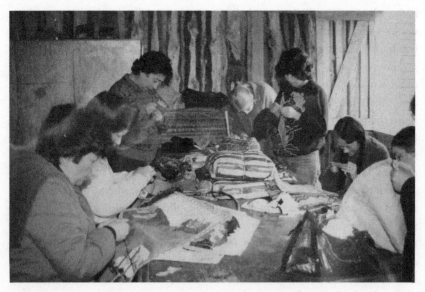

Inside a workshop in northern Santiago, mid-1980s. Photograph by Liisa Flora Voionmaa Tanner.

with it," all trying to correct the mistakes, so that your work would not be wasted. Because if they found something wrong, they would return it, and the work would be wasted. So we would try and improve as much as possible. And previously there were about sixteen of us, something like that.

Bárbara's choice of the word "mistakes" shows the extent to which the women made *arpilleras* in accordance with the Vicaría's wishes, and how their goal was to prevent them being returned. They helped each other in this endeavor.

All was not rosy, however. There were tensions that resulted from working together. Laura reported, for example, that their group's president kept some money that was donated to the group and used the rest to buy the wrong sort of wool. There was also distrust; Anastasia explained that when it was time to go to the central Vicaría office to be paid, two or more women would go, as a member had once claimed she had been robbed but had kept the money, it was thought. This was not the case in all groups, however; members of the San Francisco group, for example, saw their leader as honest.

HANDING IN WORK AND UNDERGOING QUALITY CONTROL
Workshop Leaders' Quality Control

The completed work was normally due a week, two weeks, or a month after the women had received the order. The leader always gave the group a deadline

130 before the one that Talleres had given them. Normally the deadline was in a
week's time when demand was high, and in two weeks or a month when it
was lower. Sometimes there were orders for rush jobs, which the women called
pedidos especiales (special orders). When these came, the women dropped their
other work and focused on the rush job. On the due date, the women would
bring their finished or almost finished *arpilleras* to the workshop meeting to
hand them in to their group leader. In Lo Hermida, one of the rules was that
they finish the work they had committed to doing, and if a woman did not do
so, she would be punished by having work taken away from her and given to
another woman who was reliable.

Quality control began in the workshops themselves, when the group leader
would look at the finished *arpilleras* and, in a spirit of helpfulness, suggest what
their creator could add or alter so as to avoid rejection during the Vicaría's
quality control. They called this *revisar* (checking). They might point out,
Anastasia says, a house on which some stitches were lacking, a window or door
that was missing, or the wrong color wool on part of a house. Teresa recalled
similar feedback from her group leader:

Teresa: She would look at them and say, "There isn't enough here," "This is bad, correct
it, or otherwise they will send it back from there." Sort of correcting like that. She knew
a bit more than we did; she had been in the workshop longer. "I do it so that they don't
return your work, girls, that's why I do it." [Laughter]

JA: Would that woman hand in work as well?

Teresa: Yes, also.

JA: So was she sort of part of the small group?

Teresa: She was part of the group, yes. She had her work ready, so when you were going
to hand yours in, she would start, one by one, with "Look, that's bad, it's badly lined,
look at this *mono*, it doesn't have any movement," and that's what she would say, all
the time.

JA: What other criticisms would she make, what else would be badly done?

Teresa: For example, the houses. For example, "This house is not straight; the trees have
to be below the house." Like that. "And the *monos* have to be moving. They can't be
like this." Because the *monos* have to have their hands stuck together, they have to be
doing something. For example, when we did the washerwoman, you had to have the
sheets hanging there, and one of them sort of hanging things up, and the other hold-
ing them. Those were the *monos*' movements. And these were the criticisms, but these
were the things you could repair. Sometimes there were such tiny things [defects] and
they would hand them back. Sometimes, when the little points of the houses were
round, the roof had to be a point. Yes, sometimes people who had had all their *arpilleras*
returned were driven to tears. The hope of receiving a bit of money, and then for all the

work to come back … We suffered a lot with the *arpilleras*, but it was a matter of simply working hard, not any old how.

JA: So she would examine them, and then the ones that were "good," what would she do with them?

Teresa: She would take them to hand them in. And if you could do those details that were not well done, you did them right there, and she would take them.

The women would make their alterations at that very meeting, help each other put in the missing details, and then give their *arpilleras* to the group leader.

The leader would take the *arpilleras* to a *coordinación* meeting that very evening or the next day. All the *coordinadoras* that made up the *coordinación* were present at this meeting, each with their group's completed work. Three to five of these *coordinadoras* made up an *equipo de comercio* (selling team, in charge of selling to the Vicaría and elsewhere) and would conduct the first round of quality control. They called this *revisar el trabajo* (checking the work). A *coordinadora* could not conduct quality control on the *arpilleras* of her own group. In their minds, they were checking for the same things the Vicaría would check for in its quality control session later. Sometimes, however, Nancy says, they "missed details" and the Vicaría would send back the work. They checked that the work was "well done, well finished," according to Nancy,[13] a selling team member in the southern zone's *coordinación*. This included, she explained, making sure the stitches were well sewn, the *monos* were of the right size (as some turned out larger than others, or larger than the houses), and that the trees were well done. Cristina, a member of the selling team in the eastern zone, said they checked that the *arpilleras* were clean, without loose threads, ironed, well finished, and clearly expressing the theme that had been ordered. She and I discussed some of these criteria:

JA: When you did quality control before, what would you look for? What things would you reject, what things were good, what were the criteria basically?

Cristina: Well, we had a criterion that was, the basic criterion for the sewing was that it be completely clean, above all clean, very much without loose threads, very well sewn, you see, very well finished. That was sort of our first criterion. A second criterion we had was whether it was on the theme that had been given.

JA: Ah, because they would give you the theme.

Cristina: Themes, yes. So you would look at it and say, "Right, what did you want to say here?" when you didn't understand it. Sometimes you would open an *arpillera* and it was surprising, surprising what they achieved; you would look at it, fold it like this, and it was clear.

JA: You could understand it.

Cristina: Immediately.

The quality controller had to be able to understand what the *arpillera* was about. According to Francisca, in the southern zone, the selling team also checked that the stitches were straight and "well done," and that the *arpillera* was not *fea* (ugly).

In the process of checking, the selling team would reject some *arpilleras*, with comments, and the group leaders would have to take them back to their creators for alteration, explaining the problems. The selling team kept the *arpilleras* that they had not rejected to take them to Talleres for a second round of quality control. When the various group members had altered their faulty *arpilleras*, the group leader took them back to the selling team. Through this checking of the work, selling teams exercised control over the form and content of the *arpilleras*. They also did so by suggesting to the women what the *arpilleras* had to be like, during *convivencias*, that is, get-togethers of several *arpillera* workshops in a zone. In these respects, they were a go-between between Talleres and the members of the groups in their zone.

In the earliest months of *arpillera* making in the eastern zone, the system had been different; the Comité lawyer Hilaria had checked the *arpilleras* during group meetings. They had to be self-explanatory, she said, based on something that had really happened to the women, *bonitas* (attractive), and not missing key elements such as the mountains. As there was sometimes conflict with the women at these quality control sessions, Hilaria and the staff of this Comité office soon passed on the responsibility for this checking to a group member.

"La Entrega"

The selling team would take the *arpilleras* to the Vicaría, in what was called *la entrega* (handing in), one of the most dangerous parts of the *arpillera* process. In the earliest years, a *comisión* (committee) made up of two eastern zone group members took them to a Comité employee in the eastern zone, in Plaza Ñuñoa, and because of the repression, they had to be careful. Anastasia described how they had to go there "secretly":

> We would hand in the first *arpilleras*, the first ones, when it [*arpillera* making] had just started, in Plaza Ñuñoa. In a theater in Plaza Ñuñoa. That's where we would hand them in, very secretly, very quietly.

The repression forced the women to hand in their work as unobtrusively as possible.

In later years, they took them to Talleres at the Vicaría headquarters in the center of Santiago, as did all other selling teams. This was a perilous journey, as they might be stopped and checked on public transport. Cristina, a member of the eastern zone selling team, said:

> Afterward we would take them to the central Vicaría in the Plaza de Armas, and French people, English people, people from all over the place would come and buy. We often had problems because—I was, for a long time, in charge of selling, like the head of the selling team, so I would often hand in the packets of *arpilleras*, which afterward were confiscated by the police, by the armed . . . So sometimes you would see that the cars were following you right to your house, in those years. But, well, it was like that back then, and it was what you did, you see.

The risk of being followed or of having their *arpilleras* discovered at the airport seemed from Cristina's words to have weighed on the women's minds as they made this journey. Anastasia similarly recalled:

> We would do the work secretly; we would make the *arpilleras* secretly. To go and hand them in to the Vicaría, you had to do this secretly because there was a period when the *arpilleristas* were hunted down. So we . . . difficult problems, very difficult situations, sometimes. We also had *arpillera* workmates who were arrested, and the daughters of *arpilleristas* were arrested as well.

Secrecy was a strategy the women adopted because they believed they risked arrest if caught with *arpilleras* and saw taking the *arpilleras* to the Vicaría as dangerous. They felt tense or frightened when they undertook this journey. One Agrupación *arpillerista* felt intensely afraid on one trip to the Vicaría, when her parcel of *arpilleras* began to come undone just as she was passing in front of an important government building. The women's poverty compounded their fear and the risk involved, in that they could not easily afford a ride in a car. However, in the mid-1980s, the selling team in the southern zone managed to get a ride in a car to Talleres, as their bags of *arpilleras* were so heavy, and this was safer.

Once at the Vicaría, the selling team showed the Talleres employee their *arpilleras*, for the *control de calidad* (quality control). The Talleres employee would examine them, looking for errors of both form and content. Regarding form, she made sure that the *arpilleras* were *bien terminadas* (well finished, meaning properly sewn and not carelessly done); not *chuecas* (lopsided), *descuadradas* (irregularly shaped but rectangular), or *peladas* (bare, that is, with large empty spaces); that they did not have loose threads; that the elements within them were of the appropriate color;[14] that the sewing was well done;

134 that brown instead of flowery or printed cloth had been used for the mountains (in the earliest years, printed cloth was acceptable); that the mountain peaks were rounded instead of pointed and all of the same size; that the trees were of the same height and not crooked; and that the sky was all in one tone of light blue. Often she would reject some, giving reasons, of which the selling team would take note.

Selling team members who took the *arpilleras* to the Vicaría perceived that the Talleres staff rejected *arpilleras* easily, even if there was only the smallest defect. Anastasia recalled:

Anastasia: So two of us would go, with big bags, with loads of *arpilleras*.
JA: How many, more or less?
Anastasia: In those days we would take sixty—two *arpilleras*, perhaps up to three, per person. There were orders for sixty, fifty, or more sometimes. We would hand in a lot, a lot. So we would arrive there, and go into a small office where Yanni was, and she would examine them with another person, who was Gertrudis, I don't remember the last name. So they would examine them, which was called, we would call it "quality control." So they would examine them one by one, and any little detail that they found, they would return them for us to correct and hand them in on payment day.

In the years of high demand, the Talleres staff member would also, during this meeting, tell the selling team what *arpilleras* were needed for next time. They then either put the accepted *arpilleras* in a storage room or prepared to ship them abroad.

What the Talleres employees checked for changed slightly over time, in that they began to insist on better "quality." They came to require new cloth, for example. Gertrudis, who began working for Talleres in 1982, described what she checked during quality control:

Gertrudis: So what I would usually do was correct everything; that was quality control.
JA: What was it that you were looking for?
Gertrudis: I, personally, would check that it was well finished, well done. In other words, that the stitches were well done, that there were no loose threads, that the cloth was . . .
JA: Not wrinkled.
Gertrudis: Not wrinkled, flat; usually that. And that they were well finished around the edges, because usually they would do the edges with crocheted wool. Make sure that the color of the crochet that they used for the edge was related to and combined well with what was inside the . . . so that it would not be, for example . . . as they would use leftover wool, they would put in pink, or light blue, and there would be nothing matching, you understand?

JA: Yes.

Gertrudis: In other words, it didn't look nice. Usually that: things not well finished, and sometimes also very unusual themes.

Gertrudis's words suggested that she wanted a high-quality finish rather than expressivity of the content.

What the Talleres staff looked for in terms of content varied over time as well. In the early 1980s, they began to reject *arpilleras* with sharply denunciatory themes (*arpilleras "fuertes"*).[15] Teresa, for example, said that they at one point asked for *arpilleras* with "few protests," and then "no more protests." "Strong *arpilleras*" that were rejected showed raids on houses, soldiers beating people, or torture. Francisca's *arpillera* showing a raid on homes, with soldiers shooting, people hiding behind houses, and fires in the street, was one such *arpillera*. Talleres's rejection of strong *arpilleras* was initially sparked by *arpilleras* being discovered by government officials at the airport; this produced great fear. It also resulted, beginning in the early 1980s, from the perception that foreign buyers did not want *arpilleras* that were too violent or sharply denunciatory. Gertrudis added to her list of what she would look for:

Gertrudis: Usually that, things not well finished, and sometimes also very unusual themes.

JA: Which ones, for example?

Gertrudis: Like very bloody things, you see? Sometimes they would put in people whose throats had been slit, for example, and people with heads rolling, and with puddles of blood. So no, you are not going to hang that up somewhere; I mean, it's fine to make a denunciation, but not that way.

Gertrudis's thinking about clients not wanting violent *arpilleras* points to the Vicaría's increasing emphasis on selling over and above enabling the women to denounce.

In the early stages of *arpillera* making, Comité staff had rejected *arpilleras* that were not denunciatory enough. Hilaria said:

So, I want to tell you that in a way the *arpillera* was a personal moment, like when you had to sew things like . . . and Yanni did not respect that because she would sometimes return them. Well, and the person . . . the *arpilleras* were for their subsistence, their survival, and sometimes she would return the *arpilleras* because of their content. If someone who, for example, didn't want to talk about tragic things was obliged to . . .

136 Hilaria's words suggest that Yanni wanted the *arpilleras* to be about tragic events.

In the mid-1980s, the Vicaría accepted "subsistence themes," as Francisca called them, that is, the *amasanderas* (women baking bread), the *comprando juntos* (buying cooperatives), the *lavanderas* (women washing clothes in wooden basins), and women receiving training, typically in personal development. Other themes of which the Vicaría approved included *niños jugando* (children playing in the street), the *rondas* (children holding hands in a circle), the *columpios* (children on swings), the *leches por cuadra* (distribution of milk in neighborhoods by the local church), and unemployment in the form of a factory with a sign saying "no vacancies" and people lining up to ask for work. It tolerated some denunciation. Francisca's group, for example, made many *arpilleras* showing the funeral of the local priest André Jarlan, who was French and had been killed by a policeman's bullet, and marches to the center protesting about hunger, and these were accepted.

Over time, there were more rules about elements in the *arpilleras*, more precise instructions from Talleres regarding form and content, stricter quality control sessions, and more orders for particular themes. Talleres began rejecting *arpilleras* for reasons that did not seem justified to the Vicaría staff in the eastern zone, one of whom said:

Wilma: So after a short while there was a problem. At the beginning the women would get hold of all the little rags, scraps, and so on. But later on they [Talleres] began to ask them every time they . . . As the number of *arpilleras* increased, they had to be better, so as to be able to sell at the same rate. So there starts to be, in a way . . . and this was an ongoing conflict we in the zones had with the department in the Vicaría. You must have spoken with Yanni.

JA: Yes.

Wilma: We would receive sort of directions, like "The mountains can't be red; the snow has to be white." And on the other hand, you would see that when the women told you the story in their *arpilleras*, it really was their life. So there had been a sort of directing of something that they were creating. And it had a lot to do, also, with the times when . . . so there were periods during which they all embroidered, I don't know, protests in the street, or in the old days, for example, I remember when Lonquén happened [bodies of disappeared men were found near the village of Lonquén], many of them would embroider Lonquén, you see. [. . .] There were [in an *arpillera* mural by the Puente Alto group] various panels that showed, for example, the way a woman was born, what happened to her in her marriage. But the Vicaría would not buy these things; the Vicaría was not interested in an *arpillera* with an ox-drawn cart, because here in Chile there were no oxen, you see, and because the idea . . . So they had to

denounce, but not too much, because I remember when sometimes there was an *arpillera* with blood flowing, and Yanni would return them, and you can imagine the reaction. So there . . . something was happening here, in some ways, at some periods; the creativity of the women and the women's expression in the *arpilleras* were being controlled. And obviously, with the enormous need that they had—I mean the women—their work was wasted.

The Vicaría began to insist that colors, materials, and elements in the *arpilleras* be a certain way, different from what had been acceptable previously, and rejected the *arpilleras* that did not conform. This caused the women distress and led to a tense relationship between them and Talleres. However, they were dependent on Talleres and needed the money desperately, so they were forced to comply.

After the quality control session, the *coordinadoras* would return to the shantytowns with the rejected *arpilleras* and tell the leaders of the groups that had produced them what was wrong with them. At the next workshop meeting, these leaders would pass on the information to the group members concerned, and these members would have to *arreglar* (make corrections) or *desarmar* (undo) part of their *arpillera*. They could normally hand it in a few days later, when the *coordinadoras* returned to the Vicaría to collect the money they were owed, or at a later date. Rejected work made the women very upset, and sometimes angry. There was "*hasta llanto*" (even crying) sometimes, as Bárbara put it, because the *arpilleristas* were not paid for their rejected work, which they had sometimes stayed up all night to finish. Some found rejections demoralizing. However, it was not merely this that the women resented. At the time when Talleres was rejecting *arpilleras* that were "too strong," some resented not having the freedom to depict the state violence and repression that they knew existed. Francisca described her reaction to a rejection:

JA: And when the Vicaría rejected your *arpilleras*, how would you react?

Francisca: Badly. We would get annoyed, it made us angry, because it was our work. We had stayed up at night working, and then were left with the work unsold. You had to undo it, undo it and do it differently. So it would also leave us demoralized, and make us sorry, because you were counting on that money, as it were, and suddenly it just wasn't there.

JA: And was it the Vicaría de la Solidaridad in the center that rejected them?

Francisca: Yes, [pause] yes.

JA: Was there another quality control session here?

Francisca: No, no.

JA: Just there, directly?

138 **Francisca**: Well, there was a quality control session by the *coordinadora* that we had, for the workshops. We were organized, as workshops, and there was a group that checked them and did quality control. They would check them as well, and reject the ones that were badly done, where the stitches were crooked and so on, that were not well done.

JA: Did they ever reject them because of the theme, or not?

Francisca: Yes, also.

JA: Could you give me some examples?

Francisca: Well, the raids by soldiers on homes. When what we had depicted was too "strong." So there were things that would be rejected as well. I remember how I did a raid that made a deep impression on me, so I depicted it, and it was returned. And it was very difficult for me to do the soldiers in cloth, to do all that, and every detail [pause]. And it was returned. So I got very angry, because I didn't think it was ugly. The theme was strong.

JA: What did it show, the soldiers?

Francisca: Yes, the soldiers, the soldiers shooting, people sort of hidden behind the houses, the fires, because people would make fires.

JA: And what other themes would they reject?

Francisca: Well, for example, when they would hit someone; showing the soldiers hitting someone, torturing them. So sometimes those things were not very well accepted. And we couldn't understand why, because those things really could happen.

JA: And apart from the anger, [pause] did you decide to not make any more *arpilleras* or did you continue to make them?

Francisca: Well no, we had to make them, because if we didn't make them, we weren't going to sell them. No one would buy them, so you had to accept the rules.

Francisca wanted to depict the violent events that were occurring and believed that *arpilleras* should not be rejected if they depicted what was really happening, but her group had no choice but to conform. Fortunately they had a buyer in Belgium, and their local priest, who was French, would send the *arpilleras* to France without conducting quality control on them.

Not all women were upset by not being able to portray certain themes, however. Many were interested mostly in being paid. Nancy, for example, said:

JA: What was your motivation for joining [an *arpillera* group]?

Nancy: My motivation was to have a bit of money. It was the poverty we were facing. So that was everyone's motivation in the workshops; it was to be able to bring some money home. It didn't matter what theme it was, what you did didn't matter; the thing was to bring in some money because everyone had children, and the children were the ones who were suffering the hunger, their fathers' unemployment. There were children

who became orphans because their father died, so the mother had to carry all the responsibility for the home. With unemployed husbands, the money you made wasn't enough, and on top of it, imagine, with five children in my case. There were others who had more, well, others had less, but the thing was that everyone had money problems.

Nancy did not mind what themes she made; her poverty, husband's unemployment, and responsibilities as a mother made her willing to depict any theme if it meant bringing money home.

Quality control was a highly effective means of exercising control for Talleres, since a rejection meant to the women that they would not receive the money they had counted on, that their time had been wasted, and that they had to redo the work. Because of their poverty, their husband's being unemployed, and the fact that they had children to feed, they needed the money very badly, as Nancy's words indicate; rejection meant a threat to their family's livelihood. Two further factors enabled the quality control system to exert control so effectively: the women did not see themselves as artists with a right to freedom of expression, and they were working class, whereas the Vicaría staff were middle class, and it was not unusual for working-class people to be ordered around by middle-class people, and to behave in a humble and respectful manner toward them when conversing with them one-on-one.[16]

Because of the risk of rejection, what was uppermost in many of the unemployed women's minds while they worked was to avoid having their *arpillera* returned with corrections to be done. Nancy said:

> The only thing we wanted was to do the work well, not have the *arpilleras* returned, and we thought that more would be better. So we had to do the work well.

Nancy's words "to do the work well" (*hacer bien el trabajo*) suggest not only a willingness to comply with Talleres's rules, but also an acceptance of these rules as constituting "good work." Like Nancy's group, the San Bartolomé group concentrated on avoiding rejection, as two women suggested in the process of explaining why the group sometimes met more than twice a week:

Bárbara: Yes, to, to prepare the work, and sort of tell them [group members] what we had to sew, what we had, how we had to do it.
Fanny: So that the work would turn out perfect, and not be rejected.

The word "perfect" shows Fanny's acceptance of the Vicaría's criteria.

Focused as they were on the money they would earn, the women anticipated the criticism their *arpilleras* would attract, from both their group leader and

140 Talleres, and worked to avoid it. This was particularly true in the mid-1980s and subsequently, when Talleres focused on "quality," as Natalia said:

> Señora Nancy would also check them, before going to drop them off, so she would check them as well [...], and when the peaks, sometimes, were a bit rounded, it was no good; they had to be sharp points. They had to be straight. They had to not be badly done because if an *arpillera* was like that, they would notice immediately that it was not good and reject it. Because they were very fussy over there. They had to be well done, otherwise they would simply return them, and so it was wasted work; you had to be undoing it, and doing it all over again [...]. So I, at least, I took the precaution that they turned out square, that they looked nice, so that they would not return them. And with that, I had worked out what I would do with that money; I was going to buy this, that, and the other. So I tried to make sure that they all passed. If they gave me, for example, 1,200 for the small ones, I can only remember about the small ones, then if there are six, it is about 7,000 pesos, so I would say, "How good it would be if they passed all the *arpilleras*; it would be wonderful." Because as I say, the situation was bad, you had to have money. [...] Because also there were some that were returned that were not straight or not well finished. Or if some appliqué parts were missing, they were very "bare," as we say, very empty, with not enough flowers, that would fill the *arpilleras* more. As I knew, I would try to fill it with grass, with flowers, with *monitos*, so that it would be very full. That's why, also, they hardly ever returned them, but with some people they returned them.

Natalia knew the reasons why *arpilleras* were rejected and strove to avoid this happening. She kept in mind the money she would earn, knowing, even before handing them in, how she would spend it.

Some days after quality control, the treasurer and *coordinación* leader would go to the Vicaría for payment, called *el pago*, taking with them the modified *arpilleras*. In some groups this job was done by a rotating team of two, called a *comisión* (committee), so as to avoid the distrust that might arise from the person being "robbed" on the way home. At the Vicaría, they would put the money for each group into a different envelope, in accordance with the amount of work done,[17] and later in the day give it to the group leaders. The group leaders would take it to their groups, where the treasurer would distribute it, having previously written down what each woman was owed, but taking away a *cuota* of 100 or 200 pesos for the *fondo* (group fund). The money in this fund would be used to buy material or wool, or to pay for an outing, or for the transport fee for trips to the Vicaría, special *onces* (teas), or lunch for the workshop's anniversary or end-of-year celebration.

The *arpilleras*, then, were not the "free" expressions of their makers. The 141
arpilleristas worked within constraints and controls imposed by the Vicaría
through quality control; orders for particular content and form; the banning
of certain depictions; and instructions regarding colors, type of cloth, and ele-
ments within the *arpilleras*. From the beginning, Comité staff told the *arpille-
ristas* how best to make an *arpillera*, what not to put in and what to include, and
the women had to show their *arpilleras* to the teacher, and make corrections
according to the teacher's recommendations. Talleres was not the only shaper
of the *arpilleras*; so, too, were shantytown gender expectations, motherhood,
and the women's poverty, influencing the choice of materials and subject mat-
ter, when and where the women worked, how they juggled work and women's
responsibilities, and the degree of control the exporting organization was able
to exert over them. The regime's repression also impacted aspects of the work:
the precautions the women took when making *arpilleras* at home, the sense of
danger that accompanied the trip to Talleres, and the rejections by Talleres staff.
This trip and the handing in of the work were normally the last the women saw
of their *arpilleras*; they marked the end of a process that had begun with receiv-
ing orders for the work, acquiring the materials, composing, and sewing. The
next chapter takes us to the next stage of the *arpilleras'* journey, from Talleres
to sellers abroad.

6 Selling *Arpilleras*

A system for selling solidarity art abroad does not fall into place immediately. Initially, the art may be sold locally, at the initiative of the artists. The international selling may begin quite by chance, when a trusted person living abroad offers to try and sell; at first it will be on a small scale.

FIRST STEPS IN CHILE

The selling of *arpilleras* began locally. Comité staff were important buyers. At first they bought as individuals, and not for the Comité. Anabella, the Comité teacher, for example, bought *arpilleras* from groups in the eastern zone. Similarly, Hilaria, the Comité lawyer, bought the *arpilleras* that made up the "Vía Crucis" mural made by the relatives of the disappeared. Celinda, one of her colleagues, said:

> I think we were the first, I think, the first consumers, I mean, I think all the Vicaría staff and the members of this zone—this world of solidarity, resistance, petty bourgeoisie, let's say. Because we were the ones with the ability to, we had work and the ability to buy. We were perhaps the first who bought *arpilleras* in large quantities.

As Celinda's words suggest, the first buyers were people involved in resistance. The unemployed women would also sell their work to visiting foreigners who contacted them via the Comité and to people recommended to them, at whose doors they would knock. They would also ask Zoe, a Comité volunteer, to sell for them, which she did, to her university classmates. As well as selling, the unemployed women engaged in bartering with the Agrupación *arpilleristas*,

giving them their *arpilleras* in exchange for shoes, uniforms, and other items
they needed.

Much of the women's selling was affected by the repression. As the *arpilleras* contained critical commentary on the regime, the women took precautions when they went out to sell, limiting themselves to those people whose addresses they had been given. Cristina said:

> They [the Comité] took the first steps, in doing *peñas* [organizing Chilean folk music evenings] and things like that to raise money to be able to buy the materials and things, to be able to—because we were not selling our product. So we would go from door to door, and who on earth was going to buy an *arpillera* that was a denunciation? So you would go sort of from door to door, but doors where, doors that they had told you about. I mean, "Go there, because this, this friend, might buy them." Later on, we started in the Vicaría; we started selling our products abroad. And at that point many people started to group together, myself and my cousin, we started off in this together.

Since the women could not just knock on any door because of the danger involved in what they were doing, they relied on information from the resistance community; the giving of information about who to sell to was an example of solidarity within this community. Similarly, the women would sell to people who sought them out only if they had been recommended.

JA: And what did you have to do, as the leader of selling; what was your role?

Cristina: My role was to check, to do the quality control. It was to sell people *arpilleras*, I mean, to make it possible for someone to come. All this was clandestine, so it had to be people who were recommended, in terms of buying *arpilleras*; it was not just anyone who could go and buy *arpilleras*. Now it's very free, now they are sold all over the place, anything is, but in those days no, we were very, very careful.

Because of the repression, then, the women sold their work with caution, in a clandestine fashion.

They risked arrest. Zara, an Agrupación *arpillerista*, sold *arpilleras* at the Vicaría's eastern office to a foreigner who was then caught with her packet of *arpilleras*. The Vicaría decided to apply for the enforcement of constitutional rights (*recurso de amparo*) for Zara in case she was arrested. Some time later, an article appeared in a newspaper, saying that the *arpilleras* were "a defamation." Zara explained:

I was selling *arpilleras* in the eastern zone and the gringos would come there, because they knew more about the first workshop that had been created. They would come to the eastern zone. I would sell them in lots of one hundred, two hundred *arpilleras*, because it wasn't just the *arpilleras* of the Agrupación but also of the unemployed. The gringos would buy the *arpilleras* and go and have them framed. Carrying a packet. There was severe repression. One [gringa] was afraid, and gave her name. They came to warn me. Employees went to the Vicaría and applied for the enforcement of constitutional rights for me, with the best of intentions. Afterward they realized that they were applying to a murderer [Pinochet] for the enforcement of constitutional rights. I was involved in searching [for my brother]; that's why. They punished priests. Articles appeared in the newspapers: "*Arpilleras* of defamation." It went on for several years.

Selling *arpilleras* meant risking arrest not only because the buyers might be interrogated but also because they might turn out to be spies.

Soon the Comité as an institution was helping the women sell. Cristina, from Villa O'Higgins, alludes to its importance in terms of support:

> The *arpillera*, after that, became, from these beginnings that I was telling you about, it later became something very open. Everyone was making *arpilleras*, everyone was trying to sell *arpilleras* and make *arpilleras*, and Zoe [a Vicaría volunteer] showed up to buy [. . .] and everything. But it was the Vicaría that started before anyone else, getting its hands wet, as we say in this country, who got its hands wet first. It was the Vicaría with Monseñor Silva Henríquez. After that all the others showed up.

Cristina used the phrase "getting its hands wet" because supporting *arpillera* making, as the Comité did from very early on, and selling *arpilleras* were dangerous activities.

In 1975, at Christmas, the Comité organized an exhibition of *arpilleras* and other items produced by the *bolsas de cesantes*, at the Jesuit school of San Ignacio, in central Santiago. The *arpilleras* sold very well, and indeed better than the other items, according to Zoe, the Comité volunteer. Soon afterward, the Comité organized another exhibition in the church of San Francisco, also in central Santiago, which was celebrating an anniversary. The *arpilleras* for this exhibition had Saint Francis as a theme. Not long after that, Anabella approached Rita, a gallery owner in Bellavista, Santiago's Latin Quarter. Rita normally exhibited paintings, sculptures, and engravings, including works by artists whose political views the Pinochet government did not appreciate. She agreed to help sell the *arpilleras* because, as she saw it, it was a way to help

people and contribute to efforts against the dictatorship, and because selling
arpilleras meant that it was possible to speak out:

JA: How did you feel, having *arpilleras*?
Rita: It was important for me.
JA: Why was it important?
Rita: For three reasons: First, because it was possible to say something, via the *arpilleras*, in a
 plastic art medium, and [second,] to be able to help several people. And psychologically,
 I was against the regime; it was my way of being able to help all the others.

Rita's selling *arpilleras* in part to help others points to her solidarity orientation.
The *arpilleras* she sold were by unemployed women, the relatives of the disap-
peared, political prisoners, and men's groups. She began selling them from a
cupboard in her gallery at the beginning of 1976 to buyers who included people
connected with the Vicaría and with embassies. She also began sending them
to contacts in Europe, and her sister bought two hundred and shipped them to
Europe and Cuba, where she exhibited them. Together with Hilaria and Ana-
bella, she organized an encounter between the *arpilleristas* and professional art-
ists. with the aim of persuading the women that they were artists. During this
encounter, both groups talked about the way they approached their work and
what it meant to them.

To exhibit *arpilleras* openly was risky, as her gallery did not have the
protection of the Catholic Church or a foreign government. For a short time
between exhibitions of other work, during the summer holidays of February
1977, a very quiet time in Santiago, Rita hung up *arpilleras* by a group in
Conchalí (northern Santiago) and by the relatives of the disappeared, depicting
the gospel of Saint Matthew and the Way of the Cross. Although she did
not send out invitation cards, people found their way to the gallery for the
exhibition, in particular, people connected with the Vicaría, the human rights
community, and embassies. However, the *arpilleras* had not been on the walls
for long when her gallery was mysteriously destroyed by a bomb, in the same
month. Rita described:

Rita: Not only one, there were several [exhibitions]. I mean, when my gallery was de-
 stroyed, there was an exhibition of *arpilleras*. I mean, one of the reasons for . . . that was
 it. But before that one [the exhibition] they started with the distribution, and display-
 ing them, and it was in the gallery that this happened. [. . .] I had them, well, it was
 not always *exhibitions* of *arpilleras*, but rather I had them—people would come and I
 would show them to them. But at the moment of the assault, which was in 1977, I had

146 taken down the exhibition of paintings that I had, and I had put *arpilleras* on the walls. It was exactly the one that, the story of the gospel according to Saint Matthew, of the Stations of the Cross, but the Stations of the Cross of here. But it wasn't like an exhibition; it was just "in the meantime," during those days of few visitors. I had them up just to have them up, otherwise I would have them in a cupboard, and if people came, I would show them.

JA: How would the people who were looking for *arpilleras* end up at the gallery?

Rita: That's a mystery, how people came. It must have been that word got around; they knew me. Naturally I could not put ads in the newspaper or make invitations, no. But people just know about such things; people in the Vicaría knew, people from human rights, many people from the embassies knew. A lot of people would come and buy; it was not difficult to sell, and that bothered them [the government] a lot.

Because of the repression, Rita could not advertise that she was selling *arpilleras* or make invitations, and her gallery was soon blown up. However, she and her buyers initially circumvented this repression, she by keeping the *arpilleras* in a cupboard, and her buyers by finding out about her selling them via word of mouth, from their network. The religious themes she mentions would perhaps have been ordered by Hilaria, who, in persuading the head of the eastern zone Vicaría office to allow the Agrupación group to meet in his buildings, assured him that the subject matter of their work would be religious.

Selling in Chile continued for the duration of the regime. The Vicaría sold *arpilleras* from a room in its headquarters, and the women sold directly to solidarity-oriented foreign visitors to Chile, to the spouses of exiles, and to Left-leaning Chileans living in Chile, who sought them out. Zara, the Agrupación *arpillerista*, told me she sold a hundred, even two hundred *arpilleras* at a time, made by the unemployed women and her own group, to foreigners who would come to the Vicaría's eastern office. However, the number of *arpilleras* sold domestically soon came to be far smaller than the number sold internationally.

BEGINNING TO SELL ABROAD

Selling abroad began in 1976, somewhat by chance. A Frenchman, Claude, who was director of a refugee services and human rights organization in Paris, was visiting the Comité at the end of 1975. He had been sent by the World Council of Churches, the ecumenical organization based in Geneva, Switzerland, that was one of the main funders of the Comité and Vicaría. The purpose of his visit was to provide "fraternal accompaniment," and he spent a month and a half with Comité staff just weeks before the institution's closure:

Claude: So I left for a month and a half at a very, very difficult period for the Vicaría, no, 147
for the Comité Pro-Paz.

JA: What year was it, sorry?

Claude: 1975. Just before it closed down. And a few weeks after my departure it was indeed
closed down. So I, of course, was fraternally in contact with all the staff members, and
I worked with them.

The fact that the Comité was a religious organization connected with other
such organizations internationally contributed to bringing about Claude's visit,
through the shared concept of "fraternal accompaniment." One day Yanni and
Marina, both Comité employees working in the central office, showed Claude
some *arpilleras*. Finding them to be "such an extraordinary testimony," he
offered to sell them in France and to photograph them and make cards, which
he would also sell. Claude and his wife, Hélène, described the conversation:

Claude: I was in the Vicaría one day with two friends, one of them was Marina, who had
been a professor of [Hélène: Of law, criminology.] of law, of criminology. And the
other, who was a volunteer, Yanni.

JA: Yanni?

Hélène: There you are, you know them.

Claude: You know them? Okay. And they worked together. They called me and said,
"Claude, come and look at this!" So they showed me what for them were the first
arpilleras, practically. The attractive ones, maybe, the most, the ones with the most
value. There were maybe some that were sort of like trial ones, like, like practice ones.
So I said to them . . .

Hélène: You were enthusiastic.

Claude: Enthusiastic, as were they, and, and they carried the enthusiasm in them [laughing]
magnificently. And I said, "Look, this is a popular art form. It's extraordinary. It's
the birth of a popular art form. And it's a way, if we manage to sell them abroad, of
having some resources [Hélène: And to make known the . . .] for the groups [Hélène:
The struggles . . .] and at the same time to inform people about the struggles." Yes, a
double . . . yes. And we started. And things multiplied, and I became, for a moment,
Mr., Mr. [Hélène: Arpilleras.], Mr. Arpilleras. But very soon there were others who, who
became involved, or who started via other organizations, not only the World Council
[of Churches].

[. . .]

JA: And you yourself, when you saw the *arpilleras* and said, "Ah, you should sell them," they
were not yet selling them?

Claude: Well, I don't think so.

JA: So what were they doing with them at that time?

Claude: I don't think so. It was the beginning. These two, at least, there were two, well, my memory, you know what memory is, well. As far as I remember, Marina and Yanni, who worked with the groups, and called me and said, "Look at this, how marvelous." And I'm not sure that they said they were the first ones they had seen. Because I, I was not interested in whether they were the first ones or not; I looked at them and said what can we do with them. Because it's, it's, it's such an extraordinary testimony. There you are.

Marina and Yanni's showing Claude some of the earliest *arpilleras*, these *arpilleras'* powerful content, and Claude's willingness to sell them started off the process of selling abroad. Claude became an important distributor of *arpilleras* in France, arranging for a colleague to sell them whenever Claude gave talks about the situation in Chile in different parts of France, and sending the money back to the Vicaría. He and his wife also gave them to members of the Committee for the Defense of Political Prisoners and to other activists in Paris to sell. Yanni confirmed Claude's story:

> After that, foreigners came to the Comité. Concretely, I remember a Frenchman who was very important and helped us a lot. He said, "But this is very beautiful, we have to take photos, we have to . . ." and, well, that was the start of all the . . . And they left, but at the beginning the *arpillera* was clearly tied to a form of emotional release.

Claude and Hélène became the first people to receive shipments of *arpilleras* from the Comité. Thanks to their work, the Vicaría was able to start buying the women's *arpilleras* in larger quantities, seeing this as a way of helping them survive their poverty and distress.

Claude and Hélène also produced and sold the first "*arpillera* products." They took photographs of the *arpilleras* and had them made into postcards, with a few lines of text at the back explaining the situation in Chile. They gave the postcards to fellow members of the Paris-based Committee for the Defense of Political Prisoners in Chile, who sold them through their own networks. Through these and other contacts, they sold 150,000 postcards. Claude recalled, enthusiastically:

Claude: So when we received the *arpilleras*, not only did we sell packets, enormous packets, and when I say "we," it's not us two, it's . . . we would distribute them. So there was that, and not everyone could or would buy *arpilleras*. So we had the idea of making postcards.

Hélène: We can give you a set.

Claude: We have a collection of postcards. We sold 150,000.

JA: And you created them yourselves?
Claude: Yes.
Hélène: Yes.
JA: How did you do that? By taking a photo?
Claude: Yes, I took a photo.
Hélène: On the floor, of the house.

Later on, they published a slim book with photographs of the *arpilleras*. They approached bookshop owners and asked them to take the book, often meeting with a positive response, and also arranged for their employer, the refugee services organization, to send the book out to people who asked for it. They sent all the money earned from the *arpilleras*, postcards, and book back to the Vicaría.

Solidarity was central to the *arpillera* system from the beginning. When Claude first saw the *arpilleras*, he immediately thought they could be sold to help with solidarity:

> With Marina and Yanni, we had this idea of, immediately, extending this and having it so that abroad it could be useful for solidarity. And what's more, I was enthusiastic, and I was game; I did everything I could, well, I didn't sell them myself, with my own hands.

What Claude meant by solidarity was raising support, in the form of money and pressure on the French government to take action against the dictatorship. The *arpilleras* informed people about Chile, in his and Hélène's view. I asked him about the book with photographs of *arpilleras*:

JA: And the book, what motivated you to create a book like this one?
Claude: Ah, it's the extension of the idea [Hélène: To make known . . .], the banal idea of making the situation better known. We made the postcards, and one day we said, "Why not a book?" And we sold 35,000 books. So it brought in money that went to Chile.

Claude and Hélène wanted to inform people about the situation in Chile so as to strengthen French solidarity for Chile, that is, to have more people be supportive of victims of the regime. Hélène explained:

> It's in relation with these two dimensions: the aspect of humanitarian aid, let's say, but also the political solidarity side, that we had the intuition that the *arpilleras* and the distribution and their sale, on the one hand, but also the spreading of their message, were an important way of strengthening solidarity for Chile.

150 Hélène saw the selling of *arpilleras* as enabling them to send money and raise political support. Hence, Claude and Hélène's interest in developing solidarity in France and their own "solidarity orientation" or willingness to help were important for the beginning of international selling.

THE INTERNATIONAL DISTRIBUTION SYSTEM EXPANDS

Before long, the Vicaría staff had begun exporting to other sellers like Hélène and Claude, in other European countries, and to sellers in Canada, Latin America, the United States, and Australia. Most of these sellers were personal friends or acquaintances of the Vicaría staff. Some were exiles whom the Vicaría had helped escape from Chile, and some were church-related individuals and human rights activists. The Vicaría staff asked them if they would be willing to sell *arpilleras*. Silvia, a Vicaría staff member, was European and helped provide contacts abroad. I asked her colleague, Roberta:

JA: To sell, how did you make contact with, with people abroad? I mean, how did you start to sell this?

Roberta: Friends. In fact, among them, Silvia Elliver. Since she was European, since she had contacts, she opened doors for us abroad. Other doors that were . . . I mean, later there were many people who left, who left in exile, who would help us. They would . . . all this is in the book that was produced about support in Chile. They would buy these products from us, and set up a market, and sell them. [. . .] Amnesty, many, many organizations that were more international would also buy the products from us, and they, in turn, would distribute them to a group of collaborators and would sell them. And it started out, as I say, via friends, and exiles also. Because there were many, many people who went into exile, and we would send them a quota of crafts every month.

Contacts abroad were vital for the development of the international distribution system initially, and the Vicaría had this social capital.

Yanni, a Vicaría employee, described sending the *arpilleras* to "our friends all over the world" in order to be able to buy one *arpillera* a week from the women. She mentioned monks, nuns, other church-related individuals, exiles, ambassadors, and the Catholic organization Fundación Missio, which had contacts in Germany:

The Vicaría, from the beginning, had a program for the selling of *arpilleras*. So we would try to buy at least one *arpillera* a week from them, from each woman, and we would sell them to all our friends, all over the world. To churches, to groups of exiles, to anyone, so that they might help us. There were also other institutions, there was

the Fundación Missio that also helped; some individuals, some ambassadors also collaborated with selling *arpilleras*, members of the clergy, many people.

Affiliation with the Catholic Church and links with exiles afforded the Vicaría a large number of contacts that were invaluable for building up a distribution network. In addition, some of the Vicaría's leaders traveled abroad occasionally, making direct contact with organizations and individuals who could help them in various ways.

In time, people abroad whom the Vicaría staff did not know personally began writing and offering help, and the Vicaría staff would reply with a request that they sell *arpilleras*. The Vicaría's reputation as the foremost organization assisting victims of repression, and its connection with the Church, may have gained these individuals' trust. The Vicaría continued to receive offers to help sell *arpilleras* from people abroad for many years. Gertrudis, who worked with Talleres between 1982 and 1986, discussed this with me:

JA: And how would you make contact with those individuals and institutions abroad, so that they would buy *arpilleras*?
Gertrudis: People would write.
JA: They would seek you out?
Gertrudis: Yes. And usually they would ask how they could [help], and we would answer that the support was by selling the products people made. [. . .] And sometimes you had people who would write letters and say, "I heard about the situation in Chile and I would like to help in some way, and how can I help?" Or "We know that you are selling some things; let's see, what sort of product might I help with?" I mean, people always gave a lot of support.

In what constitutes an example of international solidarity and its importance for the *arpillera* system, individuals abroad would spontaneously write and offer their help.

The number of sellers and buyers grew in the first few years of the regime. The total number of exiles was growing, and each developed a network abroad. In addition, tourists or visitors would come to the Vicaría and sometimes offer to help sell in their home countries. More and more people abroad heard about the *arpilleras*, causing a snowballing of interest in both buying and selling them. Silvia said:

What we did then was that gradually it became known, abroad, that these products existed, mainly in a number of European countries. We hardly worked with the

United States at all, with Canada a little. Gradually we had more and more people who were interested.

The growing number of sellers meant that more and more people abroad were coming into contact with *arpilleras* and might become interested in selling or buying them, which in turn enabled more *arpilleras* to be sent out, in a positive feedback loop.

At the same time, exiles were forming or joining exile organizations abroad, and growing numbers of Europeans, Canadians, and others were organizing to help victims of the repression or put pressure on their government to help Chilean refugees. Some of these organizations and groups sold *arpilleras*. Moreover, many of their members had their own networks within which they managed to sell. As Claude and Hélène put it, the "centers of distribution" multiplied:

Claude: But I think that what happened [Hélène: Throughout the 1970s.] was that they were still making them, maybe a bit less, but the centers of distribution multiplied all over Europe, yes. So there was a Committee in London, a Committee in Germany, in Italy.

Hélène: And there is maybe a bit of, yes, there was all the novelty of it, you see. [Claude: Yes.] At first, Claude was one of the main people who distributed this in France, maybe even in Europe somewhat. After that, it really multiplied; it went very well.

Hence the Vicaría gradually exported to more and more individuals and groups, in more and more countries. As exporting increased, the Vicaría created the unit called Talleres, mentioned previously, which was in charge of selling the *arpilleras* and products made by other kinds of groups, and of buying them from the women.

Once the Vicaría was selling abroad steadily, it could buy *arpilleras* from larger numbers of women. However, this led to new *arpillera* groups forming, which put pressure on the Vicaría to sell still more *arpilleras*. As a result, Yanni, the Vicaría employee, tried to boost sales abroad by writing letters to potential buyers in which she related how difficult the women's situation was. Gertrudis recalled:

And what helped us an awful lot was all the selling abroad, and for that, Yanni was responsible for writing and telling very sad stories to people abroad, so that they would buy. I mean, to tell them about the financial situation, the social situation of the people who made the *arpilleras*; I mean the people who made the products in general, all the craftwork.

Gertrudis's words suggest the importance of emotion in the distribution of 153
arpilleras: Yanni told "sad" stories so people would be moved and either help
sell or buy them.

THE SELLERS

The sellers of *arpilleras* abroad may be broadly divided into two categories:
Chilean exiles and "locals" affiliated with human rights or humanitarian or-
ganizations. All were of a humanitarian bent. The exiles tended to have jobs in
varied fields and during after-work hours to engage in efforts to raise awareness
about the regime and collect money to send back to Chile as discussed later.

The locals who sold *arpilleras* were members of Chile solidarity organiza-
tions, human rights organizations, refugee assistance organizations, trade
unions, or churches. They tended to have either a professional or a personal
interest in human rights or in helping groups in need. Many had had contact
with Chile or Chileans, and some had a special interest in Chile or had worked
there. Claude and Hélène, for example, had jobs in a refugee services organi-
zation, in which they helped Chilean exiles, Hélène sharing an office with a
woman who had worked for the Comité. Both were also members of Comités
Chili (Chile Committees), groups of mostly French but some Chilean leftists
and leftist Christians between the ages of thirty and forty, who were profes-
sionals active in human rights and solidarity, working to help other countries
and causes but particularly responsive to Chile, wanting to express solidarity
with the victims of the regime, and working to raise funds and consciousness
in France about Chile. They were also members of the Comité de Défense des
Prisonniers Politiques au Chili (Committee for the Defense of Political Prison-
ers in Chile), a group of mostly French people working to help political prison-
ers by raising awareness and putting pressure on the French government, in
part by selling *arpillera* postcards to the French public. Barry, a British seller in
Manchester, had worked in Chilean human rights organizations for a number
of years, although he had not yet been to Chile when he began to sell the *arpi-
lleras* in 1986. A seller in the American Midwest had been involved in activism in
Chile and been arrested and tortured, and her boyfriend had disappeared. She
was connected with the Chilean solidarity network in this region and would
give talks about the disappeared and about her experience of being tortured,
and try to encourage Americans to write letters to have Chilean political pris-
oners released. Members of France Amérique Latine, a solidarity organization
"fairly close to the French Communist Party," as Claude and Hélène put it,
sold *arpilleras* and gave them to trade unions to sell. The organization Kinder
His, run by Protestant churches and lay people, including Chileans,[1] sold *arpi-
lleras* in Germany. Some of these organizations and individuals did not limit

154 themselves to selling *arpilleras*, but raised support or money in other ways, sending the money to the Vicaría for its other activities, such as its legal work.

Belinda, a seller of *arpilleras* in Switzerland, was a teacher who did work to help victims of human rights violations in her spare time; she was also a member of Amnesty International. She had Chilean friends and had been interested in the Allende government and upset by its downfall. She explained:

Belinda: I have never been to Chile. Everything I know is through contacts, the things I have done here.

JA: Could you tell me about what you have done?

Belinda: It was minimal. I have been a rights activist for a long time. Within that, I make choices related to more or less fortuitous encounters or things that I know. With Chile, it is a country where I had, where I still have, friends, and I know a lot of Chileans in Europe. And when Allende was overthrown, it's something that affected me, more than when that happens in other countries.

The interest that Allende had inspired in Europe and his violent demise had meant that many locals, like Belinda, were arguably more interested in events in Chile than in dictatorships in other distant countries.

Belinda had a well worked-out strategy regarding what sorts of groups she liked to support: the victims of human rights violations, and in particular popular organizations. Within this, she was particularly interested in helping women:

No, it's not a hobby. I worked with a lot with movements here. But this was something extra. From my perspective, this is what solidarity is. I don't really make anonymous contributions. I make choices. I am interested in all those who try to remain standing. Because I find that situations usually beat you down, and that after that there is no hope, there is despair. I also have a preference for women, because they know less about sources of help, and because I always admire their courage. I find that women's situations are often more dramatic. [...] At the moment I have chosen to support in a concrete way things I believe in. I believe in the importance of counterpowers, and with counterpowers it is important that they organize at the base. I believe in popular organizations, from the experience I have had with Chile and other countries. From my perspective, they are essential for things to get done. And within that, I am particularly sensitive to women: to the place they occupy, the roles they play, to the burden of responsibility they take on—whether they like it or not, it ends up on their shoulders—to their courage, too, their ability to hold out. So, very concretely, I made inquiries to learn what form help could take. And, well, to help is first to get rid of the silence, and that's why I did an enormous amount of informing

here, in all the circles I mixed with. And, it's a choice as well, the support of people who are standing up, so that they continue to stand up. And to stand up is very easy, it's very concrete; you have to have a minimal amount of control over what's happening to you. And you have control if you can make what you do meaningful, at least a little, and so give some weight to the image that you have of yourself, and [if you have] some level of financial resources, however minimal. Well, with these workshops we don't have to teach them anything at all; they have expertise, a whole set of wisdom, a culture. You only have to give them a little bit of help.

Belinda was particularly interested in supporting people who were still struggling, women, and popular groups against those in power; her strategy was well thought out.

Local sellers saw selling *arpilleras* as helping, primarily in two ways: raising the public's awareness about repression, poverty, and other problems caused by the dictatorship, and raising money for the women and the Vicaría. Claude and Hélène understood their organizing of the selling of large numbers of *arpilleras* and postcards in these ways:

Claude: You will see how much they [the photos of *arpilleras*] speak, what they say. That's the most important thing, the message they carry. And also, the financial support that it brings them.
Hélène: Yes, but that's almost secondary.

Claude understood the *arpillera* postcards as carrying a message (informing the public) and raising money for the women and Talleres, while Hélène placed more importance on the former.

Sellers believed that there was a need to raise awareness locally about the situation in Chile. They thought people needed a more "concrete" sense of what was happening and considered that the *arpilleras* helped achieve this. Claude said:

Many French people were affected by the coup d'état, because there was a sort of sympathy for Allende. And, how shall I say, and his rise to power. And so there was real potential. But it was also necessary to make known what was happening in the most concrete way possible. Because of course, like today for African countries or others, yes, it's terrible, but it's not very concrete for most people.

Claude's term "concrete" can mean in French both more vivid and more understandable, and the *arpilleras*, being tangible pictures of repression and poverty, achieved both.

156 Sellers also had a strong sense of how much Talleres wanted the money so as to be able to give it to the women, who needed it badly. Claude and Hélène, for example, said:

> **Claude:** There they [Talleres] were waiting for the money impatiently. [. . .] In our correspondence with Yanni, there was . . . on the one hand they were, well, they thanked us, and said, "But quickly, have it continue, because we are under pressure from people who have nothing."
>
> **JA:** Yes. And from your perspective, was the money from the sale of the cards and *arpilleras* important for the Vicaría, since there was also funding [Claude: Yes, yes.] from the World Council [of Churches]?
>
> **Claude:** Yes.
>
> **JA:** Or was it of very small importance, as you were saying earlier?
>
> **Claude:** I would say, more like of very small importance.
>
> **Hélène:** It was important for Talleres.
>
> **Claude:** It was important for Talleres.
>
> **Hélène:** It was very important for Talleres
>
> **Claude:** Because it was a branch with its own funding.

Claude and Hélène had a vision of desperate *arpilleristas*, with Talleres as an institution that would channel the money to them.

Much the same was true of Barry, an employee of a Chilean human rights organization in Britain, although he understood that the Vicaría needed the money for other goals as well. He talked of keeping the turnover of *arpilleras* high so as to send money back frequently. Like Claude, he also wanted to "get the solidarity message across":

> But because for me what was important wasn't just the solidarity message, it was the fact that the Vicaría needed the turnover. One 'cause they needed it to, for the women; and two because it meant, it was more promotion, which meant more success, more employment, whatever. You know. And the Vicaría again, as I say, paid the women, to some extent, bought them, when they bought them. But there may have been an initial, the balance to be paid off when they were shifted, or at least the Vicaría would then take another batch once they'd shifted them. So I was very much into the turnover. I would rather sell five at twelve pounds than two at twenty-five.

Barry saw the Vicaría as needing the money in part to pay the women, who, he later added, needed the money to survive, given that the main breadwinner was in prison or disappeared. It also needed it for its own promotion, success, and ability to provide jobs.

Sellers had additional understandings of why it was important to sell *arpi-*
lleras. Belinda, for example, thought that it was important to the *arpilleristas*
to know that people cared about them, supported them, and could speak for
them:

> I think it's important for them, too, from their letters, to know, first, that elsewhere
> people are . . . to know that if you want to speak, someone is speaking to say what
> you can't say. And also to know that someone cares about them and supports them
> without judging them.

Belinda's words point to her awareness of the importance of moral support as
well as tangible forms of support for the *arpilleristas*. Hélène and Claude found
that once they had started selling *arpilleras,* it was difficult to stop, given that
the need for money still existed and they had become friendly with Vicaría staff
members who were being persecuted:

Claude: It was to help. And when we started to help, we, it's difficult to stop.
Hélène: When the need still exists.
Claude: The need continues. And afterward, those who are on the spot, like Yanni, it's, we
become, we become friends. We know about their . . . because Yanni, I don't know if she
told you, but she was, she was harassed by the police. They would phone her ten times
a night, to stop her sleeping.
Hélène: And threaten to take away their children.
Claude: And threaten to kidnap their girl. It was necessary to accompany the girl to school
[Hélène: These were threats.] every morning. And so, at the same time, to give them
some support, at some level. Because the price they paid was high.

For Claude and Hélène, to sell *arpilleras* was to lend support not only to the
women but also to the Vicaría staff.

The sellers received *arpilleras* from the Vicaría mostly by mail, although
occasionally a Vicaría staff member or friend brought them from Chile in
person. They would communicate with the Vicaría by letter or telegram when
they needed it to send more *arpilleras*. The sellers were aware of the repres-
sion in Chile, and so adopted four strategies to protect the Vicaría: using code
words, giving numerous or less risky addresses to which to ship the *arpilleras*,
asking for smaller numbers of *arpilleras* per package so that the packages
would be light enough to go via parcel post, and requesting only a couple of
more sharply denunciatory *arpilleras* in order for less denunciatory ones. Barry
in Britain, for example, would ask the Vicaría for "the colored ones" when he
wanted *arpilleras* with what he called "political content," that is, showing, for

158 example, people demonstrating, being beaten up by the police, and standing with banners saying "Dónde Están?" (Where are they?). Meanwhile, Constanza's father in Belgium used the word "*artesanía*" (handicrafts):

JA: How would you ask for them [the *arpilleras*]?

Constanza: By letter, you would send a letter by registered mail, you would write, but without saying anything political, "Send me handicrafts," not "*arpilleras* protesting against the government of Pinochet," no. [. . .] The parcels always reached us. What did go missing were the letters, or they would arrive open, but the parcels, luckily, always reached us.

Both Barry and Constanza's father chose a word with innocuous connotations to ask for denunciatory *arpilleras*.

Sellers would also have the packages shipped to addresses that would not arouse suspicion, and if there were several packages, have them shipped to more than one address. Claude and Hélène in France, for example, were careful not to give the address of their employer, a refugee services organization; they had the packets shipped to their home instead. Barry had some of the *arpilleras* shipped to his home and some to his office. He told me:

By 1989–90 [. . .], I was shipping boxes that were that by that [gestures to indicate the size] through the post and, and sometimes I would order two of those; one would go to my office, one would go to my home. Again sort of the . . . split them up.

Asking for packages containing fewer *arpilleras* was another way sellers tried to protect the Vicaría and ensure that the *arpilleras* would arrive, since smaller packages were less likely to be checked by customs.

A final strategy was to have the Vicaría slip in a small number of more sharply denunciatory *arpilleras* about the repression among more innocuous *arpilleras*. Sellers sometimes used several of these strategies together. Barry, for example, said:

And don't forget that this was at the time of Pinochet, the country was under emergency, a state of emergency law, and the *arpilleras* were effectively outlawed. Those which had a political content—so that was the second type, those with a political content rather than a social content. Political content, which was scenes of people demonstrating in the streets, um, people being beat up by the police, they would simply show a lady—even with the flat type as well as the 3-D type— people standing with a banner saying "¿Dónde están?"; it was the relatives of the

disappeared. And sometimes it would have a name [. . .]. Now, those ones were 159
certainly risky in Chile. So if we asked for them, say, in the letter, we would ask for
the colored ones. It was understood they were, that's what they were. They had to
send them out in batches of six as well. The reason we picked six was because—it
was five or six—it was, um, two kilos. [. . .] And two kilos you could do parcel post,
but it had to go through customs, so it could be checked on the way out. But if we
put one, max two, it was a six pack, or, if we went, I think, it might have been that six
was a kilo. Sometimes we'd get an order for twelve, in which case we'd stick in maybe
two or three of the political ones and they were generally all right. If they went
beyond parcel post, you know, it was a big package, they had to be sorted by cus-
toms in Chile and that was a bit difficult.

Barry preferred, he later added, to have many small packages rather than one
big one.

The Vicaría staff, for their part, were aware of the dangers involved in exporting
arpilleras, felt nervous about what they were doing, and took precautions. They
saw that the telegrams that sellers sometimes used to order *arpilleras* were
occasionally intercepted, knew that DINA agents disguised as buyers came to
the shop where they sold crafts, heard the two or three announcements on the
television news about the sending of defamatory *arpilleras* abroad, and had
read the article in the newspaper *La Segunda* of December 12, 1979, entitled,
"They Use the 'Tapestries of the Vicaría' for Defamation," describing a calendar
with pictures of "defamatory" *arpilleras* ordered by the Vicaría being sold in
Washington, D.C. One Talleres employee from Europe was denied a visa when
she tried to reenter Chile in 1989 on the grounds that she had done things
against the government. In response to these dangers, the Vicaría staff were
vague about the contents of the packages of *arpilleras* and the sender on the
customs papers and packages, and they asked the *arpilleristas* to tone down the
level of denunciation in their work.

When organizations in Chile other than the Vicaría sent *arpilleras* out to
sellers abroad, the members of these institutions also took precautions. Belinda
in Switzerland mentioned that *arpilleras* were shipped in church mail, from
one church employee to another. Constanza, in Belgium, said: "Often the
priests in Belgium worked things out with priests in Chile so that the parcels
could get through without much checking, without problems." Members of
the Communist Party would sometimes bring *arpilleras* to exiles in Belgium,
leaving Chile disguised as tourists, and using a false name with their col-
leagues in Belgium for everyone's safety; this was understood and accepted
by all concerned. Whether it was the Vicaría or another organization sending

160 the *arpilleras* to sellers abroad, then, all concerned shared a sense of danger and worked out systems for evading repression. Complicity, shared secret information, mutual trust, and care for each other's safety characterized the solidarity art community in its transporting of *arpilleras*.

PRIMARY, SECONDARY, AND TERTIARY SELLERS

Many of the sellers abroad who received *arpilleras* from the Vicaría sold them themselves. Others, however, sold some, and gave the rest to people they knew who were eager to help with the selling. I call those who received the *arpilleras* directly from the Vicaría "primary sellers," and the others "secondary sellers." Some of the secondary sellers gave them to still others, "tertiary sellers," to sell. Hélène and Claude, for example, sold relatively few *arpilleras* and postcards themselves, but they supplied many secondary sellers, who were varied groups and individuals with a leftist or humanitarian orientation. These included Amnesty International, women's groups, trade unions, Comités d'entreprise (Company Committees, that is, groups organized by trade unions to manage social events and holidays in the company), shops belonging to associations, people who were organizing solidarity events in other cities, and groups trying to help political prisoners and other victims of the regime, including the Comité de Défense des Prisonniers Politiques au Chili and the Comités Chili. They would order *arpilleras* or postcards from Claude and Hélène to sell at solidarity, political, or cultural events they knew about.

Claude and Hélène also mentioned Christians as secondary sellers; these individuals typically sold at church events. The pastor of a Protestant church in Geneva, Switzerland, for example, offered to sell *arpilleras* at a Latin American evening he organized. Others sold them after Mass. Claude and Hélène described a Franco-Chilean couple in Brittany:

Claude: For example, there was a guy, a wonderful guy, a Chilean who had married a Frenchwoman, in Brittany.
Hélène: Yes, that's it, Marie, she's called.
Claude: Who would sell at the end of Mass.
Hélène: Every Sunday.
Claude: Every Sunday. And every Monday he would phone me and say, "Claude, we sold forty! We sold forty!"
JA: The end of church Masses, you mean in the church itself.
Hélène: At the exit of the church, yes.
[...]
JA: How did she sell them?

Hélène: Well, just like that, like an activist, with her husband. She would take her little car and every Sunday they would go to places, with little banners from Chile, solidarity with Chile. They would sell them at the exit of churches; they were supermilitant.

Christian sellers tapped into church events; Christian circles were good networks in which to sell, as Hélène later mentioned.

These various groups and individuals would pay for the *arpilleras* and cards directly, or give Claude and Hélène the money after having sold the items. To pick up the *arpilleras*, they would either phone or write to Claude's employer, and if they lived in or near Paris, they would come and fetch them; otherwise, Claude and Hélène would mail them. Hélène said:

Hélène: There were Comités [Claude: Yes.], there were Comités Chili in many cities in France, and there were sometimes people who, enthusiastic about the idea, would say, "Right, in such and such a place there will be the festival of whatever," or "There is a big demonstration on the occasion of whatever, cultural or otherwise; send us 150 *arpilleras* to such and such an address." We would send 150 *arpilleras*.

Each secondary seller possessed information about relevant events at which *arpilleras* could be sold, enabling Claude and Hélène to import more and more.

Belinda, the teacher based in Switzerland, was another primary seller of *arpilleras*, receiving them directly from the Vicaría and from *arpillera* groups in the Santiago shantytown of La Victoria and in the city of Valparaíso. She sold many *arpilleras* herself, but also gave them to secondary sellers, who, in turn, sold them to the public. These secondary sellers were primarily humanitarian groups and fair trade shops in other cities, and included Christian Action for the Abolition of Torture, the fair trade chain Magasins du Monde, groups supporting Chile, women's groups, and women involved in the United Nations who sold outside the meeting hall of the United Nations General Assembly. As a result of her own selling efforts and those of the secondary sellers she sought out, Belinda sold between 10,000 and 15,000 *arpilleras* in Switzerland. Barry was another primary seller who received *arpilleras* from the Vicaría. He sold many himself and sold or lent *arpilleras* to secondary sellers, including shops and groups putting on exhibitions. Another primary seller was France Amérique Latine, an organization based in Paris, which distributed *arpilleras* in trade union networks.[2]

How did the primary sellers find their secondary sellers? Many secondary sellers were in the primary sellers' social network. I asked Hélène:

162 **JA:** Where would you sell the book?

 Hélène: The same networks [Claude: The same networks.]. The same networks as the postcards.

They also contacted people they did not know but who had been recommended as potential sellers; hence they drew on information within their networks of friends and acquaintances. Each time, Claude and Hélène said, they heard about somewhere that might sell their book or postcards, they would make contact. They kept stacks of postcards ready in their car:

Claude: We always had some [postcards] on us, because . . .

Hélène: We had cars full of them.

Claude: My goodness. And we would distribute them, and every time someone gave us a tip about a place that might want to sell them, a shop or anything, we would give them to that place to sell.

Hélène: We would organize their distribution. The same for the book. We went to bookshops in Paris and said, "Right, do you . . ." and we would tell the story.

Claude: People would help her; we didn't do it all alone.

Claude and Hélène were ready to follow up on tips right away, and took the initiative to make contact with potential sellers.

It also happened that secondary sellers approached primary sellers, wanting to do something to help Chileans under the dictatorship. Many of Claude and Hélène's secondary sellers, for example, had heard that they, or the Committee for the Defense of Political Prisoners, were receiving *arpilleras* from Chile, and they would contact them, asking for *arpilleras* for a solidarity event they were putting on. Claude and Hélène said:

Claude: As we were receiving them and many people knew we were receiving them . . . so we didn't sell them directly.

Hélène: We distributed them a lot, always with the same system of distribution; we distributed them to Committees that would say, "We would like, because there is a fête for solidarity for Latin America in June, could you send me fifty *arpilleras*?" Yes, it worked like that also.

Primary sellers found secondary sellers within their or their acquaintances' networks, and thanks to information acquired from these networks, but in some cases, secondary sellers took the initiative to contact them.

The *arpilleras* passed along *solidarity chains*, that is, chains of people stretching from the shantytowns of Santiago; through the Vicaría; to the primary, secondary, and sometimes tertiary sellers; and finally to "end buyers." The end buyers were mostly members of the public who had heard about the dictatorship in Chile and wanted to give support to those struggling against it, or who came to want to do this in the course of talking to the seller of *arpilleras*. Solidarity chains radiated out from the *arpilleristas* to end buyers in countries on several continents.

The *arpilleras* passed from hand to hand down the solidarity chains, and money traveled back to the women in *solidarity flows*. These solidarity flows not only carried money and *arpilleras*; they also carried information about what was really happening in Chile, conveyed when one link in the solidarity chain spoke to another, and contained within the *arpilleras*. Moral support "flowed" in the opposite direction, to the women and the Vicaría, to whom the knowledge that people abroad were selling and buying *arpilleras* gave a sense that there was interest in their plight and brought hope that international efforts might help bring about a return to democracy. These flows, then, brought what was wanted or needed by members at opposite ends of the flow. Sellers and buyers wanted to hear what the *arpilleristas* had to say, and they wanted a concrete way to give them their support, while the *arpilleristas* came to want and need to tell the outside world what was happening in Chile, and they needed the money. Zoe said:

Zoe: Because the *arpilleras* were sold abroad, it was a way people had of telling what was happening in the country, and they were very anxious to tell, moreover.

JA: So the denunciation side of things was very important?

Zoe: Yes, and as they were basically bought by solidarity groups, it was a little like a chain of solidarity. These people wanted to know what was happening in Chile.

The flows carried needed "items" in both directions, helping the parties at either end and arguably strengthening their capacity to engage in resistance.

Information was an important resource that traveled along the solidarity chains. Clandestine members of the Communist Party in Chile traveled to Belgium disguised as tourists, bringing information about what was really happening in Chile, along with *arpilleras* for exiled party members to sell. They would give talks that the exiles would organize and that were attended by locals and Chileans wanting to keep abreast of what was happening in Chile. During their trip, these clandestine travelers would photograph and film the demonstrations that exiles and locals in Europe organized in protest against

164 the Pinochet dictatorship and take these photographs and films back to Chile, where they were a source of moral support for members of the clandestine resistance, helping them feel less isolated in their struggle. This comes through in the explanation of "participation" that Olivia, an exile in Belgium, gave me:

> **JA:** The fact that people participated, did it help in the resistance against Chile? Apart from the money that you could send?
>
> **Olivia:** Yes, morally, I think. Morally. When Chileans [in Chile] learned that there were protests, that there were demonstrations, that people were supporting them, yes. Because also, before I forget, the Chileans who would travel abr—. . . the ones of the interior, the ones who would travel abroad, would take photos of the activities, of the demonstrations, and then using microfilm, or I don't really know how, they would take them to Chile. And distribute them around here. So that way people learned that in other countries, in other languages, in other cultures, people were thinking about Chile. At least thinking about Chile. No one was going to be able to intervene, and no one could intervene militarily or whatever. Least of all the United States because they were not interested; they were happy that there was a dictatorship here, quite happy.
>
> **JA:** And knowing that people abroad were doing things, what do you think the outcome of that was? Did it help?
>
> **Olivia:** Yes, yes, yes. With morale. That's what I was saying. In terms of morale. To help morale . . . not to feel so, so isolated, so alone, so much like here nothing, nothing will ever happen.

The travelers took back with them information that raised morale in the anti-dictatorship community, and this was important in a context in which the military regime was so powerful that there seemed to be no hope. At the same time, they took the *arpilleristas* money and the comforting knowledge that others abroad were supporting them. The solidarity chains, then, became channels through which flows happened recurrently, with money, information about supportive activities abroad, and moral support flowing to Chile, and *arpilleras* and information about the regime traveling out from Chile.

Numerous solidarity chains, like Olivia's, did not include the Vicaría. Some *arpilleristas* sent their work directly to sellers abroad who had visited their workshop. Some shantytown priests sent *arpilleras* to their contacts abroad to be sold. Institutions other than the Vicaría also exported *arpilleras*, and these had their own solidarity chains. The Fundación Missio (Missio Foundation), a Catholic organization in northern Santiago, for example, sold *arpilleras* mainly in Germany, as the foundation's head was a German nun. The ecumenical human rights organization Foundation of Christian Churches for Social

Assistance (FASIC) sent *arpilleras* made in southeastern Santiago to an exile in Paris. Still other organizations, as well as individuals, tried to help the shantytown women by buying their *arpilleras* and sending them abroad. However, the Comité and the Vicaría had the largest distribution system and exported more than any other institution or individual, hence they were part of most of the solidarity chains that existed.

While producers, exporters, sellers, and buyers were the key parties making up the solidarity chains, some solidarity chains contained "collaborators," whose work enabled goods to move along the chains smoothly. Customs officials in France, for example, did not check the packages that arrived at the Paris airport, because they knew what was in them and were sympathetic with the cause, and this made things easier for Claude and Hélène. There was also the printing house that printed the *arpillera* postcards and later the *arpillera* book for Claude and Hélène, offering them an exceptionally low price. A pilot helped Belinda, the primary seller in Switzerland, by taking to the Vicaría the money she earned from selling *arpilleras*. A travel agency employee in Chile and an employee at Santiago's airport helped get the *arpilleras* onto the plane without being checked. Silvia, a Vicaría employee, told me:

Silvia: We had a contact through a travel agency where there was someone we trusted, and that person had another contact at the airport, so it was a whole solidarity network if you like, to get these products [the *arpilleras*] to reach foreign countries. [. . .] Either I or someone else would take the boxes [of *arpilleras* to the travel agency], or that person came to fetch them, because there was a door at the back of the Vicaría in a street where . . . If I remember rightly, this was the process: he [the travel agency employee] went to fetch them and then we always had to go to his office to do the paperwork and he took them from his office, which was right there in Huérfanos [Street], right in the center of town, he took them to the airport. I find this very interesting because it was a team of people; they were all cooperating for this to happen, of course. There was tremendous complicity. [. . .] He [the travel agency employee] must have been left wing, of course. Yes, it was all left-wing people, left-wing people. And the person at the airport also, but what party they belonged to I don't know.

JA: How did you get them involved in this?

Silvia: We looked for them.

These collaborators, then, included bureaucrats who made exceptions or bypassed institutional barriers, people in the travel industry who moved things along or did the necessary paperwork, and others helping in other ways; their solidarity kept the system working.

166 All the collaborators; primary, secondary, and tertiary sellers; buyers; and exporters in all the solidarity chains that radiated out from the shantytowns made up a community that was working to support the *arpilleristas* and resistance in Chile. Because this community was linked by the desire to help, I call it a *solidarity art community*. The solidarity art community was like a web that spread across the globe; some sellers in different countries were connected, and there were some exchanges. For example, the Committee for the Defense of Political Prisoners in Chile, to which Hélène and Claude belonged and within which they distributed *arpillera* postcards, was in touch with the Chile Solidarity Campaign in London. The latter also made *arpillera* postcards, which it sent to the Committee in France. Within one country, many solidarity events brought members of the solidarity art community together. When a bishop arrived from Chile and said Mass at a church in Paris, for example, Chileans and French people who were selling *arpilleras* and working in other ways in solidarity with Chile came together.

The solidarity art communities in different countries were influenced by political changes occurring internationally and within Chile, and by the ways in which these changes were reported in the media. Allende's coming to power and the junta's coup and repression, for example, provided the impetus for the formation of these communities in the first place; we saw earlier how Allende's fall contributed to Belinda's becoming involved with the *arpilleras* and starting to look for secondary sellers, for instance. Much later on, when Chile moved toward a return of democracy, some members of solidarity art communities saw Chile as no longer in need of their support, and consequently stopped selling or buying *arpilleras*. When other crises emerged on the global stage, they turned their attention to these.[3] Political changes had a profound impact on these communities.

The Solidarity Orientation

What kept the links of all the solidarity chains connected and communicating was a solidarity orientation, that is, as mentioned earlier, a desire to help the *arpilleristas*. It was shared by all members of the solidarity chains except the *arpilleristas* themselves. This orientation grew out of a bundle of emotions that included sorrow and sympathy for the *arpilleristas* and other of the regime's victims, and hatred and anger toward the junta. The buyers, sellers, and members of the Vicaría and other exporting organizations shared this sentiment. Motivated as they were by a solidarity orientation, buyers and sellers were acting altruistically, primarily. The buying of *arpilleras*, unlike the buying of most things, was not so much for the purpose of acquiring as for the purpose

of helping the victims of the regime, even if buyers did also think of personal 167
benefit derived from buying. Buyers often bought after a conversation with
the seller, during which they became deeply moved by the women's plight.[4]
Similarly, sellers did not do the work of selling as much for personal gain as
to be able to send the money to the Vicaría and women; they, too, were acting
altruistically. A discussion with Claude and Hélène was suggestive in this regard:

JA: I'd like to know what motivated you to continue with this program of *arpilleras*.
Claude: Because we wanted to do everything, everything we could to help the Chileans who
were in difficulty. It was to help.

They wanted to help and emphasized that they understood their work as part
of solidarity for Chile. Hélène said:

Claude traveled to Chile almost every year, and, on his return . . . it was in the
context of solidarity, it was always that way. It was never a commercial thing, never.

Hélène opposes their solidarity orientation to a commercial one; they were
not interested in making money for themselves, but rather in helping others.
However, because selling was involved, the solidarity art system did in fact
blend altruism and commerce.

Secondary sellers, too, had as their primary motivation the wish to help.
Claude and Hélène told me about one set of secondary sellers, the Comités
Chili:

JA: What did they say?
Claude: Well, "We want to help. We know we can help via the postcards, so we are prepared
to distribute them"; that's all.

Selling postcards was a concrete way in which sellers could help.

Because their primary motive was to help, sellers tended to send all the
money back to the Vicaría, knowing that it would be given to the women and
used by the Vicaría itself. Claude and Hélène, for example, understood that the
money they sent to the Vicaría went to the women and was used in their social
and political work and the running of their workshops, but also to Talleres.
Some sellers tried to make a small profit, yet even here the ultimate goal was
to help victims of the regime. A Chile-focused human rights organization in
Britain, for example, aimed for a profit so as to have funds with which to raise
awareness about the situation in Chile. Barry, an employee, said:

So the profit margin would be quite small, but we were certainly going for a profit margin because we were using it as a fund-raiser for our human rights activities here, running our actual schemes, campaigns, so we had all that printing, conferences, etc.

The human rights activities, campaigns, and printing that this organization did were aimed at raising awareness about the consequences of the dictatorship. Belinda, like Barry, sent money back to the *arpilleristas* or organizations that exported their work, but sometimes used some of this money to fund local education and health programs in Chile. Sellers and buyers, then, sold or bought *arpilleras* because they wanted to help the women and victims of the regime, as opposed to gaining something primarily for themselves; they had a solidarity orientation.

The *arpilleristas'* gender and their being mothers contributed to the arousal of the emotions that formed the basis of the solidarity orientation. The *arpilleristas'* gender was present in sellers' minds; sellers saw the women in a maternal role, as trying to feed their children despite the poverty they faced. Hélène and Claude, for example, envisioned the women as running *comedores*. Talking about the money the Vicaría received from the sale of *arpilleras*, they said:

Hélène: In this case it was to help the women.
Claude: Most of it was to help the women who were running the children's community kitchens.

Their words suggest that the image of poverty-stricken mothers feeding hungry children was salient in their minds. Similarly, Belinda, a seller in Switzerland, was interested in helping women first and foremost, as we saw earlier, and this was partly why she helped sell *arpilleras*. The fact that it was women and mothers of children who would be receiving the money was part of why sellers sold *arpilleras*. When speaking to buyers, sellers described the *arpilleristas* as impoverished mothers struggling to keep their families going, and in some cases, as women who had endured the disappearance or imprisonment of a child or other family member. In so doing, they tapped into a notion of womanhood as motherhood, and motherhood as devoted to children and struggling for them. Mothers and children are constructed in Western societies as categories of people worthy and deserving of help and in need of special protection, and buyers responded to this. However, buyers also, according to Hélène, responded to a different idea of women, as active in the resistance. She told me:

They knew that it was women who were expressing the resistance, their organizing,
etc., and it's that, also, that met with a good response, so people would buy it. Both
because it was attractive, and for what it represented. Knowing that the money was
not going to make us richer; it was to send to Chile.

Many *arpilleras* showed women participating in protests and running commu-
nity kitchens and other groups aimed at surviving poverty.

The Ethos of Solidarity

As well as acting in solidarity-oriented ways themselves, sellers tried to promote
solidarity-oriented behaviors in others, believing such behavior to be highly
desirable; they had an *ethos of solidarity*. Ricardo, a Chilean exile in France, for
example, was a primary seller of *arpilleras* who attempted to promote solidarity
among *arpilleristas* and, while still in Chile, among prisoners he had worked
with:

Ricardo: The other thing that we would try to do was never to receive anything from
individuals. If one person sent me something, then no. [JA: Groups.] Groups and
solidarity. [JA: You mean . . .?] It is work that is *solidario*: "We meet, talk about our
problems, express solidarity, and the person with the greatest need should have the
right to sell more, receive more. And a part of what I produce with this *arpillera* has to
be for the group. It has to be for solidarity." It was important to defend that a lot.

JA: And it was threatened?

Ricardo: Constantly.

JA: How?

Ricardo: When I was a priest working in prisons, for example, in the penitentiary here, in
the prison in Santiago, the first things they did, the first craftwork . . . I remember that
I had just begun to go to the prisons, and even the political prisoners didn't trust me
because they didn't know if I was one of them; I might have been acting on behalf of
the government or even the secret police. There were priests who even collaborated in
torturing. Anyway, so they didn't trust me, and I remember when someone gave me a
product and I said, "But who did you make this with?" and he said, "No, I made it by
myself; I don't mix with the others because there is a lot of conflict, and I work alone,"
and I said, "I won't receive it from you if that's the way it is." So I spoke to all of them
and said, "Look, once and for all, if you are prisoners here, it's because you have an
ideal and you believe in something and have given yourselves for that cause, but it is a
cause related to solidarity, and if you, here, are not capable of coming to an agreement
to make, to struggle together and to produce something together, or cope with your
financial problems and send money to your families, but working *together*, then don't
tell me that you are revolutionaries, don't tell me that you are faithful to your principles

for which you are prisoners right now." When I made that speech, later, a political prisoner said, "From that day on we believed in you." But you had to be continuously saying, "Look, I won't accept this from you alone, this business where you want it to be just yours, no. Together as a group, with leaders, with an organization: that way, yes." Well, because you have to be an educator as well, and human misery shows up everywhere. And in the group of women [*arpilleristas*], also, there is a woman who still asks me if I can send—the group of women from Villa O'Higgins—Gabriela asks me, and I say, "Alone, no; organize yourself into a group, but alone, no. When you are a group and you are giving a social meaning to what you are doing; then, yes."

Ricardo promoted *trabajo solidario* (mutually supportive work), which to him meant working together as a group, expressing solidarity with each other, and giving a social meaning to what the group does. His words also make clear his encouragement of organizing. The ethos of solidarity was pervasive among those working in resistance or human rights organizations. Comité and Vicaría staff, exiles, and locals who sold *arpilleras* abroad had it and were aware that they shared this ethos.

There was a sense among Vicaría and Comité staff and sellers of *arpilleras* of working together for the cause of solidarity. When money passed from primary sellers to the Vicaría, for example, it was not a coldly commercial transaction as one might expect in the case of a business and client. Rather, there was a sense of joint purpose; that of giving support to the victims of the regime. This shared purpose of helping others may have provided a foundation for trust between the individuals that made up the solidarity chains. Trust was essential because they were dealing with money and supplies of *arpilleras*, and because the making and exporting of *arpilleras* was dangerous. Trust established between Yanni and Claude, and Yanni and Barry, for example, enabled them to work together. Barry visited Yanni in 1987, and he trusted her to send out work he paid for, while she trusted him to send her money. He said:

> During the trip I did in '87, I brought back a bag, basically just patchworks [*arpilleras*], and most of them were good quality. So that was a fund to draw on. I was always topping it up to be ahead of the customer, so we had that in mind as much as possible. And so, because I knew the Vicaría, that was all right, things worked out. If I bought in bulk, then we would try and pay in advance, but we would always pay certainly no more than two months after receiving them. You know, they knew us and trusted us, so it meant that through that arrangement, we could have more confidence that we could market them. We could promise them and they would turn up. For example, sometimes I would just phone the Vicaría if they [the buyers] wanted the big ones.

Trust made the export and distribution of *arpilleras* abroad smoother; sellers 171
did not have to pay in advance, and they knew they would receive the *arpilleras*,
while Talleres knew it would be paid. Trust, then, contributed to making the
arpillera system work well.

FERTILE GROUND

The number of people abroad willing to help sell or buy *arpilleras* was high
in the early years of the regime. How might this be explained, when Chile was
just one among many distant dictatorships? In a number of countries, "the
ground was fertile," as Claude put it, referring to France, meaning that there
was potential for support for Chile. First of all, people were aware of what
had happened in Chile. Even if not involved in the fields of human rights or
development, they had heard about Allende's presidency, the coup, and the
repression that followed. In Belgium, for example, Constanza found that those
who approached her when she sold *arpilleras* knew about the dictatorship:

> Because many Belgians would ask you, "You are Chilean, ah, that's good, and do you
> help Chile?" People at that time knew what was happening here in Chile, terrible
> things because of the Pinochet dictatorship.

The same was true elsewhere. Olga, a Chilean exile who lived for a time in
France, where she sold *arpilleras* that she herself made, said:

> . . . In addition to the fact that there was still interest in Chile, so there was a level
> of awareness about the things that were happening in Chile; there was sort of an
> atmosphere for this. And also, you would sell to people who were more sensitive
> to what was happening in Chile. [. . .] Those were the activities [including *arpillera*
> making] we would engage in, because that was what we thought of—the easiest way
> to earn some money. And we knew that French people were sensitive to the situation
> of the disappeared, and they knew about the *arpilleras* as well. They were famous
> because they showed, more than anything else—the mothers of the disappeared
> who made *arpilleras* while they were waiting—the idea of waiting for their children,
> their husbands, made a lot of sense.

People in France were interested, aware, and sensitive to what was happening
in Chile; Olga's mention of "an atmosphere for this" was akin to Claude's "fer-
tile ground." A considerable amount of information was available in Europe
and North America. For most people, it would have come from television and
newspapers. Images of the bombing of the presidential palace of La Moneda
in central Santiago were shown on television screens all over Europe and

172 elsewhere on September 11, 1973, and the newspapers covered some aspects of
the repression that followed. Some individuals would have gained additional
information thanks to the efforts of human rights organizations, which put out
reports about violations and communicated what was happening at solidarity
events. Exiles, as well, worked hard to inform the public by organizing talks and
demonstrating. Hence many people had heard about the events in Chile.

A second reason for the "fertile ground" was that a substantial section of the
public, particularly in France and other European countries with a significant
Socialist presence, had been sympathetic toward Allende's rise to power, and
shocked and upset by the coup. Claude explained:

> So many French people were aware of the coup d'état. Because there was a sort of
> sympathy for Allende and the, how shall I say, his rise to power. So there was real
> potential.

Many people had had positive feelings about Allende and his becoming presi-
dent, and for them, the coup was a disappointment.

The situation was similar in Belgium where, according to Olivia, there was
a community of Belgians who had been interested in the Allende regime and
its violent end. In part because of this interest, these people came to Chilean
solidarity events where *arpilleras* were sold:

JA: And who were the Belgians who would go?
Olivia: People who felt solidarity with Chile, left-wing people, intellectuals, very, very
attached to what Chile had been, who had known about Chile from before, who had
read a lot about Chile, who were very interested in the process that was unfolding
and that was violently interrupted by the military coup. So these people were very
hospitable; they welcomed us very warmly, they tried to make us comfortable, morally,
spiritually. In a country that was so different.

Olivia later mentioned that the Belgians who went to solidarity events had a
"social consciousness." A number of European countries had strong Socialist
Parties, whose members were interested in the attainment of Socialism by
democratic and legal means and had felt an affinity with Allende's ideas and
government. But it was not only leftists who had been interested in Allende;
when he made news as the first Socialist to become president as a result of
democratic elections, he had caught the interest of the broader public as well.

A possible third reason for the "fertile ground" was that the coup happened
just after the 1960s and about thirty years after the Second World War. Men and
women in their twenties and thirties in 1973 would have been affected by the

ideas of the 1960s, when an interest in social justice and disapproval of states perceived as oppressive ran high in many European countries, and these ideas may have contributed to making them sympathetic toward the victims of the Pinochet regime. Meanwhile, their parents were, in some cases, sympathetic toward these victims partly because the repression and human rights violations that accompanied the Second World War were not unlike those of the Pinochet dictatorship. Constanza in Belgium, for example, mentioned that among her buyers were many who had been in concentration camps and were thus solidarity oriented, sensing a connection between what they had experienced and what people in Chile were living through:

JA: And the buyers, were there more women than men, also?

Constanza: No, the same. Men, women, children. Many elderly people who had lived through the Second World War, and really identified with what was happening at that moment in Chile; people who had been in concentration camps at that time, so they were very supportive [*solidarios*], and they often brought their grandchildren, to show them [the *arpilleras*] to them: "Look, here is a story, in this piece of cloth there is a story; these children are not playing just because. All this is happening here." And they would explain them to their grandchildren, and that was very lovely.

The timing of the coup was such that what was happening resonated both with people who had lived through the Second World War and with young adults of the 1960s.

A final reason why there was "fertile ground," specifically in France, was that there were special ties between the two countries. The Chilean Nobel Prize–winning poet Pablo Neruda had been cultural ambassador in Paris. There was much similarity between France and Chile, Hélène explained, in that both had had Socialist and Communist Parties. There were also cultural links between the two countries. For most European countries, however, the first three factors produced a large body of people open to appeals for support for the dictatorship's victims: populations informed about the coup, the presence of people sympathetic toward the Allende project, and relative closeness in time to the 1960s and the Second World War.

A related set of conditions helps explain the fact that it was relatively easy to find sellers and buyers of *arpilleras*. First, in some European countries there was widespread activism on behalf of the regime's victims, and activists were often willing buyers and sellers. Large numbers of people participated in protest marches, cultural events that combined protest and music or the arts, and groups aimed at informing the public and putting pressure on one's government. Claude and Hélène said:

174 **Hélène:** At the time of the coup d'état in Chile, there was, in France at least, a real movement of solidarity. There were Chile Committees [Claude: Yes.] in many cities.

JA: Why? What did it represent for French people?

Hélène: The brutal end of a Socialist experience. [Claude: That's it.] Which was not very distant from French culture. There were a lot of similarities with Chile, maybe more than in other countries. There was a Socialist Party, a Communist Party, a democratic Left, and quite a few cultural ties [Claude: Yes.] between France and Chile. Pablo Neruda had been ambassador in France; there was this sort of cultural sympathy. When the Pinochet dictatorship began, with very severe repression against working-class milieux but also against the middle class and artists, there was a great deal of mobilization in France, which you didn't have for any other country. It was really . . . there were enormous, we had enormous demonstrations at Vincennes-le-Julien; [Claude: My goodness!] I remember the "Latin American nights" with thousands of people, etc. And that there was large potential for solidarity, with people who wanted to do something. We gave a little means [of expressing solidarity] to people, precisely by buying, by selling, by distributing the *arpilleras* and our little book.

JA: But when you said that you gave a means, what do you mean, giving a means to whom?

Hélène: To, to young people, to Christians, to activists. [. . .] And so it produced people who were aware of the sufferings and struggles of the Chilean people, and who were willing to distribute—like for Christmas, instead of using postcards or whatever else—to use cards like these [*arpillera* cards], to distribute *this*. It was useful for that. People would buy cards and there you go, it was their Christmas card.

[. . .]

Claude: Maybe we should tell you—because it's very important, I think—that exceptionally, in the case of Chile, there was mobilization in the whole of France. [Hélène: Right, not just Paris.] It was not centralized in Paris, but there were initiatives, participation in the, how shall I say, even in welcoming Chileans, for example. Sometimes you had to welcome Chileans who were, how to say, who arrived, who had nothing. Because it is, it's terrible to arrive, with children, for example, and not to have anything. So there were groups that, like that, that spontaneously helped. And this happened all over France. I insist on this point because I think it was more or less unique in terms of solidarity, yes.

Hélène: And so it produced people who were sensitive to, to the suffering and struggles of the Chilean people, and who were willing to distribute.

A large solidarity movement in France saw people mobilizing in vast numbers against the repression in Chile. These individuals wanted to do something to help, and selling and buying *arpilleras* and *arpillera* products was something concrete with which they could contribute. The mobilization itself further sensitized people to the sufferings of the Chilean people, creating a positive

feedback loop that was conducive to the solidarity-oriented selling and buying 175
of *arpilleras* and *arpillera* products.

It was not only in France that there was considerable activism for Chile. Other European countries also saw locals, or locals and Chileans together, engaging in solidarity work for Chilean exiles or the regime's victims in Chile. Olivia, for example, described "Chile Comités" [Committees] in Belgium that expressed solidarity by sending money to resistance groups in Chile and worked to inform locals about the dictatorship and Chileans' experiences, making booklets, brochures, photos, and posters. The committees were financed by the Belgian government, and the people on them were both Chilean and Belgian. Other Belgian groups and individuals were also active; a group of women called Belgian Women for Chile, for example, sent money to the Agrupación, and shops in Belgium donated clothing to be sent to Chile, Olivia reported. With more and more people mobilizing, taking action to help Chile by selling or buying *arpilleras* was not an odd thing to do. To be in contact with Chile was even fashionable in some circles. Barry, in Britain, said it conferred "street cred."

While there was much interest and mobilization in some countries, this was not the case everywhere. Not all European publics were equally aware of what was happening in Chile or active in protests, pressuring their government, and expressing solidarity. In Switzerland, for example, in Belinda's view, the public was somewhat less informed and also less understanding. Some people there were unaware of what was going on in the world, thought that if a person was arrested it was because he or she had done something wrong, believed that General Pinochet was not a dictator and was doing good work, could not imagine what repression was, could not understand the phenomenon of disappearances, did not accept that there was an organized practice of repression, and thought that the *arpilleras* were propaganda:

JA: What were the reactions of people who would buy?

Belinda: People express what they are. There are many who were not aware of the reality of the world, here or elsewhere. In a country like Switzerland, you find, still now, people who say, "If so and so was arrested, it must be because he did something." But they say that when it happens here too. There are ideological problems. People thought that Pinochet was not a dictator and that he was doing a lot of good things. The reactions depend on what people are, what they know, what they imagine. For example, repression can be very difficult to imagine for someone who has never seen it, either close-up or at a distance. The disappearances can be impossible to understand. Sometimes people say, "It's propaganda." It happened to me that people thought it was propaganda. And moreover, I think that years had to go by here for public opinion to

accept that there was an organized practice, just as a long time had to pass for them to realize that there were concentration camps. There are phases of denial that require consciousness-raising projects that take just as long here as elsewhere. But there is a lot of solidarity nevertheless. Just now, there are a lot of requests for help: the mothers of Russian soldiers from Chechnya; it's the same slowness for people to become aware. People here believed more of what the ambassador of Argentina said than the mothers [of the disappeared]. These are things that get repeated.

Belinda encountered ignorance, distrust, and incomprehension, but also a good measure of solidarity in Switzerland. Célestine, also in Switzerland, had a different perspective; she recalled a higher level of awareness about Chile, saying: "There was awareness, though, in western Switzerland; there were quite a few refugees in western Switzerland." Overall levels of social conservatism, understanding of and contact with refugees, inward-looking media, and other factors may explain why sympathy and mobilization were so notable in France and less so in Switzerland, in the accounts of the sellers interviewed.

A second condition making it easy to find buyers and sellers of *arpilleras* was that the governments of some countries adopted an anti-Pinochet dictatorship stance, which meant that groups working to support the regime's victims, such as by selling *arpilleras*, were working in a favorable political environment. The French government, for example, granted large numbers of visas to Chileans and condemned Chile unambiguously in the United Nations. Hélène explained:

Hélène: And public opinion applied so much pressure that the embassy of France in Chile played a very positive role [Claude: Very positive.], very positive, opening its doors to refugees, giving visas, etc.

JA: What else did the ambassador do?

Hélène: That in itself was significant; it was significant. In the Chilean context, it was very significant to give visas. When you see what is happening now, for example, that, that was an attitude France had, the French state. Apart from public opinion, which had also become sensitized. And the reprobation, the condemnation of Pinochet was unanimous.

JA: Reprobation by the government?

Hélène: Yes, yes, yes, I think so. And also by the United Nations, etc. France took a position that was unambiguously against the Pinochet government.

Claude: It's thanks to this large-scale movement that, for the first time in the United Nations, a special group was created [Hélène: A special rapporteur.], a special rapporteur, and I was a witness, after one of my trips, because after that I went on several, many trips, and I would testify before the commission. And the same was not done for other countries.

It's to show you that there was an atmosphere that was quite special, I mean, that
many people experienced, and in milieux that were very, very, very varied, sometimes
official like [Hélène: The UN.], and which did not exist in . . . because we worked with
Argentina as well, or, I don't know, Bolivia, Peru, in the same way. And there was a sort
of closeness, a political sensibility, between France and Chile.

Hélène: And French public opinion and Chile.

French activists successfully put pressure on the French government, which
helped victims of the regime and condemned the Pinochet dictatorship, and
their mobilizing contributed to the appointment of a special rapporteur
on Chile at the United Nations. Meanwhile, the governments of many
other European nations, Canada, the United States, Australia, New Zealand,
Communist countries, and some Latin American countries accepted refugees.[5]
Such actions by governments meant that groups helping Chileans were in
harmony with their stance. Had the governments disapproved of support for
Chile, activism might have been more difficult.

A third factor conducive to people being interested in, specifically, buying
arpilleras was an interest in Latin American cultural forms, including music
and cuisine. Sam, an exile in England, described:

Sam: So, really, you know, the Latin movement, let's say, was very, was getting quite popular
in those days too, so.

JA: What do you mean by "Latin movement?"

Sam: Well, basically, you know, well, specifically the Chilean cause. In those years, for
example, I mean, we ended up with a Chilean restaurant, an established Chilean
restaurant. Many Latins were arriving in England. Salsa started becoming popular and
so, at all of these events [where Sam's family had stalls and sold *arpilleras*], for example,
they would see the flags and the music, and then people would just literally—we were
like magnets. [Laughter] People would just come over.

Sam's words imply that people were attracted to many things Latin American,
and the *arpilleras* fell into this category. When this attraction drew people to
Chilean stalls that had music playing and sold Chilean food, it made them more
likely to come into contact with the *arpilleras*.

Meanwhile, there was a healthy demand for *arpilleras*. Many individuals
who were emotionally engaged with Chile and interested in what was happen-
ing there wanted information, and the *arpilleras* satisfied this need. Larry, an
academic based in the United States who was knowledgeable about Chilean
arpilleras, said:

178 Early on, the Vicaría realized these things [the *arpilleras*] were very appealing.
 There was a great deal of sympathy for Chile, distress, desire for information, and
 exhibitions for these things satisfied the need to know that Chileans were surviving
 and protesting as well—some sense that the militant spirit did not die.

For people who were emotionally engaged with what was happening in Chile,
the *arpilleras* supplied some of the information they wanted. Hence, the
widespread anti-dictatorship activism, government support, interest in Latin
American culture, and thirst for information were conducive to people's being
willing and able to sell or buy the *arpilleras* and *arpillera* products. Thanks to
these favorable conditions, the Vicaría was able to build up a large international
network of sellers, who in turn found numerous buyers. These sellers were
located in Europe especially, but also in Canada, Australia, elsewhere in Latin
America, in a smaller measure in the United States, and in other countries. It
was through this international network that the Vicaría sold the vast majority
of the *arpilleras* the women made.

VENUES

Local sellers, as I call sellers who were from the country in which the selling
took place, tended to sell at events that attracted people with an interest in
helping victims of human rights violations, the poor in developing economies,
or Chileans specifically. These included solidarity events for Chile, such as talks
or musical evenings with a political component, and solidarity events focused
on a range of countries. Local sellers also sold at neighborhood street fairs,
Christmas markets, and by correspondence. Barry, in England, said:

> But in our office, after the first couple of months, I realized that there were these
> *arpilleras* hanging around, and if we had a stall somewhere for a solidarity event, a
> speaker's meeting, like if someone from Chile turned up, then we would leave these
> out on the table, and you could buy them.

"Speaker's meetings" were typically events at which people living in Chile de-
scribed conditions under the regime.

Local activists sometimes gave talks about Chile or other repressive regimes,
and these, too, were events at which local sellers sold *arpilleras*. Linda, for
example, gave talks about the Ferdinand Marcos regime at church assembly
halls and various community centers in the Twin Cities in Minnesota, while
a colleague gave talks about being tortured in Chile, and *arpilleras* were sold
at these talks. The purpose of these events was to "educate and agitate," as
Linda put it; to make people aware of the problems of American support for

these regimes and of the fact that the United States had military and business interests in both countries, in the hope that they would act as communities and write letters. Different human rights organizations were represented at such events, supporting activities on different continents. On the tables at which the *arpilleras* were sold there were often articles made of copper by political prisoners, as well as books and a sign-up list. Linda herself bought *arpilleras* in Chicago and Minnesota in the late 1970s and early 1980s, and was also in close contact with sellers of *arpilleras* through her activism for human rights in the Philippines.

In France, the venues were similar. Claude and Hélène, for example, said:

Claude: We gave lectures, lectures on Chile, solidarity for Chile, so we would bring them along.

Hélène: And there was someone who would sell the *arpilleras*, but not us.

Claude's lectures took place in different parts of France, and a colleague sold the *arpilleras* at these talks.

Local sellers also sold at church-connected venues or events. A woman in the Presbyterian Church in Minnesota, for example, bought *arpilleras* and other items made by groups of people around the world, and sold them at church conferences around the United States. She would say the money was going directly to the women, making it clear that she was not interested in making a profit but rather in supporting a community.[6] In Geneva, Switzerland, a pastor put on a Latin American evening at his church at which many *arpilleras* were sold. In Minnesota and Chicago, Linda and her fellow activists gave talks to church groups at church assembly halls, selling the *arpilleras* at the same time. Linda said:

We did this in different churches and it was an incipient solidarity movement for Chile that then became Central America's solidarity network that was very broad, so a lot of people, progressive church people, folks, would also buy them. And that would be, basically, in Minnesota that would be a white middle-class or rural community. I mean, basically throughout Minnesota, which would have been rural as well as quite urban.

Church bazaars and church communities were fruitful venues.

Primary sellers were extremely dynamic about finding places and ways to sell and worked hard at it. Most sold at several different venues and many sold both during and after normal working hours. Barry, for example, sold at an annual Christmas market, at Chilean solidarity events, and at "speaker

180 events," several of which took place in the evenings or at weekends. He also mounted *arpilleras* on boards to create an exhibition, made a calendar out of *arpillera* photographs, and sold *arpilleras* via an advertisement in the Amnesty International newsletter. Belinda, in Switzerland, sold at school fairs, neighborhood street fairs and fêtes, Chilean *peñas*, and other solidarity events. She also did mail-order selling, and asked whether groups or companies could include Christmas presents in their budgets, offering several items for them to choose from, including the *arpilleras*. She actively made inquiries about events at which to sell, traveled to other cities to sell, worked to convince buyers to buy even the more violent *arpilleras*, and found large numbers of secondary sellers of different kinds:

> **Belinda:** I sold ten to fifteen thousand [*arpilleras*]. There were years when I sold several thousand. I did selling by correspondence, for example; I tried to sell in other cities in Switzerland—Lausanne, Yverdon—wherever I have a contact, and where there are opportunities. If I heard about a party for Chileans, I would offer things like that.
> [...]
> **JA:** What were these contacts in other cities? Shops?
> **Belinda:** No, people, groups, for example, groups belonging to ACAT [Action des chrétiens pour l'abolition de la torture; Christian Action for the Abolition of Torture], Magasins du Monde [a chain of fair trade shops] in different cities, groups that offered support for Chile, women's groups. I like to take opportunities as they come. I read a lot of bulletins, and I receive a lot. If I think there is an opportunity, I telephone.

Belinda sold in several Swiss cities, with the help of varied groups whom she contacted, reading and taking the initiative to telephone when she thought there might be a new opportunity. Claude and Hélène were equally dynamic. They sought out large numbers of people willing to help them sell *arpilleras* and, as mentioned earlier, created a set of postcards and a book and offered these to people to sell, brought along *arpilleras* whenever they gave talks on Chile, and arranged for packets of *arpilleras*, postcards, and books to be sent to different cities. Sellers sold at multiple cities and venues, and used varied methods to sell.

EXILES AS SELLERS

Chilean exiles started arriving in Europe, North America, Australia, New Zealand, Latin America, the Eastern bloc, and other countries almost immediately after the coup, their estimated numbers reaching 200,000.[7] Many of them wanted to help the struggle against the dictatorship and assist the regime's victims, and they became important sellers of *arpilleras*. The exiles interviewed

who sold *arpilleras* were highly committed to helping the resistance against the 181
dictatorship and were active in organizing protests, writing letters, and giv-
ing talks—all with the aim of informing people in their host country about
the situation in Chile. From their perspective, selling *arpilleras* was part of this
informational work and also a way to raise money. Their overriding goal was
to help the victims of the regime and the resistance movement. My notes about
an interview with Ignacio, an exile in Britain, for example, say, "Ignacio doesn't
like them much but bought them out of solidarity." Some exile organizations
kept some of the money from the *arpilleras* for office maintenance and salaries,
however.[8]

For the Vicaría, the increase in the number of exiles during the first few
years of the dictatorship meant a potentially expanding distribution network.
As mentioned earlier, many of these exiles were people whom the Vicaría had
helped in some way. Some wrote to the Vicaría, asking how they might be of
use, and the Vicaría requested that they help by selling *arpilleras*; in other cases,
the Vicaría approached them. If they agreed, Talleres began sending packets
of *arpilleras* to them regularly. Other Chilean human rights organizations also
contacted exiles, or exiles made contact with them. Still other exiles became in-
volved in selling *arpilleras* because they were members of an exile organization
or Chilean political party that asked them to help in this way. Such organiza-
tions had mushroomed in Europe and North America; they organized talks,
protests, and fund-raising events, and helped new exiles.

Exiles sold *arpilleras* from stalls at solidarity fairs, events focused on devel-
oping economies, music festivals, church Masses and other church events, ex-
hibitions at universities and women's buildings, craft markets, theaters (such as
Sadler's Wells in London), trade union conferences, and left-wing party confer-
ences, as well as from their homes. Those who sold because they were asked to
by their exile organization or political party did so at *peñas*, talks about repres-
sion in Chile, and "politico-cultural acts" that combined a talk with a perfor-
mance of political music. Some exiles organized exhibitions of *arpilleras*. Like
local sellers, exiles were creative about finding places at which to sell, and some
sold at two or three events a week.

At these varied events, exiles typically sold the *arpilleras* by displaying them
on panels on the wall or on stalls or tables. When Olivia, an exile in Belgium,
sold *arpilleras* at *peñas*, for example, she put them up on wall panels and on
tables, along with their price. When talking to potential buyers, she would take
them off the panels or show the *arpilleras* on the table, one by one. Stalls tended
to be decorated with Chilean flags and banners, and to have Chilean music
playing. There would be leaflets or flyers with information about Chile, Chilean
wine and food, and sometimes also Chilean pottery and other craft products,

182 music records, Chilean cookery books, pin-on badges, and books. For many exiles, selling *arpilleras* was a family affair; their children helped.

Like the local sellers, exiles had secondary sellers who sold for them. These included the shops of charities and relief organizations. Sam's family in England, for example, gave the *arpilleras* to Oxfam (a relief organization), Amnesty International, Dr Barnardo's (a children's charity), and the charities that had helped them when they had first arrived in England. Exiles in other cities also acted as secondary sellers, sometimes telephoning the primary seller and asking them to send *arpilleras* for an event they were organizing.

Some exile and local sellers and a small number of scholars and artists abroad organized exhibitions of *arpilleras*, and at some of these, viewers could buy the *arpilleras*. The countries in which exhibitions were held included Britain, Finland, Sweden, Germany, France, Spain, Holland, Cuba, Mexico, Kenya, and the United States. Some exhibitions traveled to various cities within a country. Their venues were mostly educational, cultural, or policy research institutions, and included libraries, schools, universities, Oxfam shops in Britain, churches, the Peace Museum in Chicago, the Women's Building in Los Angeles, a center of contemporary art in Mexico City, UNESCO in Paris, the United Nations International Women's Conference in Nairobi, the Institute of Policy Studies in Washington, D.C., a commercial gallery in Spain, and the House of the Americas in Cuba. There was also an exhibition in a traveling bus in the United States. Some of these exhibitions became collections belonging to the organizer. A handful of academics also became collectors of *arpilleras*, often using them for their work.

NUMBERS AND PRICES

Approximately 100,000 *arpilleras* were made in the Santiago Metropolitan Region over the sixteen years of the dictatorship. Abroad, different buyers sold different amounts. Some sold large quantities; Belinda, in Switzerland, for example, sold "ten to fifteen thousand," ordering 300–400 at a time, and selling over 1,000 in some years. Constanza's family in Belgium sold 1,200 a year, Sam's in England about 850, and Ricardo in France 540. Claude and Hélène, also in France, sold about 1,000 *arpilleras* between 1975 and 1981, and between 1976 and 1978 they sold 150,000 *arpillera* postcards and 35,000 books. Josefa, who was in exile in the United States, bought approximately 600 *arpilleras* over the course of the dictatorship, some of which she sold, and many of which remained in her own and other collections. A Chile-focused human rights organization in Britain was selling about 72 a year when Barry joined their staff in 1986, but he "up[ped] the numbers" considerably.

Constanza's family always sold two large packets of *arpilleras* a month, 183
amounting to one hundred *arpilleras*. Ricardo, on the other hand, sold forty-
five *arpilleras* a month. In terms of numbers sold per event, Constanza reported
up to thirty; Olivia talked of selling thirty to forty at evening events, but
sometimes as many as fifty. Sam recalled that fifty sold at an event was "a good
number." The longer the event lasted, the more *arpilleras* were sold, according
to Olivia, who sold fewer at events that lasted only from 6:00 PM until midnight
than at those that went on all day from ten in the morning. The numbers sold
fluctuated with the seasons and over time. In part, this was because the number
of events per month fluctuated. There would be more events in summer than
in winter, Constanza explained. Also, more *arpilleras* were sold on occasions
when special visitors came from Chile, attracting crowds, Ricardo recalled. On
the visit of a Chilean bishop to Paris, for example, Ricardo sold US$1,000 worth
of *arpilleras* at the entrance of the church where the bishop said Mass. Numbers
also fluctuated in accordance with the public's level of interest in helping Chile.
Claude and Hélène reported that the years in which they sold the most were
1977–1979; these were years when activism for Chile was at a high level in France.
Sam reported that his family sold the most *arpilleras* between 1975 and 1987,
and fewer after 1987, because in 1988 and 1989 exiles started returning to Chile.
This coincides with reports from the Vicaría that sales abroad diminished when
international support for Chile dwindled. Roberta, a Vicaría employee, said:

> Further down the line, because of this business of foreign support changing, the
> support we received from abroad began to diminish, there was a drop [in the
> number sold], and we didn't have the ability to buy such a large quota from the
> workshops. There was some conflict with the workshops; they couldn't understand
> that we couldn't buy everything.

When support for Chile abroad lessened, so did the number of sellers, and
so the Vicaría sold fewer *arpilleras*. There was also a drop in sales when the
Vicaría stopped exporting *arpilleras* out of fear for a time, after some packets
were opened at Santiago's airport, as we shall see.

Prices for an *arpillera* varied from salesperson to salesperson. Barry reported
in 1995 that he charged £10 for a small *arpillera*, £15 for a medium-sized one,
and £40 for a large one; but what he sold for £10 or £12, others might sell for
£25 or £30. A man he knew in London, who sold *arpilleras* through the Amnesty
International catalogue, priced them at £25, while Barry was selling them for
£15 through his ads. Barry charged different amounts depending on whether
he was selling them by mail order, at a stall, or through friends who had a shop.

184 His prices rose a little over the years, from £10 in 1987 to £12 by 1989, to £15 in 1995 for the medium ones, and from £5 to £7.50 or £8, up to £10 over a seven-year period for the small ones. Larry, a small-scale collector, also reported that prices rose; the price of *arpilleras* being sold at stalls set up at the Fête de l'Humanité, an annual event in Paris that brought together humanitarian organizations, almost doubled over the years, from US$20 to $40, he said.

The *arpillera* system had come a long way from the days when, in the early years of the dictatorship, the women sold their *arpilleras* only locally. As this chapter has shown, an international distribution system began when a foreign human rights activist offered to sell them abroad. Solidarity chains radiated out from Chile, with Chilean exiles and locals abroad with an interest in Chile or human rights becoming the main sellers, both groups being motivated by the wish to help the women or the Vicaría and the desire to send the money back to Chile. Primary sellers often passed on the *arpilleras* they received to secondary sellers, who might give them to tertiary sellers. This international selling of *arpilleras* was intimately bound up with solidarity, which was the primary motivation for the work that sellers, buyers, the Comité, and the Vicaría did; all wanted to assist the *arpilleristas*. Some sellers had an ethos of solidarity and made efforts to promote solidarity-oriented behavior in others. These parties, together with the *arpilleristas*, constituted a solidarity art community, the sum of all the solidarity chains radiating out from the *arpillera* workshops. Traveling along these solidarity chains were solidarity flows of money and moral support to Chile, with *arpilleras* and information about Chile going in the opposite direction. In the next two chapters, we explore the end point of the solidarity chains: the buyers.

7 The Buyers Abroad

The individuals who bought the *arpilleras* wanted to help the *arpilleristas* and express solidarity with them, and they were sympathetic to the anti-dictatorship cause. Because they bought out of solidarity, I call these buyers a *solidarity market*. As Gertrudis, a Vicaría employee, said: "The *arpillera* was something that was very solidarity focused (*solidario*) across the world. In other words, people bought them for solidarity reasons, like a reflection of the denunciation and like a reflection of what was happening in the country, to give support to the women, to support what the women were doing." Buyers abroad were mostly locals from the countries in which the *arpilleras* were sold and Chilean exiles. A small proportion of buyers were leftist Chileans and foreigners in Chile.

LOCAL BUYERS
Local buyers tended to be politically sensitive, Left-leaning individuals interested in helping people in less fortunate circumstances; a number supported struggles against oppression around the world. Sam, in Britain, described them in this way:

> I would say mostly leftists. Yeah. Socialist leftists. Yeah, sympathetic to, you know, anti-military [laughter] feelings, if you know what I mean.

They were apt to be interested in politics or human rights, knowledgeable about world politics, and, according to one seller, not focused on money. Many of them had heard about what was happening in Chile. Some were vaguely

aware about what was going on and happy to learn more by talking to the *arpillera* salesperson. Others were quite knowledgeable because they were activists in other human rights struggles against repressive regimes and were in contact with people selling *arpilleras*. Still others had a particular interest in Chile and were attracted to things Chilean, especially objects connected with the resistance. Olga, who sold *arpilleras* in France, found that buyers were aware of what was happening in Chile, often wanted to know more, and were sympathetic toward the anti-dictatorship struggle. Meanwhile Olivia described the Belgians who went to the *peñas* where *arpilleras* were sold as interested in the Allende government and having read a lot about Chile. In some contexts, levels of interest varied, however. Belinda recalled that some people who stopped at her stall in the street during neighborhood fêtes in Switzerland asked questions about the *arpilleras*, while others did not, merely buying because their children wanted one. On the other hand, her buyers at the United Nations General Assembly in Geneva were interested, she said.

Sellers described buyers as *gente solidaria* (solidarity-oriented or supportive people), and as possessing a "social consciousness"; Linda used the term "solidarity folk." Olivia, in Belgium, used similar terms when I asked her about her buyers:

JA: And the public in these different places, in the *peñas* that you described, in the churches, in the "Souterrain," was it the same, or were there differences? I mean, the people who bought *arpilleras*?

Olivia: No, I'd say it was the same. I mean the same group. I mean, a big group whom we would ask to please bring their neighbors, their cousins, their, for example, their friends. So they would show up with more people, but it was always these types of warmly supportive faces, of solidarity-oriented people. I mean, for example, if you asked me if it was the bulk of the Belgian population, I'd say no, it wasn't; it wasn't the bulk of the Belgian population. I don't know if at some stage Belgium as a country got to know what an *arpillera* was; I don't know, I couldn't tell you. Because it was not something so, so popular like pop music or like, I don't know. But yes, groups of Belgians who were frie—, people who liked Chile, solidarity-oriented people, intellectuals, workers with a social consciousness, that type of person. Left-wing people, let's say. [. . .] It was always the same type of person. Left-wing people, solidarity-oriented people, intellectuals, workers with a social consciousness. These were the people who would buy the *arpilleras*.

Solidarios, meaning warmly supportive or solidarity oriented, is an adjective that Olivia and other sellers used often when describing the buyers of *arpilleras*.

Some buyers were churchgoers. In Belgium and France, there were Catholic buyers who bought as they left Mass, from sellers who set up a table just outside

the church. Constanza's family in Belgium sold *arpilleras* to people as they came out of Mass, while Olivia recalled that there were Christians in Belgium who not only bought *arpilleras* but also helped Chilean exiles borrow rooms in churches for their events. Hélène, in France, described "Christian milieux" as fruitful places for the sale of *arpilleras*, because people were aware of what was happening in Chile. In Minnesota, meanwhile, many buyers were "progressive" churchgoers, according to Linda.

The buyers were male and female and included young adults, working adults accompanied by children, elderly people, and even the occasional child alone. Olivia in Belgium, for example, described buyers as couples in their thirties, sometimes with small children; people alone in their thirties; elderly women; students; and elderly couples. Sam, in England, on the other hand, reported a narrower range of people, in their twenties to early forties; he called them "British hippies." Linda in the United States said they were in the eighteen to twenty-seven age range and just out of college. These buyers went to solidarity fairs, music festivals, churches, or the musical and informational events that exiles organized.

Buyers tended to want *arpilleras* with "political themes," that is, about issues related to the dictatorship. Linda, who worked alongside people selling *arpilleras* in Minnesota and who bought some herself, noticed that buyers looked for *arpilleras* with more politicized statements, because in buying such *arpilleras* they were purchasing "a piece of the revolution," as she put it, and expressing support for the movement in Chile:

... The ones that had more politicized statements, because those were always the ones that people wanted [laughs]. Because they represented more for whoever was buying them, why they were buying them. Because they were more ... it was kind of purchasing, purchasing a piece of the revolution, purchasing a piece of the support for, you know, the movement, for what was happening in Chile.

The *arpilleras* with more political themes suited the meaning that buyers gave to their buying, that is, support for resistance to the regime.

The Vicaría staff noticed the interest in repression in the orders received from abroad. Silvia, a staff member, recalled that in the earlier years of the dictatorship there was increasing demand for *arpilleras* with sharply political themes:

I also remember the orders from abroad for more and more virulent themes as time went by. What they asked for from abroad was really to learn about what was happening here. [. . .] But I know that people abroad were interested in the more

political themes, like, for example, this one that says "¿Dónde están?" [Where are they (the disappeared)?] in La Moneda [the square next to Chile's presidential palace], in 1977; a special date when they would ask for a particular theme.

Silvia had worked for the Vicaría in the earlier years of the regime; later on, the demand for overtly political *arpilleras* declined.[1]

When buyers bought *arpilleras*, they did so for a mix of reasons, both altruistic and acquisitive. For the most part, they did not buy because they needed a product; rather, they wanted to assist the women. Yet they did also buy because they liked the *arpilleras* or because doing so communicated something about them or benefited them in some way. Many bought because they understood buying as a way to support the women who were struggling to survive, and as a way to express their solidarity with them, but also because they were attracted to the form and content of the *arpilleras*. Linda, the buyer in Minnesota, said:

> And at that point a lot of people were buying them for solidarity with the women. [. . .] They were directly related to people who were struggling to survive, when they were made by women, in a . . . We heard a number of things: the women in the community kitchens, women in the poor areas, women who were the families of political prisoners. These are the three kinds of narratives about these pieces. And so you felt if you were buying one, then you were giving some support for the communities in Chile. And so I think it was . . . people bought them for those two reasons, one if they had a certain aesthetic, and they were commentaries on daily life, and sometimes hidden political life, sometimes more explicitly. Also because it was a way to provide support to that community without being patronizing by just offering money, you know, or doing something else. There was a kind of sense in which you were supporting an industry, you know. It's also to send a message of solidarity that was about, well, if they make them and, you know, it provides a livelihood, then we will buy them.

In Linda's analysis, people bought *arpilleras* because they wanted to provide support to communities in Chile without being patronizing, and send a message of solidarity, but also because of the aesthetic and because the *arpilleras* were commentaries. These first two motives are altruistic and solidarity oriented. Yet to buy for these reasons was to feel that one was giving support to communities in Chile, and this suggests that there was satisfaction or a "feel-good" factor involved, meaning that altruism and self-oriented acquisition were inextricably intertwined. There was also an acquisition orientation in the last two motives,

namely, the aesthetic and the fact that the *arpilleras* were commentaries on life in Chile.

In Linda's own community of human rights activists concerned with repressive regimes, one reason members bought *arpilleras* was that it was part of the culture of the group and a way of making a statement about one's ideas. Linda said:

JA: So you were different from the other buyers. Were there any other buyers like you who were, you know, activists in this group? Would they also buy?

Linda: In this particular group, we already had them, we were saturated.

JA: So everybody had them?

Linda: Oh, everybody had them. Yeah, I mean, it was something that you did; I mean, we all had them, I mean, most of my friends had one.

JA: Friends in your *marcada*?

Linda: My *marcada*, my group. We would all buy one. I mean, it was, the thing to do was to buy, [to] have one.

JA: Why was it the thing to do? Or how was it the thing to do? How did it become the thing to do?

Linda: Well it's like, you know, "Let us now bridge." Posters of different groups around the world, it was, it was a kind of a political mo— . . . it was a kind of statement, a political statement to have one in those days.

JA: And what was it saying?

Linda: It was saying that you understand what was going on in Chile in particular and that you had, and that you were concerned about it. Basically, it was indicating that you had some little extra kind of military analy—, some analysis about the U.S. military in Latin America. I mean this is only Chile but a lot of, there was a lot of concern about, you know, South America. So it was one of, I mean, I wouldn't have separated it from a number of other, you know, the Che Guevara posters, you know, there's a whole kind of, say, paraphernalia of solidarity work, you know, that was part of the culture of kind of making a statement of aesthetic of solidarity work, which was itself the story. I think that everybody did it 'cause they wanted to make a contribution, and it was something, you know, it's like buying coffee now. We were all buying, you know, at that point people were buying Nicaraguan coffee. A little later you buy, you buy the items to support these kinds of economies, or these communities that are looking for income.

Linda's words point to the force of group culture and the wish to affirm a certain identity as reasons why people bought, in addition to the wish to support the communities of arpillera makers. Buyers were also attracted to the content, meaning, and type of art form; Linda later mentioned that she bought

190 *arpilleras* because she thought they were "lovely," "beautiful," "very vibrant," "energetic," "primitive art" or "ethnic art," as well as "commentary," and she associated them with Hmong art (by refugees from Laos) and Che Guevara posters. Hence altruism and the wish to acquire were bound up together in Linda's and her community's buying.

Some buyers bought because they were so concerned about the victims of the regime and moved by what they learned about them that they wanted to have a "testimony." Here, too, altruism and the wish to acquire merged. Olivia remembered explaining *arpilleras* showing the black cars of the CNI (National Center of Intelligence) without license plates, and CNI agents taking away someone whose wife was crying on the ground; she would tell buyers that many of these people disappeared. Buyers felt it was terrible, she recalled, and wanted an *arpillera* as a testimony:

Olivia: . . . And when people are being arrested, [they] have their arms raised as they go out. That also made a big impression; it was very powerful.
JA: What would that say, in this case?
Olivia: Well, it was sort of terrible, really terrible, but still, they wanted to have it as a testimony.

Olivia's words "big impression," "powerful," and "terrible" suggest that the buyers were moved by what they saw and empathetic, while her phrase "wanted to have it" indicates the acquisitive side of their buying.

Other buyers wanted to buy to better *compartir*, that is, share in some way in the experiences of people in Chile, and at the same time to have in their homes a "window onto the world"; they even bought because they saw the contents of the *arpilleras* as a lesson to their children not to waste food. Olivia described:

JA: Concretely, why did they buy?
Olivia: To share the experiences, to share that experience. For example, in the case of the *comedores populares*, they would often say, "I am going to show my children this, for when they complain about the food and don't want to eat and think that they can throw everything away and buy an ice cream and eat half of it and throw it away, etc. I am going to show them this so that they know that there are children who are hungry." And it was also, usually, like having in their homes a, let's see, a window open onto what was happening in the world. And not happening in Belgium obviously, of course. Of what is happening in Chile, the experiences. To share the experiences in that way, because for example, yes, if you sell *empanadas* [meat pies] or a glass of wine, it's something pleasant, of the moment, and it's something Chilean, but it stops there. On the other hand, if you sell an *arpillera*, you are giving a piece of the history of

your country. That's it. It's, they are pieces, fragments of what was happening in this country.

As Olivia describes them, these buyers wanted to buy *arpilleras* mostly for their own benefit, but Olivia's phrase "to share that experience" (*compartir la vivencia*) points to a high level of compassion. In France, Hélène also indicated a mix of compassion and acquisition as motives. She mentioned that people bought *arpilleras* from stalls at solidarity events because they were new, inexpensive, attractive, and transportable, but the meaning was important to them as well. As with many art forms from developing economies,[2] features of the *arpilleras* that made them more "buy-able" were factors in people's buying. Hence solidarity and the desire to acquire were both prominent motives when people bought *arpilleras*.

Because of their interest in helping those in need and their compassion, I call these buyers a "solidarity market." A solidarity market is one in which compassionate buyers buy to help improve the welfare of others or to express empathy with victims of oppression or disaster. Buyers of *arpilleras* were concerned about the victims of the regime and wanted to do something to help, and sellers repeatedly described buyers as *solidarios* (warmly supportive and solidarity oriented).

EXILES AS BUYERS

Exiles were the other main buyers of *arpilleras*, purchasing mainly for their homes. Among them were exiles who sold *arpilleras* and exiles who did not. Sam described:

> Yes, and all the Chilean families, we had about four [*arpilleras*] in our own house, I mean, so we would buy them ourselves, and that money would come back. So in every chapter there were twenty-five families, let's say, a hundred Chileans; they all had at least two or three in their houses. So whenever we could, we would buy them. And as I said, it was very informal, so, I mean, any visitors who would come to our house, we would say, "You've got to buy one of these; take one of these."

"All" the exiles in the chapters of Sam's family's Chilean exile organization had two or three *arpilleras*, making them significant buyers. However, not all the *arpilleras* in exiles' homes had been bought by them; some had been gifts that friends and relatives in Chile had either given them before their departure or sent once they had arrived in their host country.

The *arpilleras* held a number of meanings for exiles. In Olivia's view, they were an "identification with Chile," something "sentimental" in the home,

192 something containing a story about Chile, a way of receiving news about Chile, and a record or testimony about what was happening there:

Olivia: Chileans would buy them, yes, to have something sentimental in their homes. In every house, in almost every Chilean home in exile, there were *arpilleras*. Just as there were posters about solidarity with Chile, posters, for example, of Salvador Allende with . . . posters that had been produced in Belgium, I mean; they were in French, inviting people to a demonstration, or some act, some concert, or some *peña*. So they were . . . in the homes of Chileans you had this type of poster, they were there, and also *arpilleras*, which were an identification with Chile.

JA: Yes. What motivated Chileans to buy *arpilleras*?

Olivia: The identification with Chile. Because each *arpillera* has its story, as you know. [. . .] So for example, the *arpilleras* that came from the prisons were very symbolic, because they evoked the neighborhoods where the political prisoner lived, for example. So she would make the *arpilleras* with, with subjects like the *ollas comunes*, the *ollas populares*, the *comedores populares* [different forms of community kitchens], or also protests in the neighborhoods where they lived. And, [. . .] it boosted people's spirits when they lived in exile; people who knew that they could not yet return.

JA: It boosted their spirits . . .

Olivia: It boosted their spirits in the sense that people in the countries of exile get very depressed. They get depressed because it is very different when you travel to a . . . Belgium is wonderful, it's a beautiful country, but not to live in because we are not Belgian. And above all, I think that it's basically . . . it's not so much that we want to live in our own country, but it's the idea that you *have* to live abroad. That's the problem. So people got very depressed and were always waiting for news of Chile, and one of the ways of getting news about Chile was via the *arpilleras*. Because the *arpilleras* were very much based on what was happening. Well, this idea of the *ollas comunes*, as I say, which was very well portrayed in the *arpilleras*. There was also news, there were *arpilleras* that told stories about the raids on homes. When they would go into the houses and ransack them, when they would arrest people. That was atrocious, horrible, whatever you like, but it was also a record. And something characteristic. Look, it was like saying, "Look, this is what is happening in my country."

The fact that the *arpilleras* depicted events in Chile was significant in several ways for the exiles Olivia mentions. They valued them because of the news they provided, because they offered a way to express one's identification with Chile, and because they were "something sentimental," that is, to have one was to express one's strong feelings about Chile. Among the positive consequences associated with having one were that it boosted exiles' spirits to see the *arpilleras,* and satisfied some of their hunger for news.

Similar to Olivia's "identification," for Sam in Britain, to have an *arpillera* in one's home meant to be in touch or connected with Chile. It also meant knowing one was helping a very important cause:

> What did it mean to have an *arpillera* in the house? Well, being in touch with Chile, knowing that we were helping a very, very important cause. We were all very politically motivated because, as you know, we were politically exiled, so, so anything to help. I didn't like to think of it as charity work, you see what I mean. It is more like we are selling these things, you know, to help a cause. I mean it's not charity at all, if you see what I mean. So it was very important to have these kinds of objects, I mean, the Pomaire pottery, everyone had it. So being in touch with Chile, knowing that we were doing something good. I mean, we were not . . . we weren't living in, you know, very good conditions ourselves, you know, in those years back in England, you know, so knowing that we weren't doing very well, let's say, and people here were doing, you know, really badly, we were like really in touch with really what was going on here, so the political side of things was very important, so I'd say that was the most . . . just being in touch, being connected. I mean we all spoke Spanish at home.

Being in touch and connected with Chile, helping an important cause, and knowing they were doing something good was what it meant to Sam to own *arpilleras*, and also to sell them, as the two were closely associated. Hilda had been an exile in Mexico, and like Sam, she said that every exile home had its *arpilleras*. For her, they were a piece of Chile in a foreign land and a reminder of the suffering and struggle back home. Both exiles and locals, then, bought *arpilleras*: locals for both altruistic and varied self-benefiting reasons, and exiles largely because to do so expressed something about themselves, and the *arpilleras* were a concrete link to Chile.

THE BUYING PROCESS

The buying of an *arpillera* typically happened during a conversation between the buyer and the seller about what the *arpilleras* depicted, who made them, how they were made, and the situation in Chile. During this conversation, the buyer's emotions were aroused, and in particular the bundle of emotions I term the sentiment of solidarity, that is, compassion for the victims of oppression and indignation at the oppressor. The act of buying was the end point in a process.

Attracted to the Stall

The process began with the potential buyer being attracted to the table or stall at which the *arpilleras* were exhibited, because of its liveliness, the association

194 with Latin America, and the wine that was often sold there. Sam's family sold *arpilleras* at *peñas* and music festivals, and Sam said:

> I mean our stalls were very attractive; I mean we always had music blasting, we had, you know, flags, always very busy, kids, myself included, you know, running around. So as I said, that acted as a magnet to people, really. So as I said, once they came over, the flags, they saw the *arpilleras*, you know, then the discussion, the analyzing, the, what I said before, really. [. . .] And so at all of these events for example, they would see the flags and the music, and then people would just literally—we were like magnets [laughter]. People would just come over. So you know maybe just out of curiosity and, but compared to the other stalls, ours were always very popular. Yeah. As I said, the kids, the dancing, the food. We would sell punch for example, which was always very popular. Fruit punches were very popular.

Whether because they were attracted by the stall's visual appeal and liveliness, wanted the punch, or liked the music, Sam's buyers would first be drawn to the stall.

Sometimes buyers were attracted by the *arpilleras* themselves, which they had noticed. Sam said:

> The first reaction [to the *arpilleras*] would be "God, that's a really . . . ," you know, "What is that?" You know, I mean, it wasn't about us having to advertise. It wasn't like, oh, we would have to write, I don't know, to the local newspaper and say you "Look, *arpilleras* are this." No, they would come to us because they would see them up on the stalls, you know; I mean genuinely interested in the whole thing really. As I said, the music, the food, the *empana*— . . . I mean people would come and buy *empanadas* [meat pies] and then people would see the meat and *empanadas* and then more people, and then, you know, we'd have a big group of people always.

The *arpilleras* themselves drew people to the stall, along with the music and food, and inspired surprise and interest.

Answering Questions and Explaining

Once at the stall, buyers would begin asking the seller about Chile and the *arpilleras*, and it was typically as an outcome of this conversation that they bought an *arpillera*. They would ask about who made them, why, and how, and what was happening in Chile. The sellers would answer, explain the *arpilleras* on display, and talk about the situation under Pinochet. Sam and I discussed this process:

JA: So can you remember what these people said to you when they were buying *arpilleras*?

Sam: Very interested, very motivated, as I said, very sympathetic to the cause. As I said, in these, for example, in Saint Paul's festival, which is the reggae festival held in Bristol every year, it was really, every time we would sell an *arpillera* it would go directly along with "Why are you selling, who made them?" So it was always talking; it wasn't just buy and sell, "Oh, that's nice." It was never like that. That's why I mentioned this hippie kind of, er, because they're very interested, well informed, so every *arpillera* that was sold, I would say, would go along with the roots of it and why and the causes.

[. . .]

JA: Can you remember what else they asked? Some specific questions?

Sam: Well, basically what materials they were made of, who made them, why they were made, and then that led to deeper conversations: "Oh, what happened in Chile, and who's Pinochet, and what's happening?" So, you know, small talk would be converted into, let's say, an in-depth analysis of the political situation of . . . because you cannot just say, "Oh, these *arpilleras* are made of bits of fabric." I mean, that means nothing to anybody, so yeah, obviously once they started asking, they were more interested, and that's when the children, let's say, of the political [exiles], myself included, you know, who spoke English [laughter] better than our parents, that's when we would come in and, you know, through our parents we would pass on ideas, "Oh she wants to know, you know, who made this, you know, and why they made it." And then we would, you know, act as interpreters, I suppose [laughter], which I am today; a professional interpreter. [Laughter]

JA: So these people, how much did they know about Chile on average?

Sam: Well, if we're talking about early 1980s, a lot. As I said, the people were politically interested, so they were quite well informed. So any time they saw a Chilean flag, for example, it was an instant magnet for people to come along and say, "Oh, I heard about this; tell us more," and then the *arpilleras*, you know, that kind of, you know, dialogue would just come through, you know, through them coming over to the stall and asking, and then buying *empanadas* and all kinds of food.

Potential buyers asked sellers many questions. Often they had heard about what was happening in Chile and wanted to know more. The sellers would answer their questions, explain the reasons for *arpillera* making, and offer an analysis of the political situation. Hence, a central part of the buying process was the conversation between buyer and seller about the situation in Chile and the *arpilleras*.

Olivia recalled that her Belgian buyers were initially drawn to the colors in the *arpilleras*, and then would start asking questions:

196 Because what would happen was, let's see. The impression the Belgians had, the first impression was that they would see the *arpilleras* and were guided by the colors. The colors. They would say, "I like this one, this one, because, ah! The colors are very nice." And later, "What is this, what is this? And what is that? And what's that?" And they would start to learn about a history that they didn't . . . that was shocking. So usually, as I say, they would all ask what it meant. And I would explain to all of them.

Buyers' asking about the meaning of the *arpilleras* prompted sellers to explain about what was happening in Chile.

A close examination of the *arpilleras* was part of this process. Olivia would take the *arpilleras* off the panel where they were hanging or pick them up from the pile on the table, and the buyers would come closer to look at them:

> Look, they were on the wall, on a panel, you see? That's where we would put them. And I would take them off the panel and bring them closer. We also had masses of *arpilleras* on the table, and each of them was different, so you had to be showing them one by one, so that they could see them. Because no two are the same. So they would come closer to look.

As Olivia showed buyers the *arpilleras*, she would explain the contents in some detail, and in the process tell the buyers about the *ollas* or other aspects of shantytown life:

Olivia: I would tell them what was in them.

JA: I see. For example?

Olivia: For example, I would say, "Look, in this *arpillera*, the base is the Andes; this is what we have," for example. Often I would ask them what they saw there, and so they would say, "Children eating," and I would say, "Exactly, children eating, because this is a *comedor popular* [community kitchen], these children are not bro— . . ." They would ask me if they were brothers, for example. "No, these children are not brothers, but they are brothers in their suffering, for example, they are all children of political prisoners, or children who don't have anything to eat, and although he is not his brother, they share the same problem, they don't have anything to eat, so the mothers get together and they organize to set up an *olla común* [community kitchen] and give food to all the children from that *olla común*, even if it's not their own children. That's the idea, the basis of the *comedor popular*. Supported by the [Catholic] Church." You know that in Chile there was a lot of support by the Church, by the Vicaría de la Solidaridad. So later I would say, "This little girl is going to school," for example, "She has already eaten, so she is looking for her books and is going to school." I would explain, "This lady is going to buy bread," to give you an example, "She is also going to go out shopping, and

here are the houses with the roofs of different colors, and so on." And then you would wait and see what else they wanted to ask. If they asked, often they would ask things that I didn't have an explanation for because all the *arpilleras* had a story, but there are stories that I didn't know, or there were details that I didn't know. And also, if I didn't know them, I would say I didn't know, that . . . right. And I repeat, based on that, they would be looking, and decide which one to buy. [. . .] Ah! Protests. Protests as well. So I would explain the . . . because there were drawings, I mean, *arpilleras* with drawings and embroideries of fire, you see? So I would explain that that was a way of protesting, a way people organized themselves to burn car tires, or wood, paper, you see, and to make, to build fires. That was a protest, you see? And afterward, of course, the police would come with repression, putting the fires out and throwing things away, but there and in the . . . There were others showing protests with saucepans, you also have some with protests with saucepans. And I would explain that that was the way to attract attention, and to resis—, . . . it was for resistance, let's say.

Olivia would explain the *arpilleras*, and in the process tell buyers about the community kitchens and forms of protest, and explain the *monos'* actions, and elements such as the mountains and houses. Meanwhile, the buyers would ask questions. Based on this conversation, they would decide which *arpillera* to buy.

Constanza, another exile in Belgium, who did not sell with Olivia, remembered much the same: buyers would ask her to explain the *arpilleras* and she would tell them about their meaning and about what was happening in Chile:

On several occasions there were Masses to help Chile, things like that, and on one side of the church we would put out the tables and sell the *arpilleras*. Many people would come up, and notice the little *monos* [human figures], and say, "How attractive, but what is it about, really?" So we would start to explain that it was not just about some little *monos*, but rather it explained everything that was happening at that time in Chile. Each *arpillera* was a tale, a story. So we would explain what each *arpillera* meant, and people liked them a lot and started to buy them. They would even phone the house to buy more *arpilleras*.

Buyers asked about the meaning of the *arpilleras*, and the seller would explain, relating it to events in Chile; buyers were enthusiastic and bought.

The buyers would choose the *arpillera* whose story had most interested them, Olivia recalled:

The concrete example is that the Belgians *always*, always asked what the story meant. And depending on the interest they had in the story that I told, they would buy the *arpillera*. They would always ask what it meant. And I would go about explaining.

And also, they were very struck by the fact that almost every *arpillera* shows the mountains, the Andes. So they were very struck by that, the identification we had in Chile with the Andes. So, "Ah, the Andes, the Andes." That . . . they liked that a lot. So about the *arpilleras*, as I say, I would tell the story, saying, "These people come together and bring together food to create *comedores populares* so that children can have a plate of food every day. And here are the children eating, the mothers cooking, the dog barking [laughs], the Andes." If they found that story interesting, that's the one they would buy. There were, you know that inside the *arpilleras* there are some messages that the prisoners . . . that you'd open a little door and find the message, right? They really loved that too.

Buyers wanted to know what the *arpilleras* meant, and Olivia would tell their stories; they then made their choice based on the story that had most interested them. Hence the conversation with the seller was a crucial part of the buying process, and it was also a means by which the buyer learned about the repression and poverty that existed in Chile.

Creating a Vivid Sense of the *Arpilleristas'* Lives

A number of sellers tried to foster in buyers a vivid sense of the *arpilleristas'* lives, and in so doing tended to arouse strong reactions or emotions. This was not a cunning strategy aimed at selling effectively; rather, sellers seemed genuinely interested in making buyers understand what people in Chile were experiencing. For example, Ricardo, an exile in France, gave buyers a vivid impression of the *arpilleristas'* experiences when he showed them the *arpilleristas'* handwritten messages in pockets at the back of the *arpilleras*. He would introduce these messages in such a way as to encourage the buyer to feel what the woman was experiencing. He also pointed out spelling mistakes in the messages to convey to buyers that the *arpilleristas* were real people who suffered deprivation and so had little opportunity for an education. These messages made a substantial impact on buyers, he said:

> And also, behind each *arpillera* there was a little envelope written in their handwriting, often with their spelling mistakes, in which they would explain. So when I was selling, I would explain to people, "Here is a message from the person who made it, which will tell you what they felt when making this *arpillera*." So I would explain it to the person, and it made a big impact. It made a big impact to the person buying the *arpillera* because there was the handwriting of the person who had made it. "Look," I would say, "this is written with spelling mistakes even, and it's a person who has had little access to education and is expressing what they are feeling in writing this, in making this *arpillera*."

Ricardo tried hard to conjure up a sense of the real person behind the *arpi-* 199
llera, including what they had been feeling.

He placed great importance on the moment in which the real person came
alive to the buyer, to the extent that he called it "sacred." The word suggests a
moment of connection or even communion. When it happened, people were
so moved that they would buy the *arpillera* without necessarily knowing where
they would put it, or caring which one they bought. He explained, talking first
about the postdictatorship period:

> So they don't know about the poverty that exists in Chile, they don't know about the
> huge separation between the rich, the few rich people, and the many poor; people
> in Europe don't know. So at the moment it is unlikely that they [would] be moved
> when faced with this as before, when there were political prisoners, disappeared
> people, a lot of poverty, a lot of injustice. But I think the *arpilleras* produced that
> powerful impact because they carried that message. I think that was it. For me, the
> fact of this little envelope, this little piece of paper behind the *arpillera*, for me it was
> very important, very important. It was like coming close to the person herself. It was
> not just a product where you didn't know who made it, "I don't know who made
> it," but this little piece of paper at the back, from my perspective, was tremendously
> important. That moment in which I opened the envelope and showed it, for me it
> was like something, something almost sacred. And that's how I tried to pass it on.
> "Here is the person, here is, here is what this person is thinking." I remember that
> many people bought without even knowing where, where they were going to put
> the *arpillera*, but for the principle of it. There were many people who would say to
> me, "Let's see, which one do you like?" "It doesn't matter, any one," I would say. They
> would say, "I want to buy something for these, for these people."

Ricardo's use of the word "sacred" to describe the moment when he showed
his buyer the message suggests that he considered it very special when his
buyer felt a connection with the *arpillerista* and gained a vivid sense of the real,
living person. The fact that people bought without knowing where to put the
arpillera suggests a strong altruistic and compassionate impulse and sentiment
of solidarity, which came about as a result of Ricardo's showing the message
and talking about the *arpilleristas*.

The feeling of connection that he fostered was between two distant people
with very different lives. He explained:

> I think that through the *arpilleras* we achieved a human contact that was quite, to
> repeat what I told you before, every time I opened a little envelope with a message
> about the *arpillera*, I felt that that Frenchman or Frenchwoman, and I always

remember a mother with her daughter, for example, to whom I read a message, "We don't have, we don't have enough to eat; we have to go around collecting cardboard," for example. A mother talking about it with her daughter. [. . .] And I think that, well, as a Christian I think of this thing about one's fellow man. "Fellow" means "close." But we have to come close, because it is not one's fellow man who has to come close to us; we have to be the fellow man, I mean, we have to come close to others. And I think that the *arpillera*, for me, was that. The *arpillera* was a marvelous way of bringing two people together, one who is looking at the *arpillera*, the Frenchman, far away, comfortably off, not suffering human rights violations or lacking material means, and bring him close to, close to that reality. And to speak to him and say, "I experienced that, I was a prisoner, I was in a torture center, I have been with these people who make these *arpilleras*." I mean, to humanize relations. And I think that is tremendously necessary.

Ricardo fostered "human contact" or a feeling of connection between the comfortably-off French buyer and the impoverished *arpillerista*, while also bringing the buyer close to her reality. He was influenced in this by the Christian notion of one's "fellow man." The conversation was also an opportunity for Ricardo to open up to the buyer, disclosing facts about his experiences of repression.

While Ricardo's buyers, in his view, gained a feeling of connection with the real person by hearing his words and seeing the *arpilleristas'* written messages, Olivia's buyers in Belgium experienced the same through touching the *arpilleras*. She described how her buyers reacted to the *arpilleras*:

Admiration, also admiration for the techniques, for how nice the work is, how they mix the colors together, how they mix together the textures. Also, they would touch them; they would touch them a lot. That was another thing that always . . . Because, ah, yes, there were Belgians who did not dare to touch them, and the first thing you have to do with the *arpilleras* when you exhibit them and are going to sell them, is say, "Touch, touch, touch, touch all of this; touch the material, feel in your hands the, whatever, the girl's hair, the hair, the shoes. Touch them; touch them. This is to touch." So that, also, was, it would amaze them and . . . the texture really amazed them. To touch everything that, all those experiences, because when you touch them, you live them more. It's not the same as a picture where you say, "Aha, hmm, yes, very attractive," and you have to have your hands behind your back; you can't touch the picture, the girl's hair, the . . . you can't. And you have to look at it from a certain distance, because if you look at it from close up, you see the lumps of paint. Here it doesn't matter. It doesn't matter because that's not the idea. By the way, they also liked it when I would take the *arpilleras* and enable them to see them from a

little farther away, to be able to see one as a whole. So I would do that; I would wait, and after they had come close and touched all those experiences . . . The thing about the *arpilleras* is that they are living things; they give the impression that they are living things. And if you look at an *arpillera* for a long time, the longer you look, the more vividly you feel it. And the more . . . you even start to hear the sounds, and feel the heat, the atmosphere, the heat, and so on. In one it is early morning, or it seems like midday, and so on. It's probably early morning and they have just started having breakfast; that is their breakfast, here is the sun rising up behind the Andes. You see? So you begin to feel it, and sometimes if you see a dog, you hear it barking, you hear it barking.

Olivia efforts helped buyers experience the real-life scenes depicted in the *arpilleras*, and the buyers were "amazed" as the *arpilleras* came alive for them.

That buyers really did gain a vivid sense of the *arpilleristas* and their world, as Olivia and Ricardo describe, is supported by Célestine, the manager of a fair trade shop that sold *arpilleras* in Switzerland. She described how, when she saw the *arpilleras*, she felt she could hear the women, and her emotions were aroused:

Célestine: At the beginning it was quite a well-known product. But it's a craft that is, how to describe it, emotional. It arouses a special emotion. [. . .] For me, it was always something that engaged me. And there was no need for a speech, no need for a piece of paper to accompany them. You had the impression you could hear the women in the *arpilleras*.

JA: What did they mean to you, these first ones you saw?

Célestine: It was women who wanted to tell the world, to shout out to the world, about their pain.

Célestine's phrase "women who wanted to tell the world" suggests that through contact with the *arpilleras* she envisioned real people, with things to say, and a wish to communicate. She felt enough connection with them to gauge their thoughts. The *arpilleras* roused emotions in her, as Olivia and Ricardo had described. Whether through the sense of touch, the sight and sound of handwritten messages being read out, the visual images in the *arpilleras*, or the stories that sellers told, buyers felt the presence of struggling women behind these works and gained a feeling for their lives.

Still other aspects of the *arpilleras* may have contributed to buyers gaining a sense of the real person behind the artwork. Being in cloth, rather than oil paint, for example, the *arpilleras* may have carried the look of work by real women as opposed to aura-bound artists from whom the viewer would have felt more

202 distance. The cloth and sewing made the *arpilleras* look homely, and so may have helped foster a sense of connection between the buyer and the *arpillerista*. The gender and poverty of the *arpilleristas* contributed to these effects. The *arpilleras* were made using old cloth and sacking rather than, for example, watercolor paints on paper, because the women were poor. The technique was appliqué because many *arpilleristas* possessed the traditionally feminine skill of sewing, having learned this in school and from their own mothers, as we saw earlier; they did not know how to paint.

Becoming Moved

As suggested above, part of the process that led to the buying of an *arpillera* was buyers and sellers becoming deeply moved. Many sellers described high levels of emotion. Olivia, for example, said her buyers were very moved by messages of a personal nature in the *arpilleras*, and she clearly was as well:

Olivia: There was one where there were, I think the political prisoner's wife, his partner was pregnant, because you would see a woman sort of expecting a baby. And in her belly, I mean, you would lift up her blouse, and there was a message where it said, "We are much more than two," "We are much more than two," like that.

JA: It was by a woman?

Olivia: Poetic things. Er, no, by a man.

JA: A man.

Olivia: By a man, yes; by a man in prison. Yes. Those messages were, what were they like? Like very strong slogans that are engraved on my mind. But the others said, "Here we are; we will continue to struggle for freedom," these sorts of things, very repetitive things, or saying, "Resistance is important," or "Here in the prison, they are torturing"; these sorts of messages.

JA: And in the exchange between, for example, you and the Belgian, what else would be said?

Olivia: Ah, the Belgian was very, very . . . he would listen and feel very moved, very moved.

Poetic messages about the *arpillera* maker's family life moved her buyers, and they also moved Olivia deeply.

It was partly this emotion that pushed buyers to buy. I asked Olivia:

JA: And what else would they say, in front of you?

Olivia: Well, they were full of admiration, very moved. [They would say] "I will do this for my children," as I say. Others would say, "Ah, how powerful, yes, I want to take this one because I want to put it in my bedroom," for example, "to see it, to be sharing this situation." Even the terrible things, because sometimes there was much more color in

terrible things, with, like putting in the black cars, and putting in the night, but there were the stars, there was the moon, so this aspect of between life and death.

The use of the word "powerful" and the desire to share in the experiences depicted, even hanging the *arpillera* in the intimacy of one's bedroom, suggests that buyers were emotionally affected and felt considerable empathy.

Part of what made the buyers emotional was the sellers' presentation of the *arpilleristas* as impoverished mothers who were struggling to feed their children, as we saw above. The sellers would explain some of the *arpilleras* in such a way as to draw this out, albeit not with the intention of manipulating buyers into buying. We saw above how Olivia described the community kitchens in the *arpilleras*; her words show her constructing the *arpilleristas* as mothers with hungry children, whom they were working hard to nourish. Some individuals were so moved that they responded by asking whether these children were up for adoption, Olivia said. Buyers responded emotionally to the fact that it was women trying to keep their family going in the midst of poverty, who made the *arpilleras*.

In other ways, too, the *arpilleristas*' gender encouraged buyers to buy. The *arpilleras* depicted the experiences and suffering of shantytown people as seen through women's eyes, and these experiences were sorrowful to behold; common images were the arrest of children and husbands, the women's search for them, their husband's unemployment and alcoholism, their children's hunger, and the measures the women were taking to earn some money with which to feed the family. The used cloth of which the *arpilleras* were made and the use of sewing as a technique communicated the gender of the *arpilleristas*, and hence the worthiness of these beneficiaries of buyers' money, as women and mothers. The spelling mistakes and unrefined handwriting reflected shantytown women's limited resources and opportunity for an education, and this "made a strong impression" on buyers, as Ricardo explained. These gendered features of the *arpilleras* contributed to moving buyers deeply.

Linda, in the United States, reported that sellers made it clear to buyers that it was women in Chile who were being supported by the sale of *arpilleras*, and that these were poor women, women in community kitchens, and women in the families of political prisoners or the disappeared:

> They went all over the country, selling, and their point was that they got it directly from the community and the money went back, and so it was really not about making a profit. It was about supporting the community. It was like a fair trade community support network. And it was very much about agitating and advocating for the women, and it was women, very clearly the women, who were being supported.

JA: How do you know that, for example?

Linda: Well, that was part of the message of these . . . that these were made by the women of Chile, poor women, women in the community, as I said, women in the community who had community kitchens; it was the kitchen community, it was the wives or families of political prisoners, of the disappeared, and then maybe this [category of] poor women, and then another category of unidentified women. So I mean people . . . it was basically supporting women's industry. Which is different, because there was also a whole set of items that were made by political prisoners.

Sellers made it clear that the sale of *arpilleras* would support women. Likewise, Belinda, in Switzerland, described the *arpilleras* to sellers as being by women. She talked about the women as she sold, and when some potential buyers said that some of the *arpilleras* were too violent, she reasoned with them, explaining that they were violent because they reflected the reality of the women's experiences.

The Moment of Sale

After the seller and buyer had been talking for some time, the buyer would ask the price of an *arpillera*. This moment felt dissonant to Olivia, who had been wrapped up in the *arpilleristas'* world while she was talking. She preferred to put the price on the wall, next to the *arpillera*, so that buyers saw it and paid without asking:

Olivia: Well, I would pick them up, they would look at them, and then when they were . . . ah! Usually there was a part that was the most unpleasant part, which was the price. Because as, because at that point you sort of [makes a sharp sound with her hands] . . . At the beginning you are off in another world, you are telling the story, and all the romance of it, and suddenly [makes a sharp sound with hands], "Yes, it costs ten francs." It's very violent. So to avoid that we would display the price; they wouldn't have to ask. There were even people who didn't ask, who saw the price, and took the money out, and paid. Without saying, "Ah, and this costs?" And it wouldn't occur to them, either, to say, "And can it be cheaper?" Yes, you could give them a good price if they bought five. Instead of fifty francs each, yes, they would ask you and, and you would see if it was worthwhile, of course.

JA: How many would they take, usually?

Olivia: Two, two, two.

The dissonance Olivia experienced shows how involved she became in communicating about the *arpilleristas'* lives. The buyer would not normally negotiate unless they were buying more than one.

If a couple were buying, they might debate a little about which *arpillera* to buy. Olivia said:

> Sometimes you could tell, when it was a couple, that there was some discussion about which one to buy. "I like this one," "I like that one more," "But this one is more interesting because of this." "Yes, but that other one has this thing that is more attractive, more romantic," and so on.

Olivia's words suggest that couples were drawn to how interesting an *arpillera* was and whether there was something attractive or romantic in it.

Trust was crucial in the buying process. Buyers of *arpilleras* bought because they trusted that the person selling the *arpilleras* would not use the money for him or herself, but rather to send back to the women in Chile, who really needed it. This trust enabled the *arpillera* system to function. Hélène said, for example, that people bought knowing that the money was not to make the sellers richer, but for the women and to send to Chile. Even when the person selling the *arpilleras* had made them herself and was going to keep the money, buyers still trusted that she was not abusing their confidence but needed the income. Olga, an exile who supported herself in part by making and selling *arpilleras*, said:

> So they [buyers] would do it [buy] knowing that no one was making themselves rich, but rather that it was to support yourself any way you could.

Trust that the money spent would be used by people who were victims of the regime and really needed it enabled the buying of *arpilleras* to happen.

Buying an *arpillera*, then, was the end point in an interaction between buyer and seller, which began with buyers approaching the stall because of its attractive features, then being drawn to the *arpilleras* and asking the seller questions about them and about the situation in Chile. The seller would answer their questions, and sometimes a discussion about Chile would ensue. During this process, the buyers gained a vivid sense of the women and their lives and a feeling of connection with them; their emotions were aroused. Finally, the buyer would ask or notice the price and pay for an *arpillera*. Buyers bought *arpilleras* primarily to help the women but also because doing so benefited them in some way. The fact that the *arpilleristas* were women contributed to buyers' willingness to buy, and trust in the sellers enabled them to buy with confidence. Many buyers put their *arpillera* up on the wall at home; some even framed them.

The selling process was different when primary sellers sold *arpilleras* to secondary sellers. Sam, the primary seller in Britain, preferred selling directly to

206 the public, as this entailed having a conversation about Chile. The interaction between secondary sellers and buyers was also different from that between primary sellers and buyers. If the secondary sellers were organizations or shops, there was sometimes less exchange of information from seller to buyer. When the secondary seller was a person who sold to the public, there would also be less conversation and exchange of information, in part because the secondary seller was not necessarily well informed about Chile. Secondary sellers' work with the *arpilleras* had the character of a more commercial transaction. The next chapter examines the selling and acquiring of *arpilleras* as shaped by repression, danger, and the absence of freedom of speech.

8 Selling, Giving, and Exhibiting *Arpilleras* in Chile

SELLING IN CHILE

Only a few places in Chile sold *arpilleras* during the dictatorship. The Vicaría headquarters had a room where it sold some, along with crafts made in prisons, and the eastern Vicaría office sold *arpilleras* occasionally. The Fundación Missio, a Catholic organization, sold *arpilleras* made by *arpilleristas* in northern Santiago. These venues benefited from some protection due to their affiliation with the Church. Others, however, did not. In early 1976, the owner of a gallery in the neighborhood of Bellavista began selling *arpilleras*, as we saw earlier, and in February 1977 her gallery was bombed, while the *arpilleras* were on the walls. In the late 1970s, a shop in the middle-class neighborhood of Providencia also began selling *arpilleras*, resulting in a negative article in the Chilean press. Hence the repression affected where the *arpilleras* could be sold.

It also affected the way the *arpilleras* were sold, as sellers had to take measures to lessen the danger involved. Rita, the gallery owner, for example, did not advertise or make invitations when she sold and displayed the *arpilleras*; as mentioned previously, word simply got around. Despite the protection that Church affiliation afforded, the Vicaría headquarters staff felt they must be careful when selling from their premises. They chose a room well inside the building that did not look out onto the street and did not advertise the fact that they sold *arpilleras*, although when an article appeared in the first issue of the Vicaría bulletin *Solidaridad*, this served as publicity, according to Hilaria, the Vicaría lawyer who fostered *arpillera* making. The article did not mention Hilaria's, Anabella's, or the *arpillera* group's names, although it discussed their work. Because agents of the secret police would come and see what they had for sale, posing as buyers, the Vicaría staff displayed only the more innocuous

208 *arpilleras*, keeping the more sharply denunciatory ones hidden and only showing them if they judged that the potential buyer was not a secret police agent. Roberta described these precautions:

Roberta: And in Talleres we had a place, and people from the CNI or DINA[1] would come and visit us there; they pretended to have come to buy. And obviously we wouldn't have those *arpilleras* in view. So, but there was always a stock of *arpilleras*, sort of so that people who wanted to go and buy them at the Vicaría could see them. So there was a stock of denunciatory *arpilleras* that were stored away, and others that were more, more normal. Yes. But we wouldn't say to the *arpilleristas*, "Now don't do these ones"; no, no.

JA: When you say "more normal," what . . . ?

Roberta: I mean, in the sense of more innocuous; that's what I mean. With the little houses, the sun, the mountains, the little trees, you see, that sort of thing.

JA: And without a political theme.

Roberta: Yes.

JA: And this was even in the years . . .

Roberta: The whole time.

Hiding and selective display were the strategies employed. Roberta continued:

And later, in the selling we did here, usually gentlemen would visit us from the service—from DINA or the CNI. So they would go to buy things, but obviously you would realize that these gentlemen were not going to buy, they were going to see what you had, to ask questions. And it was a source of a lot of tension. You couldn't have all the products in view. I mean that really was one, one of the really big sources of tension.

The Vicaría staff were afraid of what could happen. The repression, then, affected where and how the *arpilleras* were sold, and how the sellers felt.

Buyers in Chile, who included both foreigners and Chileans, tended to want *arpilleras* with political content. Many tourists and other foreign travelers went to visit the room in the Vicaría and buy *arpilleras*, wanting the more sharply denunciatory ones.[2] Buyers who came to Rita's gallery were connected with the Vicaría, embassies, or the human rights community; we discussed what they wanted:

JA: Do you have the impression it was like a souvenir, or was it something deeper?

Rita: It was something deeper; in fact, they were looking for the ones with more meaningful

content. It wasn't a souvenir. They wanted sort of what was happening in this country, basically, and that applied to people from all over the world.

Buyers were interested in events in Chile, and their choice of *arpilleras* reflected this.

Foreigners and locals also bought *arpilleras* directly from the women, finding their way to their workshops, usually via the Vicaría. The women were careful, only allowing people who were considered safe to come and visit them. When foreigners arrived at the workshops, they usually wanted to know about the groups and about *arpillera* making, and so would ask questions, sometimes take photos, and then buy. Some continued to order *arpilleras* from the women after returning to their home countries. The *arpilleristas* allowed these visitors to come to them in the hope that they would buy their work, since they felt that the Vicaría did not buy as many of their *arpilleras* as they would have liked. Babette, an *arpillerista* in northern Santiago, for example, said that the search for new clients was "a continuous task," and receiving visitors and showing them their work was part of it:

> In the middle of the dictatorship we welcomed many people, many foreigners who would come. So you had to put on many exhibitions, tell them about what the *arpilleras* were about, and what I am doing with you. So that was a way to be able to sell, when people came from abroad. As well as via the priests, there was an opportunity to sell *arpilleras* via the people who came from abroad and would buy them.

Receiving visitors was not risk-free, but the women took the risk because they were very eager to earn more money for their subsistence.

The Chilean buyers tended to be leftists sympathetic toward the poor and politically persecuted, and toward resistance efforts. When they bought from the Vicaría, they knew they were buying products made by unemployed people.[3] Some of these Chilean buyers were about to go abroad and wanted an *arpillera* as a present. Others had a friend or family member who was about to be exiled, or was already in exile, and wanted a gift for them. Many bought *arpilleras* to send abroad to exiles because the *arpilleras* symbolized the values of the resistance community. Lilly, a Vicaría employee, said:

Lilly: Chileans bought *arpilleras* to send to people abroad. At the time of Pinochet there were many people in exile. Because it was a symbol.

JA: What sort of people bought?

Lilly: Left-wing people, sensitive people.

210 Chileans who wanted to support those suffering under the regime and re-
sisting it bought *arpilleras*. Another category of Chilean buyer was Chileans
living abroad as spouses of exiles. They could travel to Chile, and during
their trips they would buy *arpilleras* as gifts for exiles and other friends in their
host country, sometimes in response to these friends' requests. Macarena, the
wife of a Chilean exile in Switzerland, came to Chile and took back *arpilleras*
as gifts, and Nadia, who lived in Canada, bought some for friends in Canada
who had asked her to do so. Both types of Chilean buyer, like the foreigners,
tended to be anti-regime and sympathetic toward its victims.

THE GIFT OF AN *ARPILLERA*

When *arpilleras* exchanged hands in Chile, it was often as a gift. For the staff of
the Vicaría, the *arpilleristas* themselves, priests of the churches in which the *ar-
pilleristas* met, relatives and friends of exiled individuals, and other members of
the anti-regime community, the *arpillera* was a special and favored present. Al-
though it signified slightly different things to different people, for all concerned
it symbolized suffering and struggle under the dictatorship. For all but the *ar-
pillerista*, to give an *arpillera* was to indicate one's sympathy with this struggle
and one's membership in a secret community of people who were against the
regime. Celinda expressed a Vicaría employee's perspective:

Celinda: But if you had to give a present to some . . . for example, when we had the
symposium of human rights, we had to offer presents to the participants, who came
from countries all over the world.

JA: When was that?

Celinda: In 1978. You would give *arpilleras*. When . . . I remember murals, big murals. It
might have been when, for example, when the pope came. I am thinking of sort of big
events, like that, like important international visits. And not only an *arpillera* but . . .
afterward we would laugh, even today we laugh, because someone will say, "I can't
believe it, they almost certainly gave him an *arpillera*." Because it was like if [Spanish
flamenco guitarist] Paco de Lucía came to play for the employees of the Vicaría, we
would give [him] an *arpillera*. If, for example, [the Spanish singer] Joan Manuel Serrat
came, they gave him an *arpillera*. It was like, it became like a symbol, right, of a . . .

JA: Of what?

Celinda: Of the resistance. I don't know if of the resistance, but definitely of the political
situation we were living through at that time. It was a mixture of, of suffering with ar-
tistic expression. It was the suffering of these people who were . . . and who sewed things
that also had the positive connotation of being made out of remnants that did not cost
anything, that didn't cost money, that were not a symbol of consumption, shall we say.

Celinda's words express that the *arpillera*, while serving as a gift for important
visitors, was also a symbol of the political situation, an encapsulation of suffering
and artistic expression, and an embodiment of alternatives to consumption.
The gift recipients whom she mentions were people whom the Vicaría staff
would have thought of as sympathetic to the anti-dictatorship struggle and
human rights, be they dignitaries or artists. The Vicaría would order *arpilleras*
from the women in preparation for their visit; when the pope came in 1987, for
example, they ordered one for him.

The *arpilleras* were also a way of paying homage, expressing nostalgia, and
recording an important moment. Hilda, also a Comité and Vicaría employee,
described:

Hilda: It was often a present; I mean, for example, if the church was having an anniversary,
the women would make *arpilleras*. About those people who were in the church. Or if
the Vicaría was celebrating something, the women, the organizations would make a
collective *arpillera*. When it was your birthday, they would give you an *arpillera*. It was
also sort of a way of paying homage, you know? It could be nostalgia. It could be like a
photograph. Very varied.

[...]

JA: Were there public events with *arpilleras*?

Hilda: Yes, I think so. I remember an anniversary of the Vicaría when they brought
arpilleras. But what I remember most are these birthdays, parties, where people would
give you one, you see?

The *arpilleras* were presents that the women could afford, but also expressive
of joint membership in the resistence community. The *arpilleristas* gave *arpille-
ras* to their local priest, to the Vicaría as an institution, and to particular Vicaría
staff members on special occasions, such as their birthday, the anniversary of
their church, an anniversary or celebration in the Vicaría, or the departure of
an exiled employee. They also gave *arpilleras* to NGO staff who worked with
them, and to certain sellers of their work.

For them, the giving of an *arpillera* held still other meanings. It was often
an expression of gratitude or friendship, and a commemoration of time spent
working together. When the Vicaría employee Lilly left the Vicaría and created
an NGO, the *arpilleristas* who had worked with her gave her an *arpillera* about
her work setting up women's schools. *Arpilleristas* gave the French seller Claude
an *arpillera* in gratitude for his efforts to sell their work, and sewed onto it
words of thanks. The Agrupación *arpilleristas* gave Rita, whose gallery was
bombed, *arpilleras* to express their sorrow and solidarity. Rita said:

That day, they organized an exhibition of solidarity, after this happened in the gallery; in a gallery for all artists, in the Chilean–North American Institute. It was a terrible day for me, that period. And the groups of women, relatives of the disappeared, arrived, and they gave me about six *arpilleras* about everything that had happened in the gallery. I have three; unfortunately I don't have any more. They also got destroyed; it's such a pity. But it is very lovely; you can see the cars coming, the guys throwing the bombs. So it was an act of support. They were relating everything that was happening to them via the *arpilleras*; that was the beautiful thing about them, and with an important artistic component.

The *arpilleristas'* gift was also, very likely, an expression of their gratitude to Rita for having helped sell their work. The institute where the new exhibition took place was a safe venue because of its connection to the United States.

For the recipients of these gifts, the *arpilleras* held special significance, sometimes aroused strong emotions, and were highly valued. The Vicaría employee Gertrudis felt deeply moved when the relative of a disappeared person gave her an *arpillera*, and she kept it carefully "folded up and put away," because it made her "want to cry." Hilda took two *arpilleras* with her into exile, given to her by the *arpilleristas* with whom she worked, even though she was probably limited in terms of how many possessions she could carry. Two decades after the bombing, Rita still had some of the *arpilleras* the Agrupación *arpilleristas* had given her, which suggests how meaningful they were to her. In 2006, Claude and Hélène still had the *arpilleras* the women had sent them some thirty years earlier.

For Chilean exiles who had received *arpilleras*, these gifts were an important part of their lives. When Hilda left for exile in Mexico in 1981, the two *arpilleras* she took with her signified a group of people working against the dictatorship, were like photos, and were a "piece of Chile":

JA: And for you what was the deeper meaning of the *arpillera*?

Hilda: Many things. I was in exile between '81 and '85. You would see how abroad there wasn't a single Chilean who didn't have an *arpillera*. And I brought along my *arpilleras*. I mean, it was sort of impossible to think that you were not going to take them along, you understand. It is like . . .

JA: Why did you take them?

Hilda: Because they were a very important symbol. And because they gave them to me. When I left, they gave me one called—that was sort of about exile. They made one that was a farewell, in a bar, really nice. So I had that. I had another one from Puente Alto that showed, sort of, what our work in Puente Alto had meant. I had these two in my house in exile. And everyone, if you like, who was left-wing, had an *arpillera* in their house. Everyone. I mean, it was sort of a way of valuing creativity perhaps, but

also working-class organizing at the time; a symbol, a very important symbol. I think
part of it was that it meant, for many women, some type of income at a certain point
in time. But that was one side of things. The other was how it became a symbol of a
fairly large collection of people who, at that time, were working socially against the
dictatorship. You see? That was sort of the key thing. I mean, for you to take this with
you—I took it with me, but there were people who had been in exile for many years
abroad, and who didn't know the process of the *arpillera* but their relatives or friends
had sent them one. [...] This happened in Europe, everywhere. I was in Mexico. [...] I
never was a specialist in the *arpilleras*. I was involved tangentially, you see? Nevertheless,
as I say, I went into exile with my *arpillera*. All the same. I say, "It's my *arpillera*."
JA: Why did you take it with you?
Hilda: It was as if I were taking some photos with me, you see? A very important photo. It
was a symbol. Taking with you a small piece of Chile.

Hilda emphasizes the symbolic value of her *arpilleras* and their emotional sig-
nificance. Her seeing them as important photographs and a piece of Chile sug-
gests that they were transitional objects or links with home, her earlier life, and
the people in it. "All left-wing Chileans," according to Hilda and other exiles,
had one in their home. The *arpilleras*, as gifts, then, represented the resistance
community's understanding of Chile as a place of suffering and resistance, and
embodied this community's sorrow and its wish to keep struggling to end the
dictatorship.

EXHIBITIONS IN CHILE

Arpilleras were exhibited in Chile on several occasions during the regime, but
cautiously. When the *arpilleristas* or Vicaría staff were the organizers, they chose
"safe" or "hidden" venues and displayed the *arpilleras* with care, conscious of
the danger involved. Some exhibitions were "*escondidas*" (hidden), according
to Anastasia, an *arpillerista* from eastern Santiago; one was held in the Theater
El Ángel, a place that she described as being "like in an underground."[4] At this
exhibition there were both "strong themes," such as shantytown raids, and
milder themes such as community kitchens, learning to read and write, laundry
workshops, kindergartens, *rondas*, and kitchen gardens. The *arpilleristas* would
display the milder *arpilleras* on top and the strong themes below.

Exhibitions also took place in venues that were not hidden but still
considered safe. The Casa Canadá (Canada House) was one such venue, as it
was linked to the Canadian consulate. There, the women felt they could exhibit
any sort of theme, but this still involved some danger, in that they risked
being caught with their *arpilleras* in the street on their way there, and could
be arrested if this happened.[5] A number of other exhibitions were held at safe

214　　venues connected with foreign governments, including the Goethe Institute (a German language and cultural center) in later years, and the Instituto Chileno-Norteamericano (Chilean–North American Institute). Church-related venues were also relatively safe. One of the very first exhibitions of *arpilleras* in Chile took place at San Ignacio, a Jesuit school in the center of Santiago, and soon afterward, another was held in one of central Santiago's colonial churches, San Francisco, as mentioned earlier. In subsequent years, the Vicaría displayed very large *arpilleras* in the corridors of its inner courtyard on the upper floor of its headquarters next to the cathedral.

Some exhibition places, such as the Mapocho Station and what Anastasia refers to as Quinta Normal, were not safe, and so the women avoided exhibiting "strong themes" there. Anastasia explained:

JA: But how were you able to exhibit during the dictatorship?
Anastasia: Secretly.
JA: Ah, they were secret exhibitions.
Anastasia: Secret ones.
JA: Not open to the public?
Anastasia: Er, for example, in the one in the Theater El Ángel, we had all kinds, every sort of theme, strong ones, not strong ones. But for that one it was like in an underground. So we had the attractive ones on top and the stronger ones below. And in the other exhibitions it was the same. In the Casa Canadá it was not a problem. The problem was if we went out to the street and they caught us, they could arrest us. But we could exhibit all sorts of themes, there, anything. And in Mapocho Station, also, we didn't have strong themes there either, or in the exhibition at Quinta Normal. But yes in the Theater El Ángel; yes, there we had exhibitions, let's say, with strong themes.
JA: And what is it that you call not strong themes?
Anastasia: Attractive things, *comedores*, literacy training, laundry workshops, kindergartens, the children's *ronda*. Those were the themes that were not strong. The kitchen gardens, all those things, let's say, that are not strong. The strong ones are the rest, what I was saying before, the raids, all that sort of thing.
JA: And those exhibitions, were they in the 1970s or 1980s?
Anastasia: I think until 1980 something.

The women chose which *arpilleras* to exhibit in accordance with the level of safety of the venue, and in venues they considered unsafe, they chose *arpilleras* that were not sharply denunciatory.

Exhibitions in places not protected by the Church or foreign governments suffered repression. As mentioned earlier, Rita's gallery was destroyed by a bomb in February 1977, during an exhibition of *arpilleras* from Conchalí and

by the relatives of the disappeared, depicting the gospel of Saint Matthew and
the Way of the Cross. In 1984, shantytown organizers in La Victoria put on an
exhibition for the inauguration of their Casa de la Cultura (House of Culture),
constructed with money sent from France. One room contained *arpilleras*
together with tools of repression used by soldiers, such as tear gas containers.
The other room contained newspaper cuttings with information about what
was happening in Chile. The building was raided the night it was opened, and
the *arpilleras* were taken away by soldiers. Francisca told me:

> After the death of Father Jarlan, some money arrived from France, to the church,
> and they bought a house with it, a house for the organizations. And later on we
> moved to that house. And that house, well, there is a whole story behind it; that
> house still exists. When it was inaugurated, in 1984 I think the House of Culture was
> inaugurated, they raided it. We inaugurated it one day, I mean, and that night they
> raided it; they broke everything in it. We put on an *arpillera* exhibition. In one room
> they put elements of repression, things you could collect, the tear gas bombs, the
> remains that were left, the pellets. All that was exhibited in one room, everything to
> do with the repression, let's say. People had collected in their homes the coverings
> that were left of the bullets, the tubes of tear gas bombs they would throw; people
> would save these. So they put all that in a room where the *arpilleras* were. In another
> room, I remember, there were newspapers, cuttings from newspapers where there
> was news about what was happening. So the soldiers raided the place, they broke
> everything, they stole the *arpilleras*; they didn't leave a single one. And something
> very strange happened. Some years ago, two *arpilleras* from that time were returned.

The exhibition was raided after barely twelve hours. Despite this, Francisca
remembered participating in several local exhibitions for La Victoria's anni-
versary, organized by shantytown leaders and numerous local groups. There
were also exhibitions in some of the other neighborhoods where the women
lived. The *arpilleristas* of Conchalí in northern Santiago and of the town of
Melipilla held exhibitions, the latter group inviting the *arpilleristas* of eastern
Santiago to exhibit with them.

GOVERNMENT AND MEDIA CRACKDOWNS

The *arpilleras* had an unintended audience in Chile that impacted *arpillera*
making considerably: the Chilean government and right-wing media. A num-
ber of articles about the *arpilleras* and their sale abroad appeared in Chilean
newspapers, which called them defamatory and described the selling of *arpi-
lleras* as unpatriotic. One of the first instances of this occurred in 1976. The
Vicaría had been sending *arpilleras* to Claude and Hélène's home in France,

216 and one shipment was discovered on its way out of Chile, resulting in an article in the newspaper *La Tercera* that mentioned Claude's address. After this happened, the French police examined his international mail. He and his wife, Hélène, described:

Claude: The packages arrived in my name usually, at the airport, and we had to . . .

Hélène: To our . . . we didn't want the words Refugee Services [their employer] because the police might be suspicious, so they arrived in our name, in Claude's name, and to our personal address.

Claude: And one day the . . . [Hélène: *La Tercera.*] *La Tercera, La Tercera*, you have seen it; you haven't seen the article? There was a double-page article, right in the middle, "The *Arpilleras* of Defamation."

JA: What year was that?

Hélène and **Claude:** '76.

Claude: So they said, they wrote, "We have followed the, the path of these *arpilleras* that blacken our country in a shameful way, and we have discovered that they end up at the home of Claude Kraft [laughing] in France." Giving the address. [Hélène: The exact address.] The exact address.

Hélène: 28 Rue du Four. It was in the newspaper.

Claude: The result was that the French police, who was at my [laughs], at my heels, and who checked my . . .

[. . .]

Hélène: We learned later, much later, that the police [Claude: All the mail.] had come to check our international mail, let's say.

The Pinochet government was unhappy about *arpilleras* being produced, and even primary sellers in Europe did not escape its long arm. The article inspired fear in both Vicaría staff and the *arpilleristas*. Claude and Hélène's words also reveal the strategies that sellers and the Vicaría used to evade repression, including giving addresses that would not arouse suspicion, and they hint at the fear that both they and the Vicaría had that the *arpilleras* would be discovered at the airport on their way out of Chile.

 The dominant left-wing print media had been closed down after the coup, and although there were alternative and opposition print media during the regime, their circulation was restricted. The remaining media were right-wing or self-censoring. In 1978, another article in the newspaper *La Segunda* said that Marxists were forcing the women to make *arpilleras* and that the Vicaría was joining in with the denunciation. There was also negative coverage on television. Silvia, who worked for Talleres, described how on two or three occasions the *arpilleras* were called "unpatriotic" on the news:

Silvia: They showed the *arpilleras* on television, some of them, saying they had found this,
and that they didn't know where these things had been sent from.

[. . .]

JA: How did they describe the *arpilleras*? Was it negative?

Silvia: Yes, it was "smuggling on a big scale." It was terrible. And also those doves that they had, some cardboard doves. And also in the *arpilleras* there often were little bags at the back that described what it was, and there were many comments against the government, obviously, and this was "*The*" big scandal. It was always "smuggling," and that sort of thing. This happened about twice on television, or three times.

JA: Was this in the news?

Silvia: Yes, yes, in the news. In fact it was incredible, because if they had wanted to, they could have closed down the shop [in the Vicaría]. But what they wanted wasn't to close the shop but to close down the Vicaría, but there was always this understanding between the Church and the military government, the dictatorship, that the Vicaría would exist. It wanted the Vicaría to help the victims of the dictatorship; it was a double game in fact, because obviously the cardinal must have said that this was here to stay, and it was going to keep functioning, because otherwise it would have been easy for them to come into the Vicaría, and look at the shop where I was working, and end it. That was very important, but also, suddenly, when they showed these things on television, they wanted to give a "warning," they were saying, "Be careful."

The government used the media to present the exporting of *arpilleras* in a negative light and, in Silvia's view, to give a warning to the Vicaría. This was one of many acts of state harassment to which the Vicaría was subject.

This news incident and the articles in newspapers produced considerable fear. The Vicaría staff were shaken, and they reacted on at least one occasion by asking the women to tone down their denunciation. They also stopped sending out *arpilleras* for a while. Such articles and news contributed to the pervasive climate of fear that made Talleres take precautionary measures, such as sending out *arpilleras* in such a way as to avoid having them checked by customs. Roberta described:

> But we had a good network of friends abroad who would sell the *arpilleras* for us. But, as much because of internal issues as the fact that they would discover these boxes in the airport, there were accusations, saying that the Vicaría was engaging in politics, that we were exporting articles of infamy abroad. It made us take many precautions, and let some time go by before sending out products.

This censure not only stalled the Vicaría's exporting of *arpilleras* for a period; it also affected the women. Hilaria, a Vicaría employee, said about the *La Segunda*

218 piece: "This event was very serious because it produced a lot of fear." Wilma, another employee, described how the women came to the Vicaría in a panic after reading one article:

> Well, so imagine how frightened these women were, as they were housewives, you see, whose husbands had worked until a certain time and suddenly became unemployed, and they had to support the household, so they start . . . I remember how once it said in the newspaper, "The *arpilleras* . . ." The *arpilleristas* arrived at the Vicaría out of their minds, "What do we do?" And a lot of fear and so on. But they survived and would help each other, you see?

The new situation the women were thrown into, finding themselves having to support their families and join groups, was bewildering enough; when they found themselves mentioned in negative terms in the newspapers, they became very frightened. Such articles intensified the fear that the women and the Vicaría already felt.

In addition to attacks via the media, other forms of harassment were carried out by the armed forces. Silvia used to participate in protests, and seeing her in a square one day, policemen said, "The gringa in the square again." When Silvia, who was English, left Chile between 1985 and 1989 and asked for a visa to return, they would not give her one at first, saying she had done things against the government. Her colleague Roberta experienced cars waiting outside her house, and said she had an ulcer for the duration of her employment with the Vicaría, which she attributed to the tense situation. Yanni, another colleague, received calls in the middle of the night and threats directed at her daughter. Other Vicaría staff members were harassed, and one, a Communist, was murdered.

Meanwhile, CEMA (Centros de Madres) Chile, a national network of mothers' centers in working-class neighborhoods, run by Lucía Hiriart, General Pinochet's wife, encouraged the production of pro-regime *arpilleras*. The shantytown women who were members of these mothers' centers made *arpilleras* depicting the coup as a glorious event. One of the directors of this organization discussed this with me:

JA: I had read in a book that *arpilleras* were being made, and many of these *arpilleras* were against Pinochet.

Marta: Ah, yes, embroideries, yes, they are embroidered pictures.

JA: Were *arpilleras* made in CEMA Chile?

Marta: But not against anyone.

JA: What was the theme?

Marta: We would call it, how do they call it, naïf. But we would say that it was very childlike,
let's say, spontaneous; it is spontaneous art. So what would they [the women] do? We
had competitions. We would say, "What is the institution like, from your point of view?"
And they, they would put down in pictures what it meant to them. "How do you view
the education we are giving your children? Do that in an *arpillera*." There are beautiful
ones; "What was September 11 [the day of the coup] for you?" The pictures were really
marvelous. I remember one; it was beautiful, I have it, they gave it to me. You saw the
dark days, the three dark years [Allende's presidency], everything in gray, a gray moun-
tain. Then September 11 began, it started to lighten up, until the sun appeared. Beautiful
things, a very beautiful allegory, very well embroidered. Of course, other people, there
was a group of people manipulated by leftists, and they would give them the materials
so that they made pictures, of course, referring to what they perceived themselves as
experiencing. It was not the truth, because they were embroidering . . . they were not
living what they were embroidering; but anyway. They thought. Of course those ones
sold a lot abroad because European countries, many of them, helped these people, often
without knowing the reality, I think, right? Because there was a lot of misinformation.
And others knowing the reality, but because they were leftists from other countries. And
leftists help each other a lot. What we thought was that things should be done honestly.
That's what we thought. That there are values that are fundamental.

Marta's words suggest that the women in CEMA Chile were turning out pro-
regime and pro–CEMA Chile *arpilleras* with encouragement from the organi-
zation, and that she saw them as countering the untruths of the other *arpilleras*
being produced. We may call such art counter-dissident art.

Buyers in Chile, then, who included foreigners, leftist Chileans, and the
spouses of Chilean exiles who came to visit, bought *arpilleras* from the Vicaría
and the *arpilleristas*. They tended to be sympathetic to the anti-dictatorship
cause and defense of human rights. *Arpilleras* were often given as gifts, and for
their recipients, they were special objects laden with political and emotional
significance. Exhibitions of *arpilleras* took place during the dictatorship, in
venues that the *arpilleristas* categorized as "safe" and "unsafe." If the venue was
unsafe, the women chose not to display their "strong *arpilleras*" openly, with
a view to lessening the danger. The government cracked down with negative
reports in the media, harassment of Vicaría employees, and encouragement of
low-income women to produce "counter-*arpilleras*" that expressed appreciation
for the Pinochet government. The first two of these measures produced fear in
the *arpilleristas* and Vicaría staff. The fact that the government reacted in these
ways suggests that the *arpillera* system was a thorn in its side. The next chapter
explores the political significance of this system.

9 The Consequences of *Arpillera* Making

THE *ARPILLERISTAS'* PERSPECTIVE

The *arpilleristas* saw their *arpillera* making as having contributed to the downfall of the dictatorship, and as having been important for their survival and social and intellectual development. From their perspective, it enabled them to inform people abroad about what was really happening in Chile, provided them with income and donations, gave them the opportunity to learn, helped them relax and forget their problems, and raised their self-esteem.

Informing People Abroad

The *arpilleras*, the women thought, were a means by which people abroad could learn about life under the dictatorship at a time when the media did not talk about what was really happening in Chile. Natalia said:

> Because it's something that you had in your hands and were working on with love, and knowing that it was all going to go abroad, and they would see the reality of what was happening in Chile. Because it was like a letter, you understand, a letter. Via this letter you were telling people how we were faring here. An open letter, something which, how can I say, something very personal but which at the same time was going over there and was going to be useful because it was going to say, "This is happening in Chile," you understand? Showing what we were experiencing. And that's why I say it was something lovely, something very nice.

Natalia's phrases "the reality of what was happening" and "how we were faring" suggest that she saw the *arpilleras* as describing a collective experience.

The "usefulness" of this refers to its helpfulness in the struggle; the *arpilleristas* thought that foreign support in this struggle was necessary, and the first step toward acquiring it was informing.

The women saw themselves as denouncing the poverty and repression, and telling people about their struggles for survival, their protests and desires. They described the contents of the *arpilleras* using the phrases: "denuncia de qué nos pasa" (denunciation about what is happening to us), "lo que había pasado" (what had happened), "lo que estaba pasando en la actualidad del país" (what was happening at the current time in the country), "era la actualidad que se vivía en esa época" (it was the situation that we were experiencing at that time), and "lo que queremos" (what we want). Nancy recalled:

So what you would do in an *arpillera* was show people in other countries what was happening in Chile. Because the *arpilleras* reached many countries, even Japan. And in them you would show, for example, the protests, the *ollas comunes*, the *comedores*, the bakeries where they would make the bread in little cans and sell them that way in order to help people. So all this was a constant struggle. So there, in the *arpilleras*, you would do the protests, when the police beat people, when they were arrested—all that. The marches of the relatives of the disappeared. So you would show all that in the *arpilleras*. And they would go to England, where else? Japan, Spain; Sweden bought a lot; Holland. And so on. European countries that also helped organizations here in Chile a lot.

The women saw themselves as communicating both their personal experiences and the wider problems of human rights violations, repression, and poverty. Babette expressed it this way:

I think that the important thing was that we took the opportunity, using this medium, to tell other countries about what our lives were like, all the injustice, all the human rights violations, all the forms of violence that it was our lot to face. And also all the "participation" that we women were engaged in.

Babette saw the *arpilleras* as communicating about the women's lives, which were traversed by the broader problems of injustice, human rights violations, and violence. While Babette evokes abstract concepts, another woman placed more emphasis on the personal, saying that they depicted their personal experience and vision, and their emotions: "You would do it as you saw things, as you were experiencing them, as you were feeling; it was at the same time your own feelings that you were depicting." She said they were trying to

222 communicate "that you were not well, and that you had to do things and you had to struggle for what you were doing, to give your children a plate of food."

"The truth" was what the women believed they were transmitting, as opposed to the lies of the regime. They felt that their *arpilleras* countered false information in the media about what life in Chile was like. Their phrases include the words "really" and "reality," as in, "what we were really living through," "they were going to see the reality of what was happening in Chile," "what was really happening around us at that time," and "the reality of what we adults were experiencing." Natalia talked about making the *arpilleras*:

> ... with great fondness, with a lot of love, because in them we were showing what we were seeing in the reality of that time, in life. That there were things we lacked, that there was no water; the bread that you had to line up for, lines for bread and so on. And also the ovens that we made; we also showed children playing, because they didn't understand at that time, they didn't understand what we were really experiencing, us adults, their mother, their father. So we depicted *rondas* (children holding hands in a circle) as well; all those children's games.

"Reality" and "really" imply "the truth," in contrast to falsehoods promulgated by the military regime.[1]

The women saw their communicating about life in Chile as effective, enabling people to learn about what was happening and making them aware of the problems that many Chileans faced. To describe what the *arpilleras* achieved they used phrases like "iban a ver" (they would see) or "dar a saber que estábamos sufriendo . . . los problemas en la población" (make known that we were enduring . . . problems in the shantytown), and the word "*sensibilizó*" (it made people aware). Anastasia, for example, said:

> The point of the *arpillera* was to show what we were experiencing. That was the point of the *arpillera*, you understand? I mean, if we were going to an *olla común*, to depict the *olla común*. If there were kindergartens, I mean *comedores infantiles*, to show that *comedores infantiles* existed. If there were people being beaten in the shantytown, to show that we were enduring those problems, shall we say, in the shantytown.

Even though Anastasia was talking about the point rather than the effect of the *arpilleras*, her choice of the word "show" suggests that people would be confronted with visual evidence about life in Chile when they saw them.

The women thought that in doing this work they had helped bring about the end of the dictatorship. As Natasha said:

Here, we have not been given any recognition, despite the fact that ours were some of the *arpilleras* that all went abroad, showing the things that were happening here, telling the story, helping the democracy at that time.

Natasha saw the *arpilleras* as helping bring about the return of democracy by communicating what was happening. Her words also suggest a strong sense of agency and the belief that the *arpilleristas* had made a positive contribution to ending the dictatorship. Similarly, Francisca expressed that the *arpilleras* helped overthrow the dictatorship:

JA: And for you, did it play a role in the resistance or not? In overthrowing the dictatorship?

Francisca: I think the *arpilleras* did, yes. The *arpilleras* were an important element, even if here they were not valued much. But they did enable many people, including Chileans who were abroad, to become aware of what was happening. And they were a means by which financial resources arrived to help. They would not come to the *arpilleristas*; they would come to other organizations. They might come to the *olla común*, or they might come so that a *comprando juntos* could be set up, but in one way or another they were an element that helped, that made people aware.

JA: Whom did it make aware?

Francisca: In Europe, for example; Europe especially, I feel, was where people were sort of most aware of what was happening in Chile, of what was happening in other countries, because there were quite a few dictatorships at the time.

In Francisca's view, the *arpilleras* contributed to the resistance and overthrow of the regime by making people abroad more aware of the problems in Chile and causing financial resources to be channeled there.

Income and Donations

All the *arpilleristas* affirmed that they earned money through their *arpillera* making and that this income was vital when their husbands were earning little or no money. Some saw the money as enabling their family to eat, others as enabling them to pay the bills, afford their children's educational expenses, or purchase household items that their family needed. Many used the phrase "parar la olla" (to put food in the pot) to describe what the money was most helpful for.[2] In southern Santiago, Natalia's husband was an alcoholic who spent the little he earned on drink, so she used the money from the *arpilleras* for food. After she and her husband separated, it continued to be essential for her family's subsistence:

224 **Natalia:** And explaining to our husbands that we weren't going to do anything bad; that we
were going to do something that would bring in money for the house, as well. Because,
as I say, our poverty was terrible in those days. There was no money to eat, none to buy
bread with, or milk; I didn't have any. Sometimes I would wait for the money that came
from the payment of the *arpilleras* to be able to buy sugar, bread, tea for the children.
And my children were young.

JA: What else would you buy with the money?

Natalia: Well, the milk for the children. Food, more than anything, because for clothes it
was difficult because there wasn't enough, but for food, yes; the gas, if there was no gas
left; and for when I had to go and pay for electricity or water. So all those things. And
also when I applied for this house, it cost me ten thousand pesos, imagine, at that time.
I would put a thousand pesos into SERVIU[3] so that would help me a little, to have more
points. So as I say, it was useful. The money from the *arpilleras* was useful because it was
always welcome, because precisely when I didn't have any, the money would arrive. We
would go to the workshop and Señora Nancy would say, "Okay, girls, I have the money
from the *arpilleras*," and there was a certain amount they paid to each of us. That was
how it was, with the money we made.

The money was essential for Natalia, helping her buy food, gas for cooking,
electricity, water, and part of her home. Similarly to Natalia, Bárbara from a
nearby neighborhood used the money to pay the electricity and water bills.
She said:

> And that's how I came to the workshop. And then I started to have money to pay for
> the electricity, to pay for the water.

Bárbara's words "started to" indicate that *arpillera* making brought money for
essentials, where previously there had been none.

Many women used the income for schooling expenses for their children as
well. Nancy explained:

Nancy: But for me the *arpillera* was very important in my life.

JA: Why?

Nancy: Because, as I say, I grew as a person. I educated my children with the *arpilleras*; I
paid for their schooling, I bought the things they needed for school, as best I could,
searching for where they were cheapest. So for me the *arpilleras* were very important.
[...]

JA: And what would you do, specifically, with the money from the *arpilleras*?

Nancy: With the money I received from the *arpilleras*, I would pay for my children's
schooling. I had them in school; I would buy the school things they needed, and

from time to time I would buy a cake, or something that you sometimes couldn't afford, as there was no money. And so I would take them any little thing so that they could eat their evening snack, so they were happy that I would take them anything at all. But the main thing was, for example, their clothing and the school.

Nancy used the money for school fees and materials, clothes, and food that she could not usually afford. Other women mentioned using the money for shoes for their children, wool for making sweaters, and household necessities such as a child's bed. They saw *arpillera* making as well-paid work, and compared it favorably to the emergency employment programs. Fanny earned five or six thousand pesos a month, she said.

The *arpillera* money had not only material but also symbolic significance for the women. It gave some of them a sense of self-worth, a measure of independence from their husbands, and even in some cases the possibility of escape from abuse. Babette said:

Babette: I have always really respected the *arpilleras* because they were part of our lives, they were part of our history.

[. . .]

JA: When you say part of your life, in what sense?

Babette: Part of my life in terms of agency, and in terms of the possibility I had of helping my family, of giving my children a good start in life. Eh, to stand up tall because when you have an income, you stand up tall, let's say. We ourselves say that when a woman is economically dependent on her husband, she has to put up with violence, she has to put up with everything that the family brings, because she doesn't have the choice. But when a woman has a way, economically, to protect herself, that gives her a way to stand up tall, to make others respect her, to feel worthy. So the *arpillera* also taught us to feel worthy because it also served as therapy.

From Babette's perspective, the money earned brought respect, self-respect, and agency, as well as the chance to provide for their children. For Nancy, similarly, the money brought dignity in that it had been earned in an honest way, as she put it. The income brought still another intangible benefit: it raised one's spirits. Babette described how, when the women were depressed because of unemployment, the prospect of money from the *arpilleras* cheered them up and gave them hope. The lift of mood affected not only the *arpillerista* but also members of her family. Lastly, the money provided the women with recreation. Each time they were paid, they put a little money into a fund, and with the Vicaría's help, organized activities that were enjoyable, such as day trips to the coast or a meal for the workshop.

Also important to the women was the fact that workshop membership brought with it donations. The women received donations of milk, cheese, chicken, lard, flour, soap, school exercise books, rice, yogurt, dried maize flour, and sometimes money (at the end of the year). These typically came via the Vicaría or the local priest, originating from Holland and other foreign countries; donations of yogurt came from the Chilean dairy company Soprole. The women saw these donations as very helpful for feeding their children; in some cases, they provided them with their evening meal or daily cup of milk.[4] Nancy explained:

> You couldn't buy anything; there wasn't enough money. If there was enough to buy bread or something else, there wasn't enough for meat. And thank goodness, as I say, Holland would send us milk, and that way they [our children] could have their cup of milk a day. It was not possible to give them more because you had to be measuring so that they could have food, for example, for them to have their cup of milk. Because many children would sometimes faint in school because they didn't have breakfast. So sometimes there was not enough; often they asked for one more piece of bread and there wasn't any to give them, and with pain in your heart you had to tell them that there wasn't any more left.

Nancy's words reveal a feeling of relief about the donations that enabled her to give her children milk. Her children's lack of food caused her distress, and having to deny them bread when they asked for it clearly caused her anguish. The donations reduced the women's distress and anxiety in another way as well; sometimes the women used them to make *onces* (tea) for themselves, which contributed to the warm and convivial atmosphere that made the workshop an enjoyable place in which the women could relax.

Learning
The women stressed that being in the *arpillera* groups enabled them to learn. They described themselves as having been largely ignorant of social problems and targeted repression such as the disappearances before joining the groups, although there were a few exceptions among women married to trade union or party leaders. It was upon joining *arpillera* groups, they said, that they learned about poverty, unemployment, the disappearances, human rights, the Pinochet government's policies, new legal developments, and the inadequacies of the health care system. They also learned about the family problems that other shantytown women were experiencing, about how to prevent one's husband from being abusive, about the situation of women in Chilean society, and about how to cook and do the housework better.

On the subject of poverty, for example, the women said they learned that
large numbers of people in their neighborhoods did not have enough money
with which to buy food. They also learned about the causes of their poverty,
the measures people were taking to cope with it (such as searching for food
in garbage heaps and prostituting themselves), the reasons for their husbands'
unemployment, and the extent of such unemployment. They also learned
about the poverty-related problems their workshop mates were facing, such
as not being able to afford their own home and having to put up with com-
plaints from parents with whom they lived. Francisca, in southern Santiago,
described:

Francisca: You develop a social consciousness, more than anything, a social consciousness
of justice. I acquired a lot of knowledge during that period, so I learned a lot.
[...]
JA: When you say social consciousness, what does it mean?
Francisca: Well, being aware of the reality, knowing that we were living in a period of
injustice in the country. That our values were not being given recognition, that there
were a lot of things that we were lacking. It was learning, also, to see that if the husband
was without work it was not his fault, but rather because there was no work; that the
state was not capable of giving work to people, that companies closed down. We also
had to learn how to talk about all this. During the dictatorship, many factories closed
down and the owners took their money abroad. So we had to talk about all this, to learn
about it, to learn that it was not the fault of ... because sometimes, when the husband
is unemployed for a long time, the wife tends to blame him: "You are lazy, that's why
you are not working." [Pause] So to see that this was not what was going on. What was
going on was that what was happening in the country had repercussions in the home.
So I think that the fact of getting out of the house was good, because women opened
up to another world, to another vision, to another way of seeing life.
JA: Did you open up to another vision as a result of doing this?
Francisca: I think so, because even today I am organizing, organizing things and always
trying to ... [Pause] I moved toward the issue of women, toward the issue of women's
rights.

Francisca's words point to her developing a sociological imagination, that is,
seeing the links between her family's problems and wider social forces and
coming to understand that what they endured was an injustice.

On the subjects of repression and rights, the women said they learned
about the existence of political prisoners, disappearances, torture, people
being arrested in their homes and taken to the National Stadium, the extent
of shantytown raids, and violent acts by soldiers. They learned, furthermore,

228 about the concept of human rights and the thirty articles of the Universal Declaration of Human Rights. Anastasia and I discussed this:

JA: For you, personally, what did this work mean to you?

Anastasia: For me, the *arpillera* meant a lot of things, because I was fulfilled; I acquired knowledge that I had been ignorant of, about what was happening outside, about daily life, let's say, about some workmates, because I had no idea what was happening.

JA: Like what, for example?

Anastasia: Eh, the torture, the political prisoners, the disappeared. Because, as I say, even if my husband was arrested, it was nothing compared with what other workmates suffered. I might have stayed shut up in my house, and what happened to me happened, and I might have just shut myself up. But it helped me to learn to make *arpilleras* and to, and to feel the meaning that it had for me, because it enabled me to develop as a person and be able to express my feelings. [...] And to know about things that, sometimes, you are shut up in the house and don't know about. You don't know what is happening in the world outside.

JA: And these things, did you learn about them from your workmates?

Anastasia: From the moment I joined the workshop. From the moment I joined. And I joined the workshop after my husband was arrested.

Anastasia learned about different forms of state violence and the experiences with repression that her workmates were having. She was grateful for this learning, and some of it made her feel that her own problems were not as serious as other women's. The *arpilleristas* also thought of themselves as having learned about legal and policy developments, such as new policies regarding funding for schools, changing laws regarding work and human rights, the 1980 Constitution,[5] the significance of the plebiscite, and even how to vote. Laura told me, for example, that just before the plebiscite they learned about not having the right to vote, and how to vote, while Nancy said that they learned how elections worked and how to "start a democracy."

 They also learned, the women said, about marital problems and how to cope with them. Workshop conversation included talk about difficulties with husbands, and everyone learned from these stories. I asked Laura about this:

JA: And when you joined the workshop, why did you want to be there, and to stay on?

Laura: Because I liked it there. I liked it, and each of us would talk about our issues. So you sort of, you would learn things that you didn't know. You would learn from the others, because they would speak about things.

JA: What sorts of things, for example?

Laura: For example, to not let yourself be bossed around by your husband.

JA: You would talk about that.

Laura: Yes. That if your husband said, "We are going to do such and such a thing," and if I didn't like the idea, then, "No, we are not going to do that because I don't like it. If you want to do it, you do it." So it was those sorts of things. And to not allow yourself to be beaten, and not allow them to swear at you. All these things were what we learned there.

JA: Who would teach you that?

Laura: It was just from the women talking. They would not teach us; rather it was what they said. The husband would say, "I want to do this," and as she didn't like it, she simply didn't do it. And not so for another woman, because she said that she depended on her husband because her husband gave her money for the food and everything. And if he said to her, "We are going to go over there," she would go, even if she didn't want to, but it was because he made her. So that sort of thing. The other women said, "That's not right, they have no reason to force you; if you don't want something, that's it, you just don't want it." [. . .] And if she went to see a friend, he also wanted to go with her. So she didn't want to go with a man to see her friend. And he would wait outside for her, spying on her, as if she were going to do something bad; he would spy on her. That's what . . . these are the things we would talk about. [. . .] So all that was painful for the women, it was painful for them because on top of all this they were not living in their own homes. And for the children to turn out bad, because they didn't want to go to school. All that was what we talked about there. But just among ourselves, not outside; the comments would not be repeated outside, because it was very clear that what we said there was just for ourselves, to learn more than what we knew.

Workshop conversation taught the women in Laura's group about problematic husbands, abuse, difficult children, and how to deal with some of these problems, and her words make clear that the women valued this learning. Other sources of such learning, the women said, were talks and courses given by the Vicaría and feminist organizations, and *jornadas* (meetings or training sessions lasting up to three days) organized by the Vicaría.

Relaxing

Arpillera making enabled the women to relax and forget their problems, they reported; many said it was "like therapy." Both the work and the workshop conversation produced this relaxation. Natalia said:

> As I say, I am very grateful, I liked doing it; it was something I liked. I liked doing it, because for me it was something that . . . as I say, therapy, relaxation. Because sometimes I would start doing it, and then with the work that I was doing I would

230 forget about the problems, about everything. When the day for the workshop came, at three o'clock I would go . . . we would start at three and go until six; sometimes we were there until seven, something like that. And we would talk about everything there. Sometimes we would have tea as well; yes, we would have tea. So we had a good time. Even with our poverty, our deprivation, everything that was happening here in Chile, in the country, we nevertheless had a pleasant time.

The work made Natalia forget about her problems, and the workshop meetings were an enjoyable interlude. Teresa, too, found that *arpillera* making "relaxed her nerves," although she also suggested that it could be a source of frustration:

JA: What do you feel you gained from the workshop; I mean, what did you gain, personally?

Teresa: The *arpilleras* are very useful; they are useful for relaxing you from your nerves, they are useful for so many things. And the money, when it comes in, is also useful. They are useful for many things. And you like making them. You do it out of pleasure, when the *arpillera* turns out well; when it turns out badly, you want to throw it across the room.

Teresa felt that the work relaxed her and gave her pleasure, at least most of the time.

The workshop conversation gave the women an opportunity to forget their problems, laugh, and *desahogarse* (vent their feelings, or experience emotional release). They would share their problems and receive sympathy and support, which made them feel better. Many would talk about difficult husbands and children, and not having enough money to pay the bills and buy food, and the other women would respond with sympathy and kind words. Natalia explained:

I remember how one Christmas I spent the whole day without a penny, nothing, without a plate of food to give her [her fetus], I mean, to eat myself, because I was pregnant. So these are things that you experienced directly, that you suffered; but just as we would cry, so we would also laugh. But I really had a hard time, because he [Natalia's partner] wouldn't come home; he would stay out. Imagine, I was expecting my baby and didn't even have a cup of tea. And in those years, I remember, they would sell tea bags. Not now, now they sell it by the box, but in those years they would sell big bricks [of tea] that you would buy and cut up, and they would share them out among each of us. So that's why when the money from the *arpilleras* arrived, I would buy sugar, tea, bread, all those things to give her, because there really was no money. So it was like that. We would tell each

other these things, and cry a little, and then we would laugh, and that way we had a good time.

The women would share their woes with the others, "cry" about them, and then "laugh" and enjoy themselves. Although one *arpillerista* described herself as very private, it was clearly important to many women to have others with whom to talk. Nancy said:

> And we would all talk, and there were people who said that it did them a lot of good because they felt better for talking; so that was how we lived our lives.

Talking helped ease the strain of multiple economic and family problems. Having led relatively homebound lives, the women had not normally had the experience of being part of a supportive group of women before, and they found it comforting. Even listening to the problems of others brought some measure of relief, as the others' problems were often more serious than one's own, and this would make them feel better about their situation.

The group meetings provided a few hours of enjoyment every week while taking the women away from the oppressive environment of the home and associated problems. As one woman put it, "You would have an enjoyable time." The conversation with the other women, laughter, jokes, warm environment, tea together, and recreational activities made for a few hours of pleasure during which the women were less focused on their troubles than when at home. They used the words *compartir* (talking together), "conversation," "fun," "laughter," "solidarity," "supportive," and "friendship" to describe the workshop atmosphere. Laura, for instance, talked of a happy atmosphere, and "the pleasure of being with so many women, sharing with them," and eating together. The women had meals together with money they saved, gave each other gifts, and generally had a good time amid lively conversation. Natalia said:

Natalia: For me the workshop was something fabulous, something fabulous.
[...]
JA: In what sense fabulous?
Natalia: Fabulous because suddenly we were . . . first, because I talked a lot with my work-
mates. I had a lot of contact with my children as well, because I spent a lot of time with
them; I was with both children. And we would talk, we organized get-togethers, we
would tell jokes, we had a good time. You would emerge from that trance that came
from being in the house, oppressed, thinking "My goodness, I don't have any of this,
I don't have money for that, for this other thing." So it's something great, something

lovely, something very nice; the *arpilleras* were something that, a sort of family was created in the *arpillera*.

The words "trance" and "oppressed" give an idea of the numbing pressure of household problems arising from deprivation. In contrast to this, the workshop was a place of conversation, joking, having a good time, and feeling part of a family. Nevertheless, there were other groups in which there was friction and distrust of certain members, particularly leaders who appeared to steal money or give themselves more work. Despite instances of this, with their conviviality and opportunity for enjoyment, the workshops offered relief from the many hardships the women endured.

Higher Self-Esteem

The women felt they had "developed," as they put it, as a result of being in the groups. They said their self-esteem grew, they began to assert themselves and speak their mind, they learned "how to have a conversation" with others whereas previously some had been too shy to do so, and they learned to voice their opinions and defend themselves. These developments came about thanks to the conversation with other women, the experience of earning money for their work, the new skills acquired, and the Vicaría's training in "personal development," which aimed to increase their self-esteem and self-confidence and give them an understanding of their rights. Natalia contrasted her initial fear and inability to talk to others with her newfound confidence:

Natalia: I will never forget it because it was something that, for me as a person, as I was saying, it was very useful. It was useful for coming to value myself as a person, as a woman, because, as I say, before that I did not. I was shut in all the time, I didn't have another place to go, and now it's different, I know where to go. I know that if I go to such and such a place, I have to knock on the door, and they open, and when they open, that I will be able to talk and have the words to be able to express myself, to talk. Because before, I really didn't have, I mean, I was forty, can you imagine, almost forty years old, and I didn't have any way to express myself with people. On the contrary, it frightened me to do so; I was afraid, I was scared, I felt ashamed, I would think, "My goodness, what am I going to say, what am I going to talk about?" But when they gave us this training course, training for women that they gave us, it was fabulous. It was very lovely; I really, really liked all this that I learned.

JA: Who gave you the course?

Natalia: Look, in those years, I don't really remember. But they were from the Vicaría.

JA: They were from the Vicaría?

Natalia: Yes, they would send people to train us, to give us training courses. They would talk to us, do group therapy with us; that's what they would do. So they would have us describe what we felt, what we wanted, what we desired, how we felt; so it was marvelous, because they would make all of us participate. So there you would start to lose your shame; you would start to be able to talk with others, to exchange words, conversation with your workmates. So there you would start to develop as a person.

Thanks to Vicaría training similar to group therapy, Natalia developed the confidence to talk to strangers, when previously she was afraid and ashamed of doing so and did not know what to say. Nancy, another *arpillerista*, described herself as having learned to speak out, express her opinions without fear, and stand up for herself.

The women also emphasized coming to value themselves as people. Bárbara, for example, said she came to feel that she was useful for something other than "cleaning saucepans," and to see herself as capable of meeting household expenses and providing for her children's needs by herself:

Bárbara: I started to have money to pay for the electricity, to pay for the water [thanks to the *arpilleras*]. Yes, yes. And sometimes I would be working like this, I would sew until two or three in the morning, and I would do a lot, really a lot of work. Yes, and they weren't so complicated either, as they are now. So that also helped a lot with making me feel more . . . that I was useful for something, that I could also face up to household expenses, to help my children so that they would not be deprived of so many things. So that's when I started with the *arpilleras*. And thanks to the *arpillera*, I also felt more useful; I felt I was useful for something. It was as if I discovered that I had something, that I was useful for something, for doing something. Those were the things that the *arpillera* helped me with.

[...]

JA: Why was it important to you to make *arpilleras*?

Bárbara: Why was it important? Because it was sort of to make me feel useful. To make me feel useful, that I could at least do something else, not only clean saucepans or make meals. It was sort of discovering myself in a new light. I think that it was important, because it was as if your person swelled up, to be able to say, "My goodness, I can do something different," and not just be in the house, the woman serving others.

Bárbara saw that she could do much more than housework and serving family members, and her phrase "swelled up" suggests increased self-esteem and a certain well-being. As mentioned earlier, the women also gained a feeling of dignity and the respect of others through their work.[6]

Along similar lines, the *arpilleristas* said that they learned that as women they had rights, which were being denied them. They referred especially to the right to join groups and the right to be respected and not abused by their husbands. I discussed this with Beatriz, a group leader:

JA: What training did you have in the *arpillera* workshop specifically? What training or talks and so on?

Beatriz: We also had personal development, yes, it was personal development as well. I think all of them; they were all in personal development. Why? Because all of us women felt rotten, used, terrified. If it was not because of the system, it was because of your husband, your partner, your parents, because of your mother, your brothers. And so there you had a little window of escape, which was to learn "Who am I?" and that I have rights and obligations.

Beatriz's comment that learning about rights was part of a "window of escape" echoes Natalia's description of workshop meetings as oases of pleasure away from the troubles at home and points to the extent of these women's feeling of oppression and valuing of the chance to learn.

The women described their awareness of rights as coming about thanks to courses on "personal development" and on women's rights organized by the Vicaría and a feminist grassroots organization called MUDECHI (Mujeres de Chile; Women of Chile), composed primarily of shantytown women. In one such course the women learned that they were people and should be treated as such, and that they were worth as much as men. Natalia discussed this with me:

JA: You mean the courses were more about how to make *arpilleras*?

Natalia: That's right. In addition to the course on women's rights. That was the course that was most significant for us, because there were many people who had problems in their homes because of going to the workshop. So there they told us that no, that we were people, that others had to treat us like people, that they had to value us like people, that they had to treat us like people. And that we should explain to our husbands that we were not going to be doing bad things, but rather that we were going to do something that would bring money into the home. Because, as I say, the poverty was terrible in those days. [...] But it was quite useful for me, because the thing is that there were also teachers who would teach us to be, to be people. To have our way of showing the world that we as women were people. We were not, how can I say, a man was not worth more than a woman, but instead a woman was worth the same as a man. You understand? So for me that was very useful, because these classes were done in a group; they were group classes. It made me feel better, and it made me say to myself, "I am a woman, I am a person, and I have to value myself as a person."

The training had feminist overtones, teaching as it did that women were worth as much as men and should resist husbands' attempts to restrict their joining groups. For some of it, the Vicaría, received funding from a foreign agency to teach the women specifically about women's rights. As well as through workshops, the women learned about rights at day-long training sessions (*jornadas*) organized by the Vicaría, NGOs, and MUDECHI; from talks by speakers from or invited by these organizations; by listening to the problems of other workshop members and the advice the other women gave them; and through contact with the members of the Agrupación. At a more fundamental level, they believed they learned from getting out of the house.

The women, lastly, gained a sense of themselves as doing valued and important work in making *arpilleras*. They described themselves as "journalists" or "pamphleteers," new roles for them in which they were important and had agency. In the shantytowns, *panfletos* (flyers) were often dropped on the ground for people to pick up and read, and usually contained political messages or news about upcoming protests. Francisca discussed with me:

JA: What meaning did this have for you, mainly?

Francisca: It was like making a denunciation, a denunciation that you would send abroad. You knew that they valued it abroad; abroad they valued it a lot. [. . .] Because for foreigners it was like a denunciation, it was like depicting the reality of what was happening. So we would say, "These are flyers that we are sending abroad." They were our flyers.

JA: What were they trying to say?

Francisca: What was happening; yes.

In telling the world about what was happening in Chile, Francisca saw the *arpilleristas* as denouncing, a powerful act in which they spoke up at an international level and were valued by people abroad. Other *arpilleristas* used active verbs that connote agency, such as "*demostrando*" (demonstrating) and "*mostrar*" (to show) when describing what they were doing in making *arpilleras* referring to the poverty and repression in Chile. In making *arpilleras*, they acquired a voice.

From the women's perspective, then, *arpillera* making brought them income and donations, a chance to learn, an opportunity to relax and forget their problems, and raised self-esteem. It also resulted in people abroad becoming informed about what Chileans were experiencing under the dictatorship. The women mentioned still other consequences of *arpillera* making, including experiencing the friendship and affection of workshop mates and having the opportunity to come together with other women, talk together, and have leisure

236 activities together. Also, as mentioned earlier, *arpillera* making drew them out
of the "four walls" of the home, which they considered a difficult step and a real
achievement.

Arpillera making did not have only positive consequences. Many women
talked of conflict with their husbands in the early stages of their membership in
the group, or disapproval and suspicion, and some even encountered violence
when they tried to go to a group meeting. Several mentioned poor eyesight as
a result of their sewing, much of which had been done at night. By 1995, many
women were discontented with their continued poverty and the fact that they
were no longer receiving many orders for *arpilleras* from abroad or donations;
they understood these changes as resulting from the return to democracy.
Some felt let down and unappreciated by Chilean society, as if the important
role they had played in helping bring about the end of the dictatorship had
been forgotten. However, they still felt grateful for having been able to be part
of an *arpillera* group.

VICARÍA PERSPECTIVES
A Way of Forming Groups

Like the *arpilleristas*, the Vicaría staff saw the *arpilleras* as raising awareness
abroad and bringing in money for the women. They also believed that *arpillera*
making had the important consequence of drawing people into groups.[7] As
Hilda put it, "It was a very important stimulus for organizing. There were many,
many groups." Bringing people together into groups had a number of desirable
effects, in the Vicaría's view, both for the women and for the resistance. It enabled
the women to better deal with their economic and repression-related problems
than if they worked individually, as they could help each other. It also taught them
how to act as a community and function as a group and prevented them from
becoming individualistic. Roberta, a Vicaría employee, expressed:

> The idea of these workshops was basically to organize them into groups. As a group,
> they would be much better able to deal with their problems, either vis-à-vis the
> courts, starting judicial proceedings, or with subsistence. No longer as individuals,
> but rather as a group. And a bit like therapy too. From getting together, these women
> learned to act as a community, because they were individualistic. The fact of having
> a group that meant that each one had to have one hundred pesos or two hundred
> pesos with which to buy tea, one would bring along a cake and distribute it, this
> gave them the ability to function as a group, so they became less individualistic.
> In the case of the relatives of political prisoners, it was more obvious still, because
> some mothers had no idea that their son was in a political party, and they had to
> go to a lawyer, send letters, go to the newspaper, make denunciations—all alone. By

contrast, in the group they started to help each other; those who had been in the group longer helped the newer ones with this. One of the main goals was for them to know how to organize and act as a bridge.

From Roberta's perspective, the idea of the workshops was to organize the women into groups; in groups the women would be better able to cope with their problems, help each other with what they had to do, learn to function as a group, become less individualistic, and experience a form of therapy.

Vicaría employees also saw the women's being in groups as leading to their developing a collective identity or having an already existing one strengthened and becoming radicalized. This came about through their exchanging information about their problems and coming to realize that these problems were caused by the economic and political situation, coming to define what they wanted as a group, and fighting against the source of their problems. Zoe, a Vicaría employee who then went on to create an NGO, explained:

When people come to the organization, they come alone and with a lot of sort of confusion. For example, in all that period when the husbands were unemployed, the women would come with the idea that the husbands were unemployed because they were lazy. But when they came to the group, and all the husbands or 80 percent of the husbands were unemployed, they started to realize that maybe it wasn't that. And they start to discover that there was something over and above this that created these conditions. Well, and so a whole process of confrontation would begin, which led to them asserting what they wanted. In fact, one of the things we aimed for with this training of groups was that the groups consolidate their identity. Because in organizations, the group first discovers what is outside, discovering it in the process of discovering the things that the members share. So from that they go about defining what they want: well, there is this problem of unemployment, we first have to find work so that we can then fight against what is producing this unemployment. Right, and what do we want? We want work, and what sort of work? And so in the group they discuss things, and define what the rules of the game are, and they are usually different from those that exist outside. They discover what they like, they discover that they want to go on an outing, they want to involve their children, they think that the shantytown should have such and such a thing, and so they "remake" themselves. But based on what they consider should be important, their values, their . . . basically based on their identity and traits. And, well, the *arpilleras* are also a way of reaffirming this and of reaffirming their identity, better in some cases than other forms of work, than other types of organization, but not so much, because the *arpilleras*, as you know, have to talk about the reality; well, you have to be systematically questioning yourself.

238 In Zoe's view, the groups enabled the women to realize that many of their problems were shared and that wider issues rather than personal characteristics were the causes of these problems. The groups enabled them to define what they wanted and liked, consolidate their identity as a group, and affirm their values and identity.

Another advantage of *arpillera* groups, in the eyes of Vicaría staff, was that they gave rise to other kinds of groups. Many *arpilleristas* did indeed join or create other groups, including health teams, urban summer camps, community kitchens, and bread-making groups. The Vicaría employee Wilma said:

> Now, the interesting thing is that these women, apart from sewing *arpilleras*, are involved in multiple activities. They organize outings, parties, recreational activities for themselves, for their children; they also organize health teams; I remember that many of the health teams came out of the *arpillera* groups. [...] You would find all these women sewing, but later you would find them working with children, you see, or in the summer camps. They gave rise to different organizations.

Not only did the women create new groups; they became involved in several activities within their *arpillera* group, in Wilma's view. Hilda, another Vicaría employee, told me, similarly:

JA: Did the women join other groups after having made *arpilleras*?
Hilda: Yes, the *ollas* (community kitchens for adults and children); many formed out of the *arpillera* workshops.

Vicaría staff saw the women's participating in or creating, community kitchens, and health teams as beneficial because it strengthened their ability to cope with their problems and, as we shall see, contributed to the rebuilding of civil society.

The Rebuilding of Civil Society

Vicaría staff members were deeply concerned about the fact that civil society had been weakened since the onset of the regime; groups had shut down, they noted, and people were no longer organizing. It was necessary to ask the government's permission to form an organization or even have a large gathering. They thought that by bringing people into groups, *arpillera* making contributed to the rebuilding of this broken civil society. Trini, a Vicaría staff social worker, discussed this with me:

Trini: Initially, the political, economic, [and] social crisis the country was going through, and the military coup, mean that repression was not the only problem.

The repression and institutional breakdown that happen translate not only into a loss of freedom and life but also into the loss of work and of belonging to social organizations that exist at the time. I mean, there is an end to all the reference groups that you had. For example, in the universities, student organizations cease to exist; in civil life in the shantytowns, the shantytown organizations cease to exist; I mean, any possibility is wiped out. So, and many people are fired, by the state especially. They are fired, especially those who work for the state. Private companies also. [. . .] People had lots of neighborhood, shantytown organizations. They would organize around housing, they would organize—badly, and in a mixed-up way, and they were very full of ideology, but there was the group belonging to the school, the group . . . there was an organization related to the issue of supplies of food at that time. Both well and badly organized, you see? Because they were ideological, they divided the shantytown, there were problems. Company owners had their organizations. Doctors had theirs. Some to resist the UP government [of Allende] and others to support it. I mean, there was participation [by Chileans before the coup] in an enormous number of organizations that gave you . . . and even the masons suffered, you see? I mean all the organizations were affected.

JA: Because they couldn't meet.

Trini: They couldn't meet. I mean, they couldn't meet. To organize a demonstr—, . . . I mean, a wedding celebration, you had to ask permission of the military authorities, you see? I mean, it was . . . more than three people was risky. That's why many organizations arose around the Church, because the Church was not affected in this way, so many things . . . And so organizing emerges, and with positive aspects and also complications, confusions, because people organize around the Church and people think it is for more religious reasons, pastoral, and others see it in terms of using it in a utilitarian way.

In Trini's view, civil society had been severely weakened in that people ceased to belong to organizations and could not meet or organize gatherings of more than three people. Churches, however, were not affected to the same degree, and organizations began to emerge here.

The rebuilding of civil society was no small task, in the Vicaría staff's view. People were shocked that opportunities for solidarity, cooperative work, and organizing had broken down, meaning that they could no longer turn to groups if something happened to them. The new groups that were forming, including the *arpillera* groups, were important in this context. Trini continued:

> I think that the space of the group for making *arpilleras*, and also for other things, because people also got together to make key chains, you see, was an important space at a time when everything . . . I mean, in this country there was a certain experience

240 of solidarity, of cooperative work, of organizing, you see. When all chance of this breaks down, it's a shock, I mean, it's a shock in a country where you knew that if something happened to you, you could turn to your workmates, to the shantytown group, to the children's school, you see? And all that breaks down. It disappears, and it can't be put together again. This was the beginning, in my opinion, of the possibility of surviving the very difficult moment, from the psychological point of view, from the point of view of organizing. I think it was the seed of organizations that later had a different character. I mean, it's not that that was the seed of the resistance in Chile or anything of the kind. No.

In Trini's eyes, the *arpillera* groups were an important space when other organizations had closed down.

The Vicaría staff believed, along similar lines, that the creation of *arpillera* groups fostered contact and communication between individuals, between *arpillera* groups, and between *arpillera* groups and other anti-regime groups. This helped strengthen civil society and resistance in that ideas could be exchanged and groups could support each other or work together. The *arpillera* groups did indeed come into contact with other *arpillera* groups in their own and other neighborhoods, meeting at *jornadas* (one-, two-, or three-day-long meetings or training sessions), protests, *actos litúrgicos* (Masses with anti-regime undertones), celebrations to commemorate special events, religion-oriented talks to which their local priest invited them, exhibitions of several groups' work, and *coordinación* (coordinating committee) meetings.[8] In the 1980s, subsistence organizations in the same church or zone often ended up forming umbrella organizations run by coordinating committees containing representatives from each group. Referring to the eastern zone, Zoe mentioned frequent contact between groups:

> Then suddenly Anabella [a Comité teacher of *arpillera* making] arrived and they created the workshops, but we all participated, the people in the different workshops; we would meet very often.

The various workshops in the same zone or meeting in the same church came into contact with each other, on occasions such as the handing in of work, training sessions, raffles or the selling of food to raise funds, and recreational events.

Arpillera making also led to contact between *arpillera* groups and other anti-regime groups and individuals, in the Vicaría staff's view. These included members of the Agrupación, unions or groups of workers, shantytown-based "Comités de derechos humanos" (human rights committees), NGOs and other groups of professionals, women's organizations, artists, and sympathetic

foreigners. The *arpillera* makers often took the initiative in making or contin-
uing contact, and they accompanied or expressed solidarity with some of
these groups when they were protesting and needed support. The eastern zone
Vicaría staff facilitated encounters by lending a room in which the groups
could meet or being receptive to outside groups wishing to meet with the *arpi-
lleristas*. In some instances, they organized meetings between groups, as when
they enabled the Agrupación *arpilleristas* to meet unemployed *arpilleristas*
in the Comité's eastern zone office. Zoe said:

> So the Vicaría started to bring these workshops together, so those [*arpillera* groups]
> of the eastern zone started to meet with those of Puente Alto, basically creating a
> broader consciousness of this condition of *arpillerista*. And in the process they also
> started to meet with the relatives of the detained and disappeared. Since at that
> time during the dictatorship there was no training and they were all very isolated,
> it made a deep impression on the *arpilleristas*, and they talk about it in the book, to
> meet with the relatives of the disappeared, because that's how they learned about
> all this terrible situation that these other people were experiencing that they didn't
> know about; that there were disappeared people and that it wasn't fiction, shall we
> say; that they were people of flesh and blood. And the people of the relatives of the
> detained and disappeared came to discover from more close-up the world of the
> shantytown women, and so an encounter was taking place there.

The Vicaría fostered a coming together of groups from different shantytowns
facing different regime-related problems, and in the process, the women
learned about aspects of the repression and poverty.

The *arpilleristas* also met with artists of several kinds. As mentioned earlier,
a group of student actors made contact with a Vicaría staff member to ask per-
mission to study the *arpilleristas* of eastern Santiago, and when permission was
granted, they started going to *arpillera* group meetings and helping the *arpi-
lleristas* depict figures in their *arpilleras* while at the same time creating a play
about them. The left-wing folk musician Pedro Yáñez visited the *arpillera*
groups of the eastern zone. The *arpilleristas* participated in a meeting with
well-known middle-class painters in which they compared their different
kinds of art making. The *arpilleristas* also expressed solidarity with artists in
their protests. Hence the *arpilleras* fostered contact, communication, and ties
between groups and individuals that shared an anti-regime stance, and even if
such contact was not expressly for the purpose of political organizing, it had
the potential to be politically fruitful.[9]

Meeting other groups was not an automatic process, nor was it always
problem-free, in part because of the repression. Agrupación *arpilleristas*

242 recalled that some of the unemployed *arpilleristas* were a little afraid of mixing with the women of the Agrupación. Group dynamics were also a barrier. At the beginning, according to Celinda, a Vicaría staff person, the unemployed *arpilleristas* were inwardly focused, trying to constitute themselves as a group:

JA: What was the contact between the women of the Agrupación and those of the shantytown?

Celinda: They decided at some point on a strategy, the women of the Agrupación, to have closer contact with the world of the shantytowns. So they went to see them often. They would arrange to meet, try to make contact, try to mix the issues. It was not always very successful.

JA: And in the Vicaría branch offices, how did they contact each other, concretely?

Celinda: Look, we would make an effort, often, to organize meetings directly enabled by us, but in general I would say that the groups did not connect that much. The logic is more communitarian, more closed, let's say. The group protects itself. Moreover, imagine, in a context of repression, the groups would make a protective wall around themselves. It was not so easy. Moreover, the identity . . . in general among the working class, there is the tendency to differentiate yourself from others: "We are better than that other group." So if they met, because they often used the same room, they would greet each other; sometimes we would invite them. Sometimes we would encourage, for example, the women of Lo Hermida to invite the women of the Agrupación; those of the Agrupación to invite . . . But usually I think the job was to constitute themselves as a group. I mean, if you are still working on being a group, you are not going to make contact so much with others. The group invests a lot in being a group. And women, even more so.

Group dynamics and the repression, according to Celinda, made connection between the shantytown and Agrupación *arpilleristas* less close than it might have been, but the groups did have a fair amount of contact. The creation of *arpillera* groups, then, was a step toward re-creating the organizational belonging that had existed before the coup, and the groups led to communication[10] and the formation of ties both within groups and between varied pro-democracy groups.[11]

The Preservation of Alternative Values

In Vicaría staff members' eyes, the *arpillera* groups were important in that they were spaces in which values alternative to those promoted by the regime were preserved, namely solidarity (in the sense of caring for others), unity, and democracy. The regime promoted individualism and a consumption orientation, they believed. Bertha, a Vicaría employee, explained:

Because basically the system provokes and promotes you as an individual, suggesting that you can struggle for yourself, to have your things. And the group doesn't promote that, and they [the women] promote the opposite, which is a society that is much more solidarity oriented, where you share with others, where you go and see them when they have a child who is ill, where they put together money when someone in the family dies. It's a completely different world, and I think they have kept themselves in it somewhat, in this more solidarity-oriented world, despite all that bombarding with propaganda, consumerist propaganda, which carries us all along; we haven't escaped it. But I think that at the same time, they have preserved certain nuclei of solidarity, at least in the workshops, and that, I think, has been a development or process that has been fruitful.

In Bertha's eyes, solidarity in the form of expressing concern, helping others, and "talking together" (*compartir*) had survived among the women, despite the promotion of individualism and consumerism.[12] One Vicaría employee, Hilda, saw the preservation of these values as a form of resistance:

It was a very important organizational stimulus. There were many, many groups. And basically, if you look at them today, they were all resistance groups. Cultural resistance, some more political than others, but basically cultural resistance, you see? Representing unity, staying together, the value of solidarity, of keeping a record of history. Many things, I'd say.

The values of solidarity and unity were preserved, and this was a form of resistance at the cultural level, in Hilda's eyes.

In addition to solidarity and unity, democratic values were preserved in the groups, along with democratic practices, and this was particularly important in the absence of democracy as a political system, from the Vicaría's perspective. By the late 1980s, after many years of dictatorship, the groups were spaces in which people could relearn what democracy meant. One Vicaría staff member mentioned that because the regime was authoritarian, the women in the groups tended to reproduce this model, so the Vicaría tried to teach them how to operate democratically. Scholars of popular economic organizations similarly point out that such organizations played an important role in the teaching of democratic practices to shantytown people.[13]

Creating Records of the Truth

In referring to "keeping a record of history," Hilda intimates the idea, widely held in the anti-regime community, that it was important to communicate and record the truth about the human rights violations and social problems under

244 the dictatorship. The Vicaría staff believed this truth was concealed by the government, which instead put forward another version of events, which many believed. The truth was not being heard and was not widely known. Reliable information about the extent of poverty and repression was indeed not readily available under the dictatorship. The mass media, being largely government controlled, did not adequately cover protests, instances of repression,[14] poverty, and social problems. The authors of books on sensitive topics had to be careful; they knew they faced censors and might be personally at risk. When foreign organizations and media produced information, the government denied its validity. Representatives of many human rights groups, including Amnesty International, the Organization of American States Human Rights Commission, the Red Cross, the International Commission of Jurists, and the International Labour Office, were admitted to Chile to investigate human rights violations, but as each group verified allegations of repression and torture, the military regime systematically denied their reports and alleged that those carrying out the investigations were "agents of Moscow."[15]

In an effort to inform people of the truth, both inside and outside Chile, and to keep a record about what was really happening, the Vicaría staff collected information from people who sought legal help, built up an archive, and published some of this information in the Vicaría's bulletin, *Solidaridad,* and in numerous reports that the Vicaría distributed to churches, human rights organizations, NGOs, the alternative press, and other interested groups. The Vicaría staff who worked with the women, like the *arpilleristas,* saw the *arpilleras* as an additional medium through which the truth could be expressed.[16] Meanwhile, other institutions such as research units, clandestine parties, and shantytown groups also produced alternative media.

Serving as a Symbol

The *arpillera* was a symbol of suffering and resistance, important in varied ways, in the eyes of the Vicaría staff. Different employees put the emphasis on different aspects. We saw above how Celinda believed the *arpillera* was a symbol of the political situation they were living through and of people's suffering. For Hilda, another Vicaría employee, the *arpilleras* were the symbol of a community of resistance, one that shared the same values, and knowledge of what was really happening in Chile. She compares them to the Christian symbol of a fish in ancient Rome, when Christians were persecuted. I asked her:

JA: This network, the people here, the people abroad who sympathized, what was the glue, what was the thing they had in common? Apart from the obvious thing, being against the dictator. Was there anything else?

Hilda: As I was saying, solidarity. Like all the words that mean a society that is more educated, more equal. Maybe also like the affection between us, the people who together, jointly, struggled with this; I think a lot of affection, also. I think that was the glue. The truth, the hidden truth. I mean we knew, those of the *arpilleras* knew things that were not necessary to voice, you understand? I mean, I think that the closest thing to it at that time was this symbol of a fish. [. . .] And really, everyone gave it their own symbolic meaning.

In Hilda's eyes, those who were connected with the *arpilleras* constituted a community bound together by affection and its valuing of solidarity and a more educated and equal society, as well as by the idea that they shared a hidden truth about the situation in Chile. This community, she added later, was against the regime; believed that it was important to communicate this truth about Chile to others; and valued democracy, equality, unity, and solidarity. Like early Christians in the Roman era, members of this community had to be secretive about their membership, and the *arpilleras* were their symbol, like the Christian fish.

As such, the *arpilleras* served to communicate that one belonged to this anti-dictatorship community. When a member of the community saw an *arpillera* in the house of a person they did not know well, it signaled to them that the stranger was also anti-dictatorship, solidarity oriented, and taking action to bring about the end of the regime. Hilda continued:

Hilda: But what was very clear was that it was very important, I mean the cultural aspect. I mean, beyond the economic aspect, its [the *arpillera*'s] being a source of work, which was how it started; a cultural symbol.

JA: Cultural in what sense?

Hilda: In that behind this there was much more. I mean you might be trying to think . . . when you had an *arpillera* in the house, you could assume that the person was solidarity oriented. If you came to a house where there was an *arpillera*, you felt comfortable with the person, you understand? I mean, obviously you felt comfortable because you could assume that the person had a way of thinking that was against the dictatorship, that the person was putting herself at risk in a way to end this. Friends who had left. People who had died. Very deep things.

In communicating membership, the *arpilleras* helped break down barriers and foster trust. In the discussion that followed, Hilda gave an example of this:

JA: What else, on the deep significance or what it means in Chile? How is it that the *arpillera* started to be a symbol that was so widespread?

246　**Hilda:** I associate it with what the fish might have been at the time of the catacombs. This is the symbolism, if you like: of identification, of complicity. I mean, there were times when you didn't know whom you were dealing with; for whatever reason, you established a new relationship. I moved house in 1974, for example. So you start to have new neighbors. And you have no idea who these neighbors are. I, personally, was in a very difficult situation because I wasn't living with my husband; my husband was in hiding, and so on. And the fact that a neighbor, I saw an *arpillera* in a neighbor's house, in a totally new neighborhood, it was as if, "Okay!" I felt sure of everything, you understand? That I could talk about whatever I liked there. I mean, it was that strange. So it was many things together. As if you needed very few words to know what was happening there when you saw the ...

The *arpillera* communicated, to those who knew what it meant, that one was a member of the resistance community,[17] and in so doing, created a sense of security and the possibility of more open conversation, important in a context of repression and spies.

It was partly the *arpillera's* status as a symbol that made it a meaningful gift that the Vicaría gave important people who were visiting, as we saw earlier, or that the Vicaría commissioned to commemorate an important event. Celinda explained:

> For every event that took place here, for the Day of Life, for the death of André Jarlan, for the closing of the Vicaría, the symbol was always an *arpillera*. And they [the women] would be asked, "Please, could you make a mural?"

The *arpilleras* signified sympathy with the resistance and facilitated trust and communication.

Effect on the Women

Prominent in the minds of Comité and Vicaría staff when considering the impact of *arpillera* making was its impact on the women. Primarily, like the *arpilleristas*, they saw the *arpillera* groups as providing the women with income and work at a time when they were severely impoverished because of unemployment and ideologically based firings.[18] Some Vicaría staff members thought that the *arpilleras* provided the women with money that was really crucial for their survival and enabled them to put food on the table, while others thought the income was insufficient for this and instead just a help. By the late 1970s, the Vicaría staff had come to see the *arpillera* workshops as a better means of providing the poor with food than the *comedores* (community

kitchens for children), because the *comedores*, they thought, fostered dependency, were "paternalistic," and were not "spaces of liberation," to use the phrase of one staff member, whereas in the *arpillera* groups, the women had to work for their food.

The Vicaría staff also believed that the workshops had profoundly changed the women. They had "grown" or "developed" as people. Gertrudis, a Vicaría employee, said:

Gertrudis: The fact that the women could participate in workshops didn't solve their financial problems.

JA: Why?

Gertrudis: Because it was very little money, very little money. I mean, it solved the financial problem to the extent that they were able to have money for transport, very minor things within the family's needs. But what really was very good was the psychological side, personal development; that was very good. Because at least once a week, a group of women would come together, all afternoon, to work together and talk. And we, the Vicarías in the zones, made the most of it, giving them courses on different things: women's rights, how to learn to vote—because there was no voting for a long time, there were people who had never voted, and didn't know how, how to defend their rights—personal development, and often workshops on sexuality; different workshops, with instructors from various places. And all this [was] financed by foreign agencies.

This "development" came about in part because the women had received training and heard talks on topics including personal development, human rights, women's rights, civic education, political and social rights, drug addiction, sexuality, resistance to the dictatorship, the relationship between their social class and the problems they were experiencing, social movements in Chile, the situation of women generally and of shantytown women in particular, and their relationship with their partner. Some staff members thought that their training had not gone far enough. Wilma said, for example, that it was not possible to set up a women's program in which the group would talk about sexuality, because of opposition from the Church. The Vicaría staff mentioned that the women attended talks about art and participated in plays, and they saw these new experiences as having contributed to their "growth" as well. *Arpillera* making also, from the Vicaría's perspective, caused the women to come out of the "four walls" of the home and live less isolated lives. The women came to "participate" and *compartir* (talk together), both desirable outcomes in the Comité's and Vicaría's view, and to experience *convivencia* (conviviality). Their social circle became wider as they met other *arpilleristas* and categories

248 of people they might not otherwise have met, including the relatives of the disappeared, artists, and middle-class professionals in NGOs. They formed ties of solidarity with members of the Agrupación and other groups, helped them, and even participated in protests with them. The women's worlds opened up.

The Vicaría staff emphasized, in particular, like the *arpilleristas* themselves, that the women had gained in self-confidence and self-esteem. *Arpillera* making caused them to see themselves as creators and artists, made them realize that they could earn an income, helped them understand that their work in the home was important and valuable, and made them value the more "public" space (to use the Vicaría staff's term) that they had acquired with their workshop. *Arpillera* making also, through the self-development training, made them aware that they had rights, including rights as women, and resulted in their becoming more assertive in the home, insisting on their right to participate in groups; some had conflicts with their husbands as a result. The knowledge that their *arpilleras* were appreciated abroad contributed to their coming to see themselves as important members of the community that worked to resist the dictatorship and bring about a return to democracy. To be an *arpillerista* became a source of pride, since the *arpilleras* were highly valued in the resistance community; the women acquired recognition and status in that community through their work. Hilda, a Vicaría employee, said:

Hilda: It [the *arpillera*] was also valued by the agencies. Because the European aid agencies saw in this a symbol. So when they made a very lovely book about the *arpilleras*, there was a valuing of the *arpillera*. And the fact that it could be printed, in Christmas cards, in these books; there was even a poster. It made you feel better still, like this was valued by others, valued abroad, and so on.

[...]

JA: In these groups, what was happening at a deeper level?

Hilda: Different things. Valuing oneself as a creator and artist, which was something that no one expected, as the initial motivation was to make things to sell. In every group there were some women who were more talented. When the *monitos* appeared, which was a second stage, they all made *monitos*. Discovering you had certain creative abilities, etc. Another point: discovering that you were capable of generating an income.

In Hilda's view, the *arpillera* groups made the women feel valued, come to perceive themselves as artists and creators, and see themselves as capable of earning an income.

In particular, the Vicaría staff emphasized that the women had acquired the ability to speak in front of a group, when previously they had been extremely

shy about talking. Wilma, who worked in the eastern zone between 1979 and 1986, said:

> I would go to the workshop of Villa O'Higgins once a week, so you would see the daily problems, the dynamics of the meetings, you see; so you can see how they [the women] change. I remember even today how the first thing they would say they had learned was to speak, learning to speak. Expression is the first thing they point to as something they had learned. And after that comes having a few pesos. And it's very interesting, also, because they think in terms of hierarchies, you see. "What I learned from the workshop was to mix with others; I acquired social graces," they said.

Some women, the Vicaría staff recalled, had started off too timid to speak in their group but later become their group's leader, or the leader of another shantytown group. The increased confidence with regard to talking had come about thanks to the repeated interaction with other group members, and because the groups brought the women into contact with a variety of other people, including NGO professionals, foreigners, artists, and the members of other shantytown groups. In addition to self-confidence and development as a person, the *arpilleristas* had gained knowledge of how to run groups[19] and learned to act together as a group, in the Vicaría staff's view. As we saw above, these staff members considered this more effective than working alone and thought it led to the women's becoming less individualistic.

Furthermore, from the Vicaría staff's perspective, *arpillera* making was like "therapy" for the women. It provided relief from anxiety and tensions and allowed the women to pour out what they had inside, expressing what had happened to them. Hilda said, for example, "You connected with your sorrows, your anguish, your ideals, to be able to compose it [an *arpillera*]." *Arpillera* making also enabled the *arpilleristas* to be with others with whom they could talk, and who listened, empathized, had shared the same experiences, and offered support. The groups were an environment in which the women had their needs for affection and conviviality met. They fostered friendship and strong ties even if, as the Vicaría staff noted, tensions occasionally arose in the groups because some women were "more political" than others and more eager to participate in protests. For women whose families had been the targets of repression, the groups enabled them temporarily to escape stigmatization. Trini discussed this with me:

Trini: I made sure, rather, that the women who came to see us joined a group, because I believe that it was good for them, and they could make an *arpillera*, and so on. More

than the other thing, you see? My relationship to the *arpillera* was that of a social worker more than that of an artisan.

JA: I mean how, in that sense, how did you see the *arpillera*? What did it contribute to the groups?

Trini: Well, what it most contributed was the chance to meet. I mean, from my perspective, based on what I was doing and on my work with the victims and their relatives, this was a moment of coming together. I mean, to be able to be, for one afternoon a week, in a place belonging to the Church, or in a room if they had one, making them, meant sharing what they were experiencing, bringing out the good things, organizing to know how to deal with this. You understand? I mean, I valued it from that perspective. And more than once we referred people so that they could connect with whatever, in the Vicaría, to see if they could connect with a group.

JA: And how is it that this coming together was good for them; I mean, how is it that, for you it was a positive thing, why positive?

Trini: Why positive; because at that moment, to be a victim of the repression was to be a pariah in society. I mean, mothers had to hide from their children the fact that their father was in prison, so that the children didn't have problems in school. I'll tell you about one case: in Calamá there was a massive killing in 1973. The widows were forbidden to wear mourning clothes, at a time when in the culture of this country mourning clothes were important; mourning was important. And this prohibition was so tough that the friends of these women, when they saw them in the street, would cross the street so as not to talk to them and not infect themselves; to not be victims themselves. The women had to tell their children that their fathers, who had disappeared, had gone to work abroad, so that the children would not be contaminated and put at risk. The families did this so as not to infect themselves. I mean, the initial period was very, very tough. So to be able to talk with others, to understand that what I was living through was not just happening to me, and was not because my husband had done bad things or because my son was perverse or because he was a delinqu—, . . . you understand? I mean, they were affected, the communication campaign was very powerful, saying "He was a murderer, a criminal, he wanted to murder soldiers." And when perhaps it was just that he thought differently. Especially in the first period. Later, the repression becomes focused on groups with weapons, etc., but in the initial period, just for having been linked to the government of Salvador Allende or . . . you were at risk. So that was why it was valuable that the women have a space for . . . and in those spaces they organized, they created associations, they organized themselves to pay visits, to go to talk to the authorities.

Arpillera making, in Trini's view, brought with it the opportunity to come together with others, which brought therapeutic benefits, including the chance to talk to people who had suffered the same forms of repression and to find

relief from stigmatization. *Arpillera* making also met the women's need to denounce what had happened to them when the legal system had failed them in this regard, and one staff member thought that this was comforting to them.

As well as bringing about changes in behavior, *arpillera* making caused the women to become radicalized politically, the Vicaría staff thought. Since it resulted in their coming out of the home and meeting people different from themselves, who were suffering in different ways, it caused them to realize that the dictatorship produced a series of problems of which they had not been aware. It also made them see that the policies of the regime lay at the root of their problems, rather than a personal issue such as a husband's laziness, and it helped them understand the causes and extent of repression and poverty. In one staff member's words, the women had an experience of civic education. In tandem with becoming radicalized, the women came to participate in protests, even if not all were equally keen to do so, as the Vicaría staff recognized.

From the Vicaría staff's perspective, then, *arpillera* making strengthened resistance against the dictatorship and had a profound effect on the *arpilleristas*. The *arpilleras* helped raise awareness and funds, were records of what was really happening in Chile, and served as symbols that fostered cohesion in the resistance community. *Arpillera* making was a stimulus for group formation, contributed toward the rebuilding of civil society, helped preserve values other than those promoted by the regime, and had a positive impact on the women's lives and on the ways in which the women thought of themselves.[20] In the Vicaría's and *arpilleristas'* view, then, *arpillera* making had important political and personal consequences.

TOWARD A MODEL OF SOLIDARITY ART SYSTEMS UNDER DICTATORSHIP

The case of the *arpillera* suggests that under a dictatorship, for a solidarity art system to emerge, it is necessary to have people eager enough to make the art that they are willing to risk the dangers involved, or eager and not fully aware of the danger, and willing to overcome other barriers such as gender expectations and difficulties with group formation. Severe economic hardship or harsh repression give rise to a pool of individuals willing to make art if in doing so they can obtain money or a therapeutic release from their anguish. In Chile, the desperate political or financial situation in which shantytown families found themselves, caused in part by neoliberal austerity measures, politically motivated firings by companies, and the national security doctrine, produced women willing to make *arpilleras*.

Also necessary for a solidarity art system is the existence of people willing to buy. Because of the dangers involved in openly selling solidarity art with anti-regime messages inside the country, it usually becomes necessary to sell abroad. If there has been media coverage abroad of the repression, poverty, or other problems in the country in which the artists live, and if this coverage is ongoing, this provides the primary condition for buyers to emerge: a public sufficiently aware of what is happening to be open to purchasing solidarity art. This awareness makes for a potential *solidarity market* of buyers, who might see an artwork at a stall, ask about it, be moved by what the seller tells them, and buy. In such cases, the artworks and seller's explanations "make concrete" what the buyer had heard from the news. Interest in President Allende's democratic election had been so great, and the Pinochet government's acts of violence and

repression so sensational and numerous, that foreign journalists wrote about Chile and television employees beamed images of military violence around the world in the early days of the dictatorship, such that large numbers of Europeans and North Americans learned what was happening there. The fact that Chile was already on Europeans' and North Americans' "radar screen" helped produce a potential solidarity market.

A further requirement for solidarity art systems to emerge is the existence of sellers who inspire trust that buyers' money will go to the artists. The sellers are mostly refugees from the country in which the art is made, and local human rights activists. They explain to buyers who the artists are, the conditions under with the art is made, and the meaning it holds.

It is helpful for the emergence of a solidarity art system to have the protection and support of a powerful institution with some immunity to attacks by the government, such as the foremost religious organization in the country. Such an institution may aim to assist the poor and survivors of human rights violations or wish to help rebuild civil society, and it might help set up art-making groups and sell the art as a way of doing these things. It may offer such support despite the fact that its goals may be far removed from the encouragement of artistic development, and it may offer it despite initial internal opposition, as a consequence of a series of unexpected circumstances and the determination of one staff member. If the artists lack contacts abroad to whom to send their work, this organization may have the social capital necessary to build up an international distribution system, and enough resources to pay for the initial transportation costs. The organization may also provide a means of selling in the country itself, on its own relatively protected premises. Helpful, also, are the rooms in which to meet, a sense of safety, courses, assistance with acquiring raw materials, and occasional financial support that such an organization may offer. Any moral authority, reputation as defenders of human rights, and immunity from attack that the organization might have are important because in a context in which to meet as a group is dangerous, these assets make people less afraid to join art-making groups that meet on its premises. In Chile, it was the moral authority and power that the Comité, Vicaría, and Catholic Church enjoyed that made them able to offer protection and support; they were the only oppositional organizations that the regime could not violently confront, and the *arpilleristas* trusted them.[1] Hence an institution powerful enough to offer support and protection can be very helpful in the emergence of a solidarity art system.

In addition, the support of members of the clergy living in the artists' neighborhoods may help solidarity art systems emerge. These individuals are

254 known to the artists and usually trusted by them. They can lend rooms in which to meet where the artists feel safe, help sell the art, and recruit members into art groups.

The international component of the solidarity art system may not come into place immediately. A local and relatively rudimentary way of moving the art from maker to buyer may develop initially, and later on continue in parallel with a more elaborate and international system for selling. The international selling might begin almost by chance, when, for example, the art inspires enthusiasm in someone from abroad and a willingness to help sell. It will expand with the help of a supporting organization's contacts abroad. Since some of these contacts may be refugees and human rights activists, it might be said that repression in some ways helps foster the development of solidarity art systems. However, repression also hinders their development. Because of the dangers involved, the art must be smuggled out of the country. The supporting organization or artists use a number of strategies aimed at preventing the packages from being checked by airport officials and post office staff. The small amount of art that is sold locally is sold in a semiclandestine fashion. For example, the supporting organization may sell out of its offices, keeping the more strongly denunciatory art hidden, and the artists may occasionally sell their work from "safe venues" connected with foreign embassies, "underground" places known to the resistance community, or from their homes when foreigners or sympathetic locals seek them out and visit them, and the artists have made sure that they are safe to meet.

Abroad, rather than art professionals selling the solidarity art at high-art venues, it is mostly refugees from the country in which the art is made and locals with an interest in human rights who sell. Their selling takes place at stalls they set up on church porches after Mass or other services, solidarity events in aid of victims of the regime, solidarity fairs that bring together several causes, evenings of political music organized by the refugees, talks or exhibitions about the dictatorship, universities, women's buildings, trade union and political party conferences, arts performance venues, street fairs, music festivals, and craft fairs. Sellers sell in order to help the artists; theirs are largely altruistic, solidarity-oriented motives, even if they derive personal benefit as well, such as feeling better while in exile.

The buyers, aware for the most part that there is repression in the country in which the art is made, buy for a mix of altruistic and acquisition-oriented reasons. Prominent among their motives is solidarity: the wish to give money or express support for the artists. Many buyers abroad buy as the result of a conversation with the seller, during which they learn more about the artists, the content of the art, and human rights violations under the dictatorship. Quite

often, they become moved, and it is partly this emotion that pushes them to buy. Refugee families are among the buyers; for them the art is a tie with the home country and symbolizes the suffering and struggle of many compatriots. Fewer buyers come forward within the country under the dictatorship, but these can include foreign visitors, anti-regime locals, and the visiting partners of exiles. Not all the art is sold; if it has become a symbol of suffering and resistance under the regime, it may also be a popular gift within the resistance community. Its recipients may include visiting foreigners sympathetic to the upholding of human rights, visiting artists, members of supporting organizations, supportive priests, particularly helpful sellers abroad, people about to become refugees, and refugees already living abroad. The art may also be used for exhibitions held in clandestine or diplomatic venues in the country under dictatorship, or outside it in universities, libraries, women's buildings, and international organizations, for example.

Transnational *solidarity chains*, made up of solidarity-oriented individuals motivated by the desire to help the artists and the anti-dictatorship struggle, radiate outward from the country under dictatorship. At one end of each chain are the artists. Then comes the supporting organization that exports the art, followed by a series of people involved in moving the art from the supporting organization to the airplane (although these links in the chain are missing if, as sometimes happens, the artists use the post office to send the art abroad directly). Each works in such a way as to minimize the risk of the art being discovered by customs or the police. A *primary seller* picks up the art when it arrives at its destination, and either sells it to members of the public or gives it to other people (*secondary sellers*) to sell. The secondary sellers may have *tertiary sellers* who sell the art. At the end of the chain are the buyers. Solidarity chains, then, radiate out from the artists to the buyers, who may be in several countries. Taken together, all these solidarity chains make up a *solidarity art community* of producers, exporters, sellers, and buyers centered on solidarity art.

What keeps the members of a solidarity art community working together is the shared goal of helping the artists. The members of this community feel a bundle of emotions that include sympathy for the victims of a regime and hatred and anger toward the oppressor. They possess a *solidarity orientation*, or a wish to help. This orientation is a motivation for the work of every member of the solidarity art community except the artists, who are its target. The supporting organization's staff members want to help the artists, and so may make efforts to find sellers and buyers abroad, do the work of exporting, and offer training. In the Chilean case, they had an *ethos of solidarity*, that is, a belief in the importance of helping others and promoting helping behaviors.

256 The sellers abroad, also motivated by a solidarity orientation, put effort into renting and setting up stalls, selling, and sending the money back. Finally, the buyers, wanting to help the artists, purchase the art. These solidarity art community members work largely altruistically, even if altruism confers its own satisfactions, and even if they may also aim for some benefit for themselves. The solidarity orientation is the fuel that powers the production, export, selling, and buying of solidarity art.

SLINGS AND ARROWS: ART AND REPRESSION

A regime's national security policies and repression foster the emergence of a solidarity art system. Politically motivated arrests, disappearances, and firings give rise to people who desperately need an income or wish for a therapeutic activity, and they may join art groups if this brings them money or solace. In time, they may come to want to tell the outside world the truth as they see it about the situation in their country, and this may be a motivation for their continuing to make the art. Meanwhile, the repression may motivate staff members of supporting organizations to assist by fostering the creation of more art groups and finding buyers.

Repression may contribute to bringing about a solidarity art system in still other ways. If covered in the international media, it may gave rise to a *solidarity market* for the art, people who have heard about the dictatorship and plight of its victims, and who, in buying the art, feel that they are doing something concrete to help. In the Chilean case, the violence with which the military junta brought the Allende government to an end, and the extent and sensationalism of some of its repressive tactics, attracted international media coverage and produced a large potential solidarity market for the *arpilleras*. Repression also creates refugees, some of whom become the sellers and buyers of solidarity art.

Besides contributing to the emergence of a solidarity art system, repression impacts the behavior of every group within such a system. For example, it pushes the artists to arrange to meet in a "safe place" such as a church, where they feel somewhat protected from unexpected state violence. It forces them to organize their meetings so as to be home before curfew, and if a meeting goes over time, it may cause them to sleep at their meeting place. When they work at night and at home, it may prompt them to cover their windows with blankets and use candles so that soldiers will not see that they are awake. The knowledge that their home could be raided at any time makes them hide the artworks when they are not working on them. When it is time to take their products to the exporting organization, they do so with fear, hoping that they will not be checked by police or soldiers on the way, and hiding their artworks under their clothes or wrapping them in paper. Those artists who manage to sell directly

to a contact abroad without going through an exporting organization take care
to prevent their packages from being opened by the post office, as when one
arpillerista showed the post office employee innocuous *arpilleras*, and then
made up the package in their presence, slipping the more denunciatory *arpilleras*
between those the employee had just seen. Furthermore, the repression is often
the subject of the artists' conversations during group meetings, and the artists
make it the focus of some of their artworks. The *arpilleristas* depicted soldiers
acting violently toward civilians, as well as arrests, disappearances, prisons and
prisoners, and people going into exile, for example.

The repression also influences the ways in which the staff of the supporting
organization work. In the early years of exporting, they might encourage the
artists to make art about the repression and its victims, in part because buyers
want subject matter that informs them about what is happening. However, an
instance of repression directed at the organization may cause considerable fear
and prompt staff members to ask the artists to tone down their denunciation or
even stop making the artworks for a while. Packages of the art being opened at
the airport or a negative article appearing in the press, for example, may prompt
such requests. Meanwhile, if a visitor wants to meet the artists, the supporting
organization may not freely give them their address. In addition, since agents
of the secret police may come disguised as ordinary buyers to inspect what the
supporting organization is selling, the organization's staff may keep the more
denunciatory artworks hidden and only display innocuous ones.

While exporting, the supporting organization's staff take numerous
precautions. To get the artworks onto the plane, they might solicit the help
of a sympathetic airport employee, travel sector worker, or other solidarity-
oriented individual. If instead they use the post office, they might be careful
to keep the packets under a weight that allows them to send them via parcel
post and makes them less likely to be checked at customs. They may also call
on members of the clergy to carry the artworks abroad, if such individuals are
less likely to be thoroughly checked by airport security staff when traveling.[2]
Despite all precautions, the supporting organization's staff may be harassed.
Cars may follow them, policemen may show that they know who they are, and
they might be arrested. All live with the fear that the worst could happen.

Numerous organizations may be involved in sending the artworks out of
the country, in parallel with the main supporting organization, and these, too,
adopt strategies to avoid danger. Such organizations might include associations
of victims of repression, clandestine political parties, or church organizations.
Their members, if traveling abroad, may take the art with them while also
carrying other compromising documents, and so may disguise themselves as
tourists. When they arrive at their country of destination, refugees who sell

258 the art avoid asking them questions, thinking it safest that way. Meanwhile, the traveler uses a false name by mutual understanding.

The repression's reach does not stop at the border. Even sellers abroad may endure its consequences and take precautions. Sometimes letters from the supporting organization arrive opened or are lost, or other means of communication are intercepted. Sellers may resort to using code when asking the exporter for more artworks, and especially when asking for artworks with more strongly denunciatory political content. If they make a large order, they might have the exporter send the art to more than one address so as not to arouse suspicion. If the seller's employer is a human rights or refugee services organization, the seller might avoid having the artworks sent to this address so as not to direct any suspicion to them. The dictatorship's tentacles can be long, however, and sellers may find themselves the targets of acts of intimidation or slander.

The repression even enters into the act of selling. It is a focus of sellers' conversations with buyers; sellers explain depictions of repression in the artworks and describe their own experiences with it. These accounts contribute to moving the buyers, inciting them to buy. Meanwhile, in the country under dictatorship, sellers cannot sell easily or exhibit the works without experiencing negative consequences. Gallery owners intrepid enough to show the art risk the destruction of their gallery or confiscation of the artworks. They cannot advertise that they are selling the art or exhibit it openly. When the art is exhibited, it is often in "underground" venues or spaces connected with foreign embassies. If the artists themselves sell their work, they take precautions. They may knock only on the doors of people they have been told are sympathetic to their plight, and accept visits only from people who have been "recommended." Locals inside the country under a dictatorship often buy the art to give to a friend or relative abroad who is a refugee or about to become one, and in this sense also repression (of which refugees can be a symptom) affects selling and buying.

In Chile, the power of the regime was such that its repression affected almost every actor involved the *arpillera* system, at home and abroad. Many facets of the repression were at work in this process: the national security doctrine, the national intelligence service and its arrests and disappearances, the newspapers and television stations calling the *arpilleras* defamatory and accusing the Vicaría of being involved in unpatriotic acts, companies firing leftist employees, customs officials checking the contents of packages at airports, post offices checking the parcels, secret police agents keeping an eye on the Vicaría's selling room, and soldiers raiding shantytown homes. Most insidious was repression

operating through fear, causing people to stop themselves from doing what they might otherwise do. It was fear that caused Talleres to ask the women to tone down their *arpilleras*, and fear that made women afraid to join groups or depict particularly denunciatory topics in their *arpilleras* in some cases.

Ironically, the easing of repression that comes with the end of a regime may make the selling of the artworks more difficult. Many of the refugees who helped sell or bought the art may stop doing so because they are able to return home. Local human rights activists who sell turn their attention to other countries in crisis or stop selling because the group or organization they were in closes down. Just as the pool of sellers shrinks, so, too, does the pool of buyers, for whom the country no longer represents a human rights crisis. Many solidarity chains disappear and the solidarity market shrinks. These developments pave the way for a shift in the solidarity art system, from a focus on helping a dictatorship's victims to a focus on selling products to earn money, and buying because the product is attractive.[3]

CONSEQUENCES OF SOLIDARITY ART

Solidarity art systems chip away at a repressive regime's power. The art may inform buyers about conditions under the dictatorship; when these buyers see the artworks and listen to the seller telling them about the artists' lives, they gain a more concrete sense of people's experiences and of human rights violations that are occurring. They also become moved, the sentiment of solidarity is aroused, and they want to help; buying an artwork offers them a way of doing so, hence the art catalyzes their support for the artists and pro-democracy cause. The artworks, in conjunction with the awareness-raising efforts of musicians, exiles, human rights activists, and church-affiliated persons, may also help motivate members of the public to take to the streets and put pressure on their government. Some governments may respond, as happened with France, by speaking out clearly against the dictatorship at the United Nations and granting large numbers of visas to refugees.

If the artists are low-income women living under a dictatorship, these characteristics may encourage people to buy the art. Buyers of the *arpilleras* were moved upon learning from sellers that the *arpillera* makers were shantytown mothers with children, living with repression. They were also moved by the images of the women's experiences depicted in the *arpilleras*, and by the humble and sometimes "feminine" materials and techniques with which the *arpilleras* were made. The scraps of used cloth spoke of homeliness but also of poverty, and sewing is traditionally a homely, feminine skill; these materials and skills juxtaposed with sometimes distressing subject matter were potentially

260 poignant. Buyers were also moved by the spelling mistakes in the women's written messages, which reflected the difficulty of access to an education for many shantytown women. In these ways, the artists' gender, class, and condition of citizenship living under a dictatorship may have contributed to stirring buyers to lend their support.

Solidarity art systems form the basis of transnational networks that enable *solidarity flows* of financial and moral support to the artists and supporting organizations under the dictatorship, and flows of information about instances of repression, human rights violations, poverty, and resistance in the opposite direction, to the outside world. The financial and moral support boost the ability and will of the artists and exporting organizations to continue to struggle, while the information from the country under dictatorship helps keep individuals abroad aware and arguably interested and indignant about what is happening under the dictatorship, and consequently more likely to participate in protests or in putting pressure on their government. Meanwhile, it raises the morale of refugees.[4]

Where the artists have a very low income, the financial support that flows to them may enable them to buy essentials such as food, water, and electricity, and pay for their children's educational expenses and clothing. It also enables them to keep making the artworks, thereby producing messages that continue to inform foreign publics about conditions under the regime. Some of the money remains with the exporting organization and may help pay for its continued exporting of the artworks, for courses or other forms of support for the artists, and for staff salaries. The moral support that the artists derive from the sale of the artworks abroad takes the form of a comforting sense that they and other people suffering under the regime are not alone and that the international community is taking an interest and working to help them; it is also reassuring to them to know that abroad people are putting pressure on their governments to take action to help the victims of the dictatorship or denounce the regime at the United Nations. Solidarity art, then, may help undermine a regime by creating a transnational network that enables solidarity flows. Such flows and the chains that move them along have the capacity to grow extensively.

Under repressive regimes, many organizations are banned, close down, lose membership, or are prevented from functioning normally because of fear or because gatherings are forbidden. As the Vicaría staff suggested regarding the *arpilleras*, solidarity art contributes to the reconstruction of civil society because it may be a stimulus for the formation of groups. Moreover, these groups form ties with other groups, thereby creating channels of communication and potential for joint activities and mutual support. Solidarity art groups attract other anti-regime groups that make contact, and pass on information, and

they invite each other to events, support each other, and institutionalize their alliance by forming umbrella organizations with coordinating committees. Solidarity art groups may also contribute to rebuilding civil society by keeping alive communitarian values such as solidarity, unity, equality, conviviality, and democracy, which may be contrary to the values promoted by the government.

Solidarity art's role in bringing people together into groups is also important in that the groups become a forum for the dissemination of information and discussion about people's experiences of repression and poverty, and about the scope and causes of these ills. Such information is not freely available, since under repressive regimes freedom of expression is often absent. Through hearing this information and discussing it, group members come to realize that their problems are not personal, but due instead to the regime's economic and national security policies. The information also makes them open to supporting other victims of the regime in various ways, and to engaging in other supportive, community-building, or directly anti-regime activities.[5] With the encouragement of leaders and other groups, group members participate in local and national protest activities, as when, in Chile, the *arpilleristas* participated in demonstrations, marches, and candlelight vigils.[6] This helps swell the number of people expressing dissent. Another outcome of being in groups is that group members are more easily reached by human rights organizations or other local organizations that wish to teach them about human or women's rights, help people understand the extent and causes of poverty and repression, or inform them about protests.

Solidarity art may become a symbol of suffering and resistance under the regime, and in this capacity also it chips away at the power of a dictatorship by strengthening resistance. It may serve as a secret badge of membership in the resistance community, enabling those in the know to identify strangers as being "on their side." It may also symbolize peace and a wish for the end of the dictatorship if held in the frontline of a protest march in which anti-regime groups with different causes take to the streets together. Used in this way, it clarifies the overarching point of the march and confers unity. It may, furthermore, signal to those who are against the regime but not active in resistance efforts due to fear that anti-dictatorship groups exist and are taking action; as such, it may make them think about joining a resistance organization. Abroad, it may, in its symbolic capacity, provide solace to refugees and make them feel connected with the suffering and resistance efforts they have left behind.[7] In these various ways, as a symbol, solidarity art strengthens a pro-democracy community's power to resist a dictatorship. Solidarity art making, then, is a means by which marginalized individuals with little power can undermine a powerful authoritarian regime.

Despite this fact, solidarity art that contains anti-regime images is far from a pure outpouring of dissenting thought. Its makers are constrained in what they depict and how they do it. At the most obvious level, they are constrained by censorship and repression, which make the production of subversive messages dangerous. However, they are also constrained, if they make art for a market abroad, by their buyers' wishes and arguably even more so by the dictates of the exporting organization. This organization, because it is an intermediary between buyer and seller, is able to exert considerable control over the art. It may do so through orders for particular content and form; the banning or encouraging of certain subject matter, elements within the composition, or colors; and corrections demanded at quality control accompanied by the threat of nonpayment if they are not made. As we saw, Vicaría staff told the *arpilleristas* how to "improve" their work, instructed them regarding what to put into an *arpillera* and what to leave out, had them subject their *arpilleras* to corrections, devised rules for the *arpilleras*, and set up a system of quality control whereby noncompliant *arpilleras* would be rejected. Hence solidarity art of a dissident nature is defanged by some of the very factors that enable it: the presence of a supporting organization and the existence of a foreign market.

Membership in a solidarity art group has important consequences for the artists. It may enable them to meet their basic needs, as well as some emotional needs. It can mean being able to pay for food, utilities, clothing, and shelter; being able to participate in activities and groups outside the home; and escaping the isolation of "the four walls" to which gender expectations may have relegated them. It can mean the chance for emotional release and a respite from the tensions that deprivation and a dictatorship bring, and the benefit of a few hours of enjoyment. It may also signify gaining a space where one feels accepted, appreciated, understood, and supported. Such results have consequences beyond personal benefit; they may make group members better able to withstand the onslaughts of repression and poverty and thus continue to produce denunciatory art and resist the regime in other ways.

When the artists are economically and socially marginalized women, membership in a solidarity art group may be empowering. It may bring them a new sense of self as able to support their family, an enhanced awareness of their worth and deservedness of respect, and an understanding of themselves as having rights, including both human rights and women's rights. It may make them feel confident about conversing with others and defending themselves, and confer upon them the strength to stand up to abusive husbands and earn their respect, knowing that they have the backing of a supportive group of women. It can result in a broadening of their social circle to include other victims of the regime's policies, groups working for human or women's rights,

and NGO professionals. When the art becomes well known, it can bring them enhanced status within their community. The artists may gain a voice that is internationally heard, and so come to experience a sense of political efficacy (of themselves as contributing to bringing about the return of democracy) and an understanding of themselves as the scribes of history, recording "the truth," an alternative version of reality to the regime's falsehoods. Group membership can confer useful skills such as effective group management and leadership. Women members of art groups may experience a change in the gender regime, whereby it becomes more acceptable for them to be in groups and work outside the home. A dictatorship, oppressor for so many, is oppressive for women makers of solidarity art as well, but it can also, surprisingly, be liberating.

The *arpilleras* and *arpillera* making led to the women becoming citizens in a fuller sense of the word than would have applied previously. Whereas before many had faced restrictions on their economic independence and even their mobility beyond the confines of their homes, they now became more active participants in the life of their community and engaged in political work. Their coming to understand the link between their problems and the government's policies contributed not only to their participating in varied resistance activities but also to their joining still other groups aimed at solving the problems of shantytown inhabitants. Their *arpillera* making was itself a political activity that contributed to the resistance community's efforts, even if the women did not at first see or intend it as such. In addition, the *arpilleristas* came to define themselves in political terms such as "leftist" and one of "the poor" in ways they had not done previously. Hence their relationship to the state changed; they ceased to be the largely homebound, passive recipients of the state's actions and educators of the country's children that government discourse under General Pinochet proposed they be,[8] and instead they became agents of their own destiny, participating in acts of resistance against the outcomes of state policies.

Empowerment, however, can be temporary or fluctuating. In Chile, five years after the end of the regime, a number of *arpilleristas* complained that they were "back between the four walls." As they had fewer *arpillera* meetings and activities with other groups, their husbands once again became unused to and unhappy about their leaving the house. The women had lost status and political efficacy; no longer were they the admired "journalists" of the dictatorship, raising awareness among foreign publics. They felt forgotten by the foreign buyers and NGOs that had supported them, and even by the politicians they thought they had helped bring to power with the return to democracy. The dictatorship had been "very hard," but nevertheless there had been "good times" because of the unity and collective effervescence that it had inspired; now they bemoaned the disappearance of the anti-regime community within

264 which they had struggled and felt such unity. Five years after the dictatorship's end, many women described themselves as back in their homes, "more alone" and "abandoned," although some had jobs in which they worked a few hours a week.[9] Fortunately, they continued to experience many of the benefits that solidarity art making had conferred, such as higher self-esteem.

EVOLUTION

Beginning in the mid-1980s, the *arpillera* system began to lose its solidarity-oriented character and become more commercial.[10] The solidarity market shrank, as buyers were distracted by other world crises, while exiles, who had also bought, started to return home, as mentioned above. At the beginning of 1990, an economic downturn in Europe affected people's willingness to buy *arpilleras*.[11] New buyers emerged in the late 1980s but were different from the old ones. They did not know as much about Chile or have a particular interest in the country, and their orientation was more acquisitive than solidarity oriented, as they bought primarily to acquire something attractive.[12]

There were also changes in the sellers. The number of people selling primarily for solidarity reasons decreased. Local sellers turned to other causes, and many of the Chile-focused human rights groups to which they belonged closed down, while exile sellers started to return home. New sellers appeared, and were more client and profit oriented than the old; human rights violations and the political and economic situation in Chile were not their primary concerns. They included fair trade organizations and commercial craft shops abroad, and craft market stalls and craft shops in Chile. Some of these commercial sellers thought their customers would not care for *arpilleras* with political content, and so ordered less denunciatory works that were visually appealing. They exercised more control over the *arpilleras* than the earlier sellers.

Talleres was faced not only with a decrease in the number of solidarity-oriented buyers but also with competition from Peru and Bolivia, which began exporting *arpilleras*. Feeling under pressure to sell in order to keep supporting the growing numbers of *arpilleristas* and earn enough money for its staff's salaries, it developed an increasingly commercial orientation. It was willing to do what it took to sell, including change the content of the *arpilleras* according to what it perceived as buyers' tastes. Accordingly, it began telling the women to produce nondenunciatory *arpilleras* and rejected denunciatory ones at quality control. It also specified the theme more frequently when it ordered, started to order certain themes repeatedly, and began to control content and form more closely that previously, giving instructions about details and colors to be included or avoided and enforcing this at quality control. It introduced miniature *arpilleras*[13] and five standard sizes, with a set number of themes for

Arpilleras sold at Magasin du Monde in Geneva, Switzerland, 1995. Photograph by Jacqueline Adams.

each, and encouraged the making of useful products such as backpacks, with elements from the *arpilleras* appliquéd on them. It produced a catalogue with photographs of *arpilleras*, which the women sometimes had to copy when making their own *arpilleras*, and offered the women prizes for the best *arpilleras*. Its earlier interest in enabling the women to communicate denunciatory messages, express themselves, and gain therapeutic benefits from their *arpillera* making took a back seat relative to the urge to sell and produce what it believed the market wanted. Shortly after the official return of democracy, in December 1990, Talleres became a nonprofit organization called Fundación Solidaridad. The business-oriented language in which it spelled out its mission was telling: "to increase the earnings, market insertion and social participation of those people, families and groups who, by their own efforts, seek to overcome poverty and improve their quality of life by producing handicrafts and non-industrial objects in autonomous workshops and micro businesses." The Vicaría closed down in 1992.

Talleres could exercise this control because the *arpilleristas* badly needed the money, did not have contacts abroad to whom they could sell in most cases, and were nervous about approaching potential clients in Chile. The women

266 grumbled and were upset when their work was rejected, and some resisted the Vicaría's control by slipping denunciatory elements into ostensibly nondenunciatory *arpilleras*, such as a detail of glue-sniffing children behind a bush, but most did not confront Talleres. The fact that they did not see themselves as artists free to express themselves, and neither did Talleres, contributed to their not resisting the control openly. There were some who were happy that Talleres told them what to depict, as they found continuous creativity difficult, and many who needed the money so badly that what they depicted was secondary.

These changes meant that the women became somewhat like employees in a factory, or "alienated workers" turning out what was required of them, able to exercise only limited creativity. Teresa expressed, "I would like to know more themes, to put in more themes. [. . .] Because those are the ones they ask for. You can't invent anything." Although she wanted more scope for creativity, many women had internalized Talleres's rules and kept to them, and they had internalized its new values, coming to feel proud when the Fundación decided to include a photo of an *arpillera* they had produced in the catalogue. Some were reported by Agrupación *arpilleristas* to be thinking about the peso-dollar exchange rate, and to have joined the *arpillera* groups to earn money for things other than essentials. In the 1990s, as Fundación sales fell sharply, some groups began to look for places to sell in an entrepreneurial fashion but mostly disbanded.

The *arpilleras* changed as a result of these developments. Cheerful scenes replaced images of repression and poverty, in accordance with Talleres's idea of what the buyers wanted. There was still reference to economic need in images of women working, such as the bread-baking or washerwomen scenes, but these were not the stark images of begging, prostitution, and looking for food in garbage dumps of early years. Ecological themes and images of indigenous peoples emerged. The Fundación asked the women to produce images of "Chilean" characters such as the kite seller, ambulatory peanut seller, and organ player, and the *chinchinero*, a street musician who played several instruments simultaneously. However, the women continued to make a small number of denunciatory *arpilleras* in response to buyers' or sellers' specific orders for these.

In Chile in the 1990s, new social enterprises similar to the Fundación Solidaridad began supporting *arpilleristas* and selling *arpilleras*,[14] as did a government women's organization and the municipalities of Machalí and Rancagua (a village and town near Santiago). A women's center in the northern shantytown of Huamachuco sold *arpilleras* that its members made on-site, at monthly meetings of a club of Canadian ladies, via exhibitions, in an art

museum, and via its supporting NGO, World Vision. A male-led AIDS support group had members make large *arpilleras* akin to pieces of the AIDS quilt. A craft shop and several stalls in tourist craft markets began selling *arpilleras* as well.

The *arpillera* system, then, ceased to be a system driven by solidarity, in which victims of oppression expressed their suffering, and buyers and sellers bought and sold to help; instead, it took on a more commercial character. Talleres staff, like managers of a company, directed the production of *arpilleras* in accordance with their idea of what the market wanted. Most of the *arpilleristas* produced what was asked of them rather than insisting on expressing themselves or denouncing, and focused on avoiding rejection at quality control. Sellers began ordering *arpilleras* of a particular content and size. Buyers bought because they wanted or needed an *arpillera*, rather than in order to help the women or cause. New organizations started having women produce *arpilleras*, and new venues emerged at which *arpilleras* were sold. Most had a market orientation, although this was combined with an interest in the *arpilleristas'* welfare. The *arpillera* became, and remains today, a largely fair trade product, sold in fair trade venues, and within Chile mostly a form of tourist art, sold at tourist-oriented craft markets and shops.

Notes

Preface

1. I have chosen the word *shantytown* as the closest approximation to the Chilean word *población*. While *shantytown* calls to mind an expanse of wooden and corrugated-iron homes, Santiago's *poblaciones* included such expanses, but also grid-patterned streets of small brick houses whose low-income inhabitants worked in either formal or informal sector jobs, or both.

Chapter 1

1. See Brink (1997), Dorfman (1978), Neustadt (2001), and Williamson (1989).

2. Kunzle (1978). Scholars of nonconformist art under dictatorships have used the terms "underground artists," "nonconformists," "unofficial artists," and "dissidents" to describe such artists.

3. Boyle (1992).

4. Dorfman (1978).

5. Marjorie Agosín (2008) has written extensively about the *arpillera* making of the relatives of the disappeared.

6. There are other art forms, also called *arpilleras*, which were made before the dictatorship and served as inspiration for these *arpilleras*. They are not the subject of this book but are described later on.

7. Parallels exist between the content of the *arpilleras* and that of the art of other oppressed peoples. Palestinian pictorial art, for example, shares a thematic preoccupation with politics and resistance (Halaby 2004).

8. Adams (2005).

9. Smith (1982), Teitelboim (1990), Fisher (1993).

10. Adams (2002).

11. Adams (2012).

12. Ibid.

13. Interviews with Isolda, Daniela, the Conjunto Folclórico, Hilda, Hilaria, and Wilma.

14. I am grateful to my colleague Kathryn Poethig for coining this phrase.

15. There is, in my view, some arbitrariness about the distinction between art and craft.

16. It sometimes happens that trained and professional artists who are not experiencing poverty or repression sell their art to help others. These artists may live in a different country. For example, in 2007, on the University of California at Berkeley campus, local artists and students sold paintings on canvas to raise funds for the people of Darfur. Such high artists are not included in my definition of solidarity art because art by those who themselves experience the harsh conditions is bought, exported, and sold with different understandings.

17. For studies that discuss or mention artists' motivations under other repressive contexts, see Baigell and Baigell (1995), Barber (1991), Foxley (1981), Frank (2003), Morris (1984), Moser (2003), Neustadt (2001), and Olukotun (2002).

18. Adams (2005).

19. Becker (1982, 34).

20. Kanakis (2005).

21. Baigell and Baigell (1995).

22. Chametzky (2001).

23. Reichelberg and Kauffmann (2000).

24. Personal communication, Samuel P. Oliner, April 12, 2008, Pacific Sociological Association Meeting in Portland, Oregon.

25. Adams (2002).

26. Personal communication, Arlinda Moreno, September 29, 2010.

27. Easton (2000).

28. Dusselier (2005).

29. Cockcroft and Barnet-Sánchez (1993).

30. Other studies that mention or discuss how a resistance art form arises or is produced under a dictatorship include, Baigell and Baigell (1995), Brink (1997), Cushman (1995), Frank (2003), Morris (1984), and Neustadt (2001).

31. McAdam, Tarrow, and Tilly (2001).

32. For works by analysts who discuss or mention the contributions of art in the struggle against repressive regimes, see Adams (2000, 2012a, 2012b), Almeida and Urbizagastegui (1999), Baigell and Baigell (1995), Boullata (2004), Boyle (1992), Brink (1997), Burton (1978), Farge (2006), Goldfarb (1982), Gready (2003), Griffin (1994), Hájek (1994), Magnussen (2006), Milon (2000), Morris (1984), Moser (2003), Obododimma (1998), Olukotun (2002), Palmeri (2003), Schechner (1998), Schirmer (1994), Stephen (1990), and Svašek (1997).

33. For works that mention or explore how state repression affects the production, selling, reception, and content of resistance art, see Adams (2001, 2005), Baigell and Baigell (1995), Brink (1997), Brunner (1981), Dorfman (1978), Frank (2003), Halaby (2004), Haynes (2003), Morris (1984), and Rosenfeld and Dodge (2002).

34. Marín (1991) and Agosín (2008) discuss the impact of gender on resistance art.

35. A snowball sample is one in which the researcher interviews individuals recommended by interviewees.

36. Glaser and Strauss (1967).

37. Allende (1971), Sigmund (1977, 130–131).

38. Oppenheim (2007, 36).

39. Ibid., 22.

40. Ibid., 37–38.

41. Ibid., 20–23.

42. Sigmund (1977, 139).

43. The rural branch of the Movement of the Revolutionary Left (MIR).

44. Wright and Oñate (1998, 3).

45. Ibid., 4.
46. Sigmund (1977, 234).
47. Ibid., 176.
48. Qureshi (2009); Oppenheim (2007, 72).
49. Oppenheim (2007, 79).
50. Wright and Oñate (1998, 4–5).
51. Chile: Comisión Nacional de Verdad y Reconciliación (1993).
52. Schneider (1995, 75–81).
53. Chile: Comisión Nacional de Verdad y Reconciliación (1993).
54. Marta Vega, Secretaria General, Agrupación de Familiares de Detenidos-Desaparecidos, personal communication, July 23, 2012.
55. Wright and Oñate (1998, ix).
56. Ibid., 5.
57. Sigmund (1977, 262).
58. Angell (1991, 188).
59. Valenzuela (1991, 25).
60. Sigmund (1977, 262).
61. Drake and Jaksić (1991, 5).
62. Wright and Oñate (1998, 6).
63. Montecinos (1997).
64. Silva (1991, 103).
65. Ibid., 111.
66. Ibid., 113.
67. Bizarro (2005), Tenenbaum (1996).
68. Adams (2012).
69. Ibid.
70. Valenzuela (1991, 53).
71. Oppenheim (2007, 105).
72. Silva and Cleuren (2009, 20).
73. Alexander (2009, 2).
74. Ibid., 14, 16.
75. Foweraker (2009, 35).
76. Alexander (2009, 11).
77. Ibid., 19.
78. De la Maza (2009, 261); Alexander (2009, 32).
79. Alexander (2009, 27); Paley (2001).
80. Silva and Cleuren (2009); Paley (2001).
81. Alexander (2009, vii, 30).
82. Sorensen (2009, 6).
83. Chile: Comisión Nacional de Verdad y Reconciliación (1993).

Chapter 2

1. Hardy (1987), Sabatini (1995), Valdés and Weinstein (1993).
2. The husbands had, for the most part, had blue-collar jobs. Anastasia's husband, for example, was an electrician and plumber.
3. Interviews with *arpilleristas* and Vicaría staff.
4. Smith (1982).
5. Smith (1982).

6. Raczynski and Serrano (1985).

7. All personal names are pseudonyms. For the sake of historical accuracy, the place-names of the first *arpillera* group shantytown locations have not been changed, nor has "La Victoria." Others have if such information can be used to identify interviewees.

8. Smith (1982).

9. Adams (2012).

10. This was corroborated by Vicaría staff. Silvia, an early Vicaría staff member, for example, recalled that the women were not members of parties.

11. Adams (2012).

12. Interview with Bertha, a Vicaría staff member in the eastern office.

13. Hardy (1987) and Razeto et al. (1990) have produced detailed studies of the emergence of such organizations, which they call "subsistence organizations" and "popular economic organizations."

14. In 1976, there were 2,240 people participating in the *bolsas*. About half were former political prisoners. Among the remainder were men dismissed from work for political reasons.

15. Razeto et al. (1990) define *bolsas* as made up principally of workers fired from their companies, particularly nationalized enterprises, for political reasons in the first months of the regime. Trade union leaders and politically active workers were typically the ones fired, regardless of their level of training and qualification. The *bolsas'* main way of resolving their members' problems was to create workshops and small companies, with the economic support of foreign development agencies and institutions and the support and protection of local churches. Nancy, a shantytown *arpillerista* from southern Santiago, informed me that the *bolsas* tended to have a political goal, and were usually organized by the Communist Party.

16. Hardy (1987), similarly, finds that the women in these organizations were responding to family needs, prolonged male unemployment, and the urgent need to provide for their children.

17. Raczynski and Serrano (1985, 14).

18. This would appear to support Hardy's (1987) finding that since urban unemployment and underemployment affected heads of household between the ages of twenty-five and forty-four primarily, the women, without previous work experience, entered the labor market as a means of providing for their family's subsistence. Indeed, the female labor force (women over fifteen) went up from 25.2% in 1976 to 28.2% of the female population in 1985 (Alicia Leiva, cited in Hardy 1987, 136, using INE's annual employment survey); these figures neglect informal sector employment.

19. Interviews with Zoe, Katy, and Yanni.

20. On shantytown gender expectations, see Hardy (1987), Sabatini (1995), Valdés (1988), and Valdés and Weinstein (1993).

21. Interviews with Santa Teresa group and Roberta, a Vicaría staff person.

22. Interview with Cristina.

23. The women's not being employed outside the home is consistent with the findings of other scholars who describe shantytown women as not normally working for an income outside the home after getting married (Raczynski and Serrano 1985, Valdés 1988).

24. The unemployed *arpilleristas* of the eastern zone first met in the offices of the Comité in their area; later on, they met in their local churches. The Agrupación *arpilleristas*, however, continued to meet in Comité and Vicaría offices.

25. Vicaría de la Solidaridad (1991); see also Lowden (1996).

26. Smith (1982).

27. Lowden (1996).

28. Ibid.
29. Ibid.
30. Ibid.
31. Ibid.
32. Ibid. The total sum involved in financing the Comité was US$1.8 million, of which 86 percent came from abroad.
33. Lowden (1996). Smith (1982) sets the number of centers at twenty-two.
34. Lowden (1996, 55).
35. MAPU, the Movement for United Popular Action, was a party born of a 1969 split within the Christian Democrat Party, whereupon it declared itself Marxist-Leninist and joined Allende's Popular Unity.
36. Lowden (1996).
37. Ibid.
38. Ibid., Vicaría de la Solidaridad (1991).
39. Lowden (1996).
40. Smith (1982).
41. Vicaría de la Solidaridad (1991, 53).
42. Lowden (1996).
43. Smith (1982).
44. Pinochet's and the cardinal's letters are published in *Chile-América* 12–13 (December 1975).
45. There were initial misgivings in the Church about working so closely with a group of laity, the majority of whom had Marxist leanings. The Church's leaders wanted the Vicaría to remain a nonpartisan organization (Lowden 1996).
46. Smith (1982). Lowden (1996, 99) sets the figure at some two hundred in the Vicaría's earlier years.
47. Smith (1982).
48. Lowden (1996)
49. Smith (1982).
50. Interview with Cristián Precht, excerpted in Lowden (1996, 55).
51. Carta Pastoral de la Solidaridad, Archdiocese of Santiago, June 1975. Taking the cardinal's lead, in a pamphlet published by the Vicaría in February 1976, Father Precht emphasizes solidarity, saying, "The preaching of the gospel doesn't consist only of words. There must also be gestures, attitudes, commitments and real deeds. Therefore, the Church must make its message a reality. The Vicaría must make concrete the message by many acts of solidarity . . . At this time the Vicaría is planning a program of lunchrooms for university students who can't afford meals. It is also studying a scholarship program for students with economic problems . . . The Church will continue making a great effort to locate persons who have disappeared" (*LADOC* 6:3 [March-April 1976]: 30, cited in Bouvier 1983).
52. According to Lowden (1996), from a liberationist perspective, one of the most important aspects of the notion of solidarity was that it meant taking the Church from the starting point of being "for" the poor, toward becoming the Church "of" the poor. However, solidarity was fundamental to Christianity, not merely liberation theology.
53. Lowden (1996, 55).
54. Lowden (1996). To support these organizations was not only to assist the poor; it was also, in the eyes of Vicaría staff, to support a form of denunciation of the failures of the regime's policies.
55. Lowden (1996).

274 56. The "pastoral social" part of the Catholic Church had given support to the peasants'
movement and to the urban poor in matters of housing, and the Church had lent support for
the creation of some shantytowns (Vicaría de la Solidaridad 1991). However, there had been
no Catholic organization like the Vicaría, in the sense of a Vicariate intended to promote
human rights. The Vicariates that already existed in Santiago were territorial divisions
designed to manage the large archdiocese more efficiently (Lowden 1996).

57. Interviews with *arpilleristas* and Vicaría staff; Hardy (1987); Lowden (1996); Smith
(1982).

58. For detailed information on the Vicaría's work, see Aranda (2004); Lowden (1996);
and Smith (1982).

59. Eakin (2007).

60. Skidmore and Smith (2005).

61. Skidmore and Smith (2005). Acting in accordance with the ideas in liberation theology,
activist priests and nuns began to emphasize Jesus, the revolutionary figure of the Sermon
on the Mount, the Christ of the poor, the oppressed, and the downtrodden. These priests
and nuns broke with the traditional message of the Latin American Catholic Church in that
rather than telling the impoverished masses to accept their suffering and the status quo and
to await their reward in heaven, they worked to help them change their lives in this world.
They argued that salvation or liberation was not simply spiritual, but also temporal, and they
suggested that to be a good Christian one had to behave like a good Christian; belief required
action (Eakin 2007, 319).

62. Bouvier (1983).

63. Eakin (2007).

64. Smith (1982).

65. Interview with Babette.

66. Smith (1982). Smith (1982, 341) estimates that by 1975 there were at least 20,000
actively committed lay members of small base communities. Many of the base communities
included in their concerns engagement in the social and economic problems of their civic
communities. Incorporated into the small base community structures were fraternal aid
committees responsible for looking after the economic needs of citizens in their areas (*comités
de ayuda fraternal*). Participants in religious activities were often the ones who initiated social
action projects in their neighborhood, such as community kitchens, day-care centers, and
self-help employment projects, thereby fulfilling the goals articulated at important meetings
of Catholic leaders in Medellín and Puebla.

67. Smith (1982).

68. Lowden (1996).

69. Interview with Anastasia.

70. Interview with Zoe.

71. Oxhorn (1995, 12), similarly, stresses the importance of trust in the priests, saying, "It
is here [in local parishes] that these resources are most effective, given the trust that the local
parish's priests and nuns are able to develop in their communities through constant direct
contact. The Church's explicit acceptance of organizational activity can then be transformed
into an initial legitimacy that helps attract potential members who are still uncertain as to
the benefits of participating in an organization and who may fear the possible repression that
such participation can invite."

72. Oxhorn (1995, 11–12) also states, "The church's relative immunity from repression
stems from the historic importance of the Catholic Church in Latin America. This immunity
also reflects the reluctance of many authoritarian regimes to openly challenge the Church

at a time when they are trying to legitimize their rule by allegedly safeguarding Christian 275
values in the face of an atheistic Communist threat. A key variable in determining the
Church's capacity to serve as a protective umbrella for base-level organizations is the will-
ingness of the national Church hierarchy to do so. In this way, the reforms of the Catholic
Church in many Latin American countries in the wake of Vatican II and the growing accep-
tance of more progressive Church doctrines, most notably liberation theology, were critical
in allowing the Church to offer an alternative sphere for organizational activity after the
imposition of authoritarian rule in such countries as Brazil and Chile."

73. Herreras (1991).

74. Bizarro (2005).

75. Oxhorn (1995) states that the Catholic Church provided physical space for conducting
organizational meetings; leadership training; food, clothing, and the materials used by
workshops to produce goods either for the group members' own consumption or for sale;
as well as church laypeople and clergy who often contributed an essential impetus to the
formation of new groups, helping them overcome initial challenges and problems.

76. Interview with Silvia.

Chapter 3

1. Arteaga (1976).

2. Interviewees often used the word "Vicaría" to refer to both the Comité and the Vicaría,
probably because the former essentially became the latter.

3. Adams (2000).

4. Raczynski and Serrano (1985) provide an excellent description of such survival
strategies.

5. For more information on Violeta Parra and photographs of her *arpilleras*, see http://
www.violetaparra.cl/.

6. Interviews with Babette and Nicole.

7. By contrast, dissident artists producing "high art" under dictatorships tend to cite other
art movements or artists producing high art as influences. The *arpilleristas* did not do so
perhaps in part because they had had little exposure to high art.

8. However, other data contradict this. In my interview with Anabella, she said that when
she began with the relatives of the disappeared, before beginning to help the unemployed
women, she thought of having the women make *arpilleras* using the appliqué technique,
without first trying wool.

9. Agosín (2008).

10. Interviews with Cristina, Fernanda, and the Agrupación *arpilleristas*.

11. Under Anglo-Saxon law, the equivalent of "*recurso de amparo*" proceedings is applying
for habeas corpus, which means requesting that the prisoner be presented before a court or
judge.

12. The Lo Hermida group was called the Taller del Espíritu Santo de Lo Hermida;
interview with Celinda.

13. Arteaga (1976). At the bottom of the article, which is about the Lo Hermida group and
how it came to make *arpilleras*, a line says "Santiago de Chile, January 1976," indicating the
date of writing.

14. Interviews with the *arpillera* coordinating committee of the eastern zone, Cristina
from the Villa O'Higgins group, Anastasia from the La Faena group, and Fernanda and Zara
from the Agrupación group.

Chapter 4

1. Marta Vega, the Secretaria General of the Association of Relatives of the Detained and Disappeared, personal communication, July 2012.

2. Interviews with Hilaria and Hilda.

3. Interviews with Vicaría staff and Agrupación members; Agosín (2008); Sepúlveda (1996).

4. Interviews with Hilaria, Anabella, and Bernadette (one of the earliest group members).

5. Interviews with some of the earliest *arpilleristas* of the group, Fernanda, Zara, and Fabiola.

6. Julieta Neri had unfortunately passed away when I began my research.

7. Becker (1994) conceptualizes the role of chance in social life as substantial.

8. Interview with Hilaria.

9. Interviews with Hilda and Cecilia.

10. Anastasia of the La Faena group said it began in 1975. Her words are ambiguous, but could be read to suggest that the La Faena and Lo Hermida groups had merged. This would explain why Cristina refers only to Lo Hermida.

11. Some of the municipalities with the highest deficits in urban infrastructure and communal social services in Santiago, such as Pudahuel, La Florida, La Granja, Quilicura, San Bernardo, Puente Alto, Renca, Maipú, Conchalí, and Quinta Normal, are in these zones (Hardy 1987).

12. See Hardy (1987). Subsistence groups grew in number in the years following the coup, due to the high unemployment.

13. Interview with Teresa, 1995.

14. In a 2006 interview, Teresa described his prompting as if it were a suggestion, whereas in her 1995 interview, she described it as a condition that he imposed on her if she were to join the *olla común*.

Chapter 5

1. Interview with Cristina.

2. Field notes from observations with the *coordinadora* of *arpillera* groups of eastern Santiago, August 1995.

3. Interview with Barry, a seller of *arpilleras* in England.

4. By contrast, messages in the 1990s tended to thank the buyer for buying the *arpillera*.

5. Adams (2005).

6. Tamara's group of political prisoners worked in a production line as well.

7. According to Anastasia, the *temas fuertes* had disappeared by 1995.

8. There was one exception; a group from the center of Santiago made gray scenes of the buildings around them, but the Vicaría staff felt that their *arpilleras* were without charm, and so allowed them to make *arpilleras* of scenes distant from their experience, such as beaches, mountains, the places in which they had grown up, observations of nature, or scenes from postcards or photographs. This would ensure that they could sell, Gertrudis, a Vicaría staff member, recalled.

9. Interview with Hilaria.

10. Interview with the *arpillera* group coordinating committee of eastern Santiago.

11. *Velatones* and *velatorios* are the Chilean words for these vigils.

12. The pattern of working mostly at home but also in the workshops also existed among the *arpilleristas* of Melipilla and the Agrupación *arpilleristas*. The latter also made *arpilleras* during their hunger strikes, which tended to take place in churches.

13. In the postdictatorship era, the selling team would tell group members that the *arpilleras* should not be lopsided, the *monos* had to be sewn on well, the stitching around the edge had to be straight, and the *arpilleras* should not be lumpy.

14. Interview with Brigitte.

15. Interview with Wilma.

16. Personal observations from contact with middle-class families in Chile.

17. In the mid-1980s, each woman might end up receiving 5,000 pesos, according to Fanny of the San Bartolomé group.

Chapter 6

1. Interview with Gertrudis, a Vicaría employee.

2. Interview with Claude and Hélène.

3. Adams (2005).

4. This changed toward the very end of the dictatorship and subsequently, when buyers were buying decorative *arpilleras* just to acquire an attractive product (Adams 2005).

5. Bolzman (2007).

6. Interview with Linda.

7. Wright and Oñate (1998, ix).

8. Interview with Ignacio Salinas, February 3, 1995. For more information on what selling meant to exiles, see Adams (2012b).

Chapter 7

1. Adams (2005).

2. The makers of tourist art from the "Fourth World" described in Graburn (1976) made their work smaller and more transportable in response to buyers' wishes.

Chapter 8

1. Intelligence agencies at which the secret police were based.

2. Interviews with Vicaría staff members Lilly and Yanni.

3. Interview with Roberta, a Vicaría employee.

4. Clandestine exhibitions of nonconformist art are common under repressive regimes. In Soviet Russia, for example, artists exhibited in apartments, yet also participated in official exhibitions (Baigell and Baigell 1995).

5. Interview with Anastasia.

Chapter 9

1. This suggests that under conditions of repression and censorship, groups resisting an authoritarian regime become concerned that "the truth" be known. They see the regime's information as distorted and inadequate, and themselves as having to overcome the power of the regime's communications apparatus.

2. Interview with an *arpillera* group in southeastern Santiago.

3. Government housing authority.

4. In La Victoria, women connected to the Church organized themselves by the block to distribute milk bought with money sent from France; interview with Francisca.

5. Interview with Francisca.

6. Interview with Nancy.

7. Smith (1982) expresses that in the wake of the coup, the Comité acted as a surrogate form of social participation for the poor, when all their other normal channels of influence (labor unions, political parties, neighborhood organizations) came under heavy government surveillance or were outlawed or dissolved. This surrogate form of participation was important in the absence of viable secular means to accomplish these ends.

8. Interviews with several Vicaría staff, Laura, and the eastern zone coordinating committee.

9. The phenomenon of *arpillera* groups linking with other groups was mirrored in the world of popular economic organizations more broadly (Hardy 1987; Razeto et al. 1990).

10. Smith (1982, 312) suggests that the shantytown employment projects, day-care centers, and community kitchens were networks of communication along which information was passed, as well as vehicles for participation.

11. Other popular economic organizations, such as the *bolsas de cesantes* or community kitchens, produced similar results. An authority on the subject who studied the full range of such organizations (Hardy 1987, 144) points out that their existence resulted in the recuperation of broken identities, fractured ties, and social relations of coexistence, and gave rise to personal development and training, the capacity to make decisions and execute duties, active participation, and taking control of one's situation. Popular economic organizations, she says, broke the atomization imposed by the political and economic system and preserved conceptions of work, duties and rights, and a broader conception of human needs that included the need for participation, taking control of one's conditions of existence, personal development and growth, and sociability.

12. Smith (1982, 312), similarly, suggests that the shantytown employment projects, day-care centers, and community kitchens nourished a sense of solidarity among the persecuted and their families, and enabled many to survive when they might otherwise have lost hope. They also offered the people in them who had leftist views or who were pro-Allende the opportunity to preserve a sense of human solidarity and service to their neighborhoods.

13. Hardy (1987) and Razeto et al. (1990).

14. See Brunner (1981).

15. Sigmund (1977, 253).

16. Analysts of the regime who mention alternative media that communicated accurate information tend to focus on printed media while neglecting visual forms (e.g., Smith 1982, 319). The *arpillera* was an alternative visual medium that the Vicaría and other members of the resistance community considered important.

17. Prints worked in a similar way in Uruguay, where they were gestures of resistance that were significant as a form of hidden communication among the disaffected, more so than outright signs of defiance. One artist, for example, printed personal greeting cards with the letters "FA" standing out, meaning both "Feliz Año" (Happy New Year) and "Frente Amplio" (Broad Front), a left-wing party (Frank 2003).

18. This perspective concurs with Smith's assessment (1982, 312) of the work of the Comité and the Vicaría as a whole, when he states that these organizations provided economic aid to families and alleviated the suffering of the poor inflicted by the economic model of recovery.

19. Hardy (1987) notes that the popular economic organizations that arose to meet basic needs required a constant and very large number of managers to administer their daily operations, and this gave rise to approximately four thousand managers in shantytowns in

the Santiago metropolitan region. On average, the organizations had three managers each;
there were more in the *talleres solidarios* (workshops, which included the *arpillera* groups),
ollas comunes, buying cooperatives, and housing-focused self-help groups.

20. Hardy (1987) states that the popular economic organizations brought material
benefits to their members' families; the workshops, for example, brought in as much money
as PEM, an emergency employment scheme, for half the work time. The popular economic
organizations also, she adds, provided spaces in which people could learn management
and the administration of resources, accountancy, selling, stocking, cooking, and care of
hygiene; they enabled a qualified workforce to work and one without work experience to
gain experience; they enabled women to combine their domestic work with service to the
community and the ability to earn an income; and they enabled their household to save.
Lastly, they opened up spaces for the practice of democracy.

Chapter 10

1. Lowden (1996).

2. The members of the clergy, if not traveling themselves, would use church mail or call on
other members to help them carry the packages safely out of Chile.

3. Adams (2005).

4. Adams (2012b).

5. Adams (2012).

6. Ibid.

7. Adams (2012b).

8. Munizaga (1988).

9. Adams (2003).

10. Adams (2005).

11. Interview with Belinda.

12. For analyses of how art systems change when an authoritarian regime reverts to
capitalist democracy, see Baigell and Baigell (1995) and Cushman (1995).

13. As happened with the art described in Parezo (1999) and Graburn (1976).

14. Comparte, a Chilean exporter of crafts, was one such organization.

Bibliography

Adams, Jacqueline. 2000. "Movement Socialization in Art Workshops: A Case from Pinochet's Chile." *Sociological Quarterly* 41(4): 615–638.

———. 2001. "The Makings of Political Art." *Qualitative Sociology* 24(3): 311–348.

———. 2002. "Art in Social Movements: A Case from Pinochet's Chile." *Sociological Forum* 17(1): 21–56.

———. 2003. "The Bitter End: Emotions at a Movement's Conclusion." *Sociological Inquiry* 73(1): 84–113.

———. 2005. "When Art Loses Its Sting: The Evolution of Protest Art in Authoritarian Contexts." *Sociological Perspectives* 48(4): 531–558.

———. 2012a. *Surviving Dictatorship: A Work of Visual Sociology*. New York and London: Routledge.

———. 2012b. "Exiles, Art and Political Activism." *Journal of Refugee Studies: Fighting the Pinochet Regime from Afar* 25(4). doi:10-1093/jrs/feso4/

Agosín, Marjorie. 1987. *Scraps of Life: Chilean Arpilleras: Chilean Women and the Pinochet Dictatorship*. Toronto: Williams-Wallace.

———. 1993. "El bordado de la resistencia: Mujer, tapiz y escritura." In *Las hacedoras: Mujer, imagen, escritura*, edited by Marjorie Agosín, 259–267. Santiago: Editorial Cuarto Propio.

———. 1994. "Patchwork of Memory." *NACLA: Report on the Americas* 28(6):11–14 (May/June).

———. 1995. "Chile: A Fantasy of Freedom and Home, Stitched Longingly in Bright Colors by Women of Smoke." *Ms.* (March): 71–72, 110.

———. 1987. "*Arpilleras* of Chile: Using Art as a Teaching Tool." *Heresies: A Feminist Publication on Art and Politics* 22: 33.

———. 1989. *Arpilleras: Lebensbilder aus Chile: Frauenbewegung und Diktatur*. Braunschweig, Germany: Labyrinth.

———. 1995. "Majorie Agosín Responds." Letter to the editor. *NACLA: Report on the Americas* 28(5): 47.

———. 1996. *Tapestries of Hope, Threads of Love: The* Arpillera *Movement in Chile 1974–1994*. Albuquerque: University of New Mexico Press.

282 ———. 2008. *Tapestries of Hope, Threads of Love: The* Arpillera *Movement in Chile.* Lanham, MD: Rowman and Littlefield Publishers.

Agrupación de Familiares de Detenidos-Desaparecidos [cited as AFDD]. N.d. (between 1985 and 1989). *Arpilleras: Otra forma de denuncia.* Santiago: Agrupación de Familiares de Detenidos-Desaparecidos.

Alexander, William, ed. 2009. *Lost in the Long Transition: Struggles for Social Justice in Neoliberal Chile.* Lanhan, MD: Lexington Books.

Allende Gossens, Salvador. 1971. *Nuestro camino al socialismo: La vía chilena.* Buenos Aires: Ediciones Papiro.

Almeida, Paul, and Ruben Urbizagastegui. 1999. "Cutumay Camones: Popular Music in El Salvador's National Liberation Movement." *Latin American Perspectives* 26, no. 2 (March): 13–42.

"An Authoritarian Government Seen by Women." 1995. Exhibit pamphlet. Washington, D.C.: Institute for Policy Studies.

Angell, Alan. 1991. "Unions and Workers in Chile during the 1980s." In *The Struggle for Democracy in Chile, 1982–1990,* edited by Paul W. Drake and Iván Jaksić, 188–217. Lincoln, NE: University of Nebraska Press.

Angelo, Gloria. 1987. *Pero ellas son imprescindibles.* Santiago: Centro de Estudios de la Mujer.

Aranda Bustamante, Gilberto C. 2004. *Vicaría de la Solidaridad, una experiencia sin fronteras.* Santiago: CESOC-Instituto de Estudios Internacionales de la Universidad de Chile.

Armada de Chile, Asociación Nacional de Magistrados de Chile, Carabineros de Chile, Corte Suprema de Chile, Fuerza Aérea de Chile, Policía de Investigaciones de Chile, Comisión Nacional sobre Prisión Política y Tortura, Juan Emilio Cheyre y Ricardo Lagos. 2005. "Informe de la Comisión Nacional sobre Prisión Política y Tortura, y respuestas institucionales." (Valech Report). *Estudios Públicos* 97: 295–504.

"Las *arpilleras.*" N.d. Informational pamphlet. Santiago, Chile: Fundación Solidaridad.

Arpilleras: Newspapers on Cloth. 1987. Filmstrip and pamphlet. Cincinnati: The Office of Development Education Women's Division, General Board of Global Ministries, United Methodist Church and Institute for Policy Studies.

"Arpilleras para la virgen." 1976. *Solidaridad* 4 (August): 2. Santiago: Vicaría de la Solidaridad.

Arteaga, Rodrigo. 1976. "Los bordados de la vida y de la muerte." *Solidaridad* 1 (May): 4–5. Santiago: Vicaría de la Solidaridad.

Backe, Lis, and Lone Hagel. 1987. *Kludetaeppehabet: Billedtaepper Lavet af Chilenske Kvinder.* Copenhagen: Dansk Flygtningehjaelp.

Baddeley, Oriana. 1989. *Drawing the Line: Art and Cultural Identity in Contemporary Latin America.* London: Verso.

Baigell, Renée, and Matthew Baigell. 1995. *Soviet Dissident Artists: Interviews after Perestroika.* New Brunswick, NJ: Rutgers University Press.

Balderston, Daniel, Mike Gonzalez, and Ana M. López, eds. 2000. *Encyclopedia of Contemporary Latin American and Caribbean Cultures.* New York: Routledge.

Barber, Karin. 1991. *I Could Speak Until Tomorrow: Oriki, Women and the Past in a Yoruba Town.* Edinburgh: Edinburgh University Press.

Barros, Pía, and Marta F. Morales. 2001. "The Art of Women's Health and Rights [Part 4 of 4]." *Women's Health Journal* (Latin American and Caribbean Women's Health Network) 44 (October): N.p.

Becker, Howard Saul. 1982. *Art Worlds.* Chicago: University of Chicago Press.

———. 1994. "'Foi por acaso': Conceptualizing Coincidence." *Sociological Quarterly* 35(2): 183–194.

Benavente, David. 1989. *Tres Marías y una rosa.* Chile: CESOC. 283

Berru Davis, Rebecca M. 2006. *Creating Cuadros: Reclaiming the Past, Recording the Present, Revealing the Future.* Ph.D. diss., University of St. Thomas.

Bizarro, Salvatore. 2005. *Historical Dictionary of Chile.* Lanham, MD: Scarecrow Press.

Blanco, George M., et al. 2000. *Te lo imaginas?* Glenview, IL: Scott Foresman.

Bolzman, Claudio. 2007. "D'une communauté d'exilés à une communauté de residents: l'exemple de la migration chilienne en Suisse." In *La Suisse au rhythme latino,* edited by Claudio Bolzman, Myrian Carbajal, and Giuditta Mainardi, 43–65. Geneva: Institut d'études sociales.

Bonne, Valentina. N.d. Transcribed speech. Washington, D.C.: Institute for Policy Studies.

Boullata, Kamal. 2004. "Art under the Siege." *Journal of Palestine Studies* 33(4): 70–84.

Bouvier, Virginia Marie. 1983. *Alliance or Compliance: Implications of the Chilean Experience for the Catholic Church in Latin America.* Syracuse, NY: Maxwell School of Citizenship and Public Affairs, Syracuse University.

Boyle, Catherine. 1986. "Images of Women in Chilean Theater." *Bulletin of Latin American Research* 5(2): 88–96.

———. 1992. *Chilean Theatre, 1973–1985: Marginality, Power, Selfhood.* Rutherford, NJ: Fairleigh Dickinson University Press; and Cranbury, NJ: Associated University Presses.

———. 1993. "Touching the Air: The Cultural Force of Women in Chile." In *"Viva": Women and Popular Protest in Latin America,* edited by Sarah Radcliffe and Sallie Westwood, 156–172. London: Routledge.

Brett, Guy. 1977. "We Want People to Know the Truth: Patchwork Pictures from Chile." Exhibition catalogue. London: Oxfam.

———. 1978. "Patchwork Pictures from Chile." *Index on Censorship* 7: 30.

———. 1987. *Through Our Own Eyes: Popular Art and Modern History.* London: GMP; Philadelphia: New Society Publishers.

Brink, André. 1997. "Challenge and Response: The Changing Face of Theater in South Africa." *Twentieth-Century Literature* 43(2): 162–176.

Brunner, José Joaquín. 1981. *La cultura autoritaria en Chile.* Santiago: FLACSO.

Burton, Julianne. 1978. "The Camera as 'Gun': Two Decades of Culture and Resistance in Latin America." *Latin American Perspectives* 5(1): 49–76.

Butruille, Susan G., and Margaret Thomas. 1985. "Chilean *Arpilleras*: Stories in Patchwork." *The Flying Needle* (May): N.p.

Chametzky, Peter. 2001. "The Post History of Willi Baumeister's Anti-Nazi Postcards." *Visual Resources* 17(4): 459–480.

"Chile." 2002. *Faces* 19(4): N.p. Peterborough, NH: Cobblestone Pub.

Chile: Comisión Nacional de Verdad y Reconciliación. 1993. *Report of the Chilean National Commission on Truth and Reconciliation.* Vol. 2. Translated by Phillip E. Berryman. London: University of Notre Dame Press.

"Chilean Patchworks: An Exhibition by the Chile Committee for Human Rights." N.d. Exhibition pamphlet. London: Chile Committee for Human Rights.

"Chile: Patchworks of Protest." 1985. Calendar. London: Chile Committee for Human Rights.

Cockcroft, Eva Sperling, and Holly Barnet-Sánchez, eds. 1993. *Signs from the Heart: California Chicano Murals.* Venice, CA: Social and Public Art Resource Center; Albuquerque: University of New Mexico Press.

Comisión Chilena de Derechos Humanos y Fundación Ideas. 1999. *Nunca más en Chile: Síntesis corregida y actualizada del Informe Rettig.* Santiago: LOM Ediciones.

284 Culp, Kristine. 1994. "The Entrepreneurial Success of Women Artists in Developing Countries." *Canadian Woman Studies* 15(1): 59.

Cushman, Thomas. 1995. *Notes from Underground: Rock Music Counterculture in Russia.* Albany: State University of New York Press.

Dorfman, Ariel. 1978. "The Invisible Chile: Three Years of Cultural Resistance." *Praxis* 4: 191–197.

Dorros, Arthur. 1991. *Por fín es Carnaval.* Translated by Sandra Marulanda Dorros. New York: Dutton Children's Books.

———. 1991. *Tonight Is Carnaval.* New York: Dutton Children's Books.

Drake, Paul W., and Iván Jaksić. 1991. Introduction to *The Struggle for Democracy in Chile, 1982–1990*, edited by Paul W. Drake and Iván Jaksić. Lincoln: University of Nebraska Press.

Dusselier, Jane. 2005. "Gendering Resistance and Remaking Place: Art in Japanese American Concentration Camps." *Peace & Change* 30(2): 171–204.

Eakin, Marshall. 2007. *The History of Latin America: Collision of Cultures.* New York: Palgrave Macmillan.

Easton, Alison. 2000. "Subjects-in-time: Slavery and African-American Women's Autobiographies." In *Feminism and Autobiography: Texts, Theories, Methods*, edited by Tess Cosslett, Celia Lury, and Penny Summerfield, 169–182. London: Routledge.

"Economic Model Exhibit Chronology." 1995. Exhibition pamphlet. Washington, D.C.: Institute for Policy Studies.

Ellison, Kathy. 1978. "Chilean Displays in L.A.: Protest through Tapestries." *Los Angeles Times* 8: 4–5, September 10.

Ensalaco, Mark. 2000. *Chile under Pinochet: Recovering the Truth.* Philadelphia: University of Pennsylvania Press.

Farge, William. 2006. "The Politics of Culture and the Art of Dissent in Early Modern Japan." *Social Justice* 33(2): 63–76.

Fisher, Jo. 1993. *Out of the Shadows: Women, Resistance and Politics in South America.* London: Latin American Bureau.

"Flying Colors." N.d. Exhibition catalogue. London: Doran-Grady.

Foxley, Ana María. 1981. "Trovadores del Canto Nuevo." *Hoy* (January 28–February 3): 35.

Franger, Gaby. 1987. *Arpilleras: Bilder die Sprechen Organisation und Altag der Frauen in den Slums von Lima: Katalogzur Ausstellung.* Nuremburg, Germany: Schalomgruppe CVJM Gibitzenhof.

———. 1988. *Arpilleras, cuadros que hablan: Vida cotidiana y organización de mujeres.* Lima: Taller de Artesanía "Mujeres Creativas."

Frank, Patrick. 2003. "Uruguayan Printmakers and the Military Dictatorship." *Studies in Latin American Popular Culture* 22: 1–20.

Fresard, M. J. 1972. *Lo que se puede hacer con arpillera.* Barcelona: Ediciones CEAC.

Fundación Missio Cristo Vive. N.d. *Talleres artesanales de mujeres.* Santiago: Fundación Missio Cristo Vive.

Gianturco, Paola, and Toby Tuttle. 2000. *In Her Hands: Craftswomen Changing the World.* 3rd ed. New York: Monacelli Press.

Glaser, Barney, and Anselm Strauss. 1967. *The Discovery of Grounded Theory: Strategies for Qualitative Research.* Chicago: Aldine Publishing.

Goldfarb, Jeffrey. 1982. *On Cultural Freedom: An Exploration of Public Life in Poland and America.* Chicago: University of Chicago Press.

Gómez Burón, Joaquín. 1989. *Arpillera.* Madrid: Ediciones Iberoamericanas Quorum.

Graburn, Nelson. 1976. *Ethnic and Tourist Arts: Cultural Expressions from the Fourth World.* 285
Berkeley: University of California Press.

Gready, Paul. 2003. *Writing as Resistance: Life Stories of Imprisonment, Exile, and Homecoming from Apartheid South Africa.* Lanham, MD: Lexington Books.

Griffin, Dustin. 1994. *Satire: A Critical Reintroduction.* Lexington: University Press of Kentucky.

Griswold, Wendy. 1992. "The Writing on the Mud Wall: Nigerian Novels and the Imaginary Village." *American Sociological Review* 57 (December): 709–724.

Gutiérrez, Gustavo. 1971. *Teología de la liberación.* Lima: CEP.

Guzmán, Juan. 2005. "Notes from Judge Guzmán's CLAS Lecture: Truth, Justice and Reconciliation in Chile." Talk given at the University of California at Berkeley, Center for Latin American Studies, April 25. http://clas.berkeley.edu/Events/spring2005/04–25–05 –guzman/Guzman-notes.pdf.

Hájek, Igor. 1994. "Czeck Culture in the Cauldron." *Europe-Asia Studies* 46(1): 127–142.

Halaby, Samia A. 2004. *Liberation Art of Palestine: Palestinian Painting and Sculpture in the Second Half of the 20th Century.* New York: H.T.T.B. Publications.

Hardy, Clarisa. 1984. *Los talleres artesanales de Conchalí: La organización, su recorrido y sus protagonistas.* Santiago: Programa de Economía del Trabajo, Academia de Humanismo Cristiano.

———. 1987. *Organizarse para vivir: Pobreza urbana y organización popular.* Santiago: Programa de Economía del Trabajo.

Haynes, Jonathan. 2003. "Mobilising Yoruba Popular Culture: Babangida Must Go." *Africa: Journal of the International African Institute* 73(1): 77–87.

Henderson, James. *A Reference Guide to Latin American History.* Armonk, NY: M. E. Sharpe.

Herlad, Jacqueline. 1992. *World Crafts: A Celebration of Designs and Skills.* London: Charles Letts.

Herreras Vivar, Jesús. 1991. *Esuché sus gritos . . .* Santiago: Editorial Mosquito Comunicaciones.

Hörner, Heide. N.d. *Muñecos de arpillera.* Barcelona: Ediciones CEAC.

Hutchings, Margaret. 1977. *Creaciones con arpillera.* Buenos Aires: Kapelusz.

"Immagini di un ambiente e di un'epoca attraverso la vita delle donne: Cile una cronaca." 1977. *Abitare* 160 (December): 70–72.

Jacques, André, and Geneviève Camus. 1977. *Chili, un peuple brode sa vie et ses luttes.* Paris: CIMADE.

Jones, Cherlyn. 2004. "Jung and the *Arpilleristas* Phenomenon." The Jung Center of Central Florida. http://www.jungcenter.com/articles/chileanwomen.html.

Kanakis, Yiannis. 2005. "Chanter la nation: La parole chantée dans le nationalisme kurde." *Outre-Terre* 10(1): 361–373.

Kapiszewski, Diana, ed. 2002. *Encyclopedia of Latin American Politics.* Westport, CT: Oryx Press.

Ksinan, Suzanne, and Liz Bannister. 1990. *Teaching Human Rights through Chilean Arpilleras: Elementary School Unit: A Provincial Tour of British Columbia Schools.* Vancouver: CoDevelopment Canada.

Kunzle, David. 1978. "Art of New Chile: Mural, Poster, and Comic Book in the 'Revolutionary Process.'" In *Art and Architecture in the Service of Politics,* edited by Henry A. Millon and Linda Nochlin, 356–381. Cambridge: MIT Press.

———. 1982a. *Chile Vive.* Mexico City: Centro de Estudios Económicos y Sociales del Tercer Mundo y Instituto de Investigaciones Estéticas U.N.A.M.

———. 1982b. "El mural chileno: Arte de una revolución. La arpillera chilena: Arte de protesta y resistencia." In *Chile Vive,* edited by Centro de Estudios Económicos y Sociales

286 del Tercer Mundo, Instituto de Investigaciones Estéticas, Universidad Nacional Autónoma de México. Mexico City: Centro de Estudios Económicos y Sociales del Tercer Mundo.

La Duke, Betty. 1985. *Compañeras: Women, Art and Social Change in Latin America.* San Francisco: City Lights Books.

Lippard, Lucy. 1984. *Get the Message? A Decade of Art for Social Change.* New York: E. P. Dutton.

Lira, Winnie. 1989. Letter to Señora Ana María Cartagena. October 26. Santiago: Vicaría de la Solidaridad.

————. 1990. Letter to Señora Ana María Cartagena. January 24. Santiago: Vicaría de la Solidaridad.

Lorenzen, Ana María, and Christer Hamp. 1986. *Arpilleras: Textilkonst Från Santiago de Chile.* Stockholm: Etnografiska Museet.

Lowden, Patricia. 1996. *Moral Opposition to Authoritarian Rule in Chile, 1973–90.* Houndmills, UK: Macmillan Press.

Magnussen, Anne. 2006. "Imagining the Dictatorship, Argentina 1981 to 1982." *Visual Communication* 5: 323–344.

Marín, Lynda. 1991. "Speaking Out Together: Testimonials of Latin American Women." *Latin American Perspectives* 18(3): 51–68.

McAdam, Doug, Sidney Tarrow, and Charles Tilly. 2001. *Dynamics of Contention.* New York: Cambridge University Press.

"Memoria annual–1993." 1993. Pamphlet. Santiago, Chile: Fundación Solidaridad: 1–4.

"The Military Coup of 1973." 1995. Exhibition pamphlet. Washington, D.C.: Institute for Policy Studies.

Millares, Manolo, and C. L. Popovici. 1957. *Las arpilleras de Millares.* Madrid: Cuadernos de Arte del Ateneo de Madrid.

Milon, Elisabeth. 2000. "Signs of Collaboration and Resistance." *European Journal of (Higher) Arts Education* 3(1): 42–49.

Montecinos, Verónica. 1997. "Economic Reforms, Social Policy, and the Family Economy in Chile." *Review of Social Economy* 55(2): 224–234.

Moreno Aliste, Cecilia. 1984. *La artesanía urbano marginal.* Santiago: CENECA.

Morris, Nancy. 1984. *Canto porque es necesario cantar: The New Song Movement in Chile, 1973–1983.* Albuquerque, NM: Latin American Institute, The University of New Mexico.

Moser, Annalise. 2003. "Acts of Resistance: The Performance of Women's Grassroots Protest in Peru." *Social Movement Studies* 2(2): 177–190.

Moya-Raggio, Elena. 1984. "*Arpilleras:* Chilean Culture of Resistance." *Feminist Studies* 10(2): 277–290.

Munizaga, Giselle. 1988. *El discurso público de Pinochet: Un análisis semiológico.* Santiago: CESOC/CENECA.

Neustadt, Robert. 2001. *CADA DIA: La creación de un arte social.* Santiago: Editorial Cuarto Propio.

Obododimma, Oha. 1998. "Inter/art/iculations of Violence in Contemporary Nigerian Poetry and Graphic Art." *Mosaic: A Journal for the Interdisciplinary Study of Literature* 31(2): 165–183.

"Olla común distinta." 1976. *Solidaridad* 6 (October): 3. Santiago: Vicaría de la Solidaridad.

"'Olla común de ideas': Una muestra del Cristo sufriente." 1976. *Solidaridad* 7 (October): 2. Santiago: Vicaría de la Solidaridad.

Olukotun, Ayo. 2002. "Traditional Protest Media and Anti-Military Struggle in Nigeria 1988–1999." *African Affairs* 101: 193–211.

Oppenheim, Lois Hecht. 2007. *Politics of Chile: Socialism, Authoritarianism, and Market* 287
Democracy, 3rd ed. Boulder, CO: Westview Press.

Oxhorn, Philip. 1995. *Organizing Civil Society: the Popular Sectors and the Struggle for Democracy in Chile*. University Park: Pennsylvania State University Press.

Paiva, Manuel, and María Hernández. 1983. *Arpilleras: Chile, 1983*. Santiago: Unknown publisher; content of book created by *arpilleristas* of Peñalolén and T.A.C. (Taller de Acción Cultural).

Paley, Julia. 2001. *Marketing Democracy: Power and Social Movements in Post-Dictatorship Chile*. Berkeley: University of California Press.

Palmeri, Frank. 2003. *Satire, History, Novel: Narrative Forms, 1665–1815*. Newark: University of Delaware Press.

Panyella, August, ed. 1981. *Folk Art of the Americas*. New York: Abrams.

Parezo, Nancy. 1999. "Tourism and Taste Cultures: Collective Native Art in Alaska at the Turn of the Twentieth Century." In *Unpacking Culture*, edited by Ruth B. Phillips and Christopher B. Steiner, 423–456. Berkeley: University of California Press.

Parker, Scott, and Bill Meyerhoff. 1990. *Teaching Human Rights through Chilean Arpilleras: Secondary School Unit: A Provincial Tour of British Columbia Schools*. Vancouver: CoDevelopment Canada.

Phillips, Brenda D. "Women's Studies in the Core Curriculum: Using Women's Textile Work to Teach Women's Studies and Feminist Theory." *Feminist Teacher* 9(2): 89–92.

Puryear, Jeffrey M. 1994. *Thinking Politics: Intellectuals and Democracy in Chile, 1973–1988*. Baltimore: The John Hopkins University Press.

Qureshi, Lubna. 2009. *Nixon, Kissinger, and Allende: U.S. Involvement in the 1973 Coup in Chile*. Lanham, MD: Lexington Books.

Raczynski, Dagmar, and Claudia Serrano. 1985. *Vivir la pobreza: Testimonios de mujeres*. Santiago: CIEPLAN.

Razeto, Luis, Arno Klenner, Apolonia Ramírez, and Roberto Urmeneta. 1990. *Las organizaciones económicas populares 1973–1990*. Santiago: Programa Económica del Trabajo.

Rear Window. 1990. Episode from *Broken Silence* 1:4. Great Britain: Bandung Limited and Channel Four.

Reichelberg, Ruth, and Judith Kauffmann. 2000. *Littérature et résistance*. Reims: Presses Universitaires de Reims.

Remer, Abby. 2001. *Enduring Visions: Women's Artistic Heritage around the World*. Worcester, MA: Davis Publications.

Rojas, Anita. N.d. Transcribed speech. Washington, D.C.: Institute for Policy Studies.

Rosenfeld, Alla, and Norton T. Dodge, eds. 2002. *Art of the Baltics: The Struggle for Freedom of Artistic Expression under the Soviets, 1945–1991*. New Brunswick: Rutgers University Press and Jane Voorhees Zimmerli Art Museum.

Rosenfeld, Stephanie. 1995. "Human Rights in Chile." Letter to the editor. *NACLA: Report on the Americas* 28(5): 4–47.

Rowinsky-Geurts, Mercedes. 2003. "Hilando memorias: La re-configuración y transmisión del discurso chileno en los tapices de la esperanza." *Taller de Letras* 33: 35–45.

Sabatini, Francisco. 1995. *Barrio y participación: Mujeres pobladoras de Santiago*. Santiago: Instituto de Estudios Urbanos, Pontificia Universidad Católica de Chile; Ediciones SUR, Centro de Estudios Sociales y Educación.

Sánchez, Daniela. 1987. "Instituciones y acción poblacional: Seguimiento de su acción en el período 1973–1981." In *Espacio y poder: Los pobladores*, edited by Jorge Chateau et al., 123–170. Santiago: FLACSO.

288 "San Francisco en arpilleras." 1976. *Solidaridad* 7 (October): N.p.

Schechner, Richard. 1998. "From 'The Street Is the Stage.'" In *Radical Street Performance*, edited by Jan Cohen-Cruz, 196–207. London: Routledge.

Schilken, Marnie. 2001. "The Art of Women's Health and Rights [Part 2 of 4]." *Women's Health Journal* (Latin American and Caribbean Women's Health Network) 31 (October): N.p.

Schirmer, Jennifer. 1994. "The Claiming of Space and the Body Politic within National-security States: The Plaza de Mayo Madres and the Greenham Common Women." In *Remapping Memory: The Politics of Timespace*, edited by J. Boyarin, 185–220. Minneapolis: University of Minnesota Press.

Schneider, Cathy Lisa. 1995. *Shantytown Protest in Pinochet's Chile*. Philadelphia: Temple University Press.

Scott, James. 1985. *Weapons of the Weak: Everyday Forms of Peasant Resistance*. New Haven: Yale University Press.

Sepúlveda, Emma. 1996. *We, Chile: Personal Testimonies of the Chilean Arpilleristas*. Translated by Bridget Morgan. Falls Church, VA: Azul Editions.

Sigmund, Paul. 1977. *The Overthrow of Allende and the Politics of Chile, 1964–1976*. Pittsburgh: University of Pittsburgh Press.

Silva, Eduardo. 1991. "The Political Economy of Chile's Regime Transition: From Radical to 'Pragmatic' Neo-liberal Policies." In *The Struggle for Democracy in Chile, 1982–1990*, edited by Paul W. Drake and Iván Jaksić, 103. Lincoln: University of Nebraska Press.

Silva, Patricio, and Herwig Cleuren. 2009. "Assessing Participatory Democracy in Brazil and Chile: An Introduction." In *Widening Democracy: Citizens and Participatory Schemes in Brazil and Chile*, edited by Patricio Silva and Herwig Cleuren, 1–23. Leiden, The Netherlands, and Boston, MA: Brill.

Skidmore, Thomas E., and Peter H. Smith. 2005. *Modern Latin America*. 6th ed. New York and Oxford: Oxford University Press.

Smith, Brian. 1982. *The Church and Politics in Chile*. Princeton, NJ: Princeton University Press.

Snook, Peg. 1992. "A Song, a Dance, a Needle and Thread: (En)gendering Resistance in Chile." Master's thesis, Syracuse University.

Snyder, Kathlyn J. 1994. "Chilean *Arpilleras*: Embroidered Stories." In *Fifth Annual Student Achievement Awards for Excellence in Feminist Scholarship: Award Winning Papers 1993–1994*. Wayne, NJ: The New Jersey Project.

Sorensen, Kristin. 2009. *Media, Memory, and Human Rights in Chile*. New York: Palgrave Macmillan.

Sosaferrari, Ana Maria. *In the Name of the Mother: A Reading of the Peruvian Arpilleras and the Assassination of Maria Elena Moyano*.

Soto, Ximena, et al. 1981. "Les ateliers de fabrication d'arpilleras au Chili." Master's thesis, Université Paris VII.

Spivak, Gayatri Chakravorty. 1988. "Can the Subaltern Speak?" In *Marxism and the Interpretation of Culture*, edited by Cary Nelson and Lawrence Grossberg, 271–316. Urbana: University of Illinois Press.

Spooner, Mary. 1999. *Soldiers in a Narrow Land: The Pinochet Regime in Chile*. Berkeley: University of California Press.

Stephen, Michael. 1990. "Makonde: Sculpture as Political Commentary." *Review of African Political Economy* 48: 106–115.

Steiner, Friederike. 1998. *Kultureller Wandel in Chile von 1969–1993: Dargestellt am Beispiel der "Literatura Testimonial," der Liedbewegung, des Muralismo und der Arpilleras*. Münster: Lit.

Svašek, Maruška. 1997. "The Politics of Artistic Identity: The Czech Art World in the 1950s and 289
1960s." *Contemporary European History* 6(3): 383–403.

Taller de Acción Cultural. 1986. *La organización fue como nacer de nuevo.* Santiago: Taller de
Acción Cultural.

"Tapestries for Life: A Chilean Chronology." N.d. Exhibition organized by Isabel Letelier.
Washington, D.C.: Institute for Policy Studies.

Taylor-Tidwell, Sharon. 1993. "Visual Narrative in Chilean Arpilleras: Testimonios Gráficos."
Ph.D. diss., Southern Illinois University at Carbondale.

Teitelboim, Berta, ed. 1990. *Serie de indicadores económico sociales: Indicadores económicos y
sociales, series anuales, 1960–1989.* Santiago: Programa de Economía del Trabajo.

Tenenbaum, Barbara, ed. 1996. *Encyclopedia of Latin American History and Culture.* New York:
Charles Scribner's Sons.

Testimonies of the Urban Poor: Sewing and Housing Cooperatives in Santiago Shantytown. 1989.
Joseph L. Scarpaci, dir. VHS. University of Iowa.

Threads of Hope. 1996. Donald Sutherland, et al., dir. VHS.

Thunholm, Pia. 1991. *Arpilleras: Tygapplikationer sydda av kvinnor I Salvador Allendekommittén,
Södertälje.* Södertälje: Bildningsnämnden och Invandrarnämnden.

Trasciatti, Mary Anne. 1991. *Chilean Arpilleras: A Rhetorical Study.* Ph.D. diss., Emerson
College.

Unknown author. 1992. "Magic of Sewing Stories: *Arpilleras* of Latin America." *Women in
Action* (September 30): 26.

Valdés, Cecilia. 1991. Exhibition of *Arpilleras* of the Exile Group Comité Salvador Allende in
Sala de Arte Municipal of Södertälje, Sweden.

Valdés, Teresa. 1988. *Venid, benditas de mi Padre: Las pobladoras, sus rutinas y sus sueños.*
Santiago: FLACSO.

Valdés, Teresa, and Marisa Weinstein. 1993. *Mujeres que sueñan: Las organizaciones de
pobladoras: 1973–1989.* Santiago: FLACSO.

Valenzuela, Arturo. 1991. "The Military in Power: The Consolidation of One-Man Rule." In
The Struggle for Democracy in Chile, 1982–1990, edited by Paul W. Drake and Iván Jaksić,
25–29. Lincoln: University of Nebraska Press.

Vicaría de la Solidaridad: Historia de su trabajo social. 1991. Santiago: Vicaría de la Solidaridad.

"La vida de los talleres y la microempresa." N.d. Pamphlet. Santiago, Chile: Fundación
Solidaridad: 6–12.

Voionmaa, Flora, and Seija Heinänen. 1988. *Arpilleras: Tilkkutöitä Chilestä.* Jyväskylä: Suomen
kotiteollisuusmuseo.

Voionmaa Tanner, Liisa. 1987. *Arpillera chilena: Compromiso y neutralidad: Mirada sobre un
fenómeno artístico en el período 1973–1987.* Santiago: Pontificia Universidad Católica de
Chile.

Williams, Kathleen. 2007. *Arpilleras: The Colorful Appliqués of Peru.* Tucson: CRIZMAC Art
and Cultural Education Materials.

Williamson, Sue. 1989. *Resistance Art in South Africa.* Cape Town and Johannesburg: David
Philip.

Wright, Thomas C., and Rody Oñate, eds. 1998. *Flight from Chile: Voices of Exile.* Translated by
Irene B. Hodgson. Albuquerque: University of New Mexico Press.

"Zona Oriente: *Arpilleras* para San Francisco." 1976. *Solidaridad* 7 (October): 2. Santiago:
Vicaría de la Solidaridad.

Index